Graphic Design USA:10

The American Institute of Graphic Arts

The American Institute of Graphic Arts is the national non-profit organization which promotes excellence in graphic design. Founded in 1914, the AIGA advances the graphic design profession through competitions, exhibitions, publications, professional seminars, educational activities, and projects in the public interest.

Members of the Institute are involved in the design and production of books, magazines, and periodicals as well as corporate, environmental, and promotional graphics. Their contributions of specialized skills and expertise provide the foundation for the Institute's program. Through the Institute, members form an effective, informal network of professional assistance that is a resource to the profession and to the public.

The AIGA network continues to grow throughout the country, with seven new chapters in the last year alone. Separately incorporated, AIGA chapters enable designers to represent their profession collectively on a local level. Drawing upon the resources of the national organization, chapters sponsor a wide variety of programs dealing with all areas of graphic design.

By being a part of a national network, bringing in speakers and exhibitions from other parts of the country and abroad, focusing on new ideas and technical advances, and discussing business practice issues, the chapters place the profession of graphic design in an integrated and national context.

The competitive exhibition schedule at the Institute's gallery includes the annual Book Show and Communication Graphics. Other exhibitions may include Illustration, Photography, Covers, (book jackets, record albums, magazines, and periodicals), Posters, Signage, and Packaging. The exhibitions travel nationally and are reproduced in *Graphic Design USA*. Acquisitions have been made from AIGA exhibitions by the Popular and Applied Arts Division of the Library of Congress. Each year the Book Show is donated to the Rare Book and Manuscript Library of Columbia University, which houses the AIGA collection of award-winning books dating back to the 1920's. For the past six years, the Book Show has also been exhibited at the Frankfurt Book Fair.

The AIGA sponsors a biennial national conference covering topics including professional practice, education, technology, the creative process, and design history. The 1989 conference is being held in San Antonio, Texas.

AIGA also sponsors an active and extensive publications program. Publications include *Graphic Design USA*, the annual of the Institute; the *Journal of Graphic Design*, published quarterly; the AIGA Salary Survey 1987; Graphic Design Education Statement; a voluntary *Code of Ethics and Professional Conduct* for AIGA members; Standard Form of Agreement for Graphic Design Services; *Symbol Signs Repro Art*, a portfolio containing 50 passenger/pedestrian symbols originally designed for the U.S. Department of Transportation and guidelines for their use; and a *Membership Directory*.

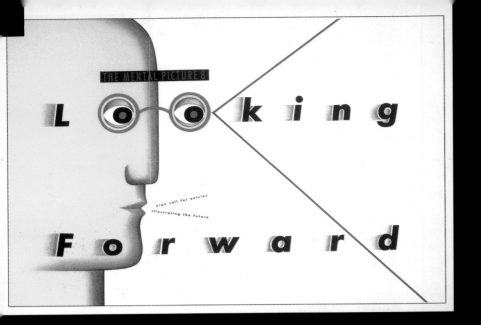

THE MENTAL PICTURE 8

L o o k i n g

aiga call for entries
illustrating the future

F o r w a r d

ISBN 8230-0176-8
Printed in Japan by Dai Nippon Printing Co., Ltd.
Type set by U.S. Lithograph, typographers, New York, New York
First Printing, 1989
Distributed outside the U.S.A. and Canada by RotoVision, S.A.
10, rue de l'Arquebuse, case postal 434, CH-1211 Geneva 11, Switzerland.

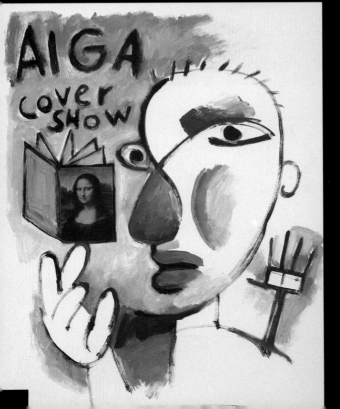

**Communication
graphics**

**Call for entries
1988 / 1989**

Graphic Design USA:10
The Annual of the American Institute of Graphic Arts

Written by Steven Heller, R. Roger Remington, Ellen Lupton,
and Karrie Jacobs
Designed by Anthony Russell
Photography by Reven T.C. Wurman

Contents

AIGA BOOK SHOW

the AIGA for the "intellectual profit" of its members were interested in a community of the mind; and that the institution that has grown through the cumulative contribution of Goudy and other practitioners through time is as strong and vulnerable as their work, and deserving of attention and care.

The AIGA annual was developed a decade ago to provide archival attention to our ongoing programs and competitions that identify excellent design—a program that dated back to our beginnings. A decade is a long time, a period in which our annuals have become a permanent and valuable resource in their role as inspiration for designers, impetus for clients, and documentation and context for historians to come.

I would like to extend our special thanks to the chairmen and juries who selected the work and determined the awards that are documented in this book. Our thanks also to Tony Russell, not only for his elegant design but also for his willingness to serve as the good shepherd throughout the production process; and to Bob Appleton for making the jacket jump. Our special thanks to our members who make our programs possible to our president, Nancye Green, for the focus and clarity of her stewardship; and to the Board for its guidance through this period of continued growth and change.

Caroline Hightower
Director

Past Presidents of the AIGA

1914–1915	William B. Howland
1915–1916	John Clyde Oswald
1917–1919	Arthur S. Allen
1920–1921	Walter Gilliss
1921–1922	Frederic W. Goudy
1922–1923	J. Thomson Willing
1924–1925	Burton Emmett
1926–1927	W. Arthur Cole
1927–1928	Frederic G. Melcher
1928–1929	Frank Altschul
1930–1931	Henry A. Groesbeck,
1932–1934	Harry L. Gage
1935–1936	Charles Chester Lane
1936–1938	Henry Watson Kent
1939–1940	Melbert B. Cary, Jr.
1941–1942	Arthur R. Thompson
1943–1944	George T. Bailey
1945–1946	Walter Frese
1947–1948	Joseph A. Brandt
1948–1950	Donald S. Klopfer
1951–1952	Merle Armitage
1952–1953	Walter Dorwin Teague
1953–1955	Dr. M. F. Agha
1955–1957	Leo Lionni
1957–1958	Sidney R. Jacobs
1958–1960	Edna Beilenson
1960–1963	Alvin Eisenman
1963–1966	Ivan Chermayeff
1966–1968	George Tscherny
1968–1970	Allen Hurlburt
1970–1972	Henry Wolf
1972–1974	Robert O. Bach
1974–1976	Karl Fink
1976–1977	Massimo Vignelli
1977–1979	Richard Danne
1979–1981	James Fogleman
1981–1984	David R. Brown
1984–1986	Colin Forbes
1986–1988	Bruce Blackburn

Seventy-Five Years of the AIGA

by Steven Heller and Nathan Gluck

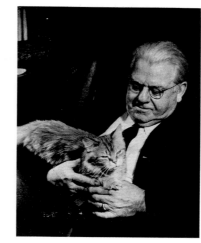

THE AIGA BEGAN AS THE OLD GUARD OF A new profession. Its charter members were not the rebels typically associated with a cultural avant-garde but veteran professionals— craftsmen and artisans —who believed that an institute would increase understanding and recognition of their craft within and outside their sphere of influence.

The AIGA was conceived during a time of worldwide cultural and social flux when print was decidedly the most important communications medium. Old commercial systems were being replaced by highly competitive markets, and industry and business were furiously producing goods and services as never before. All this required more intense salesmanship, and so advertising came into its own as a profession. Printing presses ran around the clock producing reams of ads, promotions, periodicals, and books.

Professional "designers" emerged from the large print shops to make order out of the visual clutter that characterized the ephemera of the 19th century. Though new technologies gave rise to new, more sophisticated standards of graphic presentation, some practitioners harkened back to simpler times when typography was a high art. Fearing that the classical methods were becoming endangered, members of the graphic arts communities in Boston and New York were attracted to the Arts and Crafts eclecticism of the 19th-century English designer/philosopher William Morris. His philosophy was adopted as a means to produce a graphic art based on the integrity of materials and workmanship, which was both of its time and inextricably wed to historical models. This was most apparent in book design but soon influenced advertising, too. The renaissance men who led the way, among them Daniel Berkely Updike, Frederic W. Goudy, and W.A. Dwiggins, soon became the most active members of an institute created for the propagation of their ideals and the exhibition of their wares.

Early in 1911, 14 people, graphic artists and kindred souls interested in the advancement of printing as an art, decided to meet twice monthly at the prestigious National Arts Club overlooking New York's exclusive Gramercy Park. Calling themselves the Graphics Group, they held informal meetings every other week without bylaws or minutes, simply to exchange ideas about production and aesthetics, grouse about the marketplace, and listen to prominent guest speakers talk about their specialties, including Max Weber on poster design and Alfred Stieglitz on photography.

Located only minutes away from the Lexington Avenue Armory, site of the legendary "Armory Show" which introduced modern art to America, the National Arts Club was a rather conservative group of easel painters and sculptors. Yet the club enthusiastically supported the graphic arts by making its facilities available and, for several years, had even organized an exhibition of "The Best Books of the Year." In 1914 the board of the National Arts Club realized that some remarkable cultural achievements were happening in the graphic arts and proposed to form its own organization dedicated as a "source of pleasure and intellectual profit." William H. Howland, publisher and editor of *The Outlook*, was elected its first president. The name, American Institute of Graphic Arts, was suggested

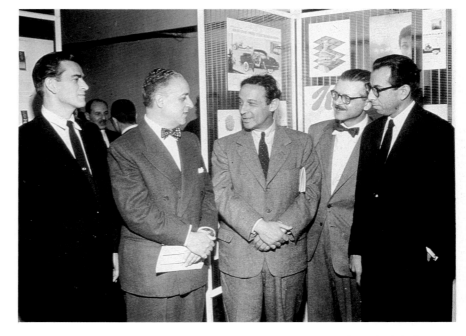

A small sample of publications produced by chapters.

by Charles DeKay, who wrote a constitution and bylaws whose foundation was:

To stimulate and encourage those engaged in the graphic arts; to form a center for intercourse and the exchange of views of all interested in these arts; to publish books and periodicals, to hold exhibitions in the United States and participate as far as possible in the exhibitions held in foreign countries relating to graphic arts; to invite exhibitions of foreign works; to stimulate the public taste by school exhibitions, lectures, and printed matter; promote the higher education in these arts, and generally to do all things which will raise the standard and aid the extension and development of the graphic arts in the United States.

Among the founding members were pioneers of American typeface, poster, and book design, including F.G. Cooper and Frederic W. Goudy, as well as the masters of fine and commercial printing, Hal Marchbanks (The Marchbanks Press) and William Edwin Rudge (the Rudge Press, which published *Print* magazine for its first decade).

Upon moving from the National Arts Club to private offices, annual dues of $25 were charged to pay for rent with only one other requirement for membership: each member had to buy his own Windsor-type chair. The $25 fee was soon after reduced to $10.

THE AIGA EVENTUALLY ABSORBED THE Graphics Group and began a campaign for broader national membership. A recruitment prospectus announcing that eligibility included "those interested in the graphic arts throughout the United States, including artists, printers, publishers, etchers, engravers, photographers, lithographers, and electrotypers" caused one of America's leading draftsmen and charter AIGA member, Joseph Pennell, to write: "By what stretch of the imagination could photography be included as one of the graphic arts?" The term graphic art, however, became an umbrella covering all forms of print communications. And in the early 1920s when W.A. Dwiggins, writing in *The Boston Globe* coined a new professional honorific by referring to himself as a graphic designer, the AIGA became even more liberal in its definition of what was graphic art.

AIGA's membership roster from its first two decades attests to its far-reaching interests. Among them were jewelry and glass designer Louis Comfort Tiffany, illustrator and editor Charles Dana Gibson, printer A. Colish, typographer and posterist Lucien Bernhard, package and trademark designer Clarence Hornung, photographer Clarence White, advertising designer and typographer T. M. Cleland, and typographer and book designer Rudolph Ruzicka. AIGA was not an "old boys' club" either; its first women members were Frances Atwater, a typesetter at *The New York Times,* and Florence N. Levy, director of the Baltimore Museum of Art.

In those early days, fine commercial printing was the major concern of the Institute. In 1921 Goudy was elected president, underscoring a devotion to typography. The first "Fifty Books of the Year" show was started in 1922. AIGA's early exhibitions furthered the interest in lithography, engraving, and etching. And for a few years the Institute awarded gold, silver, and bronze medals to those deemed best in the various shows. But in 1925 it was decided that such awards were not as meaningful as a single annual medal presented to one individual for significant contributions to the graphic arts. The AIGA

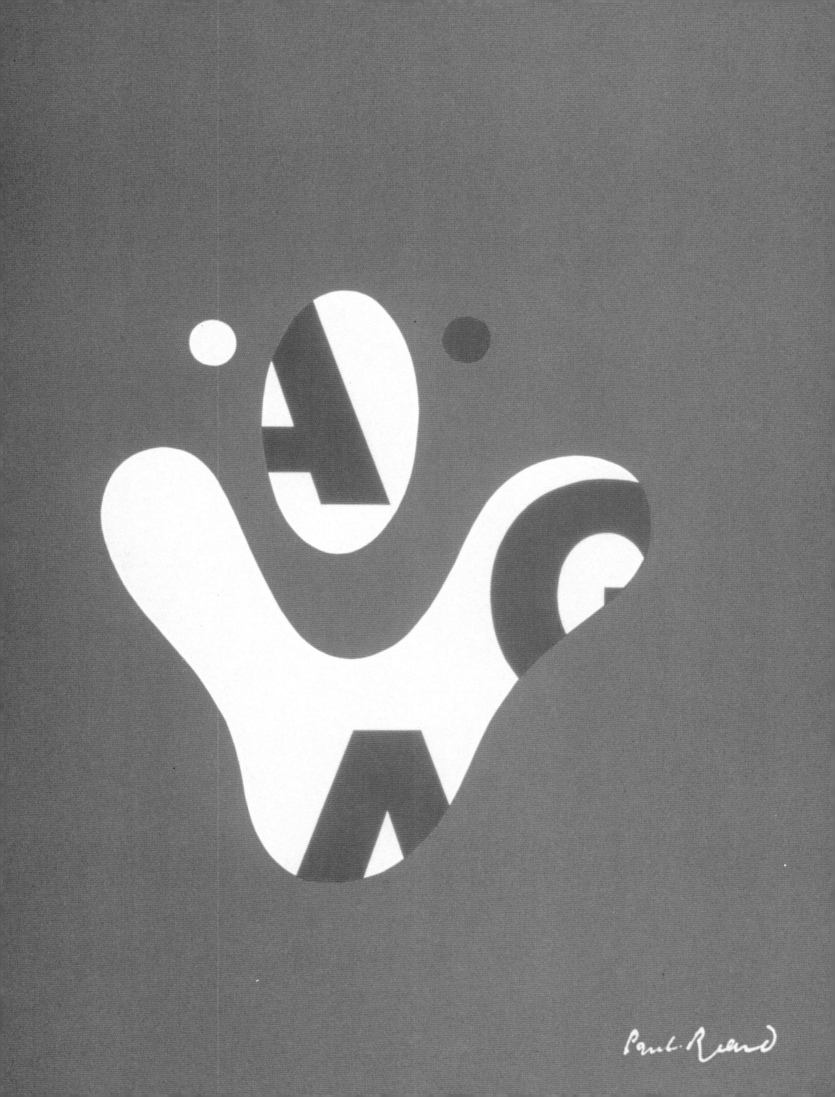

The Officers and Directors of
The American Institute
of Graphic Arts
cordially invite you to
attend a reception in honor
of the 1978-79 Medalist

LOU

ALVIN LUSTIG

graphic design 1936-1955

March 1 to March 25, 1977

Opening: Tuesday, March 1 at 5:30 p.m.

Exhibition planned by Elaine Lustig Cohen & Tamar Cohen

The American Institute of Graphic Arts

1059 Third Avenue, New York 10021

5 East 40th Street
New York 16

American Institute
of Graphic Arts

Calligraphy, Type design,
Typography and Book design
by HERMANN ZAPF

An outstanding collection of
working drawings and ephemera
November 11 - December 2
Weekdays 9 - 5:30

Members' Preview: Thursday
November 10th, 5 - 7:30 pm

Medal, designed by James Earle Frazer, designer of the
Indian head/buffalo nickel, was first awarded to the book
designer/publisher Bruce Rogers. A "Medalist" has been
announced every year since with the exception of 1936-38,
1943, and 1949 for reasons not recorded.

As early as 1923, nationwide programs were initiated and a
newsletter was published. Though headquarters were located
in New York (and moved often, from the Art Centre, to the
Squibb Building, to the Japan Paper Co. building, to Grand
Central Palace, to the Architectural League building, to the
Bedford Hotel, and to numerous other locations) there were
over 500 members in 15 states making it a formidable force
within the industry.

In 1924 the AIGA lobbied for a standardization of process
colors which was finally enacted in 1930 by the Association of
Ink Manufacturers and the American Association of Advertis-
ing Agencies. In 1926 an education committee was formed
with affiliations to New York University which offered courses
in fine printing and decorative typography. In 1927 the first
showing of American book illustration was mounted, and
reference works and catalogs in these areas were published.
1930 marked the beginning of the first of various design
clinics, a program of workshops and study groups taught by
leading practitioners. That same year the Carnegie Corpora-
tion awarded the AIGA a $5,000 grant—a considerable sum
during the Depression days—for its "widespread efforts to
promote and enchance graphic design."

The AIGA was so active and highly publicized for its efforts
that in 1929 incorporation papers were filed. The following
year Blanche Decker was hired as its first full-time employee
(and she retired in 1958 after almost 30 years of service). In
1931 dues were raised to a whopping $15, but the return was
more than worth it, given the large number of annual pro-
grams. Throughout the decade, Institute members proved
liberal in their tastes and interests as evidenced by the range of
exhibits and publications. For example, the first AIGA show of
comic strips was covered by CBS-TV and NBC-Radio. This
variety was also reflected by its past presidents who were drawn
from an expansive universe of graphic arts activity, including
Henry L. Gage, vice president of Mergenthaler Linotype Co.;
Charles Chester Lane, a *New York Times* executive; Henry
Watson Kent, secretary of the Metropolitan Museum of Art;
Arthur R. Thompson, a Bell Telephone Laboratories execu-
tive: Joseph A. Brandt, president of Henry Holt & Co., and
M. F. Agha, art director of Conde Nast.

In 1948 the first issue of a bimonthly *Journal* replaced the
AIGA Newsletter to serve the needs of its 1,000 members and
broaden the coverage of design journalism. That same year
Stanton L. Catlin was named the first executive director, and
he initiated a fund-raising campaign to support education,
research, and promotion. Many of the long-range objectives at
that time ring a familar note, including, chapters throughout
the country—including undergraduate chapters in colleges
(indeed the first student chapter was started at Carnegie
Institute of Technology); workshops with presses for printing
courses; establishment of a graduate school of graphic arts to
supplement existing programs; a speaker's service; and a
graphic arts information service.

After the war, a shift in the graphic arts field from a mix of
fine and commercial printing to corporate communications
and packaging began to be reflected in the AIGA membership
and programs. The influx of emigré European graphic design-

**Advertising for *Graphic Design
for Non-Profit Organizations*,
published by AIGA in 1980.**

**Department of Transportation
Symbol Signs, published in
1977.**

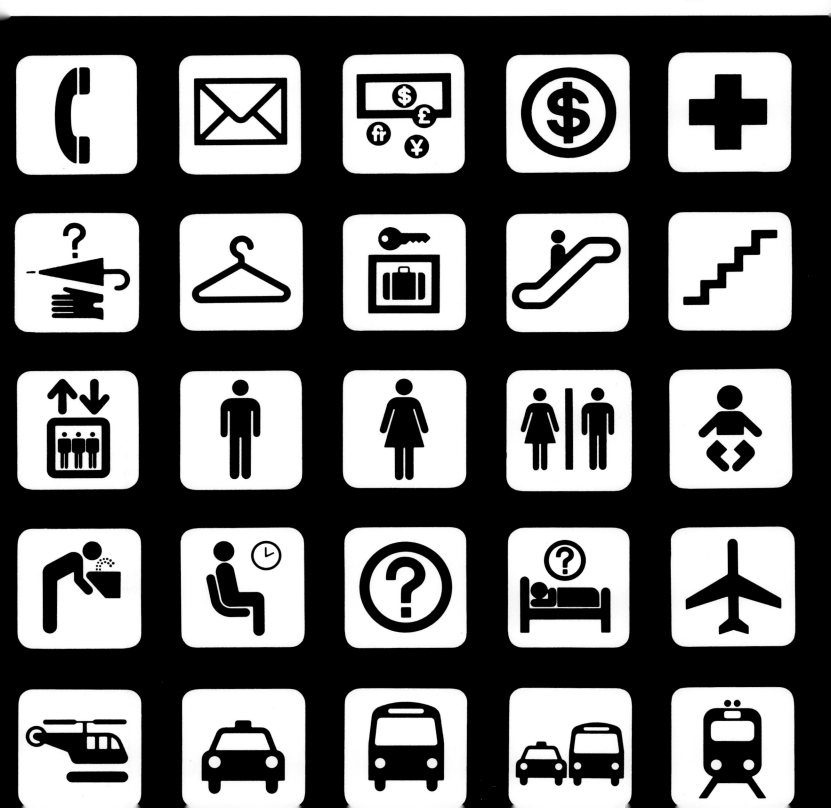

ONE COLOR

TWO COLOR

CALL FOR ENTRIES

DEADLINE 10 NOVEMBER

AIGA

THE AMERICAN INSTITUTE OF GRAPHIC ARTS

ers contributed to increased awareness of design as a business tool—changes in form, content, and media were profound. Though "Fifty Books of the Year" was still a popular show (evidenced by the fact that in 1950 it opened simultaneously in New York, Boston, Philadelphia, Chicago, Washington, and San Francisco), more progressive design disciplines were being recognized as well. Advertising was emerging from the primordial clutter of early years to a modern aesthetic wed to expressive type and photography. And as evidenced by the AIGA's first magazine competition and show in 1950, this field was benefiting from the influence of Bauhaus. Industrial design was also included under AIGA's umbrella, and in 1952 the AIGA headquarters was designed by the subsequent year's president, Walter Dorwin Teague.

By the mid-1950s, the old guard gave way to a new guard of modernists. In 1955 Leo Lionni, then the art director of *Fortune* Magazine, was elected president. Under his tenure, the first "Fifty Packages of the Year" exhibit was planned, and Henry Wolf, then the art director of *Esquire*, was selected as editor/art director of the AIGA's first annual (which, however, was never realized). In 1958 Edna Beilenson, a publisher and printer, was elected the first woman president, and May Massee, executive of Viking Junior Books, was chosen the first woman medalist.

THE AIGA ENCOURAGED SOME OF THE finest talents in graphic design to share their knowledge with students and young professionals. Lectures and workshops, often pegged to specific exhibits, were frequent occurrences at the New York headquarters and elsewhere. One of the most legendary events was a 10-week course in typography and photojournalism conducted by Alexey Brodovitch (regrettably, no record of the proceedings was ever made). In 1961 the New York headquarters moved to their present location at 1059 Third Avenue where an exhibition of Asian graphic design was held for the first time in the United States. Chermayeff & Geismar designed and mounted an exhibition called "Graphic Trends," distributed through the USIA to introduce the Soviet Union to American practice. And the USIA circulated other AIGA exhibits in Europe, Latin America, and the Orient. Taking a cue from the defunct Composing Room Gallery, the AIGA also mounted one-person shows of designers and illustrators, including Herb Lubalin, Paul Rand, Lou Dorfsman, Rudolph de Harak, and James McMullan. Indeed the AIGA exhibitions have been a major and curiously untapped source of design history.

In 1970 the AIGA and the Graham Foundation for Advanced Studies in the Fine Arts co-sponsored "The Sign and the City," an environmental graphics exhibition, which was simultaneously displayed indoors and outdoors (behind the main branch of the New York Public Library). In 1974 Seymour Chwast and James McMullan conceived the "Mental Picture" show to thematically exhibit new directions in illustration. In 1976 "Fifty Books of the Year" was opened to an unlimited number of books and renamed "The Book Show." In 1966 the AIGA *Journal* was redesigned to include exhibition catalogs, and later many other important catalogs were separately produced. In 1980 these documents were replaced by the first annual, *Graphic Design U.S.A*, designed by James Miho.

As a national resource for design and designers, the AIGA

(Opposite)
Call for entry for the One-Color, Two-Color competition, 1986-87. Design by Michael Mabry.

Calls for entry:
(top left)
Functional Graphics, 1985-86. Design by Rudolph de Harak.

(top right)
The Cover Show, 1985-86. Design by Paul Bacon.

(middle left)
Design and Printing for Commerce, 1959. Design by Gene Federico.

(middle right)
Design for the Public Good, 1987. Design by Kristin Breslin.

Certificate of Excellence for the Humor Show, 1986. Design by Tibor Kalman.

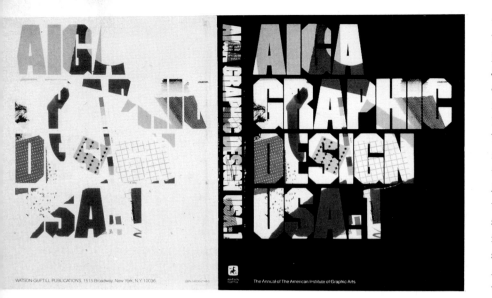

Volume 1: Thomas Geismar,
designer.

Volume 5: Bradbury Thompson,
designer.

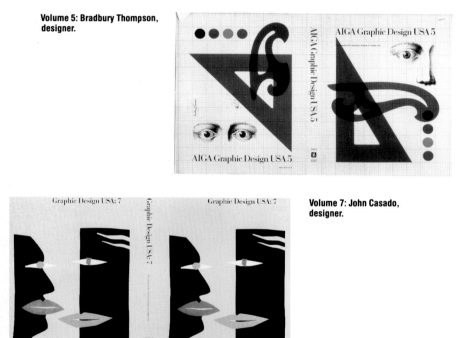

Volume 7: John Casado,
designer.

was asked in 1977 by the United States Department of Transporation to collaborate in the research and design of a program of symbols and guidelines. The resultant *DOT Symbol Signs* was published as a book and introduced throughout the country as the recommended visual signage for public buildings. For its work on the DOT program, the AIGA received a Presidential Design Citation. Under a grant from the New York State Council on the Arts in 1977, AIGA sponsored a national seminar called "Communications for Nonprofit Institutions." Subsequently, AIGA published *Graphic Design for Non-Profit Organizations* by Massimo Vignelli and Peter Laundy with a grant from the National Endowment for the Arts. That same year, in conjunction with an exhibition of subway maps from around the world, a debate on urban design was cosponsored by the AIGA, the Municipal Art Society, and the Architectural League of New York. In 1984 the *Code of Ethics* was published. In 1985 the first biennial AIGA national conference, titled "Toward a Design Community," was held in Boston, amid the tumult of Hurricane Gloria.

In 1981 Robert O. Bach proposed formation of a broad network of chapters and began by organizing one in Philadelphia, which became a prototype for the new chapters. With "community" as its watchword, the AIGA has launched chapters in almost 30 cities. In 1988 the first annual AIGA chapter retreat was held in Minneapolis to discuss programs and strategies. Local groups have taken responsibility for the programming once nationally initiated, while exhibitions of national import continue to be judged at AIGA headquarters in New York.

Throughout its 75 years, the American Institute of Graphic Arts has been devoted to the principles of its founders and has indeed *stimulated and encouraged those engaged in the graphics arts; and {has} forged a center for intercourse and for exchange of views of all interested in these arts*. Continuing this legacy, this year the Walker Art Center in association with the AIGA opened "Graphic Design in America: A Visual Language History," the first major exhibition on the history of American graphic design. As dedicated as it is to its past, AIGA nevertheless represents the design profession as a business and cultural force today. It documents its milestones, mirrors its trends, and analyzes its present and future. Caroline Hightower, our director, has often quoted Igor Stravinsky when commenting on our past and present: "'A real tradition is not a relic of the dead past, irretrievably gone, it is a living force that animates and informs the present.' We've evolved and prospered over the past 75 years because our founders established a broad educational mission with a concern for posterity and the importance of creative continuity. In founding the AIGA they were looking to the future, and that concern still animates and informs our present. We are looking forward."

Jackets of the AIGA annual,
Graphic Design USA.

The AIGA Medal

For 67 years, the Medal of the American Institute of Graphic Arts has been awarded to individuals in recognition of their distinguished achievements and contributions to the graphic arts. Medalists are chosen by an awards committee, subject to approval by the Board of Directors. This year the committee chose to recognize two individuals, William Golden (posthumously) and George Tscherny.

1988 Awards Committee

Chairman
Douglass Scott
Senior Designer
WGBH

Committee

Michael Bierut
Vice President of Graphics
Vignelli Associates

Mildred Friedman
Design Curator
Walker Art Center

Jerry Herring
President
Herring Design

Noel Martin
Designer
Cincinnati Art Museum

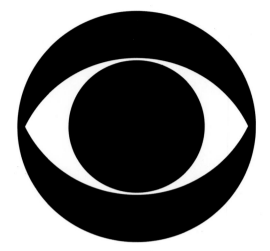

William Golden, Pioneer with a Passion for Excellence

by Roger Remington

William Golden applied new ideas, forms, and methods to the world of advertising and promotional graphics. The body of his work endures as a milestone in the history of graphic design. Providing a map of uncharted territory, Golden's program of promotional advertising and identity design for CBS was innovative and set a standard of excellence which has endured over the years. He was among a distinguished group of pioneers in the post-World War II era who gave shape to the emerging field of graphic design.

The primary responsibility of the designer is the communication of the client's message. Golden understood this goal and made it his first priority. He described the advertising designer as "part small businessman and part artist." On another occasion, he asserted that the artist and the designer were "two completely different things."

"I think that all the trouble in this field comes from someone's assumption that they are, maybe, the same person. I think the fine artist makes a personal statement about his world and his reactions to his world. He makes it to a limited audience or to a big audience —but it's all his. The advertising designer has a completely different function. He may be someone who thought he wanted to be a painter—but wasn't. If {the designer} is honest enough, he becomes a professional who can do something special. But this something special is for sale—it is communicating something that is not his own. I think the trouble comes when he tries to make it a work of art, too. I think a lot of designers who are talented and intelligent don't find this very satisfying. But they're not going to find it more satisfying by pretending it's something it isn't."

The youngest of 12 children, Golden was born on the lower east side of Manhattan on March 31, 1911. His formal schooling ended up on graduation from the Vocational School for Boys where he studied photoengraving and design. At 17, a tough and self-reliant young man, he left home to work in a lithography and photoengraving firm in Los Angeles. While there he also worked in the art department of the Los Angeles *Examiner*. Following his return to New York in the early 1930s, Golden worked as a promotional designer for Hearst's *Journal-American*. Within a few years, he had joined the staff of *House and Garden*, one of the Conde Nast magazines. He learned much during his years of apprenticeship under Dr. M. F. Agha, who, in Golden's words, "forced the people who worked for him to try constantly to surpass themselves." Golden left Conde Nast in 1937 to join the promotion department at the Columbia Broadcasting System. He was promoted to art director three years later. In 1941 Golden took a leave of absence from CBS to work for the Office of War Information in Washington. Later he served in Europe as art director of army training manuals and was discharged in 1946 with the rank of captain.

When Golden returned to CBS, television was the medium of the hour. Golden became the chief architect for the bold new graphic identity program for CBS. He selected Didot Bodoni as the typeface to be used in all CBS corporate applications. The famous eye symbol was developed to provide special identification for CBS Television. Kurt Weihs, who was involved in the project, remembers that the eye had its beginnings in an article in *Portfolio* about the then relatively esoteric subject of Shaker design.

"Among the illustrations was an eye symbol. Golden picked it

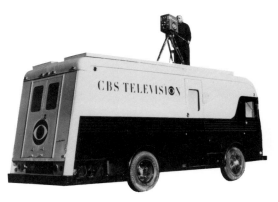

CBS identity elements applied
to vehicle used for remote
location broadcasts.

Sure, Television's amazing

–and it's practical, too!

You're missing the ball in Television
if you don't realize how well
it's paying off today. For example:
the cost of audiences actually delivered
by a full-hour CBS-TV program
is 7% lower than the cost of reaching
people through the average full-page
newspaper advertisement. Clearly,
Television is practical. And leading all
Television is WCBS-TV which
consistently delivers the largest
audiences of all New York stations,
quarter-hour by quarter-hour,
seven days a week. More people tune
more often to CBS-TV programs
than to any other—indicating clearly
where the advertiser can be
most practical in Television today.

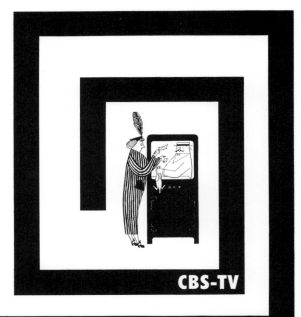

CBS-TV

NOW OPERATING IN 19 MAJOR MARKETS

One of a series of mailing
cards tells the effectiveness
of a new advertising medium
in an understated way.
William Golden, when asked
if he was influenced by
Mondrian in designing this
series, simply replied, "No!"

up and used it for a CBS sales portfolio. Then he felt there was more to it and used it in an ad. I redesigned the earlier versions, and it became the mark for CBS Television. We had done eyes before. Everybody had done eyes; but this one was something that really worked. I felt that the eye could have become the corporate symbol. We saw the eye as symbolizing CBS 'looking at the world.'"

THE EYE HAD ITS PREMIERE ON CBS TELEvision on November 16, 1951, overlaid on a photograph of cloud-filled sky. The symbol was quickly put to use in all aspects of identification for CBS Television. Its ubiquity caused Golden some second thoughts: "It is used so often that it sometimes seems like a Frankenstein's monster to me, but I am grateful it is such a versatile thing that there seems to be no end to the number of ways it can be used without losing its identity." Years after Golden's death, Lou Dorfsman, his successor at CBS, offered this praise of this symbol and its creator.

"Today as we watch the most transforming medium of our time, there is a Golden graphic message seen daily by more people than have seen a single mark of modern man. It is that majestically simple CBS eye, as beautifully appropriate when he designed it in 1951 as it is today. If I can interpret it in the special ironic way of Bill Golden, it is there to watch over our professional successes as well as spot our transgressions."

Golden carried forward the work Agha and Brodovitch had done in demonstrating that the designer in a corporation must have a role not only in the communication of ideas but in the generation of ideas as well. He insisted on playing a part in corporate policy-making.

This was supported by his working relationship with Frank Stanton, president of CBS, which continued for 20 years. They were close friends who shared a drive for excellence and a belief in the efficacy of good visual form.

Under Golden's leadership, CBS Television was clearly in the forefront of graphic design in the early 1950s. The art department, recalls George Lois, was "an atelier; it was the place to be. All the design had to be perfect: the thinking, the concepts, the production. It was the only job in America . . . Bill protected the place. We did thousands of jobs—ads, trailers, letterheads, charts, and folders. We did tons of work, and every job had to be perfect."

Golden was at his best when he was able to evolve the premise and the concept for the advertising. He was a brilliant copywriter with, as Will Burtin put it, "a sense for the explosive impact of words." Even though Golden was largely self-educated, his mind had scope. "Bill had read enormously, and his thinking was clear and bold," recalled Ben Shahn. "The world of advertising and publicity exercised no tyranny over him." Golden made enthusiastic use of European ideas in the areas of typography, photography, and layout. Golden brought the world's top artists in as free-lancers to tell the story of broadcasting at CBS in its advertisements and publications.

In developing, directing, and sustaining the visual program at CBS, Golden set an entirely new standard for American design. All the trade ads, promotional materials, reports, and other corporate design applications done at CBS during his tenure were of a consistently high aesthetic quality. That this level of excellence was taken for granted is especially impressive in view of Golden's insistence that the work was based on business and marketing objectives; in the visual problem-

(Below and following spread) Ad for CBS Radio using antique trade symbols to point up a new selling symbol—the radio microphone.

How to get them into stores

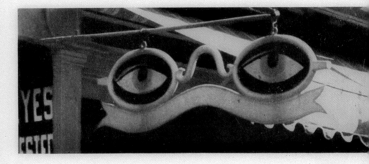

Of all the
to tell people
the most effective

devices men have used

what they have to sell,

is the microphone . . .

And this one reaches them today
at lower cost than any other advertising medium,
or any other microphone.

solving process, aesthetics were clearly secondary. It was a case of the corporation's and the designer's objectives being in harmony.

And finally, Golden himself had this to say of the nature of his work: "The kind of effort that goes into graphic expression is essentially lonely and intensive and produces, at its best, a simple logical design. It is sometimes frustrating to find that hardly anyone knows that it is a very complicated job to produce something simple."

Golden's very strengths proved, in one important sense, his greatest weakness. His drive for excellence and his natural introversion took their toll on his health. The heart attack which claimed his life at the age of forty-eight on October 23, 1959, was shock to his family and colleagues. He left a void in the field of graphic design.

One of Golden's colleagues John Cowden remembers those final years. "Simply because Bill cared so much, fought so hard, and performed so well, he prevailed and was able to give CBS advertising a distinction and quality second to none. Part of the responsibility of being in advertising meant that the designer must have the courage of his or her convictions . . . a bulldog tenacity for the things he or she believed in . . . and the recognition that constant vigilance is the price of freedom." Golden leaves this challenge of excellence as his legacy to those of us who follow.

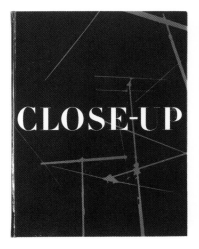

A 112-page book, illustrated by Ben Shahn, based on a 78-minute script. Adapted from the three-hour original play of The Old Vic Company.

Cover for an 80-page book about television in its early days. *Close-up* was an example of the CBS tradition of publishing books to document important historical events.

Cover and two-page spread from a 136-page book which traced the history of CBS Radio. Produced with outstanding new photographs, this book was written by Robert Strunsky.

Spread from the book "Blue Conventions" with illustrations by British artist Felix Topolski. To reproduce the pen-ink-wash illustrations faithfully, the book was printed in four colors on blue-grey paper.

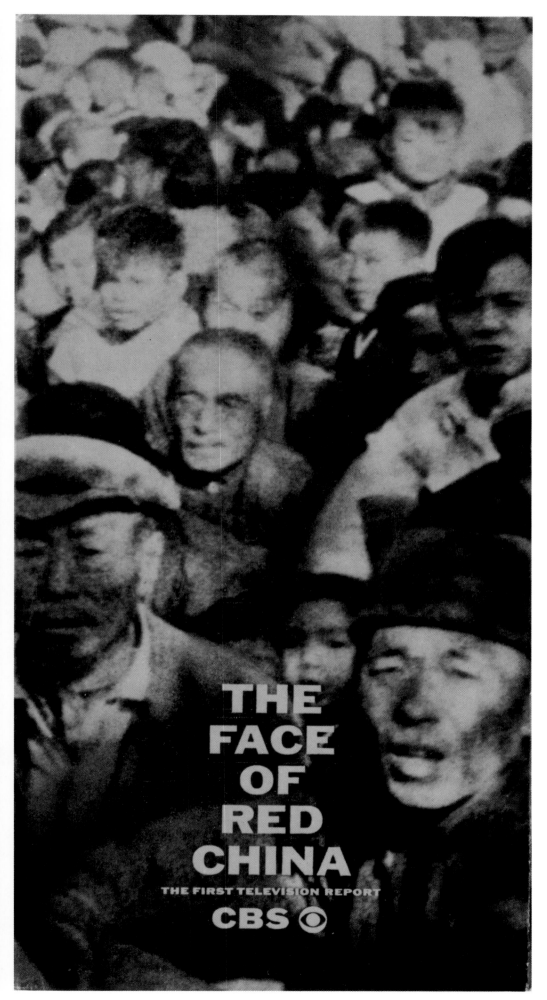

THE
FACE
OF
RED
CHINA
THE FIRST TELEVISION REPORT
CBS ◉

A book cover which contained the full script of this documentary television program.

Ad for New York television station showing Golden's wit when using typography.

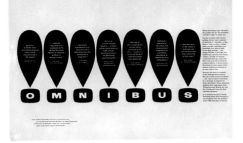

Double-page trade ad which contained comments by critics. This ad was produced as part of a campaign for the Omnibus program.

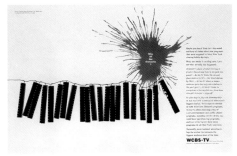

Trade ad which dramatized new programs on a local New York television station.

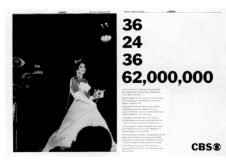

Audience size was emphasized in the headline of this double-page trade advertisement.

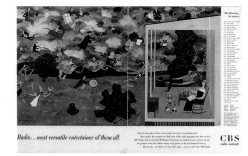

Double-page trade
advertisment

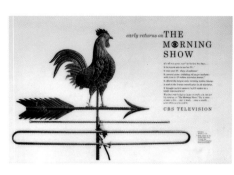

An antique weather vane is
used as a symbol for CBS
communications program
which included ads, bro-
chures, and on-the-air titles
for an early morning program.

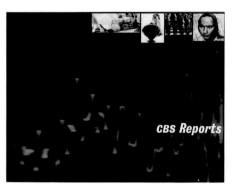

Brochure cover used to
announce a new series of
documentary programs.

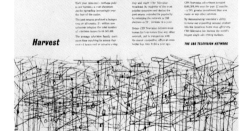

A classic Golden work from
1955, this advertisement il-
lustrated by Ben Shahn shows
Golden's interest in using fine
artists in CBS promotion
materials.

Page from a four-page folder
which utilizes drawings by
Ben Shahn to set the stage
for the dramatic side of radio.

The empty studio . . .

No voice is heard now. The music is still. The studio audience has gone home.

But the *work* of the broadcast has just begun. All through the week . . . *between* broadcasts . . .
people everywhere are buying the things this program has asked them to buy. Week after week.
From the beginning, the country's shrewdest advertisers have chosen network radio
to maintain this *weekly* contact with their customers.

And in all radio, no voice speaks today with more eloquent authority or economy than
that of CBS—first choice, among all networks, of America's largest advertisers.

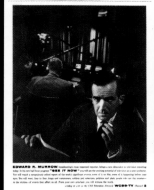

Full-page newspaper ad for "See it Now" which features a dramatic photographic portrait of Edward R. Murrow by Arnold Newman.

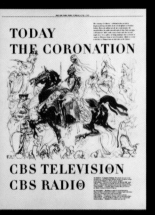

A full-page newspaper ad, illustrated by Felix Topolski, announces the coronation of Queen Elizabeth to an audience in America.

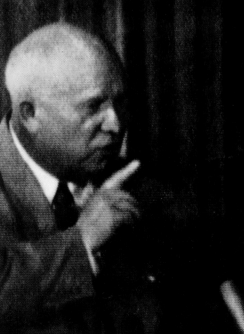

A full-page newspaper ad using a photograph of Kruschev, taken from the television screen, which communicates the urgency of the message.

A full-page newspaper advertisement from 1953 which featured an animated puppet. The puppet was used in other on-the-air promotions.

A newspaper ad from 1959 for the *Playhouse 90* production of "For Whom the Bell Tolls" by Ernest Hemingway. The ad features a dramatic illustration by artist ben Shahn.

ties. Bath room little
ground. £3 15s.—We

Anyone poss
about the case
man convicted of
Mathry at 611 River

Distressed G
ciation appe
man aged 77 livi

DU PONT SHOW OF THE MONTH
PRESENTS A.J. CRONIN'S MYSTERY
"BEYOND THIS PLACE"
STARRING FARLEY GRANGER,
BRIAN DONLEVY, PEGGY ANN GARNER,
HURD HATFIELD AND SPECIAL
GUEST STAR SHELLEY WINTERS.
LIVE ON CBS TELEVISION ◉
NOV. 25, 1957, 9:30–11 PM, CNYT
SPONSORED BY E. I. DU PONT
DE NEMOURS & COMPANY

house. ~~Light~~ cooking ~~facil~~
~~clo~~sed. Telephone. Near Under-
~~0664.~~

~~MI~~SSING INFORMATION
~~If~~ Rees Mathry ~~is~~ innocen~~t~~
~~of m~~urder, please contact ~~P~~
~~St~~reet.

~~GE~~NTLEFOLK'S AID AS~~S~~
~~ks~~ for widow of professio~~nal~~
~~m~~alone, fractured spine a~~nd~~

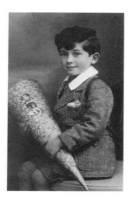

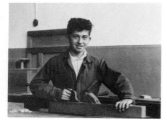

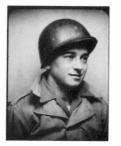

The Disarmingly Simple Design of George Tscherny

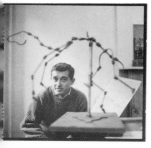

TOMAS GONDA

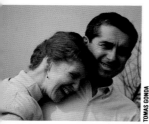

Entering ''Volksschule''
Berlin, Germany 1931

Studying cabinet making
''Ambacht School''
Amersfoort, Holland 1939

With the U.S. Army
Paris, France 1944

The first studio
New York 1956

Sonia and George, 1965

(Opposite)
Sonia and George, 1985
From ''New York design''
The Hennegan Company,
publisher

by Steven Heller

Over 30 years ago, George Tscherny decided that the real ''kick'' of design was to keep his hands firmly on all projects, not to supervise other designers' work. He is now, as he always has been, the sole proprietor of a small office located on the ground floor of his narrow New York City brownstone where he, his wife Sonia (''the conscience of the office''), and two or three assistants attend to the communications needs of some of America's most prestigious corporations. His surroundings are unpretentious, but his design is strong, provocative, and highly conceptual. Though not constricted by design canon or theory, Tscherny is respectful of the modern traditions, as evidenced by the balance between the accessibility and excitability in a broad range of his posters, annual reports, and advertisements.

Tscherny has given fresh design ideas to his clients for over three decades, but more significantly, he has toppled corporate Goliaths' misconceptions of graphic design and designers. Tscherny's professional life has been devoted to educating the people who manage business to the idea that design should not be a cosmetic service but an integral part of their corporate culture. His success as a designer can be traced back to his childhood, adolescence, and early professional years when his resolve to overcome the vicissitudes of fate proved to him how important tenacity can be.

George Tscherny was born in Budapest in 1924, but was raised in Germany from the age of two. ''Hungary,'' he says, ''exists for me only on my birth certificate.'' His mother, a Hungarian with a fervent anti-Fascist bias, so disapproved of

her nation's dictator, Admiral Horthy, that she vowed never to let her children speak Hungarian. His father was Russian, so not even the name Tscherny is Hungarian, rather a German spelling of the Russian word for *black*.

Tscherny recalls little of those early years in Germany. He knows only that his father was arrested for illegally entering the country, jailed for two days, and then allowed to settle in Berlin. However, he has total recall of the cultural stimuli on which his career is based. One such memory is of a neighborhood movie theatre, a virtual palace with huge display windows featuring a visual tableau advertising the current film. ''I remember the display for *All Quiet on the Western Front*. It had real foxholes, gas masks, and helmets. But more impressive was the huge handpainted poster of a movie star on the side of the building. This was my first awareness of graphic design —and even then I realized it was what I wanted to do.''

THE TSCHERNY FAMILY LIVED IN RELATIVE peace in a poor working-class district called Moabit. Then came Adolf Hitler. Jews, especially foreign Jews, were unwelcome in the new Germany. Yet for George and his younger brother the hardships imposed by Nazi decrees were not as devastating as for others. Not until November 10, 1938, when the 14-year-old Tscherny's security was turned topsy-turvy. *Kristalnacht*, the night of broken glass, when all Jewish businesses and institutions were attacked by the Nazis, was a vivid omen of the terror to come. The following month George and his younger brother escaped across the German border into Holland. Eventually they hoped to be reunited with their parents, who were prevented from leaving Germany at that time.

Holland was a safe haven, and the Dutch welcomed thousands of youthful refugees. But when Tscherny's parents were finally allowed to leave Germany, hopes of retrieving their sons were dashed by the outbreak of war and the 1940 invasion and occupation of Holland. The Germans ordered all refugees moved 30 kilometers away from the border, and the young Tschernys were shuttled from home to home. Finally his brother went to a Jewish orphanage, and George was sent to a farm for a brief period.

In 1941 Tscherny's parents obtained the papers necessary to bring the boys to the United States. But France, where they hoped to find a ship, was already occupied by the Nazis, and the only scheduled transatlantic departures were from Lisbon, Portugal. ''It was a Catch-22 situation,'' recalls Tscherny. In order to get to Lisbon, he needed a transit visa to pass through neighboring Spain, but Portugal would not issue one unless Spain did, and Spain would not do so unless Portugal did. ''At this point I was 16, and I learned that the only place such visas were issued were at the consulates in Berlin,'' he recalls. So in 1941 Tscherny returned to the Nazi capital, where he learned that his parents had been deported as undesirable aliens and that he, too, was subject to the same order. He was summoned to Gestapo headquarters and remembers that ''an SS man screamed at me: 'Where do you get the nerve to come back after having been deported?' I was ordered to leave Germany.'' But owing to bizarre events, the former Berlin police prefect, a Jew who miraculously continued to have some influence in official circles, helped the boys obtain the proper papers.

Tscherny and his brother were seasoned refugees by the time they arrived on what he calls a ''floating concentration camp''

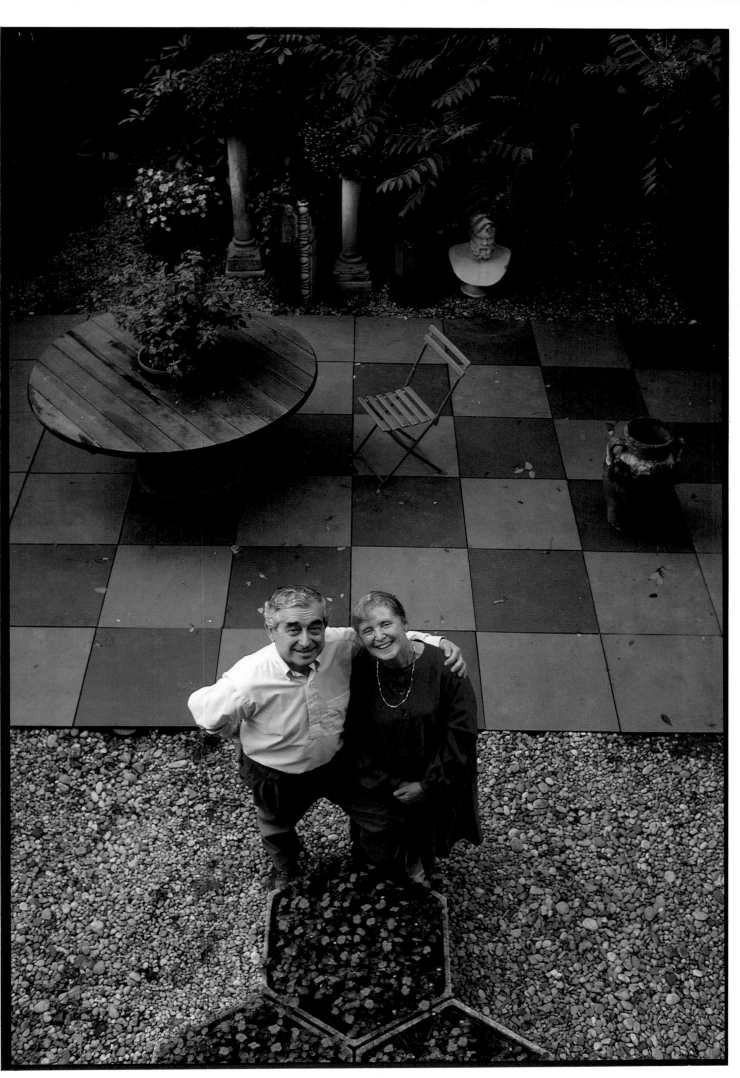

in New York harbor on June 21, 1941. "The boat sat all night off Staten Island," he says about the cathartic event, "and in the morning a tugboat pulled alongside, and a crewman held up a *Daily News* front page with the headline reading 'Germany Invades Russia.'"

His parents were already settled in Newark, New Jersey, where Tscherny took a job making automobile lights for 30 cents an hour. Not bad for a greenhorn who knew little English, but paltry for a boy who was determined to improve his lot. In 1942 he joined a government-sponsored training unit. "They made me a machinist in just six weeks," he says. However, enlisting in the army when he was 18 years old was "the best thing I could have done." With the $52 a month pay, regular meals, and a roof over his head, Tscherny had never had it so good.

Soon he was ordered overseas. Ironically, he landed in France on June 21, 1944, exactly three years to the day of his arrival in New York. While in Europe he served as an interpreter and later was attached to the headquarters of the Allied Military Government. Fortuitously, one of Tscherny's sergeants was a commercial artist who, in civilian life, worked for one of the big American advertising agencies. After learning about Tscherny's own desire to become an advertising artist, he took him under his wing. "I got my first understanding about design from him," says Tscherny.

After being discharged, he enrolled in the Newark School of Fine and Industrial Arts on the GI Bill. He wanted, however, to attend Pratt Institute in Brooklyn, but needed a high school diploma. So in addition to going to art school by day, he took academic courses at night. And when he found that he was lacking a few credits, he even took a course at a local high school during his lunch hour. A year later, he was accepted into Pratt.

But an even more significant piece of Tscherny's life fell into place at this time. As an aficionado of modern dance, he regularly attended performances at New York's old Ziegfeld Theatre where he met Sonia Katz. She, too, came from a German-speaking Jewish family forced to leave Europe. If they had remained in Europe (in better times, of course), their paths might never have crossed since class barriers were profound, and Sonia was from a wealthy family. But in the United States, they both understood the tribulations of being immigrants. They married and have been together ever since. Indeed, Tscherny cannot conceive of how different his life would have been without her intelligent and loving influence.

At Pratt Institute, industrial design was the hot department. While Tscherny was pretty good at making things with his hands, "I was afraid that industrial design would require too many intellectual activities. I was terrible at math and felt more comfortable going into graphic design where I believed I could bluff my way through." Bluffing, however, was not part of Tscherny's *modus operandi*. In his first year, he learned fast and studied feverishly on his own. In his second, he was placed into a class taught by Herschel Levitt, a highly acclaimed teacher. "It was as if I had walked through a swamp for one year and all of a sudden hit dry land," Tscherny says.

The late 1940s was a distinctly modern era of American design when pharmaceutical advertising and record album covers were reaching a creative crescendo. Tscherny devoured the work of Lester Beall, Bill Golden, and Bradbury Thompson, among other exemplars. He also developed his own approach, and soon became Levitt's "prize pupil." Levitt

ANGELO CARIERI

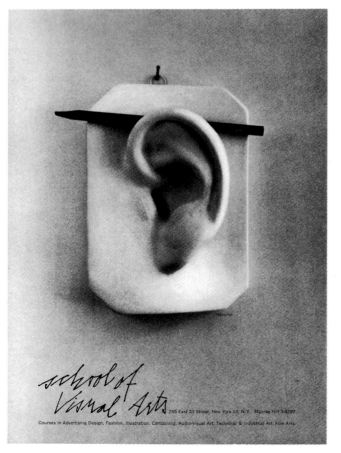

recommended Tscherny for his first job with Donald Deskey.

Deskey was the last of the glamorous industrial designers and had earned his reputation for the streamlined interiors of Radio City Music Hall, but in the late forties his office was doing staid packaging for Proctor & Gamble. Though Tscherny was not terribly excited about the prospect, he was urged to take the job. And only six weeks before graduation he went to the dean requesting permission to accept the job while completing the remaining assignments on the side in order to qualify for the diploma. The dean, a stickler for procedure, denied the request, and Tscherny left Pratt without graduating. Tscherny cut his teeth at the Deskey office rendering comps for toothpaste and shampoo packages. "By the time I left, two-and-a-half years later, I was still comping virtually the same packages."

N 1953 HE WAS HIRED BY GEORGE NELSON, THE visionary furniture and industrial designer and critic, as an assistant to Irving Harper who was responsible for designing trade advertising for the vanguard furniture manufacturer, the Herman Miller Co. As low man, Tscherny was given the sixth-of-a-page magazine ads to design. "I decided to make plums out of them," he says with pride, and he did an admirable job which earned him the full-page ad assignment. He eventually became head of the graphics department with a staff of his own.

"Working with Nelson was probably the most important thing that happened to me professionally," says Tscherny. "First of all, in those days the Nelson Office was *the* office and Herman Miller Co., his main client, shared the crown of *the* furniture company along with Knoll. I was literally thrown in with the elite of design. But more important, Nelson was one of the few articulate spokesmen for design then—and his ideas rubbed off on me. In fact, the most enduring lesson was not to bring preconceived ideas to any project. When Nelson designed a chair, for example, he didn't start with the assumption that it had four legs." But the key advantage for Tscherny was that Nelson had no proprietary interest in graphics. "He was interested in building three-dimensional monuments," continues Tscherny. "And he thought that graphic design was ephemeral.

"Although he liked me and appreciated what I was doing, he had no pressing need to involve himself in my area. That meant I could do almost anything within reason; I could experiment without anyone looking over my shoulder."

Tscherny believes that "design communicates best when reduced to the essential elements." Yet he has resisted the ideological traps of some design theory. His method derives not from a preordained rightness of form, but primarily from instinct. Indeed one of his most significant accomplishments at Nelson's was to break the cliché of how furniture was advertised. Most advertising agencies believed, that to sell effectively, furniture (and for that matter, many other products) should be presented in a photograph with some good-looking woman in the foreground. Tscherny knew that while some consumers might be seduced by this cheesecake, the approach also had negative connotations. For example, a heavy-set person might be insulted and therefore not relate to the product. He further realized that the professional audience wanted to see the product alone, but intuited that signifying a human presence was important in both cases. As a consequence, he developed a method called "the human element implied."

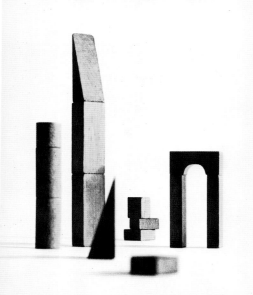

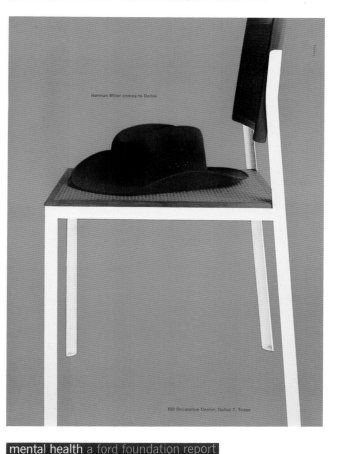

1962 Annual Report
Uris Buildings Corporation,
client

Advertisement, 1955
Herman Miller Furniture Co.,
client

Brochure, 1958
The Ford Foundation, client

Uris Buildings Corporation Annual Report-1962

Herman Miller comes to Dallas

160 Decorative Center, Dallas 7, Texas

mental health a ford foundation report

an appointment calendar with drawings from the collection of the museum of modern art

Art Auction Brunch

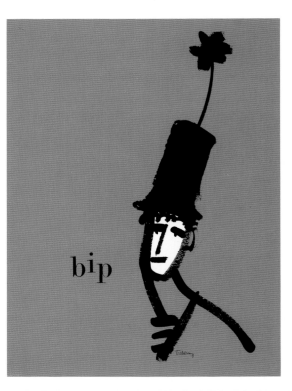

bip

A 1955 advertisement announcing the opening of a new Miller showroom in Dallas was the first time this approach was used. An extraordinarily simple design, it features two spare lines of sans serif type and a high contrast black-and-white photo of a chair with a cowboy hat resting on the seat. The ad is bathed in red ink with the chair legs dropped out in pure white. "By including the hat, I suggest Dallas," explains Tscherny, "while at the same time, I show the furniture in use, suggesting the human presence." Tscherny's promo did not discriminate against heavy or slim, ordinary or beautiful, male or female, but set an inviting stage. Years later he made a similarly provocative School of Visual Arts poster showing a plaster cast of an ear, symbolizing the study of art, with a real pencil tucked behind the ear, suggesting human practice. Human expression, rather than pure geometric form, has been the key feature of Tscherny's design.

At 30 years old, Tscherny decided that he wanted to start his own business. However, he did not want to become so big as to lose contact with his materials, and he admits, "I was afraid that it wasn't enough to simply *do* the work. Without a front.man or a partner who spoke well, I would have to *verbalize* what I was doing." The best way to hone persuasive skills, he thought, was by teaching. "If you are a conscientious teacher, you cannot just say to a student that something either stinks or is beautiful. You must tell them why. Teaching design for eight years at the School of Visual Arts {which was initially geared primarily for cartoonists and illustrators} trained me to the point where Sonia says that I can justify anything."

UNDER THE DIRECTION OF SILAS RHODES, Tscherny blazed a trail at the School of Visual Art. As no formal graphic design curriculum existed, his initial course was based on "what I would like to know if I were a student and what I missed as a student." In addition to assignments, Tscherny played recordings of jazz music and traced its origins, took students to off-Broadway theater, and exposed them to those cultural activities that were related to the broader design experience. His teaching method ran the gamut of philosophical extremes. "I attempted to teach the kids—as Nelson taught me—not to have preconceptions, but rather to be receptive to new ideas. Indeed, I am happiest when I do what I call 'Talmudic design;' when I look at the problem from top to bottom, ask myself questions, provide answers, and most important, try not to fall in love with any one answer until a mental bell rings."

Tscherny used Henri-Cartier Bresson's classic book of images *The Decisive Moment* to explain that design was not merely the decorative layering of type and image, but rather the need to capture, whether on film, canvas, or mechanical board, the *essence* of a subject. "Very often the decisive moment is manufactured," he says. "One sees it with commercials all the time. Even the flag-raising at Iwo Jima was set up. So I encouraged the students, regardless of subject, to find that essence in their problems, and let it be the focal point." In his own design, this takes various forms, such as the white face of Marcel Marceau in an otherwise red poster entitled "Bip," in which he captures the quintessential symbol of the mime. Or a poster advertising an exhibit of Picasso's sculpture, lithographs, and drawings on which Tscherny reproduces the three subtly different signatures Picasso used to sign each medium.

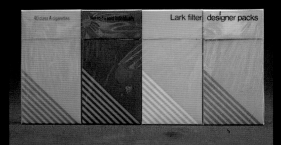

40 class A cigarettes Not to be sold individually Lark filter designer packs

40 class A cigarettes

Cigarette packaging, 1968
Liggett & Myers Tobacco C

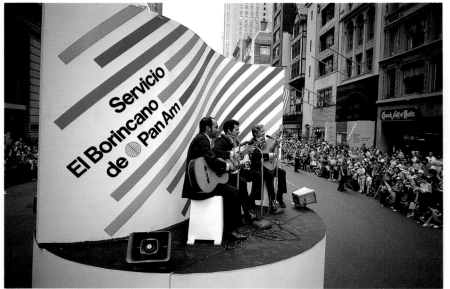

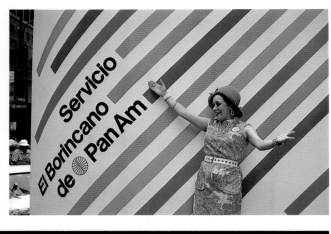

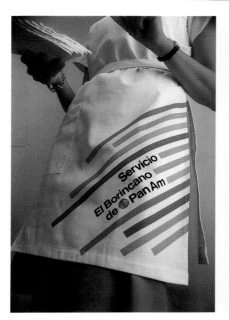

Image program, 1972
Revolving parade float
Apron for stewardess
Airport departure lounge
Pan American Airways, client

After eight years of teaching, Tscherny realized that he had learned all he could. "Up to that point, I designed like a cow grazes; just churning it out without really knowing. At SVA I learned how to talk about design and established certain concepts that have become indelible. When I started, it was virgin territory," he muses. "Silas Rhodes was the perfect client. He sensed what was good and allowed me to go as far as I wished. My early posters gave SVA a sort of presence." Moreover, Tscherny became impatient at having to be a disciplinarian. It was the 1960s, and students were becoming rebellious. "Chances are that I may have been a little what one might call Prussian in my methods," he admits. "But I always said that unless the student really assumes that he or she knows nothing (which is not the case) and the teacher knows everything (which is not the case either), the teaching process is difficult to accomplish. The student has to be extremely receptive and believing for it to work. But this was a time when questioning authority and arguing with the teacher became a sport. And I was increasingly frustrated."

He had already established a reputation for designing striking trade ads and promotions for the home furnishings industry, though as a one-man studio he sought clients in other fields. One of the first was an independent producer of souvenir programs for ballets and plays.

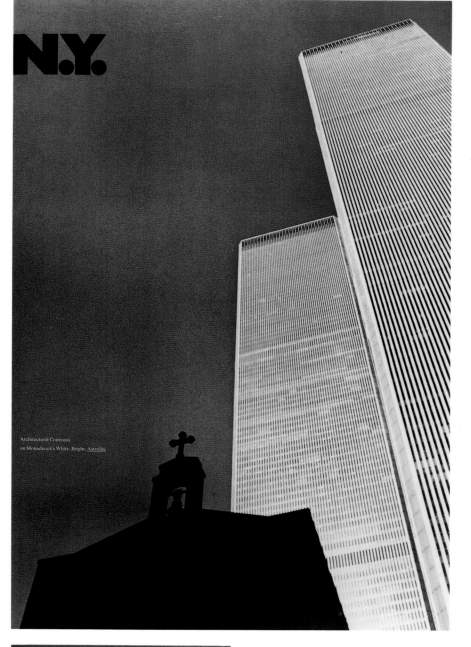

SILAS RHODES WROTE OF TSCHERNY'S WORK that "one sees popular art raised to the highest level." Indeed, he frequently relies on found objects —not necessarily cultural artifacts, such as old picture postcards, masks, and tiles, which he has used to illustrate some posters, calendars, and books —but secret graphic clues that he finds within a problem. One such discovery came when he had to graphically show that Ernst & Ernst, a large accounting firm, was changing its name to Ernst & Whinney, and found that by using the right typeface, if he turned the "E" 90 degrees it would become a "W." How simple and how memorable. A more vivid example of serendipity is a poster for Monadnock Paper Mills designed to show the contrast of its pure white paper. When folded, the poster entitled "NY" shows a stark silhouette of what appears to be a Spanish mission, but when unfolded, reveals that the church is actually in front of the gargantuan twin towers of the World Trade Center. Neither a montage nor manipulation, it was an intelligent use of a chance discovery.

Though assignments for paper companies, printers, and furniture clients are challenging, Tscherny's foremost challenge came when he entered the byzantine world of corporate communications. His first retainer client was The Ford Foundation for which he did all publications. "And that brought me to another level," Tscherny says. "I started working with printers—my first experience with quality-conscious craftsmen." It was also the first time he assaulted that ferocious beast known as the corporate annual report. He has since tamed many.

Tscherny has worked with a lion's share of what could be frankly called *difficult clients*, those relatively conservative corporations which tend to view uncommon graphic ideas as suspicious. Yet he has also had the good fortune to collaborate directly with that one person making decisions, whom Tscherny calls a "corporate rabbi." For the Uris Buildings Corporation, which during the late 1950s and early 1960s was one of the

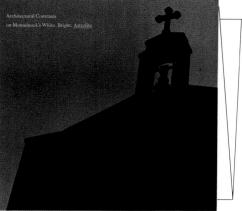

Poster, 1975
Monadnock Paper Mills, Inc.,
client

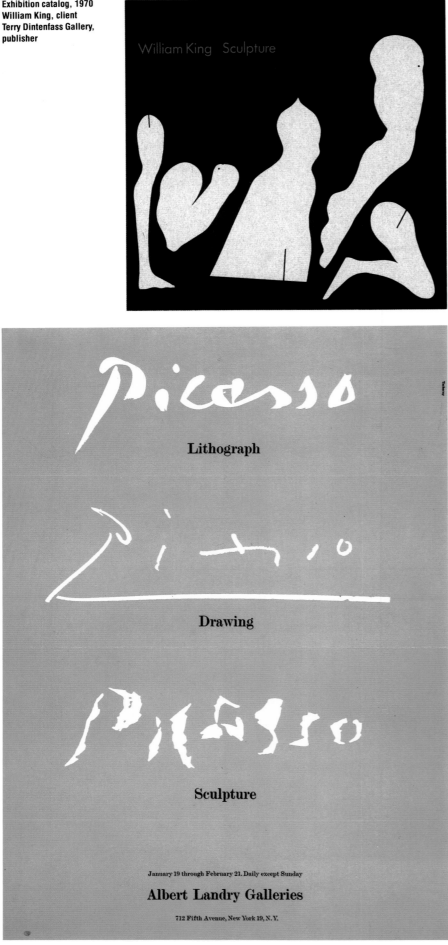

William King Sculpture

Picasso

Lithograph

Picasso

Drawing

Picasso

Sculpture

January 19 through February 21. Daily except Sunday

Albert Landry Galleries

712 Fifth Avenue, New York 19, N.Y.

major construction firms in New York, he designed a black-and-white annual report cover showing a few artless building blocks asymetrically composed—a decidedly abstract yet playful idea, which he says "sneaked its way through because one man was convinced that it was the right symbolism." For Millipore, a manufacturer of scientific instruments for which he designed the identity, Tscherny determined that a style manual—the sacred bible of corporate communications—had little value because "bad designers will use it improperly, and good designers should not be constricted by too many rules." Instead of a typically elaborate and costly system, Tscherny produced a series of "corporate identity samplers" which concisely describe the graphic parameters within which the designers should work. Again, his corporate mentor saw the logic in this strategy.

During the early 1970s, he worked for a strong decision-maker at Pan American Airways, about whom he says, "When I came to this country, I had an image from the movies of what an American businessman is like. It was Cary Grant, who always had his feet up on the desk, made quick decisions, and had a good sense of humor. My first client, who matched those specifications turned out to be, to my surprise, an Englishman. He was so astute that his decisions were right 95 percent of the time, which in a starchy company like that, was quite a feat." Together they "churned out graphic stuff like mad," including an innovative series of modular display panels used by travel agencies to promote Pan Am's vacation spots. This was an opportunity for Tscherny to play with his own "shorthand drawings," as well as with original photographs he had taken on his travels. He also worked on Pan Am's Puerto Rico campaign. "Pan Am had had the exclusive route to Puerto Rico for years," he explains. "And they became quite arrogant until faced with competition from American Airlines, when all those passengers who had been mistreated for many years switched their loyalties. I had to convince Pan Am that good advertising and promotion are senseless unless the airline treats the customer with respect." The human element, Tscherny felt, was the key to improving Pan Am's public image. And concern for the customer was underscored by Tscherny's designs, which included print promotions, airline terminal displays, and a float for the Puerto Rican day parade, all influenced by the country's folk arts interpreted in a modern idiom.

Tscherny's clients include other outwardly conservative corporations, including General Dynamics, Johnson & Johnson, CPC grocery products, and SEI Corporation. For the Liggett & Myers Tobacco Co., he developed a unique modular design system for small cigarette packs that were aimed at a female market and sold in shrink-wrapped sets of four boxes. Before Tscherny took on the W.R. Grace & Co. annual report 15 years ago, this conglomerate was known as a revolving door for graphic designers. Perhaps Tscherny succeeds where others have failed owing to his belief that "the challenge of working for these corporate clients is to do better work than they think they want and to educate them into *accepting* graphic concepts that underscore their product or philosophy in ways that they'd never imagined."

Tscherny often resubmits rejected ideas year after year. Such was the case with the wraparound cover for the 1984 W.R. Grace annual report showing the skyline of New York at dusk, looking north from 42nd Street, with the Grace building in the foreground crowned by its logo. (Incidentally, it was the

only type on the front cover, to indicate it was Grace's report.) It was a *tour de force* requiring three different photographic sessions to achieve the perfect picture.

Commemorative Postage
Stamp, 1976
US Postal Service, client

MUCH OF TSCHERNY'S SUCCESS IS attributed to Sonia (who is not a graphic designer) for her invaluable ability to distinguish good from bad and right from wrong. Tscherny admits that his own eyes are more accurately attuned to the "art within commonplace things" because of Sonia's keen perceptions and sensitivity. "Indeed, nothing leaves the office without her seeing it."

Tscherny's approach is neither about conceit nor surface. Graphics are used to enhance content, not to decorate or hide it. Philip Meggs wrote that Tscherny's process is one of "selection," a choice of appropriate tools to convey a client's message. Jerome Snyder wrote that "[he] strongly believes that the designer is the creator of his own visual vocabulary and the 'recycled' form is a denial of that commitment." Yet an equal amount of Tscherny's work is formed by traditional images and icons as it relies on original photography and illustration. In his hands, however, the traditional is afforded new life, while the new is made curiously timeless. This is vividly seen in the 1970 "Art Auction Brunch" program cover that he designed for the New York Society for Ethical Culture, showing how the disparate ideas of art and breakfast are wittily combined using contemporary and classic symbols as one seamlessly evocative image. About this process, he says, "One plus one equals three . . . Expressing more with less is a challenge which, if successful, gives me great satisfaction."

Tscherny's approach defies strict categorization, though after viewing the vast amount of graphic material he has produced, his recipe for successful communications can be characterized by three principal ingredients: a subtle, yet subversively impish, sense of humor; a refined, yet playful, typography ("In typography I strive for legibility and readibility —except when I don't"); and last, but most critical, a genius for transforming decidedly complex problems into disarmingly simple solutions.

Silas Rhodes best characterized Tscherny when he wrote that the work is "elegant but never chic, serious but never pretentious, disciplined but never dull, his posters, annual reports, etc. . . . , delight the eye and revive the spirit. They shatter once and for all the myth of the incompatibility of commercial enterprise and graphic integrity. As a designer for the highest echelons in American industry, Tscherny reveals how problems in graphic communication may be solved without the loss of aesthetic sensibility. At once free and daring, his work becomes the most classical."

1976 Annual Report
Johnson & Johnson, client

1965 Annual Report
American Can Company, client

1984 Annual Report
W.R. Grace & Co., client

1985 Quarterly Report
W.R. Grace & Co., client

Vehicle identification, 1974
W.R. Grace & Co., client

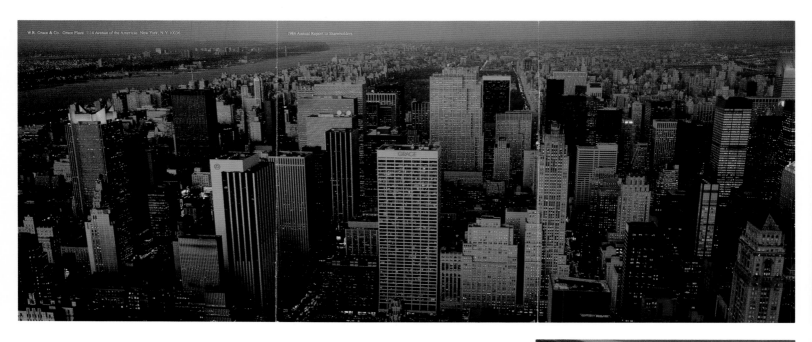

"ALL TOGETHER NOW: HAPPY BIRTHDAY USA"

Davis-Delaney-Arrow Inc. / 141 East 25 Street, New York, N.Y. 10010

the arctic

The Arctic presents an environment nearly as formidable as outer space and the deep sea floor. Yet, the oil and mineral wealth of the region is vast. Crude oil reserves in the North American Arctic alone are estimated at more than 100 billion barrels. Transportation through this frozen ocean is the problem. Modern technology is constantly probing for a solution to the problem so that man can begin to tap these vital natural resources.

General Dynamics. Working in the ocean environment nearly 70 years.

Poster, 1968
General Dynamics
Corporation, client

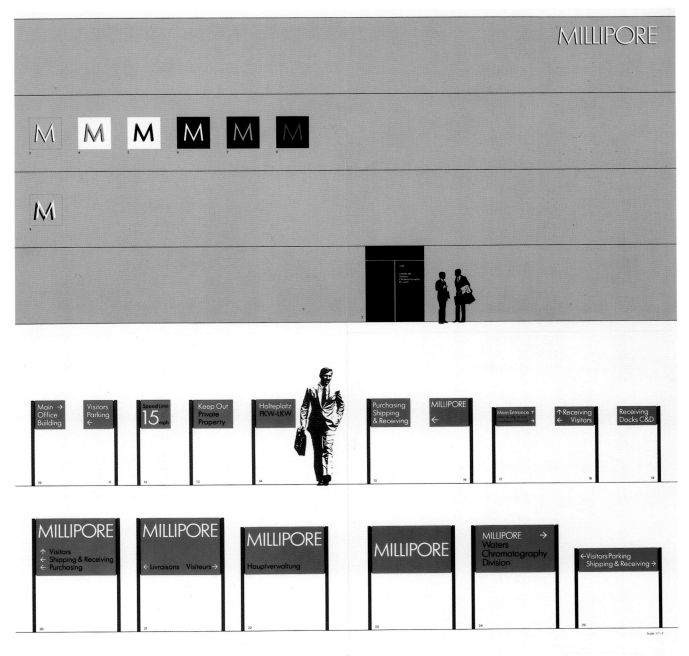

Facilities identification

Consistency of appearance is as important in signage as in any other aspect of Millipore's identification program.

Careful consideration should be given to how a facility is approached, viewing distances, and existing or potential viewing obstructions, such as foliage or parked vehicles.

In the interest of good community relations, signs should be no larger than required for efficient communication.

When planning a new facility, signage should be considered at an early stage, and local sign regulations or ordinances should be checked before planning or erecting any signs.

The corporate signature should be given primary emphasis as, for example, at the top of a building (1). Divisional identification should receive secondary emphasis as, for example, on entrance doors (2) and free standing signs (24).

Various forms of lighting (floodlights, rear-lighting, interior illumination, etc.) may be used as deemed appropriate.

Exterior building identification is largely dictated by the architecture, especially in the case of an existing structure. Therefore, each building has to be evaluated separately, and solutions will vary from location to location.

Full scale mock-ups are advisable, since mistakes are costly to correct and hard to live with.

Three-dimensional letters should be cut out of solid stock, rather than constructed with "built up" sides, unless the thickness of the letters makes the use of solid material impractical.

The thickness, or depth, of letters should be kept to a minimum. This will avoid visual overlapping of the letters from a foreshortened view.

When the height of the capital letter is 12" the material thickness should be ¼". Smaller or larger letters should vary proportionally.

Letters are best pin-mounted, with spacing sleeves separating them slightly from the wall surface. As a general rule, the space between the letter and the wall surface should range from one-half to the full thickness of the letter. The farther letters project from the wall, the more pronounced their shadows become (6), thereby hampering legibility. This is particularly a problem with black letters, because the shadows merge with the letterforms (5). Conversely, shadows will frame and set off white letters on medium value backgrounds (4) and will blend into the background on dark surfaces (6, 7, 8).

Color in signage has been restricted to white, black, Millipore blue and any shade of grey. Exceptions are Caution, Danger, and Safety signs which may use yellow, red, and green respectively. In addition, letters cut out of aluminum or any other "white" metal may be left in their natural metallic state.

Plastic has the advantage of availability in white or black stock, thereby eliminating the need for color finishing. In either case, plastic should be sanded to a matte finish.

Free-standing signage may be the best solution when it is not feasible to integrate a sign with the existing structure. This would also apply when a building is set so far back from the road that identification on the building itself would not be readily seen.

A modular system has been developed for one and two-post signs (10-25) to assure a consistent look to all signage in Millipore facilities the world over.

The typeface Futura is to be used for all signs. As noted in the typographic guidelines "effective communication is synonymous with simplicity." This means the sparing use of lettersizes and the most simple use of language in directional signs.

As in the print medium, emphasis and articulation can be achieved through color as well as size and placement. Generally, white letters will appear stronger than black letters on Millipore blue, except when viewed in direct and strong sunlight.

A master logo is available (style form 1) with a grid system for extreme enlargements or when photographic enlargements are not feasible. This master should be used for logos with a cap height of 4" or larger.

Die-cut vinyl letters are used on all one and two-post signs and are an efficient and economical method for applying letters to glass walls or doors (9). The self-adhesive letters are pre-spaced and pre-aligned and can easily be transferred from the paper carrier onto glass, metal or any other smooth surface (see illustration on the left).

E&E People / Spring 1979

Ernst & Ernst

is changing its name to

Ernst & Whinney

Winter 1985/86

P.S.

The Quarterly Journal of The Poster Society

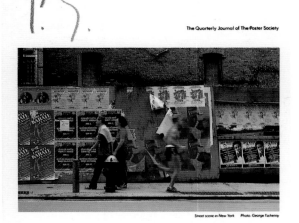

Photograph: George Tscherny

Summer 1986

P.S.

The Quarterly Journal of The Poster Society

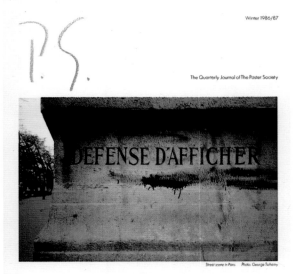

Street scene in New York Photo: George Tscherny

Winter 1986/87

P.S.

The Quarterly Journal of The Poster Society

PSssst...

DEFENSE D'AFFICHER

Street scene in Paris Photo: George Tscherny

Corporate name change
announcement, 1979
Ernst & Whinney, client

Quarterly Journals, 1985–1987
Poster Society, client

PSssst . . . Logo, 1986
Classified Ads Supplement
Poster Society, client

The birth of a dream
SEI's First Twenty Years

SEI People: 20 Years of Dedication

In the beginning, Al West and Doug McNair were SEI's only employees, completely responsible for all product development, marketing, installation, and client support. Over the past two decades, the company has grown considerably, always adding caring, dedicated professionals to its numbers. Today the company has 1,000 full-time employees, in six divisions, working in 16 strategically located offices throughout the United States, Canada, and in London.

SEI has three operating divisions and three support divisions working to develop and deliver the best financial services available.

★ The Information Services Division is responsible for the sales, installation, processing, and servicing of all SEI computer-based services.

★ The Financial Services Division develops, processes, and sells the company's line of institutional financial products.

★ The Evaluation Services Division sells and delivers all SEI pension plan and other evaluation services.

★ The Research Services Division conducts SEI proprietary research and provides the operating divisions with valuable product and industry information.

★ The Administration Division provides legal, administrative, and professional training support to all SEI divisions.

★ The Finance and Accounting Division handles all the company's financial activities.

Despite SEI's obviously dramatic expansion over the past two decades, the company's original entrepreneurial atmosphere remains unchanged. In fact, by setting up small units that are partly owned and operated by their employees, SEI plans to nurture a whole new breed of entrepreneurial groups in the 1990s.

SEI's 1,000 employees work in 16 strategically located offices throughout the United States and Canada, and in London, England.

SEI began this new program of entrepreneurial encouragement in 1988 by creating two entirely new ventures dedicated to two entirely new markets. The SEI Wealth Management℠ group was established to adapt the company's asset management services specifically to meet the unique needs of wealthy individuals and families. SEI Wealth Management provides its services to Hirtle, Callaghan & Co., an independent investment advisory firm. Hirtle Callaghan serves its clients by combining the expertise of its principals with SEI's investment management capabilities.

Hirtle, Callaghan & Co. is the first advisory firm to forge a strategic alliance with SEI. The company plans, however, to extend this unique opportunity to other investment advisers in the wealth management market, to eventually offer asset management to individuals and families in 30 international wealth centers around the world.

The Insurance Asset Group is another of SEI's new entrepreneurial ventures. The IAG, a subsidiary of SEI Corporation, provides strategic asset and liability planning capabilities to insurance companies. This group offers assistance at every step of investment management, from policy planning and asset allocation through performance measurement and continuous monitoring.

The last two decades have been years of change and expansion for SEI Corporation. The company's growth is certainly testimony to the success of its 20-year belief in the creative, entrepreneurial spirit and the importance of strong, long-term client relationships.

SEI now stands ready to expand into even more markets, with even more sophisticated products and services. But the company will stay close to its original roots, with an unwavering focus on clients. Moreover, the inventive spirit and entrepreneurial energy that originally characterized Simulated Environments Incorporated will be preserved through the next 20 years and beyond, as SEI remains focused on innovative services, client commitment, and dedicated people.

SEI's Management Committee charts the company's strategic business direction. The committee is made up of seven executive vice presidents and SEI President Alfred P. West, Jr.

Clockwise from left: Gilbert L. Beebower, Research Services Division; Paul J. Hondros, Financial Services Sales; William R. Bullion, Evaluation Services Division; David B. Robb, Financial Services Division; D. Bruce Peterson, Information Services Division; Alfred P. West, Jr.; Robert A. Nesher, Administration Division; and Carmen V. Romeo, center, Finance and Accounting Division.

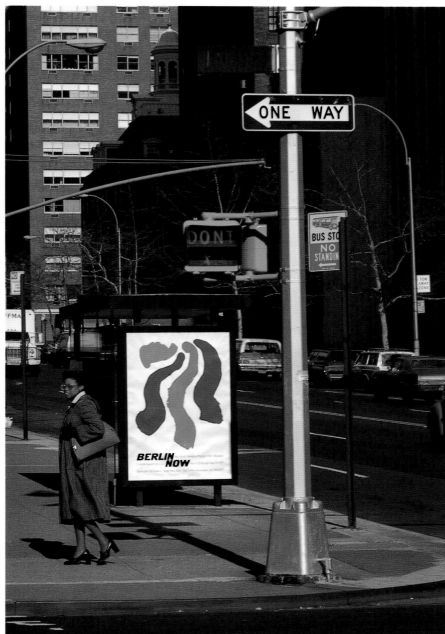

Bus shelter poster, 1977
Mobil Oil Corporation, client

Bus shelter poster, 1976
Goethe House New York, client

C O N N E C T I O N S

George Tscherny — "I have long been gathering CONNECTIONS-COLLECTIONS.
At first the fascination was with the obvious similarities, later with the subtle differences revealed."

Design Consultant: Cross Associates Lithography: B. D. Booth Printing Company Paper: Simpson Coronado Opaque SBT, White Text 60 lb. Printed in U.S.A.

(Opposite) Poster, 1982
Simpson Paper Company,
client

Shop logo applied to
shopping bag, 1987
San Francisco Clothing, client

Advertisement, 1988
San Francisco Clothing, client

Brochure, 1986
IBM, client

Poster, 1986
United Technologies, client

PARTNERS IN TRAINING...a chance to change a life

1986 Connecticut Special Olympics

A unique program
for people with mental retardation,
their families and friends

Torch Run
throughout the state
June 9-13

Summer Games
University of Connecticut, Storrs
June 13-15

The people of
United Technologies
are proud to be
part of Special Olympics

Copyright 1986, United Technologies Corporation

February

Monday 6 a.m. p.m.

Tuesday 7 a.m. p.m.

Wednesday 8 Ash Wednesday a.m. p.m.

Thursday 9 a.m. p.m.

Friday 10 a.m. p.m.

Saturday 11 Sunday 12 Lincoln's Birthday

Sandy Alexander Inc. (201) 470-8100 (212) 765-3035 5 Shop facade in Lavra, Portugal, 1871

April

Monday 10 a.m. p.m.

Tuesday 11 a.m. p.m.

Wednesday 12 a.m. p.m.

Thursday 13 a.m. p.m.

Friday 14 a.m. p.m.

Saturday 15 Sunday 16

12 Moorish tile, 16th century, Spain Sandy Alexander Inc. (201) 470-8100 (212) 765-3035

May

Monday 1 a.m. p.m.

Tuesday 2 a.m. p.m.

Wednesday 3 a.m. p.m.

Thursday 4 a.m. p.m.

Friday 5 a.m. p.m.

Saturday 6 Sunday 7

Sandy Alexander Inc. (201) 470-8100 (212) 765-3035 13 House number in Florence, Italy

**1989 Appointment calendar
Sandy Alexander Inc., client**

Esprit, 1986

Walker Art Center, 1987

The Design Leadership Award of the American Institute of
Graphic Arts has been established to recognize the role of the
perceptive and forward-thinking organization which has been
instrumental in the advancement of design by application of
the highest standards, as a matter of policy. Recipients are
chosen by an awards committee, subject to approval by the
Board of Directors.

Past Recipients

IBM Corporation, 1980

Massachusetts Institute of Technology, 1981

Container Corporation of America, 1982

Cummins Engine Company, Inc., 1983

Herman Miller, Inc., 1984

WGBH Educational Foundation, 1985

Esprit, 1986

Walker Art Center, 1987

The Graphic Journalism of
The New York Times

by Ellen Lupton

OVER THE LAST 20 YEARS, *THE NEW YORK Times* has made graphic design an integral part of the editorial process, using it to clarify, amplify, and organize the paper's dense store of information. The AIGA has chosen to honor *The Times* for vividly demonstrating the ability of graphic design to play an active role in shaping the meaning of mass communications.

The New York Times has portrayed itself as a neutral, rational recorder of public events since its first edition appeared on Thursday, September 18, 1851. Henry Jarvis Raymond, the chief editor, stated then a policy which the paper continues to maintain: it would "seek to allay, rather than excite, agitation . . . and substitute reason for prejudice, a cool and intelligent judgment for passion . . ." Today, while *The Times* represents a sophisticated and often dramatic use of design, it maintains its historic commitment to the cautious, word-conscious presentation of the news.

The Times was founded in the period when "the news" was emerging as a form of modern mass media: it was a new literary genre, an ongoing narrative with no beginning and no end, serving as both disposable entertainment and as an ethically-bound historical record. While many newspapers tapped the appeal of crime, disaster, and social scandal, they also promoted journalism as a messenger of enlightenment, defining the press as a democratic tool for bringing scientific, cultural, and political knowledge to the masses through neutral accounts of immediate events.

The popular press was progressive as an economic and literary institution, but it was visually conservative, relying on the typographic conventions of the older, more expensive financial journals, which were sold to an elite business class. Text ran in densely set columns of small type, broken up only by minimal headlines and almost no illustrations; the need for cheap, fast, uninterrupted production discouraged changes in the routine. To commemorate events of monumental significance, however, a newspaper might bend the convention. For example, *The New York Times* replaced its customary hairline rules with heavy bars to mark the assassination of Abraham Lincoln in 1865.

During the 1890s, the competing values of sensationalism and objectivity were exemplified on the one hand by *The New York Times* and on the other by the "yellow journalism" of William Randolph Hearst and Joseph Pulitzer, who employed illustrations and bold typography to increase the emotional impact of tales of scandal and intrigue. Adolph S. Ochs bought the failing *New York Times* in 1896; rather than adjust the paper's conservative style to match the appeal of "yellow journalism," Ochs chose to uphold its tradition of dispassionate rationalism. According to historian Michael Schudson, the paper's slogan "All the news that's fit to print" expressed a commitment to *decency* as much as to *accuracy*. The paper chose its subject matter with taste and discretion, appealing to the biases of a middle-class audience. *The New York Times* claimed to distribute neutral, value-free "information," while the sensationalist papers sold "stories," dramatic narratives often written by reporters with distinct personalities and reputations.

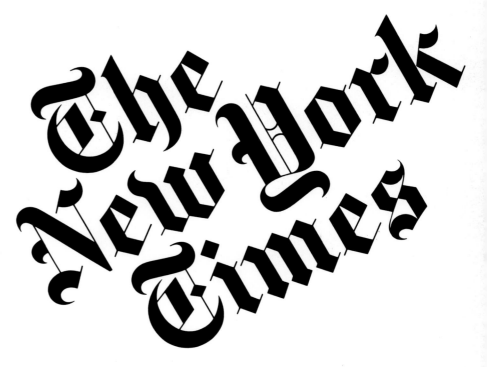

April 15, 1865
"Awful Event"
Funeral black column bars
indicate the death of Presi-
dent Abraham Lincoln

August 16, 1896
The first page one under the
new ownership of Adolph S.
Ochs.

June 17, 1963
"Soviet Orbits Woman
Astronaut"
Example of the typical eight
column grid replaced by the
six column grid in 1976
(The period in the logo was
removed in 1967.)

January 29, 1986
"The Shuttle Explodes"
Designed on a six column grid.

Ron Couture
Margaret O'Connor
and editors of the
New York Times
Designers

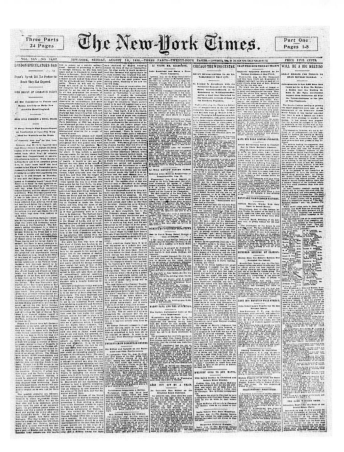

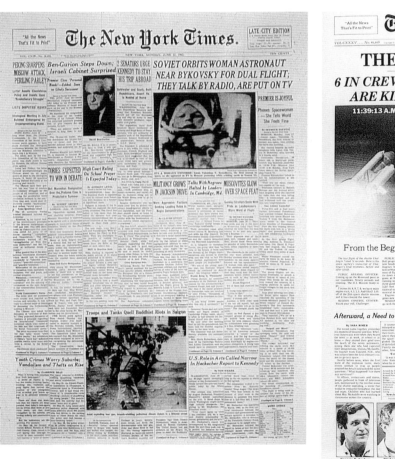

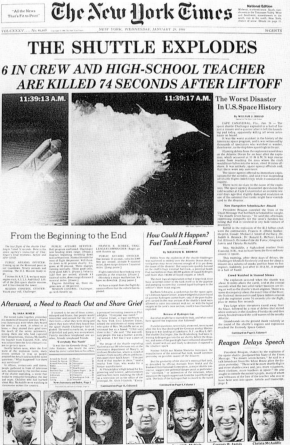

The look of *The New York Times* changed only incrementally during the following 50 years, resisting the visual trends which marked 20th-century journalism. In 1917-18, the *New York Tribune* introduced the principle of "typographic consistency" to the newspaper industry, using a limited family of typefaces for headlines. John Allen, a designer employed by the Linotype Corporation, promoted "Streamlined" headline typography during the 1930s and 1940s, advocating flush-left lines, lowercase letters, and the use of a limited pallette of typefaces. Allen's principles were adopted by numerous papers across the country. The resulting designs contrasted with the emotional typography and layouts common to tabloids. *The Times*, however, became neither theatrical nor sleek, choosing to retain its moderately scaled pictures and Victorian array of display fonts.

The New York Times slowly began to alter its look in the 1960s, a period when labor disputes and intense competition with magazines and television devastated many newspapers. The first major change was probably invisible to most readers. In 1960 the paper adopted a new text type, a decision made after fastidious research and exhaustive committee meetings. The display face Bookman was introduced in the "News of the Week in Review" in 1964 and a few years later in the Sunday *Book Review*; today it is a hallmark of the paper's feature sections.

The Op-Ed page appeared in 1970, the result of James "Scotty" Reston's idea for creating a forum for the "new frontier of ideas." Op-Ed editor Harrison Salisbury, deputy editor Herbert Mitgang, and art director Louis Silverstein developed a graphic style for the page which rejected editorial cartoons in favor of conceptual drawings by leading illustrators. Whereas a traditional political cartoon provides humorous, verbally explicit commentary on an issue, the new Op-Ed approach favored veiled, metaphoric, often surreal images freed from explanatory "punch lines." Other sections of the paper later incorporated similar approaches to illustration.

MORE EXTENSIVE CHANGES APPEARED throughout the 1970s as the paper sought to compete with other media and switch to more economical technologies. In 1971 publisher Arthur Ochs ("Punch") Sulzberger addressed a letter to each of the paper's 5,500 employees, calling for serious self-examination. He wrote, "The recession has affected other newspapers, too, but when we compare our performance, we do not look good."

A long confrontation between management and the typesetter's union ended in 1974 with a settlement enabling *The Times* to convert from hot-metal to "cold" or photographic composition; offset printing was introduced some years later. The newer technology facilitated design change, making experiments with typography and layout easier. During the late 1980s, the company has made increasing use of computers for typesetting and informational graphics, making the relationship between editing and design even more fluid and direct. Ultimately a computer workstation will be used to output type, photographs, graphics, and advertising onto a single surface.

One of the major forces in shaping the new design of *The Times* was Louis Silverstein, an advertising art director who had worked originally in the *The Times'* promotion depart-

Op-Ed pages

July 19, 1975
Steven Heller, Art Director; Louis Silverstein, Design Director; Brad Holland, Illustrator

January 31, 1983
Jerelle Kraus, Art Director; Louis Silverstein, Design Director; Marshall Arisman, Illustrator

March 26, 1989
Michael Valenti, Art Director; Thomas Bodkin, Design Director; Eugene Mihaesco, Illustrator

"I got my job t
The New York

Social Worke

rough
Times'."

PAPERBACK PEOPLE

Where else but The New York Times?

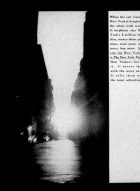

SCHOOL BUS

G G

with The New York Times 1962 International Automobile Show Section. **Sunday, April 22**

Promotional Advertising

(left)
"I Got My Job through the New York Times" Poster, series duration from 1955 to 1975;

Louis Silverstein, Art Director/ Designer; The New York Times Studio, Photographer

(top, clockwise from left)
"Where else but the New York Times"
Advertisement, 1962

Louis Silverstein, Art Director/ Designer; Robert Frank, Photographer

"Paperback People"
Advertisement/Poster, 1964

Louis Silverstein, Art Director/ Designer/Illustrator; The New York Times Studio, Photographer

"School Bus"
Advertisement, 1958

Louis Silverstein, Art Director/ Designer; Robert Frank, Photographer

"Go Go"
Booklet, 1958

Louis Silverstein, Art Director/Designer; The New York Times Studio, Photographer

ment. Silverstein's bold campaigns during the 1950s and 1960s carried on the spirit of George Krikorian, whom he succeeded as art director in 1952. Whereas the news departments of *The Times* were marked by conservative graphics, Krikorian's work took part in the "New Advertising" of the 1950s, exemplified by Doyle Dane Bernbach, Wells, Rich & Green, and CBS. These firms gave the art director a central role in the creation of ads; whereas in traditional agencies design was the servant of copywriting and market research, the "New Advertising" forged a witty interplay between text and image. It appealed to a varied and sophisticated urban audience rather than to the flat, stereotypical "consumer" imagined by scientific marketing. Krikorian and Silverstein participated in this rethinking of the advertising medium; they were encouraged by Ivan Veit, a *Times* executive responsible for the company's advertising and committed to creative design.

Under promotion director Irvin Taubkin, Silverstein designed the "I got my job through *The New York Times*" series of subway posters, a campaign that ran uninterrupted for more than 19 years. With subtle humor, he emulated the "straightness" of news reporting in the context of advertising. Silverstein recalls, "There were no frills. It carried journalistic conviction." Another long-running series of ads designed by Silverstein —working with Taubkin and copywriter Milt Franks—juxtaposed photographs by Robert Frank with succinct, direct, sometimes fanciful copy, usually with no headline or logo. Later the ads employed two identical images, each paired with a different block of text. The result was an enigmatic and yet "journalistic" series of advertisements, borrowing from newspapers a deadpan style of writing and photography.

When Silverstein moved from advertising to the conservative newsroom, he challenged ingrained editorial habits with new graphic and typographic ideas. The daily and Sunday papers were separately ruled territories; Silverstein began his pioneering work in the Sunday paper, where the rigid aesthetic of the "hard news" was not so unbending. The *Book Review* and the Sunday Magazine were early laboratories for the role of reconceiving design at *The Times*. Although today many of Silverstein's early changes might seem timid, they represented a breakthrough in a paper famous for its adamantly colorless and conventional graphics.

In 1976–77 the Sunday paper inaugurated separate suburban sections for readers in Long Island, New Jersey, Connecticut, and Westchester. Silverstein's format design included large-scale photographs and prominent teasers to inside articles, setting a precedent for later feature sections, which became graphic and editorial "magazines" within the larger paper. Silverstein encouraged the use of big type and photographs, witty juxtapositions of image and text, and poster-like layouts exploiting the full size of the newspaper sheet. Describing the format he produced for the similarly designed Sunday Travel section in 1981, Silverstein explains, "A glossy travel magazine has slick, four-color illustrations, but a newspaper has *scale*."

In 1976 *The Times* merged its Sunday and daily papers into a single entity, an administrative move which gave Silverstein the license to begin redesigning the previously inviolate daily paper. The same year, he was named assistant managing editor of the paper. For the first time, graphic design was granted a central role in the editing of a major newspaper. Silverstein worked with executive editor A. M. Rosenthal, managing

Arts & Leisure
March 8, 1987
Thomas Bodkin, Art Director, Designer; Thomas Bodkin, Format

Arts & Leisure
December 27, 1987
Linda Brewer, Art Director/Designer; Thomas Bodkin, Design Director

The Guide
February 14, 1982
Mary Sillman, Designer; Louis Silverstein, Format; Louis Silverstein, Design Director

Television
July 10, 1988
Jim Quinlan, Designer; Thomas Bodkin, Format; Thomas Bodkin, Design Director

The Summit
WHAT IT'S ALL ABOUT

On the Agenda

Arms Control:
Talking Tough

The focal point of Soviet-American dialogue has been the arms talks on strategic arms, medium-range weapons and space-based defenses. Both sides have offered cuts in offensive missiles, but there are differences on the cuts. The Russians have seemed to rule out progress on arms cuts until Washington ends work on President Reagan's plan to develop a space-based missile defense.

Both sides have discussed drafting guidelines to give an impetus to the arms talks. There are also other arms issues. Officials of both nations say they expect participants to affirm support for preventing the spread of nuclear and chemical arms.

Human Rights:
A Constant Thorn

The United States regularly raises human rights issues in Soviet-American talks, citing the 1975 Helsinki accords on human rights.

The main American efforts are directed at gaining an increase in emigration of Soviet Jews, reuniting divided Soviet-American families, and easing the lot of dissidents and rights activists who are imprisoned or harassed, like the Soviet physicist Andrei D. Sakharov.

Moscow regularly responds that American mention of such issues constitutes interference in Soviet internal affairs. The Russians say all Soviet Jews who wanted to emigrate have already done so, and that those who are being denied permission to emigrate, by and large, had access to Government secrets.

Regional Conflicts:
Problems Away From Home

Many Soviet-American strains have arisen over problems in other parts of the world. Among the conflicts likely to be discussed are:

Afghanistan - Soviet and Afghan Government troops are fighting Islamic rebels.

Cambodia - Soviet Union supports the Vietnamese occupation.

Africa - The two sides disagree over Ethiopia and Angola.

Central America - The Russians assert that the United States is planning an invasion of Nicaragua and the Americans accuse Nicaragua of aiding rebels fighting the Salvadoran Government.

Middle East - The sides have had sharp differences for years.

Washington has sought to link progress on arms control and other issues to these problems. Moscow says the sides should discuss these matters, but not tie them to arms control progress.

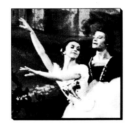

Soviet-American Accords:
A Sharing of Cultures

These include a dozen or more programs, many of them established around 1972, including exchanges and economic relations. In total, they constituted something of a framework for interaction between the two countries. Most were suspended by Washington after Soviet troops moved into Afghanistan in 1979 and martial law was imposed in Poland in 1981.

The accords include agreements governing cultural exchanges, such as those involving ballet troupes; establishing consulates in Kiev and New York; restoring direct air service between countries, and setting procedures for air safety in the northern Pacific.

There are also other matters, such as a Siberia-Alaska border arrangement, that American officials say may be taken up.

Why Geneva?

Geneva's role as a gathering point is rooted in the days of John Calvin in the 16th century, when the Reformation attracted Europe's refugees from religious persecution.

Its modern days as a "city of causes" began with the establishment of the Red Cross in 1863. Today, Geneva has countless meeting centers and a service industry geared to the business of talk. It is home for the European headquarters of the United Nations, the World Health Organization and the International Labor Organization.

The Summit Record

July 1955. President Eisenhower meets in Geneva with Nikolai A. Bulganin, British and French leaders. RESULTS: The "Spirit of Geneva" began to thaw the cold war. General discussion; no agreements.

September 1959. Mr. Eisenhower and Nikita S. Khrushchev meet at Camp David, Md. **Results:** "The Spirit of Camp David" — a general feeling that scientific and cultural exchanges would be good, and that disarmament is the world's main problem — but no concrete results.

May 1960. Mr. Eisenhower and Mr. Khrushchev go to Paris, but the Russian uses the shooting down of the American U-2 spy plane over the Soviet Union to torpedo the meeting. **Results:** Increased tensions.

June 1961. Mr. Khrushchev and President Kennedy, in Vienna, have heated exchanges. **Results:** No formal agreements. A year later, the Soviet Union tries to put missiles in Cuba; U.S. forces their removal.

June 1967. President Johnson meets in Glassboro, N.J., with Aleksei N. Kosygin to discuss Middle East, the Vietnam War and nuclear arms. **Results:** No results on Vietnam; seeds sown for later arms talks.

May 1972. President Nixon and Leonid I. Brezhnev, in Moscow, sign first treaties setting ceilings on strategic nuclear arms and limiting antiballistic missile systems. **Results:** They agree to keep negotiating on arms; regional issues still divide them.

June 1973. Mr. Nixon and Mr. Brezhnev meet in Washington. **Results:** Agreement to try to complete a new arms treaty by 1974; agreements on practical issues.

June-July 1974. Mr. Nixon and Mr. Brezhnev meet in Moscow and Yalta. **Results:** Treaty banning underground nuclear arms tests with yields exceeding 150 kilotons; 10-year economic pact.

November 1974. President Ford and Mr. Brezhnev, in Vladivostok, reach tentative pact limiting missile launchers and bombers and lay base for second strategic arms treaty. **Results:** Treaty not completed before President Carter takes office; talks go back to starting point.

June 1979. Mr. Carter and Mr. Brezhnev sign the second strategic arms limitation treaty in Vienna. **Results:** Though United States Senate never approves treaty, both sides agree to observe limits informally.

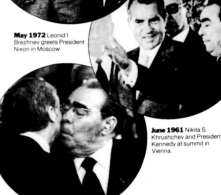

July 1955 Nikolai A. Bulganin and President Eisenhower in Geneva.

June 1979 Mr. Brezhnev kisses President Carter after signing of second SALT treaty in Vienna.

May 1972 Leonid I. Brezhnev greets President Nixon in Moscow.

June 1961 Nikita S. Khrushchev and President Kennedy at summit in Vienna.

Behind-the-Scenes Strategists

UNITED STATES

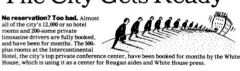

Fred C. Iklé
Under Secretary of Defense. Longtime conservative arms strategist and director of Arms Control and Disarmament Agency under President Ford.

Robie M. Palmer
Deputy Assistant Secretary of State for European and Canadian Affairs. State Department's senior Soviet specialist and the State Department summit coordinator. An idea man, known for being daring by diplomatic standards. Accomplished speechwriter.

Richard N. Perle
Assistant Secretary of Defense. Regarded as perhaps the most formidable opponent of arms control in the Administration.

Kenneth L. Adelman
Director of Arms Control and Disarmament Agency. Youngest of senior members of the arms control team. His appointment to the arms control agency met opposition in Congress because of his lack of experience in the field.

Rozanne L. Ridgway
Assistant Secretary of State for European and Canadian Affairs. Career Foreign Service woman; former Ambassador to Finland and East Germany. Not regarded as a specialist in Soviet affairs.

Jack F. Matlock
Senior National Security Council staff member on East-West relations. Former Ambassador to Czechoslovakia and former No. 2 man at U.S. Embassy in Moscow. Cautious career Foreign Service man.

SOVIET UNION

Viktor G. Komplektov
A Deputy Foreign Minister in charge of American affairs. Known for sardonic wit; a key Soviet strategist for policy matters on U.S. Considered a workaholic. Speaks impeccable English.

Andrei M. Aleksandrov
A top foreign affairs adviser to Soviet leaders since Leonid I. Brezhnev. A constant figure at talks involving Soviet leaders, whispering in the ear of the Soviet leader, be it Brezhnev, Andropov or Chernenko.

Col. Gen. Nikolai F. Chervov
Top arms control expert in the Defense Ministry for many years. Very tall, straight-backed, with a military bearing. Quite accustomed to dealing with Westerners. Speaks adequate English.

Aleksandr A. Bessmertnykh
Chief of the United States Department at Foreign Ministry. Former aide to Andrei A. Gromyko, longtime Foreign Minister, and to Anatoly F. Dobrynin, Ambassador to Washington. Known as good-natured and professional.

Vadim V. Zagladin
First Deputy Chief of International Department of party Central Committee. Does much of Central Committee's foreign affairs work; in charge of international propaganda. Has a doctorate in philosophy, of which he is proud.

Marshal Sergei F. Akhromeyev
Chief of the General Staff. Considered a soldier's soldier. Straightforward, tough in his language; brought to prominence by his former boss, Marshal Nikolai F. Ogarkov.

The City Gets Ready

No reservation? Too bad. Almost all of the city's 12,000 or so hotel rooms and 200-some private limousine drivers are fully booked, and have been for months. The 500-plus rooms at the Intercontinental Hotel, the city's top private conference center, have been booked for months by the White House, which is using it as a center for Reagan aides and White House press.

The givers. Geneva officials say the summit meeting, which has required hundreds of hours of work by thousands of people, will ultimately cost the city some 2.5 million Swiss francs (about $1.15 million).

The receivers. The hotels and summit sites have been strung together by about 1,300 miles of telephone cable serving about 3,000 special direct lines. The Swiss Post, Telephone and Telegraph estimates the job has taken 3,700 working hours.

Staying up late. Geneva's landmark, the Jet d'Eau, a water jet that spouts a geyser of water weighing seven tons over 450 feet into the air — that's higher than the Statue of Liberty — will be turned on until 2 A.M. Normally in the autumn it is shut off at night and turned on only on windless, warm days to keep the Geneva harbor from being coated by ice from its mist.

Staying on late. The Cordon lumineux de la Rade, a string of lights illuminating Geneva's lakeshore harbor and roads, will also be left on until 2 A.M., as will the lights at such monuments as the Cathedral Saint-Pierre, the 12-foot floral clock in the Jardin Anglais, and other Geneva sites. All are usually shut off at 11 P.M.

Staying on duty. The army has moved into positions around summit sites, with 2,000 troops to bolster the 1,300 Swiss gendarmes who are to provide security. The Geneva police had 900 gendarmes and inspectors available, and asked other Swiss states for a loan of 400 more. The 1,000 infantrymen of Regiment No. 10 from the Swiss states of Aargau and Solothurn are dressed in light camouflaged battle uniforms, carry Swiss-made, assault rifles and have orders to shoot anyone who ignores their command to halt.

A secure border. Geneva's borders have numerous crossings that are often left unguarded during the night. Border officials have beefed up security for the summit meeting, closing 11 border crossings, instituting tougher controls at others and patrolling areas that are not usually watched.

Michael Bartalos

On the Record

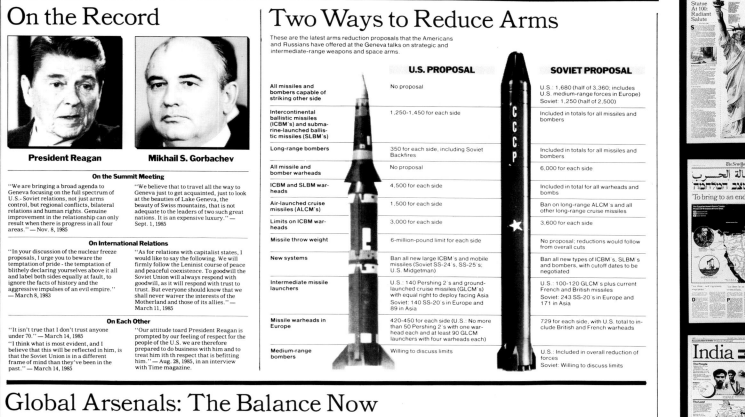

President Reagan

Mikhail S. Gorbachev

On the Summit Meeting

"We are bringing a broad agenda to Geneva focusing on the full spectrum of U.S.- Soviet relations, not just arms control, but regional conflicts, bilateral relations and human rights. Genuine improvement in the relationship can only result when there is progress in all four areas." — Nov. 8, 1985

"We believe that to travel all the way to Geneva just to get acquainted, just to look at the beauties of Lake Geneva, the beauty of Swiss mountains, that is not adequate to the leaders of two such great nations. It is an expensive luxury." — Sept. 1, 1985

On International Relations

"In your discussion of the nuclear freeze proposals, I urge you to beware the temptation of pride - the temptation of blithely declaring yourselves above it all and label both sides equally at fault, to ignore the facts of history and the aggressive impulses of an evil empire." — March 8, 1983

"As for relations with capitalist states, I would like to say the following. We will firmly follow the Leninist course of peace and peaceful coexistence. To goodwill the Soviet Union will always respond with goodwill, as it will respond with trust to trust. But everyone should know that we shall never waiver the interests of the Motherland and those of its allies." — March 11, 1985

On Each Other

"It isn't true that I don't trust anyone under 70." — March 14, 1985

"I think what is most evident, and I believe that this will be reflected in him, is that the Soviet Union is in a different frame of mind than they've been in the past." — March 14, 1985

"Our attitude toard President Reagan is prompted by our feeling of respect for the people of the U.S. we are therefore prepared to do business with him and to treat him ith respect that is befitting him." — Aug. 28, 1985, in an interview with Time magazine.

Two Ways to Reduce Arms

These are the latest arms reduction proposals that the Americans and Russians have offered at the Geneva talks on strategic and intermediate-range weapons and space arms.

	U.S. PROPOSAL	SOVIET PROPOSAL
All missiles and bombers capable of striking other side	No proposal	U.S.: 1,680 (half of 3,360; includes U.S. medium-range forces in Europe) Soviet: 1,250 (half of 2,500)
Intercontinental ballistic missiles (ICBM's) and submarine-launched ballistic missiles (SLBM's)	1,250-1,450 for each side	Included in totals for all missiles and bombers
Long-range bombers	350 for each side, including Soviet Backfires	Included in totals for all missiles and bombers
All missile and bomber warheads	No proposal	6,000 for each side
ICBM and SLBM warheads	4,500 for each side	Included in total for all warheads and bombs
Air-launched cruise missiles (ALCM's)	1,500 for each side	Ban on long-range ALCM's and all other long-range cruise missiles
Limits on ICBM warheads	3,000 for each side	3,600 for each side
Missile throw weight	6-million-pound limit for each side	No proposal; reductions would follow from overall cuts
New systems	Ban all new large ICBM's and mobile missiles (Soviet SS-24's, SS-25's; U.S. Midgetman).	Ban all new types of ICBM's, SLBM's and bombers, with cutoff dates to be negotiated
Intermediate missile launchers	U.S.: 140 Pershing 2's and ground-launched cruise missiles (GLCM's) with equal right to deploy facing Asia Soviet: 140 SS-20's in Europe and 89 in Asia	U.S.: 100-120 GLCM's plus current French and British missiles Soviet: 243 SS-20's in Europe and 171 in Asia
Missile warheads in Europe	420-450 for each side (U.S.: No more than 50 Pershing 2's with one warhead each and at least 90 GLCM launchers with four warheads each)	729 for each side, with U.S. total to include British and French warheads
Medium-range bombers	Willing to discuss limits	U.S.: Included in overall reduction of forces Soviet: Willing to discuss limits

Global Arsenals: The Balance Now

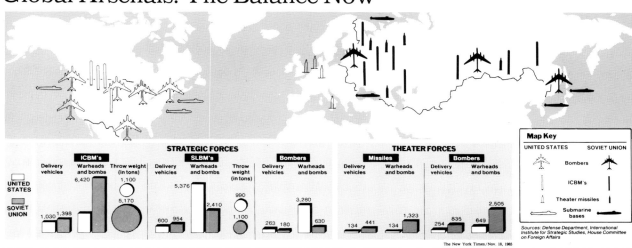

	STRATEGIC FORCES								THEATER FORCES				
	ICBM's			SLBM's			Bombers			Missiles		Bombers	
	Delivery vehicles	Warheads and bombs	Throw weight (in tons)	Delivery vehicles	Warheads and bombs	Throw weight (in tons)	Delivery vehicles	Warheads and bombs		Delivery vehicles	Warheads and bombs	Delivery vehicles	Warheads and bombs
UNITED STATES	1,030	6,420	1,100	600	5,376	990	263	3,280		134	134	254	649
SOVIET UNION	1,398	5,170		954	2,410	1,100	180	630		441	1,323	835	2,505

Map Key

UNITED STATES	SOVIET UNION	
		Bombers
		ICBM's
		Theater missiles
		Submarine bases

Sources: Defense Department, International Institute for Strategic Studies, House Committee on Foreign Affairs

The New York Times/Nov. 18, 1985

Where 'Star Wars' Fits In

Space-based weapons, and the issue of defensive arms in general, have become a central issue in Soviet-American arms talks.

In 1983, when President Reagan announced his plan for a space-based missile defense, he said the system could make the world safe from the threat of nuclear war. The Soviet Union has said the United States is seeking to militarize outer space, that the plan violates the 1972 treaty on antiballistic missiles, and that the combination of offensive and defensive arms will enable one side to strike first and blunt retaliation with defenses, thus upsetting 40 years of mutual deterrence.

Before the first talks on limiting strategic arms, the United States tried to persuade the Soviet Union that defensive systems needed to be limited in order to ease agreement on limiting offensive arms. Then the President announced his plans for the missile defense, formally known as the Strategic Defense Initiative and popularly called "Star Wars." The plan was to develop a system based mainly in space, using new technologies like lasers, particle beams and superkinetic energy weapons to shoot down incoming missiles.

The Administration says "Star Wars" could give a measure of security for both sides if the technology for such antiballistic missile systems can be developed.

The Soviet Union's position on defensive systems has also changed. Previously, the Soviet Union — which had deployed its own antiballistic missile system — resisted American arguments that such systems should be limited. Now, Soviet officials say a ban on the deployment of "Star Wars" is needed to reach an agreement on offensive arms. American officials say, however, that the Russians are still trying to develop their own "Star Wars" system. Some Soviet officials have hinted that they might consider an arms control agreement allowing "Star Wars" research and testing. But Soviet officials have not stated this formally in the Geneva talks.

The "smart" projectile moves at high speed to destroy targets on impact.

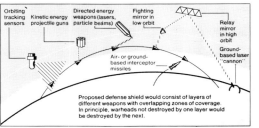

Proposed defense shield would consist of layers of different weapons with overlapping zones of coverage. In principle, warheads not destroyed by one layer would be destroyed by the next.

The New York Times/Nov. 18, 1985

Defining the Jargon

The language of nuclear arms talks includes many specialized terms. These are a few of those terms.

Ballistic missile. Powered by a rocket engine, this missile travels outside of the atmosphere for part of its flight.

Cruise missile. A missile that looks like a flying torpedo, is powered by an air-breathing engine, flies in the atmosphere, and is armed with either nuclear or nonnuclear warheads. Current cruise missiles, which are subsonic and fly close to the earth, can be launched from ground, sea or air.

Re-entry vehicle (RV). The part of a ballistic missile that carries the nuclear warhead.

Intercontinental ballistic missile (ICBM). A land-based ballistic missile that has a range of more than about 3,400 miles, such as the Soviet SS-18 or the American MX.

Intermediate-range nuclear forces (INF). Land-based missiles and aircraft that have a range of less than 3,400 miles, including the Soviet SS-20 and the American Pershing 2 ground-launched cruise missile. Intermediate-range bombers include the Soviet Backfire bomber — which is included in the American Geneva proposal as a strategic bomber — and the American FB-111 bomber. Sometimes called theater nuclear forces.

Multiple independently targetable re-entry vehicle (MIRV). One of several nuclear warheads carried by a single ballistic missile and directed at separate targets. MIRVed missiles employ a warhead-dispensing mechanism, called a post-boost vehicle, to release the warheads.

Submarine-launched ballistic missile (SLBM). A ballistic missile launched from a submarine.

Strategic. A term used to describe nuclear weapons that have range considered intercontinental, or more than 3,400 miles.

Tactical. Tactical weapons are short-range systems used on the battlefield.

Throw weight. The amount of weight a missile can carry to its target.

Verification. The process of determining whether a party is adhering to the terms of an agreement. Verification capabilities include surveillance satellites and other means.

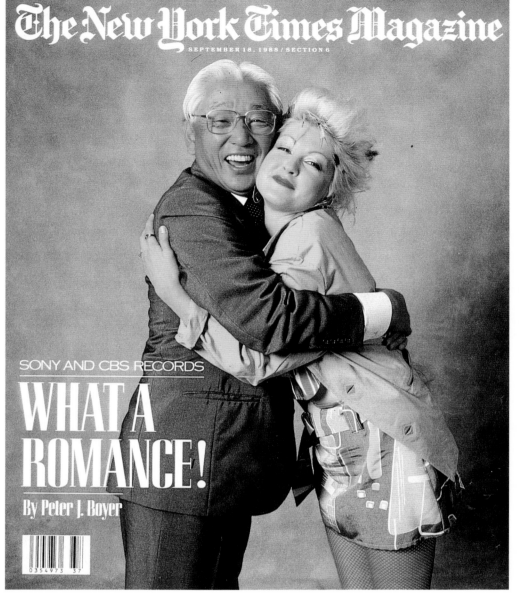

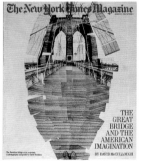

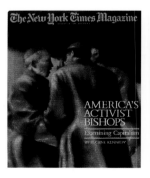

editor Seymour Topping, deputy managing editor Arthur Gelb, and assistant managing editors James Greenfield and Peter Millones.

Graphic and editorial thinking began to merge, with design sometimes leading a story's conception. For example, an art director might initiate a special feature on a topic such as the space shuttle or an election, constructing a multi-faceted account of an event through charts, diagrams, anecdotes, and pictures. Silverstein calls this kind of page a "side of beef," referring to the meat charts which hang in butcher shops. He explains, "A side of beef is not just a collection of charts. It should have wit and surprise."

BETWEEN 1976 AND 1978, THE EDITORS initiated daily "theme" sections for the weekday editions of the paper. "Sports Monday," "Science Times," "Living," "Home," and "Weekend" have the visual and editorial feel of magazines, and each one offers advertisers a focused group of consumers. Because many of the articles in the daily and Sunday feature sections are "soft news," they can be written and designed well in advance, unlike "hard news" stories. While design changes were initiated more smoothly in the feature sections, the new graphic and typographic style gradually came to influence the domain of hard news as well, especially in the business and metropolitan pages.

Silverstein designed distinct but related graphic styles for the new sections, which were subsequently assigned to art directors responsible for their weekly implementation. Silverstein explains, "There is an almost 'poetic' relationship between the format designer and the people who implement it on a daily basis. I set up guidelines which are clearly defined yet allow for infinite variations; the ultimate success of the format depends then on the people who make it live everyday." One art director recalls the changes in the paper: "A whole younger generation of graphic designers came to work for *The Times*, many of us from underground newspapers and city art schools rather than from the conventional 'old boy' newspaper environment." A number of these art directors have been women —a change for a male-dominated industry.

There are now around 16 art directors at *The Times*, each one in charge of one or more sections. Under Tom Bodkin, who is currently overall design director, the art department has come to include not only art directors and production people but also graphic editors, graphic designers, and makeup editors. All these jobs overlap one another, a trend encouraged by the growing use of computers at the paper.

The striking alterations which characterized *The New York Times* in the 1970s and early 1980s have been replaced now by more subtle, incremental changes. Whereas Silverstein's innovations occurred largely in the feature sections of the paper, Bodkin is concerned with improving the graphic presentation of the "hard news." And whereas Silverstein participated in the paper's major period of expansion—in the mid 1970s it jumped from a 96 page limit to 128 pages—one of Bodkin's jobs is to reassure readers that *The Times* has not become an unnavigable sea of data. "The more visual approach that we take in feature sections can be effectively adapted to help organize information in the news sections," says Bodkin. Like other newspapers, *The Times* has been forced to respond to the diminishing patience of the average reader whose professional and leisure time is flooded with information.

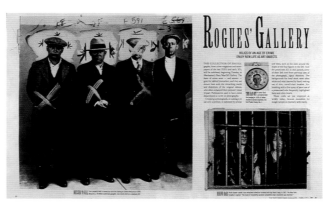

The New York Times Magazine
February 1, 1987

Diana LaGuardia, Art Director; Audrone Razgaitis, Designer; Ron Couture, Design Director

The New York Times Magazine
November 3, 1986

Ken Kendrick, Art Director; Richard Samperi, Designer; Ron Couture, Design Director; Anita Kunz, Illustrator

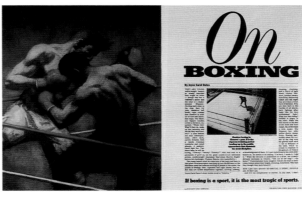

The New York Times Magazine
May 18, 1986

Ken Kendrick, Art Director/Designer; Ron Couture, Design Director; Peter Lindbergh, Photographer

The New York Times Magazine
June 16, 1985

Ken Kendrick, Art Director; Audrone Razgaitis, Designer; Ron Couture, Design Director; Harvey Dinnerstein, Illustration

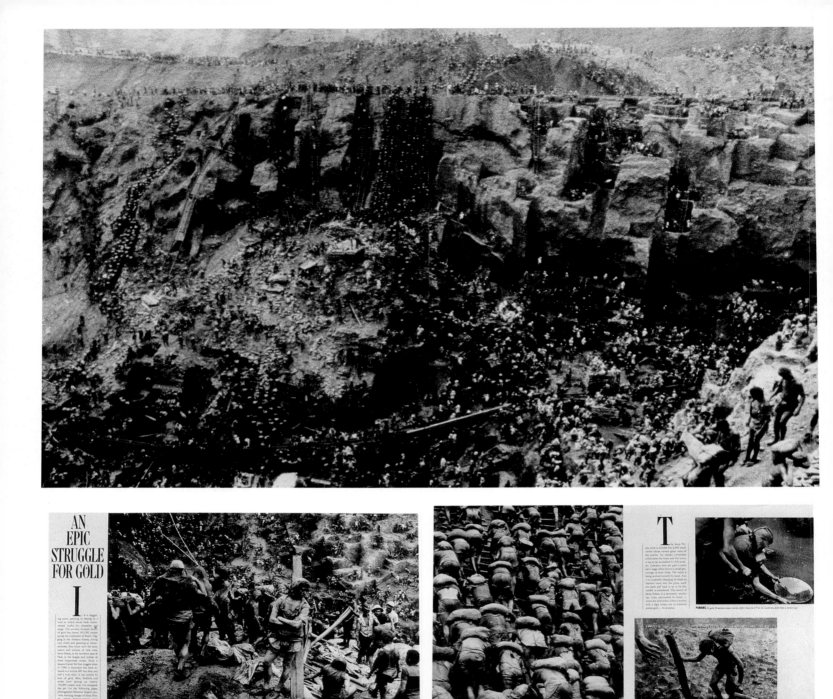

AN
EPIC
STRUGGLE
FOR GOLD

Portfolio by Sebastião Salgado
Text by Marlise Simons

The New York Times Magazine
June 7, 1987

Diana LaGuardia, Art Director; Janet Froelich, Designer; Thomas Bodkin, Design Director; Sebastiao Salgado, Photographer

Known for its in-depth reporting and its respect for the written word, *The Times* is not interested in adopting the schematic, television-style packaging of *USA Today*. Instead, it is using design to help guide readers through the information-packed pages of the *Times*. The goal is to provide the same level of detail and analysis while providing ways to move through the paper quickly and to read selectively. Devices such as pull-out quotes, information graphics, indexes, the grouping of related articles, and the use of more numerous subdivisions or "chapters" in a story equip the reader to move swiftly through the paper.

The next major change will be the introduction of color, planned to occur within a few years. While typographic subtleties may go largely unnoticed, color will shock many readers of *The Times*, who have come to associate the paper with a staid and steady grayness. Bodkin explains that while color may make the paper more visually exciting, its purpose is to enhance depth and readability. "After all, the world appears in color. Showing it in color is consistent with our dedication to truth and clarity in reporting." Bodkin assures that "the qualities we look for in black and white design— economy, purpose, logic—will also inform our use of color."

Assistant managing editor Allan M. Siegal asserts that the difference between graphic design at *The New York Times* and other newspapers is its fundamental respect for the written word. He explains that the work of designers such as Louis Silverstein, Roger Black, and Tom Bodkin has always recognized that words are the principle elements of a newspaper, and that the task of design is to make the *words* more accessible. According to Siegal, designers at *The Times* have had a contradictory mission: to preserve the familiar appearance of the "hard news" while enlivening the more leisure-oriented sections. He explains, "Our foreign and government news has a very serious, conservative readership. These people would be disoriented and their confidence would be undermined if that part of the paper adopted the same style as the other sections." Bodkin now has the task of making the hard news sections more readable without sabotaging the authority of graphic tradition.

The New York Times, one of the most widely read newspapers in the world, has succeeded in upholding its legendary standards of journalism while at the same time becoming an inventive force in the graphic presentation of the news. *The Times* offers an example not only to other newspapers, but to any institution seeking to preserve the dignity of the written word while enhancing its meaning through the resources of graphic design. The growing use of maps, charts, photographs, and cues for selective reading in newspapers need not undermine the power of the printed media, but rather can help keep them vital and accessible.

For a detailed history of newspaper design up to 1972, see Allen Hutt, The Changing Newspaper: Typographic Trends in Britain and America, 1622–1972 (London: Gordon Fraser, 1973). For a history of The New York Times, see Meyer Berger, The Story of The New York Times, 1851–1951 (New York: Simon and Schuster, 1951).

Michael Schudson has charted the ideal of "objectivity" in journalism in Discovering the News: A Social History of American Newspapers (New York: Basic Books, 1967, 1973). Dan Schiller studies similar themes in Objectivity in the News: The Public and the Rise of Commercial Journalism (Philadelphia: University of Pennsylvania Press, 1981).

Textbooks written by John Allen include Newspaper Makeup (New York: Harper and Brothers, 1936), and Newspaper Designing (New York: Harper and Brothers, 1947).

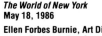

The World of New York
May 18, 1986
Ellen Forbes Burnie, Art Director/Designer; Ron Couture, Design Director; Alex Katz, Illustrator

The World of New York
April 24, 1986
Nicki Kalish, Art Director/Designer; Thomas Bodkin, Design Director; Alen Mac-Weeney, Photographer

New York, New York
April 23, 1989
Nicki Kalish, Art Director/Designer; Thomas Bodkin, Design Director; Philip Lorca Di Corcia and Lynn Johnson, Photographers

Page From
New York, New York
April 23, 1989
Nicki Kalish, Art Director/Designer; Thomas Bodkin, Design Director; Robert Van Nutt, Illustrator

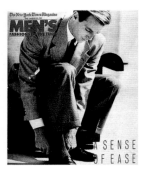

The New York Times Magazine
PART 2/FEBRUARY 28, 1988
FASHIONS OF THE TIMES

BLUE SKY

BY
CARRIE DONOVAN

(Clockwise from left)

Fashions of the Times
March 4, 1973

Louis Silverstein, Art Director/Designer; Louis Silverstein, Design Director

Fashions of the Times
February 28, 1988

Ellen Forbes Burnie, Art Director/Designer; Thomas Bodkin, Design Director; Horst, Photographer

Spread from
Fashions of the Times
February 28, 1988

Ellen Forbes Burnie, Art Director/Designer; Thomas Bodkin, Design Director; Horst, Photographer

Men's Fashions
March 22, 1987

Susan Slover, Art Director/Designer; Thomas Bodkin, Design Director; Vanni Burkhart, Photographer; Kelly Campbell, Phototone by

Fashions of the Times
August 21, 1988

Ellen Forbes Burnie, Art Director/Designer; Thomas Bodkin, Design Director; Monty Coles, Photographer

64

(First row from left)

Home Design
September 22, 1985

Nancy V. Kent, Art Director/Designer; Ron Couture, Design Director; Raeanne Giovanni, Photographer

Home Entertaining
May 4, 1986

Nancy V. Kent, Art Director/Designer; Ron Couture, Design Director; Guy Billout, Illustrator

Entertaining
May 17, 1987

Nancy V. Kent, Art Director/Designer; Thomas Bodkin, Design Director; Jeanne Fisher, Illustrator

(Second row from left)

New Season
August 30, 1987

David Barnett, Art Director/Designer; Thomas Bodkin, Design Director; Al Hirshfeld, Illustrator

Good Health
October 9, 1988

Nancy V. Kent, Art Director/Designer; Thomas Bodkin, Design Director; Javier Romero, Illustrator

Good Health
March 29, 1987

Nancy V. Kent, Art Director/Designer; Thomas Bodkin, Design Director; Robert Goldstrom, Illustrator

(Third row from left)

The Sophisticated Traveller
March 13, 1983

Walter Bernard, Art Director/Designer; Louis Silverstein, Design Director; Seymour Chwast, Illustrator

The Sophisticated Traveller
October 5, 1986

David Barnett, Art Director/Designer; Ron Couture, Design Director; Semyon Bilmes, Illustrator

The Sophisticated Traveller
October 9, 1983

Thomas Bodkin, Art Director/Designer; Louis Silverstein, Design Director; Ivan Chermayeff, Illustrator

(Fourth row from left)

The Business World
June 8, 1986

Thomas Bodkin, Art Director/Designer; Ron Couture, Design Director; Barton Lidice Benes, Illustrator; Susumu Sato, Photographer

Spread from
The Business World
June 8, 1986

Thomas Bodkin, Art Director/Designer; Ron Couture, Design Director; Bruce Wolff, Photographer

Having served as a juror for the 1988 Communication Graphics Show, the AIGA asked Metropolis *design correspondent Karrie Jacobs to comment on contemporary practice.*

On Typishness: This Is My Theory. My Theory Is Wrong.

by Karrie Jacobs

THE MORE I SEE, THE LESS I KNOW. That's how it is with me. I look at ten pieces of graphic design and an idea forms. Above my head is a thought balloon, a glistening ellipsoid of perfection. I look at an eleventh piece of design, and the balloon bursts. Can you picture the Hindenburg in flames over Lakehurst, New Jersey? It happens to me all the time.

I have a theory. Rather, I *had* a theory. I had a theory until I decided that my theory was wrong.

Working on my theory gave me an appetite so I went out for lunch. Afterward I stopped at Rizzoli, the art book store, and looked at picture books. Thumbing through a new book on typography, I came upon a *McCall's* magazine spread from the early 1960s designed by Otto Storch. It illustrated a story about parfaits, layered desserts in elongated, bell-shaped glasses. There was a photo showing several concoctions and in between two of them was the lead paragraph of the story, a block of type shaped just like a parfait glass. Now, I knew about Storch, that he was famous for that sort of thing. I knew that, but it didn't have any significance until I was standing there in Rizzoli, my belly full of chowder, my head full of theory. The Otto Storch spread became the eleventh design.

The ten pieces that preceeded Storch, the pieces on which my theory was founded, were a New Music America poster by Appleton Design of Hartford, Connecticut; a pair of Peugeot ads by HDM Advertising of New York City; a letterhead created for the industrial design firm, Design Logic, by David Frej of INFLUX design in Chicago; two catalogs designed by Thirst's Rick and Noni Valicenti, also of Chicago; a pair of annual reports by Samata Associates of Dundee, Illinois. (Are you counting? That's eight, and they're all in the Communication Graphics section of this book); an ad for a 24-hour French greasy spoon, Restaurant Florent, designed by M&Co. of New York; and an ad for Sea Breeze Facial Cleansing Gel that I tore from a fashion magazine, designer unknown.

What they have in common is a trait I call "typishness." They all use type as if letterforms were dominoes or tiddly-winks, as if lines of copy were pipe cleaners or pick-up sticks. They use type playfully, joyously, exuberantly, with utter abandon. I like typishness. I do. It's a blast. But there's something about it that makes me think that the party is a wake. I think typishness is celebrating the terminal illness of the printed page. At least, that's my theory.

My theory is wrong.

But I'll tell you about it anyway.

If I can't give you truth, at least I can show you a good time. Think about it: when have you ever gotten either from a design annual?

Our relationship is on the rocks. That's my theory. Or maybe it isn't quite so bad. Maybe it's just not a sure thing, a forever thing the way it once was. You, me, and the printed word. We used to be inseparable like Manny, Moe and Jack, like Peter, Paul and Mary. We were as tight as Orpheus and Eurydice. Actually, we're a lot like Orpheus and Eurydice. Do you know that story? No? Well, let me be your Bullfinch.

In Greek mythology, Orpheus and Eurydice were not married long before tragedy struck. Eurydice, pursued by an amorous shepherd, stepped on a snake in the grass, was bitten, and died. Orpheus traveled to the underworld to rescue her from the dead. He sang his heart out and played his lyre, and he so moved Pluto, Proserpine, and their Furies that they allowed him to lead Eurydice away from death. The one condition was that he not look at her until they'd reemerged in the land of the living. But Orpheus, at the last minute, turned to check on Eurydice—one quick glance—and she vanished like a ghost. Orpheus went to embrace Eurydice, but there was nothing there. She had been spirited back down to the underworld.

I picture this happening much the way text disappears from a monitor when the computer goes down. Where do all those words go? To the underworld, I suppose.

MY THEORY IS ABOUT ORPHEUS, EURYDICE, AND Typishness. My theory is that if we attempt to separate the printed word from its paperbound form we will make it disappear. We will turn around to look, and it will be gone. And our foreknowledge of this impending tragedy makes us a little odd about type. Some of us have become stalwart preservationists or formalists while others, those with whom I'm concerned here, have become giddy, perhaps a bit ba-thetic, and typish. Very, very typish.

My theory, of course, is wrong.

For starters, it's based on the sort of punditry I dismiss out of hand. Personally, I don't believe that books as we know them or magazines or newspapers—the ink and paper versions —are going to be snuffed out by electronic media any time soon. (But I do believe that if and when this comes to pass, graphic artists will be as much an endangered species as writers. We'll be the icemen and the punch-cutters, respec-

tively.) There is, however, a constant hum, as annoying as a three a.m. mosquito, about the death of the book, the magazine, the newspaper, the annual report, the poster, the leaflet, the postage stamp, the dollar bill. Data bases have already been substituted for reference works—Roget's is on a floppy, Webster's is on the hard drive—and there are predictions that high-definition, bit-mapped monitors will take the place of books, and be every bit as nice.

FOR INSTANCE, IN THE MARCH/APRIL 1989 *LANGUAGE Technology* (a magazine published in the Netherlands for "word-workers" who use computers), I read an article called "In the Future, Paper Will be Used for Paper Cups." The author, Avery Jenkins, savors, like so many others have savored before him, "the tantalizing promise of a paperless future.

The technology is getting better and better by the minute, says Jenkins. And Hugh Dubberly, Apple's creative director for computer graphics, wrote in the winter 1989 edition of the AIGA *Journal of Graphic Design*, "Now, I readily admit that computer screens are not great places to read books. Not today, anyway. But screens are improving—even surpassing the quality of laser printers. Last spring at the National Computer Graphic Association convention, you could see a 19-inch computer screen with a resolution of 200 dots per inch. Each dot could be any of 256 greys. Type looked like type. Photos looked like they came out of an annual report."

The technology threatens the death of type as we know it. I'm not talking about the progression from hot metal to cool digitization. I'm talking about the end product, symbols on paper. Technology portends the death of books as tangible objects. Whether or not I believe it will happen is beside the point. The potential is real.

Books have died before. In the Middle Ages, the works of antiquity were destroyed or hidden away in monasteries for centuries. Writes historian Peter Gay in the first volume of *The Enlightenment: An Interpretation,* "When Boccaccio visted the great Benedictine library of Monte Cassino, he found it a room without a door with grass growing on the window sills, and the manuscripts, covered with dust, torn and mutilated. . . . he asked one of the monks how such desecrations could have been permitted and was told that the monks would tear off strips of parchment, to be made into psalters for boys or amulets for women, just to make a little money."

The constant of our time isn't invasion by barbarians, it's rapid technological change. This change both allows and encourages typishness. Computers mean that anybody can be perfect. They also mean that anybody can be willfully imperfect. In the desk-top era, every amateur can conjure precision and so precision becomes an amateur's game. Professionals, then, are obligated to go crazy. This is part of my theory. But if the pundits are right, technological change means that the most advanced output equipment, high-resolution devices like the Scitex or the Linotronic, will be obsolete in no time. Output will be unnecesary. All the wildness and all the perfection will be for naught. Type will be a ghost. We'll turn around, and it will be gone.

Typishness indicates to me that type is being treated the way we treat our prized icons, our endangered icons, the ones we love too much to give up. Type has become a juju. Like the green glass Coke bottle which has made a recent and very calculated reappearance. Like the Horn & Hardart Dino-Mat, a camped-up tribute to the nearly extinct automat. Like

ceiling fans. Like muscle cars. Typishness is the swan song of the printed word.

Who is typish? Richard Pandiscio of the *Paper,* a New York downtown arts monthly, is extremely typish. He's been typish for years. In the April 1989 issue, he had columns of type curving to match the figure of actress Joanne Whalley, who plays a seductress in *Scandal.* Helene Silverman was typish during her tenure as art director of *Metropolis* (represented in the Cover Show), and she is currently being typish in the post-literate world of MTV. In a video for a song called "Anna Ng" by a band, They Might Be Giants, she used lyrics moving a bit too quickly to be read, emphasizing the beat. Likewise, Tibor Kalman of M&Co., who is consistently typish in print, was even more so on his firm's video for Talking Heads, which relied heavily on dancing typography. Of course, these are all people from whom typishness is expected.

Look in this book and you will find typishness at work in surprising places. There are the corporate reports by Pat Samata, whose type does everything *except* line up in columns. There are Peugeot ads from HDM Advertising, which use type in literal, so-dumb-they're-smart sight-gags. One, with the headline "It'll have you believing the world is flat," shows a car driving across a block of copy consisting of shattered letters and bumpy, potholed lines of type.

Look at the advertising in magazines and you'll find type doing the fandango, the mazurka, the limbo. Type follows the contours of a model's face in cosmetics ad, and it undulates in a department store ad. On television, commercials have become profoundly typish. In some campaigns, the entire concept is built on type. Type-writer type, reversed-out type, flashing type, blinding type, pounding type. Television commercials now have more subtitles than a festival of foreign films.

SO, IF TYPISHNESS IS THE DEATH RATTLE OF THE printed word, then what's it doing on television? Hell. I don't know. I *told* you that my theory is wrong.

What happened to me at Rizzoli was that Otto Storch's parfait glasses posed a tough question. They asked, how can contemporary typishness be the last fling of the printed word if Otto Storch was typish in 1960? How could that theory be correct if Bradbury Thompson was typish in 1949? And Lester Beall in 1935? And Ladislav Sutnar in 1941? And Alexander Rodchenko in 1923? How?

How, indeed.

Certainly we are in a period of ostentatious design. Designers have renounced the one-typeface, one-way approach of a decade ago, and they've moved on to type fetish, a fevered romance with letterforms, both perfect and distorted. And technology plays a starring role in many, but not all cases. In fact, some of the most typish designers are also the least enamored of high-technology. But this type frenzy is nothing we haven't experienced before.

The real problem isn't the holes in my particular theory. The problem is the practice of trying to coherently sum up the contents of an annual, trying to draw real conclusions from fragments of a year. It can't be done. Every theory based on a selection of a year's worth of design is bound to be wrong. Every round-up of trends in graphic design is a fiction.

My theory is that today's typishness is a final, nostalgic, heartfelt tribute to a dying medium. My theory is wrong. At least, I hope it's wrong. When I turn around, I want to see something there.

Communications Graphics

We were looking for ideas under the layers of varnish—or, for that matter, in those pieces where not even a single varnish was in the budget. Quality of thought was valued over quality of finish. For a piece to be included all jurors had to agree; proponents had to orchestrate consensus. We were particularly interested in: *Appropriateness of concept*—A great idea applied to the wrong job or client is not a great idea. *Appropriateness of solution*—A poster which cannot be read from two feet away is not a poster—maybe it's an invitation. A letterhead which is almost impossible to read once typed on cannot be a good letterhead. Maybe it's a color field painting. *Appropriate methods and materials* —Materials and production routines need to support the concept, not exist as independent exercises. *Control*—The designer needs to show that chosen methods and materials are under control, that the vocabulary and techniques have been mastered. *Newness*—We were all looking to see if the new tools available to designers would prompt new (and appropriate) solutions, or indicate an emerging aesthetic. *Audience*—There was a level beyond which it was not fair to make a reader or recipient struggle to be able to make sense of a piece. *Follow-through*—We sought to avoid one-liners—pieces where an initial gimmick, once swallowed, did not lead anywhere. We agreed to avoid cliché, giddiness, confusion, deception, contrivance, wretched excess, and mindless beauty.

We had a diverse group of jurors and a rigorous process. Only 155 pieces were accepted, but, as Spencer Tracy said of Katherine Hepburn, 'what's there is cherce.' From both brand-name and hitherto-unheard-of designers, here is the best of our craft. It's a show with range, wit, intelligence—and some surprises.

Roger Sametz
Chairman

Communication
graphics

Call for entries
1988 / 1989

AIGA

Communication Graphics
Call for Entry

John Kane and Roger Sametz
Designers

Sametz Blackstone Associates
Design Firm

Norris Litho Company
Photomechanical Preparation

**Monotype Composition
Company**
Typography

Simpson Paper Company
Paper

**Reynolds-DeWalt Printing,
Inc.**
Printing

Steven Tolleson

**Network Equipment
Technologies, Inc.**
Annual Report

Steven Tolleson
Art Director/Designer

**Network Equipment
Technologies, Inc.**
Client

reference to one of the transmission speeds of these
communications systems. Our ability to deliver the
highest quality products and services is depicted in an
independent survey of users reprinted on page 22.
This survey ranks N.E.T.'s product quality, technical sup-
port and training at the top of the industry. Moreover,
our strategic alliance with IBM® brings N.E.T. certain
advantages, both immediate and longer term; it broad-
ens our worldwide account coverage, enhances our
already enviable reputation among the world's leading
corporations and expands the opportunities for our
products to become the driving network engines for
greater numbers of major organizations into the 1990s.

We strive for continued development of products
and services dedicated to network applications, ex-
panded market presence and deeper penetration. We
intend to accomplish these objectives via a combina-
tion of internal development, acquisitions, joint ven-
tures and marketing agreements.

1988

Annual Report

NETWORK EQUIPMENT TECHNOLOGIES, INC.

Materials Technology

Komag Annual Report 1988

Komag advances mass storage tech-
nology through its leadership in the
materials technology sciences that
make higher density recording media
possible. Komag's engineers have
applied their expertise in metallurgy,
chemistry, and magnetics to achieve
storage capacities unattainable with
traditional iron oxide-coated or plated
thin-film disks. As a result, Komag
pioneered the design of thin-film sput-
tered disks and is already developing
the next generation of substrates and
media for advanced magnetic, as well
as erasable, magneto-optic drives.

Komag Annual Report 1988
Annual Report

Steven Tolleson
Art Director/Designer

Komag, Incorporated
Client

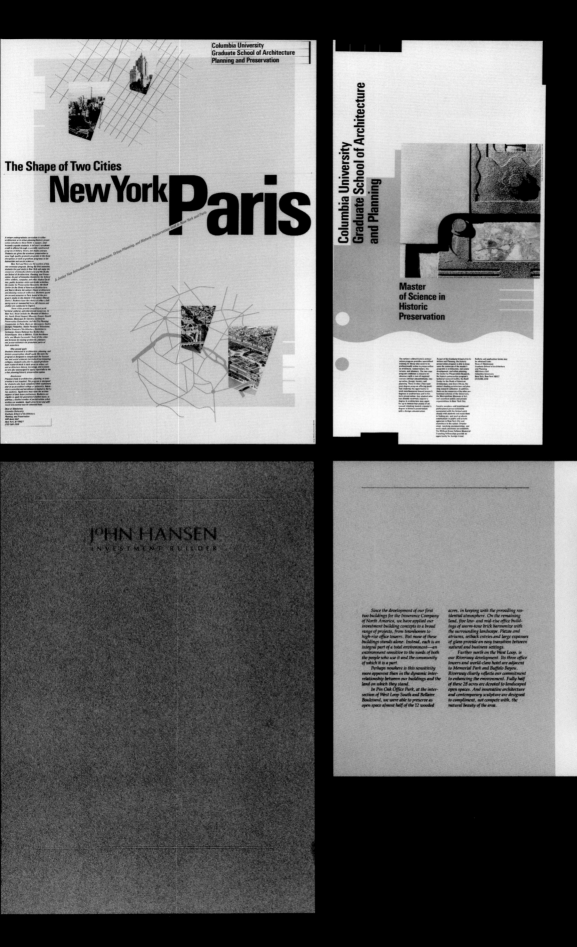

Willi Kunz

New York-Paris
Poster

Willi Kunz
Art Director/Designer

**Columbia University
Graduate School of
Architecture Planning and
Preservation**
Client

**Master of Science in
Historic Preservation**
Poster

Willi Kunz
Art Director/Designer

**Columbia University
Graduate School of
Architecture Planning and
Preservation**
Client

Paula Savage

John Hansen
Brochure

Paula Savage
Art Director/Designer

Jim Sims
Photographer

Savage Design Group, Inc.
Design Firm

**John Hansen Investment
Builder**

Happy New Year
Calendars

Roger Sametz
Art Director/Designer

Stuart Darsch
Photographer

Sametz Blackstone
Client

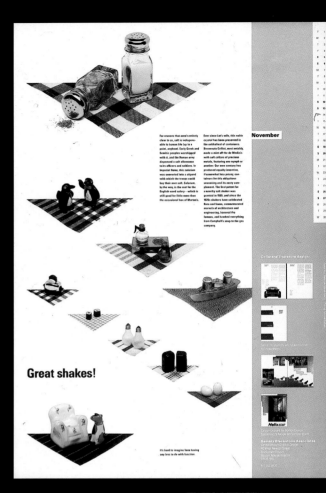

Douglas Scott

Evening at Pops 1986
Press Kit Cover

Douglass Scott
Art Director/Designer

WGBH Television
Client

The Home Planet
Book Jacket

Douglass Scott
Art Director/Designer

Addison-Wesley Publishing
Client/Publisher

THE DESIGN OF GARBAGE

KARRIE JACOBS

WHAT PACKAGE DESIGNERS CREATE IS A FORM OF ADVERTISING FOR THEIR CLIENTS' PRODUCTS. WHAT HAPPENS TO A PACKAGE AFTER THE CONSUMER BUYS IT, USES IT, AND THROWS IT AWAY HAS NEVER BEEN THE DESIGNERS' CONCERN.

Ask designers to think about cause and effect, to make the logical connection between the qualities of the packages they've created and the national glut of solid waste (as garbage is known among lawmakers and bureaucrats), and chances are excellent that they will sidestep the question.

For instance, ask Dean Lindsay, a partner in the Chicago-based design firm of Kornick Lindsay, whether anybody in his office gave a passing thought to the environmental annoyance represented by the big, multilayered, curvilinear plastic jug his firm designed for Minute Maid's new Premium Choice brand orange juice. He won't actually answer yes or no. Ask him whether that sensually rounded package will degrade in landfill or whether it can be recycled and he will instead talk about its convenience and aesthetics.

"Frankly," he says, "our concern was to develop a distinctive package."

While Lindsay does not say this in so many words, the implication is that it's a little inappropriate, crazy even, to call a designer and ask him to think beyond the shape of a client's bottle, the typeface on the label, or the snowy white of the plastic.

And maybe it is.

WHAT'S BLACK AND WHITE

The strangest thing about the bar code, the striped two-tone slice of concrete poetry that's routinely applied to an ever-widening share of every single thing on earth, is that we don't really see it. That is to say, we don't look at it. It's there; no other symbol—corporate, civic, religious, or political—has ever been so extensively or so proudly displayed. But, because it *is* omnipresent, we will the bar code into oblivion.

THE CODE

The second strangest thing about the bar code is that if, for any reason, we resolve to see it, if we begin to notice it in all its permutations—from the Universal Product Code (UPC) to the codes used on magazines and books to the long codes used for tracking air-freight packages—it becomes impossible to ignore. There it is on a soda can, rippling like a neon sign. There it is on a glossy magazine cover sitting at Jack Nicholson's heel like a well-trained pup. There it is on the back of the paperback edition of *The Bonfire of the Vanities*, shimmering like a striped suit louder than any in Tom Wolfe's wardrobe. There it is in our wallets. It's on our library cards, our employee IDs, and our **KARRIE JACOBS** health-club memberships. The only surprise is that there isn't one on the dollar bill. Not yet anyway. The bar code embodies all the traits that corporate designers want in a logo: it is strong, simple, memorable, and easy to recognize. But the bar code is not a logo; it's

AND READ ALL OVER?

5-8703-4 5

MICHEL DELSOL

Helen Silverman
Art Director/Designer

Edward E. Stern
Photographer

Metropolis, December
Publisher

The Code
Magazine Article

Karrie Jacobs
Author

Jeff Christensen
Art Director/Designer

Michele Delsol
Photographer

Metropolis, April 1989
Publisher

Michael Gunselman
Conference Facilities
Brochures

Michael Gunselman
Art Director/Designer

Kevin Fleming and
Karl Richeson
Photographers

Michael Gunselman, Inc.
Design Firm

The University of Delaware,
Continuing Education Division
Client

The Tatnall School
Viewbook

Michael Gunselman
Art Director/Designer

Ed Eckstein
Photographer

Michael Gunselman, Inc.

This consciousness has positive consequences for rates and the way we do business, but most positively, it affects our own well-being and that of our communities.

Mark Anderson
En·vōs
Trade Show Exhibit
Earl Gee
Designer
En·vōs Corporation
Client

Oracle for Macintosh
Software Packaging
Mark Anderson
Art Director
Leif Arneson
Designer
Oracle Corporation
Client

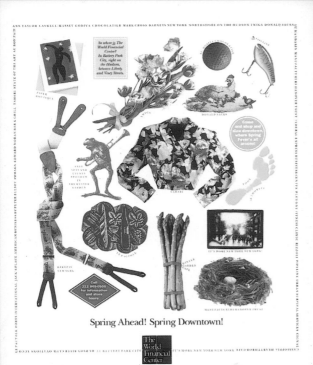

Stephen Doyle

**Spring Ahead! Spring
Downtown!**
Retail Ad
Stephen Doyle
Designer
George Hein
Photographer
Drenttel Doyle Partners
Agency
The World Financial Center
Client

White is definitely right . . .
Magazine Page
Stephen Doyle
Art Director
Andrew Gray
Designer
Drenttel Doyle Partners
Agency
***In Fashion* Magazine**
Publisher/Client

Kenneth Carbone

**Louvre Sign System
Guidelines**
Signage Manual
Kenneth Carbone
Art Director/Designer
**Etablissement Public du
Grand Louvre**
Client

Nichols Institute 1987 Annual Report
Annual Report

Jim Berté
Art Director

Jim Berté and Rebeca Vianu
Designers

Scott Morgan
Photographer

Robert Miles Runyan & Associates
Playa del Rey, CA
Design Firm

Nichols Institute
Publisher/Client

Composition Type
Typographer

Ralphs Printing
Printer

identification. Success comes with creating excellent fits, getting the most for the sponsor and the most for the event.

As a member of the UK's National Track and Field team for 13 years and as a competitor in three Olympics, I learned a lot about truly great teamwork—individual strengths are crucial, but excellent teamwork makes the winning difference. And the best teams are made up of lean, interactive yet independent players. So when APA decided to join a team, we knew what we were looking for.

We had dreams of being part of an 'expert' based culture without the problems of bureaucracy. The raison d'être for us all has been to be a part of a dynamic young group where your voice is heard, your views are sought, your contribution valued but where there is no mandate, no imposition, no headquarters and no flabby outposts who let you down because they're not expected to be anything other than small sub-divisions of a multinational conglomerate. WCRS has never felt like that—and I'm sure never will.

Our own acquisitions—four to date—have followed the WCRS philosophy of bringing in first generation entrepreneurs—do-ers, determined to become or to prove they already are best in their local market or discipline. Today our vital and creative organisation includes:
—Alan Pascoe Associates and Pascoe Nally International—sponsorship, event management and television packages in the UK through APA and internationally through PNI. (Patrick Nally created the international marriage between Coca Cola and World Soccer.)
—Bagenal Harvey Organisation—personality management and promotion.
—Sports Management—the production and sales of sports ground perimeter advertising, at Liverpool's famous Anfield Stadium, for example.
—Artline—concept, design, artwork and print.

We're now better equipped than ever for the coming deregulation of the European airwaves and other developments in international broadcasting. Moreover, we can also call on the Group's vast resource of knowledge and experience to add to our own resources in providing solutions for clients. And we see ourselves as a valuable resource for the rest of the Group. A buzz goes around the office when our showreel of sponsored programmes, our paper on airtime buyouts or our sponsored opening credits are seen, or sought by, other Group members and their clients.

Many of my colleagues and our clients have been surprised since APA became part of "The Group" because nothing appears to have changed—and yet there is a qualitative difference. We are still client led, evaluating or designing sponsorship opportunities to meet client objectives in marketing, communications or corporate awareness. But now there is an energising sense that we're part of a growing communications network.

The only one to spot a day-to-day difference is our long-suffering Financial Director, destined to spend the rest of his time complying with "the system" and attempting to prove we are the best financially managed part of the Group.

For the rest of us, the challenge of each day's work carries extra excitement as we await news of which band of talented entrepreneurs will be joining WCRS next. As leaders in their fields, each brings a broader business perspective, is a new source of vital information and is a different sounding board for ideas.

So being a member of the WCRS federation has all the advantages we sought—and most of all, it's still fun. After hours of agonising over choosing one of the half dozen communications companies that flattered us with offers, we're certain that our analysis, research and, most importantly, "feel" has proved absolutely right.

MARTIN COHN: COHN & WELLS, INC.
BRADLEY WELLS: COHN & WELLS, INC.

12

15

The WCRS Group PLC Annual Report and Accounts 1988
Annual Report

Bennett Robinson
Art Director

Bennett Robinson and Erika Siegel
Designers

Robert Risko, Dian Friedman, and Seymour Chwast
Artists

Gordon Meyer
Photographer

Corporate Graphics Inc. New York, NY
Design Firm

WCRS, PLC
Publisher/Client

Pastore Depamphilis & Rampone
Typographer

George Rice & Sons
Printer

Burbank-Glendale-Pasadena Airport Authority 1987 Annual Report ✈

A New Standard—Not At The Top Of The List

Burbank-Glendale-Pasadena Airport Authority 1987 Annual Report
Annual Report

Thomas Devine
Art Director/Designer

Stephen Turk
Artist

Scott Morgan
Photographer

Devine Design Burbank, CA
Design Firm

Burbank-Glendale-Pasadena Airport Authority
Publisher/Client

Composition Type
Typographer

Lithographix
Printer

**The L.J. Skaggs and
Mary C. Skaggs Foundation
Annual Report 1987**
Annual Report

Michael Vanderbyl
Art Director

Various
Photographers

**Vanderbyl Design
San Francisco, CA**
Design Firm

**The L.J. Skaggs and
Mary C. Skaggs Foundation**
Publisher/Client

On Line Typography
Typographer

George Rice & Sons
Printer

**San Francisco International
Airport: 1988 Annual Report**
Annual Report

Jennifer Morla
Art Director

**Jennifer Morla and
Marianne Mitten**
Designers

Paul Franz-Moore
Photographer

**Morla Design, Inc.
San Francisco, CA**
Design Firm

**San Francisco International
Airport**
Publisher/Client

Mercury Typography, Inc.
Typographer

Mastercraft Press
Printer

Cracker Barrel Old Country Store, 1988 Annual Report to Shareholders
Annual Report

Thomas Ryan
Art Director

Cathy Wayland
Designer

McGuire
Photographer

Cathy Wayland
Hand-tinting of Photos

**Thomas Ryan Design
Nashville, TN**
Design Firm

Cracker Barrel Old Country Stores Inc.
Publisher/Client

Alan Waller & Associates
Typographer

Jones Printing
Printer

Reeves Communications Corporation 1988 Annual Report
Annual Report

Aubrey Balkind
Art Director

David Suh
Designer

Paul Stevens and Michael Melford
Photographers

Frankfurt Gips Balkind New York, NY
Design Firm

Reeves Communications Corporation
Publisher/Client

Frankfurt Gips Balkind Desktop Publishing
Typographer

Lebanon Valley Offset
Printer

**Trace Products Annual
Report 1988**
Annual Report

Lauren Smith
Art Director

Alan Crisp
Designer

Mel Lindstrom
Photographer

**Lauren Smith Design Inc.
Palo Alto, CA**
Design Firm

Trace Products Inc.
Publisher/Client

Z Typography
Typographer

House of Printing
Printer

"We've defined the leading edge by listening to our customers. It's kind of unprecedented for R&D to interact with customers as much as we do, but it's what we've always done. Just about every idea has come from a customer."

JIM DICKERSON
Research and Development

Whirlpool

Corporation

Annual

Report

1987

Building

Shareholder

Value

**Whirlpool Corporation Annual
Report 1987, Building
Shareholder Value**
Annual Report

Pat Samata and Greg Samata
Art Directors

Mark Joseph
Photographer

**Samata Associates
Dundee, IL**
Design Firm

Whirlpool Corporation
Publisher/Client

TR
Typographer

George Rice & Sons
Printer

**McDonnell Douglas
Finance Corporation
1987 Annual Report**
Annual Report

John Clark
Art Director/Designer

Scott Morgan
Photographer

**Cross Associates
Los Angeles, CA**
Design Firm

**McDonnell Douglas
Finance Corporation**
Publisher/Client

Central Typesetting
Typographer

Anderson Lithograph Co.
Printer

McDonnell Douglas Finance Corporation

1987 Annual Report

Manufacturer/Dealer Product Financing

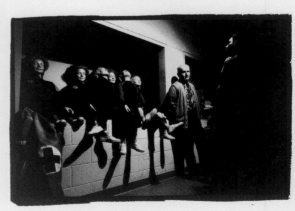

DENA MERCHANT

Casework Services Secretary II

Years of Red Cross Service: 1

ARTHUR E. BURTMAN

Health Services Chairman

Years of Red Cross Service: 10

**American Red Cross of
Massachusetts Bay:
Annual Report 1986-1987**
Annual Report

Paul Huber
Art Director

Steve Marsel
Artist

**Altman & Manley
San Francisco, CA**
Design Firm

**American Red Cross of
Massachusetts Bay**
Publisher/Client

Typographic House
Typographer

Dynagraf Co.
Printer

**National Medical Enterprises,
Inc., Annual Report 1988**
Annual Report

Kit Hinrichs
Art Director

Karen Boone
Designer

**Vince Perez, Justin Carroll,
and Tim Lewis**
Illustrators

**Michele Clement, Terry
Heffernan, and Jeff Corwin**
Photographers

**Pentagram Design
San Francisco, CA**
Design Firm

**National Medical
Enterprises, Inc.**
Publisher/Client

Andresen Typographics
Typographer

Anderson Lithograph Co.
Printer

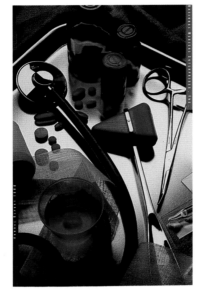

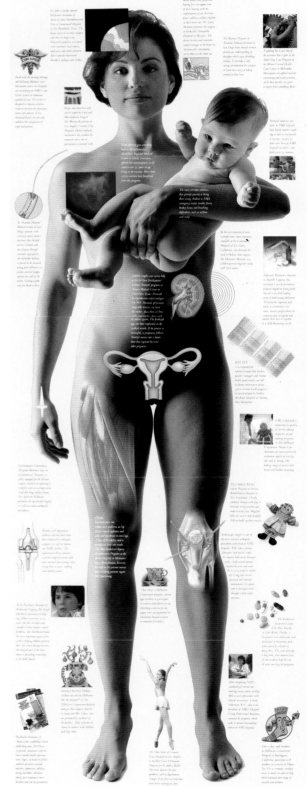

Curtice Burns Foods, Inc. Annual Report for the Year Ended June 24, 1988
Annual Report

Robert Meyer
Art Director

Brenda Mason
Designer

Scott Morgan
Photographer

Robert Meyer Design, Inc. Stamford, CT
Design Firm

Curtice Burns Foods, Inc.
Publisher/Client

Rochester Mono-Headliners
Typographer

Monroe Litho Co.
Printer

Annual Report
for the
Year Ended
June 24, 1988

The Company's popcorn brand, Super Pop, was augmented by the acquisition of two additional brands, Pops-Rite and Pop Eye. This now makes Curtice Burns the number one seller of poly bag popcorn in America.

The proliferation of special interest catalogues and magazines over the last decade has created extraordinary demand for lightweight coated groundwood printing papers. It seems that each day a new publication emerges with a mission to appeal to some carefully defined segment of our rapidly changing society. The topics cover the full range of human diversity from bee keeping to nuclear medicine and they join an established stable of familiar periodicals that have a permanent place in North American culture. Magazines continue to grow in response to an increasingly better educated and mature audience. Direct mail catalogues and free-standing newspaper inserts are also helping advertisers reach targeted audiences with glossy, full-colour printing made possible by lightweight coated paper. The market continues to grow at a rate of approximately 5 per cent per year, and BCFP's Blandin Paper Company will grow with it. A major expansion is underway at Blandin in Grand Rapids, Minnesota, which when completed in late 1989 will nearly double current capacity to 500,000 short tons per year and position the Company as the fourth largest producer in the U.S.

New orders for coated paper in the United States rose in 1987 due to excellent growth in publishing. Blandin's major expansion will bring another 220,000 short tons of annual capacity to this growing market in 1989.

14

British Columbia Forest Products Ltd. 1987 Annual Report
Annual Report

John Van Dyke
Art Director

Terry Heffernan
Major Photography

Van Dyke Company Seattle, WA
Design Firm

British Columbia Forest Products Ltd.
Publisher/Client

Pola Graphics
Typographer

MacDonald Printing
Printer

GE Identity Program
Graphic Standards Manuals

Tom Suiter
Creative Director

Donald H. Bartels
Design Director/Author

Karl A. Martens,
Rebecca O. Livermore, and
Randall Dowd
Design Team

Virginia Zimmerman
Production Manager

Doyald Young
Letterer

Landor Associates
San Francisco, CA
Design Firm

General Electric Corporate
Marketing
Client

Adobe Systems and
Spartan Typographers
Typographers

Lithographix
Printer

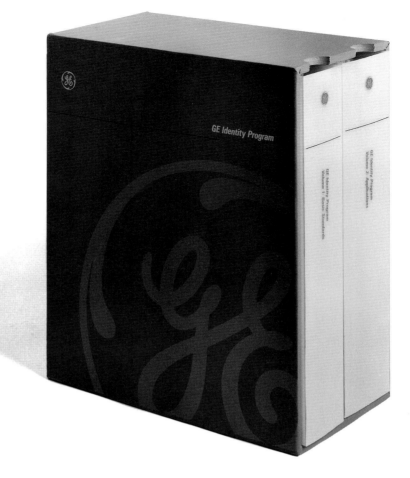

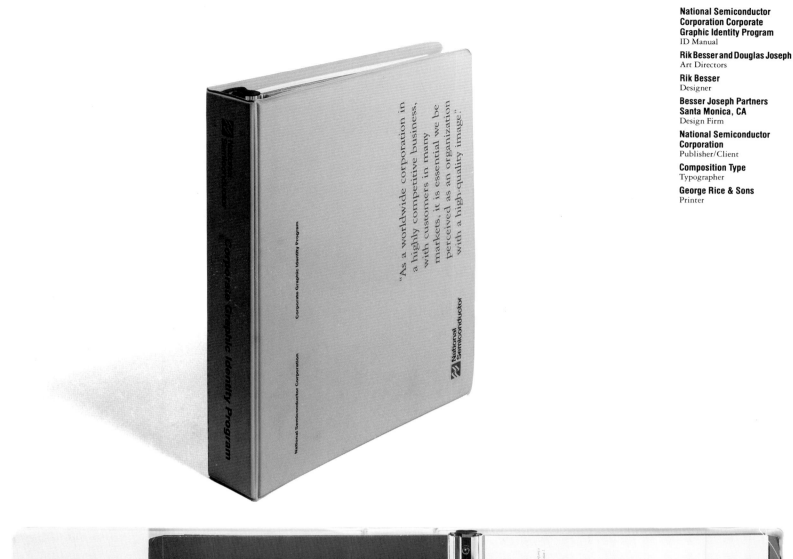

**National Semiconductor
Corporation Corporate
Graphic Identity Program**
ID Manual

Rik Besser and Douglas Joseph
Art Directors

Rik Besser
Designer

**Besser Joseph Partners
Santa Monica, CA**
Design Firm

**National Semiconductor
Corporation**
Publisher/Client

Composition Type
Typographer

George Rice & Sons
Printer

Dillon Read 1987 Annual Review
Annual Report

Stephen Ferrari
Art Director

Terry Heffernan and William Taufic
Photographers

The Graphic Expression, Inc. New York, NY
Design Firm

Dillon, Read & Co., Inc.
Publisher/Client

Gerard Associates
Typographer

Lebanon Valley Offset
Printer

CAPABILITIES IN CORPORATE DEBT ISSUANCE

DILLON READ SERVES ITS CLIENTS' CAPITAL NEEDS *in the public debt markets by combining research and analytical capabilities in Corporate Finance, trading and distribution capabilities in Marketing, and structuring, pricing, and issue management capabilities in Syndicate. The teamwork of these groups has resulted in many successful offerings for our clients. In 1987, Dillon Read acted as manager for over $5.5 billion worth of public corporate debt issues.*

AN EXCELLENT EXAMPLE OF OUR *capabilities occurred in early 1987. Institutional holders of corporate debt, who had been called out of many seasoned issues as rates fell during 1985 and 1986, were especially sensitive to the call features of corporate new issues. We suggested to clients a way of improving their all-in cost of funds on long-maturity issues by offering additional call protection through a restructuring of the call price schedule. Using this technique, which was imitated by others, we were able to raise funds for a number of clients on particularly attractive terms. In another transaction, we structured and executed an innovative financing which is backed by automobile leases for Volkswagen Lease Finance Corporation.*

OUR DEBT ISSUING CAPABILITY *is offered in the context of an overall program of client service. It is an integral part of the work we perform in analyzing our clients' long-term strategic priorities, capital needs, and financial structure goals.*

26

Times Mirror Cable Television has made great progress in an extensive restructuring plan that has reshaped this business to improve operating results and position it for future growth. During 1987, negotiations began with United Artists Communications, Inc. and Tele-Communications, Inc. to trade our Arizona operations, which are principally located in the greater Phoenix area, for systems in other markets.

Our broadcast television activities concentrated in 1987 on improving operations, especially news and other programming. Weak economic conditions in Texas adversely affected both our largest station, KDFW-TV in Dallas-Fort Worth, and KTBC-TV, Austin. KTVI, St. Louis, is addressing disappointing audience results with important programming changes. WVTM-TV, Birmingham, enjoyed improved operations.

As part of our restructuring program, in January 1988 we sold our directory printing company, Times Mirror Press, to GTE Directories Corporation, its largest customer. GTE Directories is continuing to operate the plant, thus assuring continued employment for more than 300 former Times Mirror employees. Times Mirror retained ownership of about 250,000 acres of Pacific Northwest timberlands at the time of our sale of Publishers Paper Co. to Jefferson Smurfit Corporation in 1986. As market conditions improved in 1987, we sold more than 94,000 acres for an aggregate price of approximately $65 million. We are continuing to dispose of our timberland holdings in 1988, while also harvesting timber from our lands.

While our restructuring plan has been aimed at eliminating activities no longer central to our core businesses, we also divested companies in core areas that did not meet our growth objectives. Such was the case in 1987 with *The Denver Post*. Given our other opportunities and challenges and the economic difficulties of the Denver area, we decided to turn our management attention and resources elsewhere. The sale of *The Post* resulted in a loss, after tax benefits, of $25.3 million, or 20 cents per share.

Times Mirror's most important asset is its people. Therefore it is not surprising that another corporate objective is to "attract, motivate and retain a high-quality workforce that reflects the diversity of our society, and provide a positive work environment that allows employees' talents to be developed to the fullest." In this connection, it has been and continues to be vital that we increase the participation of women and minorities at all levels of the company. We continued to make progress in this direction in 1987. Out of more than 27,000 employees worldwide, 26 percent are from minority groups and 36 percent are women. In our managerial ranks, 16 percent are of minority backgrounds and 28 percent are women.

We have also increased employee stock ownership through the Times Mirror Savings Plus Plan and the Employee Stock Ownership Plan, programs that have been widely applauded by our employees.

Opposite:
Restructuring of the company's cable operations over the past three years has resulted in important growth of this communications business.

Times Mirror

1987 Annual Report

"The Times Mirror Company

is committed to gathering and disseminating

the information that people need to live,

work and govern themselves in a free society.

We will strive to do so with the highest standards

of accuracy, fairness, quality

and timeliness."

Times Mirror 1987 Annual Report
Annual Report

Jim Berté
Art Director

Jim Berté
Designer

Paul Bice
Artist

Robert Miles Runyan & Associates Playa del Rey, CA
Design Firm

The Times Mirror Company
Publisher/Client

Composition Type
Typographer

George Rice & Sons
Printer

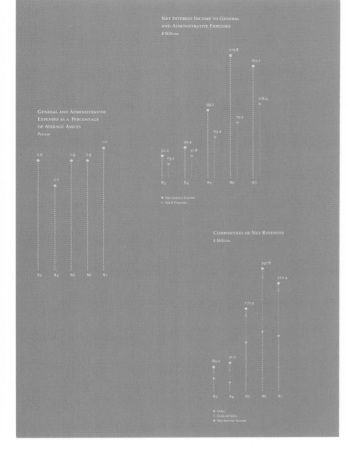

NET INTEREST INCOME TO GENERAL
AND ADMINISTRATIVE EXPENSES
$ Millions

GENERAL AND ADMINISTRATIVE
EXPENSES AS A PERCENTAGE
OF AVERAGE ASSETS
Percent

COMPOSITION OF NET REVENUES
$ Millions

We have the ability to shrink, expand or perhaps even eliminate portfolios in response to changing market conditions. The origination of economically sound and marketable loans that generally can be sold in the secondary market and investments in corporate bonds with significant call protection both serve to enhance flexibility.

In managing our liabilities, we seek to build in protection from heavy or unusual demands on our liquidity. Among our liability strategies have been:

* The offering through national investment banking firms of long-term certificates of deposit that cannot be withdrawn except under very limited circumstances.

* The conversion of our branch system into a sales force with the expertise to market longer-term certificates of deposit.

* The use of our liquid assets as collateral for lower-cost borrowings.

* De-emphasis of uninsured and volatile "jumbo" accounts.

* The offering of subordinated and securitized debt issues.

As a result of our liability management, the average maturity of our fixed-rate liabilities at December 31, 1987 was approximately three years. The lower costs associated with the "wholesale" approach to deposit-gathering enable us to compete more effectively for long-term money without adversely affecting net income.

DIVERSITY By diversifying its portfolio, management can distribute different types and levels of risk among different segments of the asset portfolio. A more conservative approach to one portion of the portfolio makes it possible to attain more attractive risk/reward relationships in other areas.

* The asset portfolio has been diversified into different types of businesses and investments, such as investment securities, mortgage-backed securities and commercial real estate.

* Each line of business or investment is, in turn, appropriately diversified by such categories as geography, industry, issuer or borrower. For instance, the corporate debt securities portfolio has been further diversified among sixteen separate industries.

Columbia Savings and Loan Association
1987 Annual Report
Annual Report

Gary Hinsche and Michael Mescall
Art Directors

Michael Mescall
Designer

Paul Bice
Artist

Robert Miles Runyan & Associates
Playa del Rey, CA
Design Firm

Columbia Savings and Loan Association
Publisher/Client

Central Type
Typographer

George Rice & Sons
Printer

Mobil Graphic Standards Manual

The Mobil Alphabet

Mobil
Graphic Standards Manual

Tom Geismar
Design Director

Cathy Rediehs
Designer

Chermayeff & Geismar Associates
New York, NY
Design Firm

Mobil Oil Corporation
Publisher/Client

Typogram
Typographer

Stephenson, Inc.
Printer

1988 Annual Report, Herman Miller, Inc. and Subsidiaries
Annual Report

Stephen Frykholm
Art Director/Designer

Various
Photographers

Herman Miller, Inc.
Zeeland, MI
Design Firm

Herman Miller, Inc.
Publisher

Type House
Typographer

The Hennegan Co.
Printer

After two years of declining earnings, Herman Miller had record earnings and sales in 1988. Can it keep up the kind of growth that distinguished the company from 1975-85?

1988 Annual Report Herman Miller, Inc. and Subsidiaries

TOUGH QUESTIONS
STRAIGHT
ANSWERS

How do you plan to maintain Herman Miller's position as a leader in design?

We can maintain our leadership only by continuing to invest energy and money in what got us here. We will continue to invest aggressively in research and design. We have already invested in an environment – the Design Yard here in West Michigan – to gather working designers, design management, the test lab, advanced manufacturing, engineers, and development people in one place. Our design and development group is working with a large, international group of talented and experienced product designers.

Our design leadership shows at Milcare, where we have under way a strong effort to research and develop new products for acute care settings.

Leadership in design is really a result of an attitude we have at Herman Miller in all areas of the company. Given the right environment, innovation can come from anybody. This leads to innovative human resource programs and distribution systems as well as innovative products. For example, our development group won a special recognition award last year from the Society of Plastics Engineers for innovative use of plastics in the furniture industry.

Leadership comes from hard work and sticking to your principles. We don't imitate other companies' products; we apply our money and resources to real problems not yet solved. Our research and design process tells us what kinds of furniture to make.

LINCOLN BANCORP

Credit accommodations for Lincoln's clients are centered on what the management team knows best — basic commercial lending. This includes working capital lines of credit for seasonal financing needs and term loans for longer term acquisition and expansion requirements. Equipment financing is also provided as well as loans to meet the growing needs of the expanding real estate industry of southern California.

Lincoln has recently established a Mortgage Banking Division which focuses on both originating and purchasing residential and commercial real estate mortgages within the southern California market and primarily in Los Angeles county. All mortgages, whether originated or purchased, will be subject to strict underwriting standards and conform to prudent loan to

value ratios. The division is headed by Doug Jones and Don LaVoi, who have strong mortgage and commercial banking experience behind them.

No construction loans were made during 1987 or were outstanding at the end of the year. Lincoln has maintained a prudent policy of avoiding this type of financing because of its inherently high risk.

As the economy in this country becomes more dependent on exports, Lincoln will be well positioned as foreign negotiated and standby letters of credit are provided by the Bank through its extensive network of correspondent banks.

Because Lincoln concentrates on loans which are usually based upon the prime rate, its interest income tends to be sensitive to changes in short term interest rates. Thus, when rates rise, the Bank will benefit as the largely prime-based loan portfolio reprices faster than the slower to change time certificates of deposit or money market accounts. However, when rates fall, the Bank would suffer as the prime-based loan portfolio reprices downward faster than deposit accounts. To mitigate this effect, the Bank has obtained an interest rate guarantee by a major correspondent bank, thus hedging itself against falling rates. Thus, a falling rate environment would benefit the Bank nearly as much as a rising rate environment.

Credit accommodations for Lincoln's clients are centered on what the management team knows best — basic commercial lending.

Pacific Palisades overlooking the
Pacific Coast Highway

Louis P. D'Agostino
Executive Vice President,
Lincoln National Bank

James W. Selin
Executive Vice President,
Lincoln National Bank

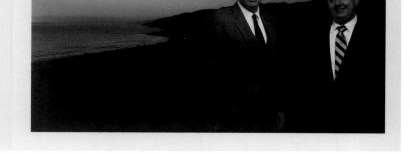

Lincoln Bancorp 1987 Annual Report
Annual Report

Douglas Joseph and Rik Besser
Art Directors

Douglas Joseph
Designer

Eric Meyer
Photographer

Besser Joseph Partners
Santa Monica, CA
Design Firm

Lincoln Bancorp
Publisher/Client

Composition Type
Typographer

George Rice & Sons
Printer

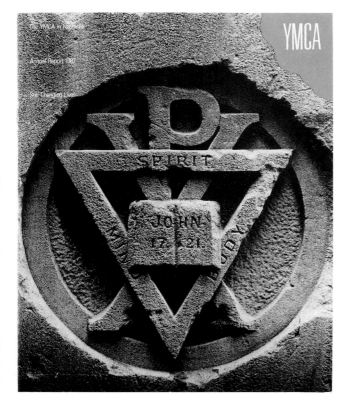

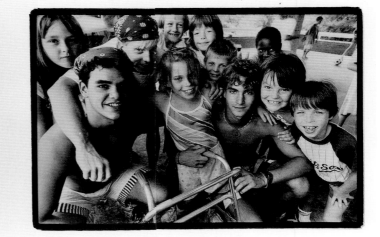

Carr: Word Processing Document Formatting Standards
Word Processing Guide

Jack Beveridge, Eddie Byrd, and Nick Seay
Art Directors

Beveridge Byrd Seay Arlington, VA
Design Firm

Edward R. Carr & Associates, Inc.
Publisher/Client

IBM Displaywriter
Typographer

Virginia Lithograph Co.
Printer

The YMCA in Nashville Annual Report 1987
Annual Report

Thomas Ryan
Art Director

Tim Campbell
Photographer

Thomas Ryan Design Nashville, TN
Design Firm

YMCA of Nashville and Middle Tennessee
Publisher/Client

D & T Typesetting Service
Typographer

Color Graphics
Printer

AFS: The experience passes quickly. . ., 1987 Annual Report
Annual Report

Terri Bogaards and Ellen Shapiro
Art Directors

Terri Bogaards
Designer

Various
Photographers

Shapiro Design Associates, Inc.
New York, NY
Design Firm

AFS Intercultural Programs
Publisher/Client

Tanatype and King Typographic Service Inc.
Typographers

Pressroom
Printer

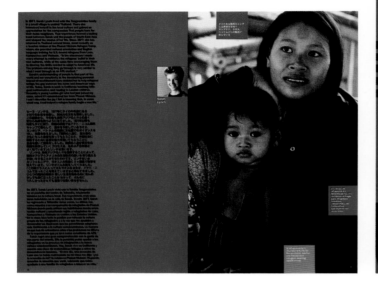

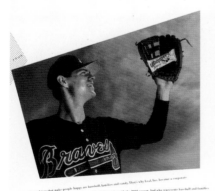

Leaf, Inc. Annual Report 1987
We Make Good Friends
Annual Report

Pat Samata and Greg Samata
Art Directors

Mark Joseph
Photographer

Samata Associates
Dundee, IL
Design Firm

N. W. Ayer
Publisher/Client

TR
Typographer

Great Northern Printing
Printer

**Chili's Grill & Bar
'88 Annual Report
Brilliant Colors**
Annual Report

Bryan Boyd
Art Director

Regan Dunnick
Artist

Robert LaTorre
Photographer

**Richards Brock Miller
Mitchell and Associates
Dallas, TX**
Design Firm

Chili's Inc.
Publisher/Client

Chiles & Chiles
Typographer

Heritage Press
Printer

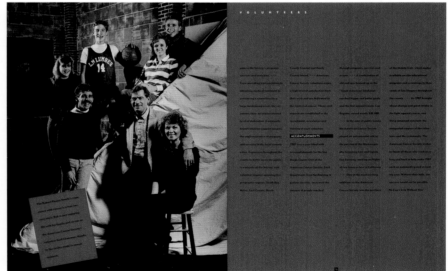

**Volunteers: 1987 Annual
Report, The American Cancer
Society**
Annual Report

Scott Mires
Art Director

Stephen Simpson
Photographer

**Mires Design, Inc.
San Diego, CA**
Design Firm

The American Cancer Society
Publisher/Client

Central Graphics
Typographer

Commercial Press
Printer

**Carter Hawley Hale
Annual Report 1988**
Annual Report

Jim Berté
Art Director/Designer

Norman Mauskopf
Photographer

**Robert Miles Runyan &
Associates
Playa del Rey, CA**
Design Firm

**Carter Hawley Hale
Stores, Inc.**
Publisher/Client

Composition Type
Typographer

Lithographix
Printer

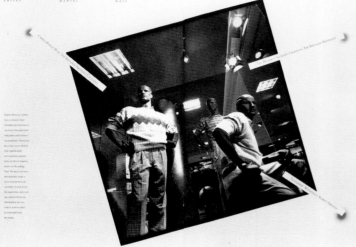

**National Futures Association
1988 Annual Review**
Annual Report

Jacklin Pinsler
Art Director

Janet Gulley
Designer

Tom Lindfors
Photographer

**Crosby Associates, Inc.
Chicago, Il**
Design Firm

National Futures Association
Publisher/Client

Master Typographers
Typographer

Rohner Printing Co.
Printer

**Boston YWCA/One Hundred
Twenty-Second Annual
Report 1987**
Annual Report

Matt Ralph
Art Director

Len Rubenstein
Photographer

**Matt Ralph Graphic Design
Cambridge, MA**
Design Firm

Boston YWCA
Publisher/Client

Type by Design
Typographer

**The Pressroom Gallery of
Fine Lithography**
Printer

One Hundred Twenty-Second Annual Report 1987

BOSTON YWCA

The YWCA has renewed its commitment to providing safe, affordable housing

REVIEW OF PROGRAMS

**Renewed Priorities:
Developing Safe, Affordable and
Transitional Housing**
The Renaissance plan for renewal led to a full-scale renovation project at the Berkeley Residence, center of the YWCA housing program since the 19th century. Almost $1 million is being invested in repairs and construction, reaffirming the YWCA commitment to safe affordable housing. This year, elevators were rebuilt and modernized; exterior masonry walls were repaired. The dining/room was given a new floor and color scheme. Common areas were renovated and the laundry room was remodeled and updated with new machines. The State Street Bank and Trust Company Farnsworth Trust and Charlesbank Homes each supported the Berkeley Residence with $10,000 grants.

The Berkeley Residence continued to operate at near full capacity, offering long-term and transient housing, with meals and other services, to approximately 200 women. The Berkeley Residence Hospitality Committee was revitalized and increased social programs and community outreach. The Berkeley Residence cafeteria served affordable lunches to the public and was used as a meeting space by neighborhood groups.

With renewed priorities, the YWCA began to investigate development of transitional housing as an alternative for pregnant and parenting teens, displaced homemakers, survivors of domestic violence and other women in need and their families. To increase options for serving this vulnerable population, the YWCA Task Force on Housing was appointed.

In Roxbury/Dorchester, the YWCA submitted a proposal to the Boston Public Facilities Department to obtain property in order to enlarge the Aswalos House Branch and develop transitional housing for pregnant and parenting teens. In partnership with the Gunwyn Company and Graham Gund Architects, the YWCA sought designation from the Boston Redevelopment Authority to implement a transitional housing program in Boston's South End as part of the city's second parcel-to-parcel linkage project. With increased exposure and experience, the revitalized YWCA included the development of transitional housing as a major priority.

**Developing Livelihoods:
Employment and Training Programs**
The Boston YWCA Industry Advisory Committee (IAC) was organized in 1987. Made up of representatives from approximately 22 corporations, including the John Hancock Mutual Life Insurance Company, Honeywell Bull, Brigham and Women's Hospital and the Bank of Boston, the IAC met once a month with YWCA program staff to add renewed vigor to YWCA employment and training programs. The YWCA and IAC collaborated to form the Paid Internship Placement Service.

The Paid Internship Placement Service was created to provide well-paid employment in IAC corporations for YWCA training program graduates and members seeking to enter the job market. In its first month of operation, 52 trainees received assistance through the Paid Internship Placement Service; 20 successfully completed their internships and were hired full-time. The Paid Internship Placement Service provided a link with other human service agencies in the city by

Texaco Star Market Design Overview and Basic Graphic Guidelines
Standards Manual

Kenneth D. Love
Art Director

Heather Wielandt and Vern Ford
Designers

David Sundberg
Photographer

Anspach Grossman Portugal New York, NY
Design Firm

Texaco Europe
Publisher/Client

Typogram
Typographer

Rapoport Printing Co.
Printer

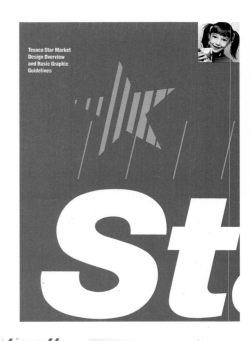

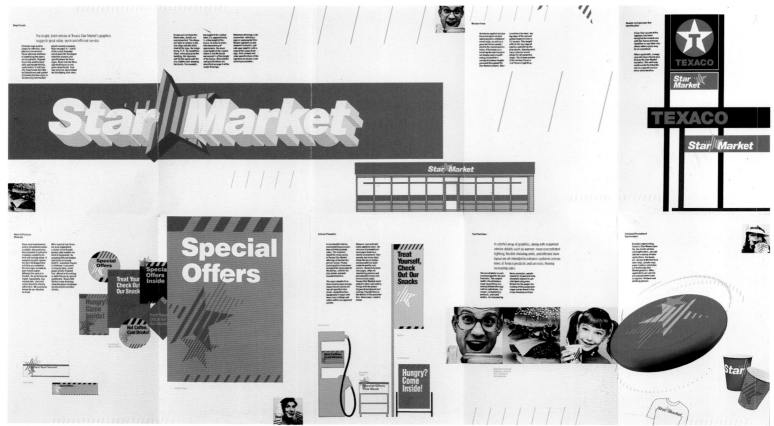

FIRE-PAL REPORT

Silicon Graphics' marketing strategy—focusing on market segments

Our products are used primarily in four broad markets: mechanical CAD/CAM/CAE, visual simulation, industrial design and animation, and the general scientific market.

The largest growth is expected in the overall CAD/CAM/CAE market, as engineers continue the transition to 3D shaded solid and surface modeling techniques instead of 2D drafting and 3D wire frame representations. This market is a major focus for us—it accounted for nearly 50 percent of our revenue this year. Being the first to market a 3D workstation below $20,000, Silicon Graphics is in a position to leverage market share. In fact, industry analysts predict that MCAE unit potential alone could increase ten-fold due to this price breakthrough. Our objective is to be a principal supplier to this market.

Our CAD/CAM/CAE Division focuses on the market requirements for automotive, aerospace and other manufacturing applications. Our manufacturing and engineering customers include companies such as BMW, Boeing, Chrysler, General Dynamics, NASA and McDonnell Douglas. Over the last year joint development and marketing agreements were announced with major CAD/CAM/CAE software suppliers including Control Data (ICEM™); MCS (Aries-5000™); Moldflow Pty. Ltd. (Moldflow™); Parametric Technology (Pro/ENGINEER™); PDA Engineering (PATRAN™); Prime Computer (PrimeDesign™); Structural Dynamics Research Corporation (I-DEAS™); Swanson Analysis (ANSYS®), as well as others.

Visual simulation represented approximately one-quarter of our business in 1988. In this market, our machines are used by the military to "pre-fly" military aircraft missions, by commercial airlines and aerospace manufacturers to train crews and confirm designs, and by engineers to simulate plant floor layouts and test process flows. Major customers include Aerospatiale, Boeing, British Aerospace, and Unisys.

Chrysler Motors

Chrysler Motors in Detroit purchased more than 180 4D workstations from Silicon Graphics. The car manufacturer's main goal is to drastically reduce the time it takes to produce its new line of automobiles and hence, increase Chrysler's competitiveness in world markets. To achieve this goal, Chrysler has developed proprietary CAD/CAM software to run on our workstations. Everything from the external surface to inner panels, engine and transmission systems to wheel design will be designed and visualized on Silicon Graphics' systems.

Silicon Graphics' Distributed Processing Environment

Janice Coelho (right), administrative services manager, oversees the Silicon Graphics corporate environment and image. "The culture put in place at Silicon Graphics years ago is still here today—it's the backbone of the Company's philosophy. People here care about making things happen."

Fire-PAL Report
Annual Report

Forrest Richardson and Rosemary Connelly
Art Directors

Diane Gilleland
Designer

Forrest Richardson
Writer

Bill Timmerman
Photographer

**Richardson or Richardson
Phoenix, AZ**
Design Firm

Phoenix Fire-PAL Organization
Publisher/Client

DigiType
Typographer

Prisma Graphic Corporation
Printer

American Color, Laserscan, and TruColour, Inc.
Color Separators

Cactus Bindery
Binder

**Silicon Graphics, Inc.
1988 Annual Report**
Annual Report

Richard Klein and Paul Schulte
Art Directors

Paul Schulte
Designer

Jim Karageorge and David Powers
Photographers

**RKD, Inc.
Palo Alto, CA**
Design Firm

Silicon Graphics, Inc.
Publisher/Client

Drager & Mount
Typographer

George Rice & Sons
Printer

**Independence Bancorp
1987 Annual Report**
Annual Report

Michael Gunselman
Art Director

Ralph B. Billings, Jr.
Designer

Ed Eckstein
Photographer

**Michael Gunselman Inc.
Wilmington, DE**
Design Firm

Independence Bancorp
Publisher/Client

Composing Room, Inc.
Typographer

Lebanon Valley Offset
Printer

Exceptional Service with Advanced Technology

A t IMP, our products are designed and manufactured to solve the needs of individual customers. Naturally then, exceptional customer service is as essential to our success as state of the art technology. We perform the complete IC design and manufacturing from functional descriptions or block diagrams or we link our customers' IC design capabilities to our manufacturing processes. From the start, customers get direct access to our technical staff—some of the best digital and analog IC designers and process technologists in the world. Together, the IMP/customer team ensures that chip performance is optimized to meet system needs. More important, the team facilitates a smooth transition to the manufacturing phase. Not only do we provide excellence in service, we also use advanced design tools and high-performance manufacturing processes. We pioneered the use of CAD for customized circuit design. In 1982, our earliest design system allowed standard cell and full-custom techniques to be combined on one chip. In March 1983, we announced the industry's first 14-week turnaround time for digital standard cell-based techniques, a vast improvement over the more customary nine months or more of development time. Now single ICs are designed hierarchically using complete functional blocks from many sources including our library of standard cells, fully customized blocks and complex megacells. The functional blocks can perform analog or digital functions or a combination of both. In the future, our design system will continue to integrate more sophisticated CAD software such as our SCF Compiler™ for switched capacitor filters, our Standard Cell IC Layout (SCIL) and our Block IC Layout (BIL) placement and routing software. In manufacturing, we plan to continue to introduce reliable, high-performance and reproducible process technologies. We were one of the first manufacturers to put the 3 and 2 micron processes into production. Recently, we announced the ACL/DCL 1.2—the industry's first 1.2 micron analog/digital cell libraries—along with the supporting MxCMOS processes. These technologies are of the highest standards of excellence. We not only pursue excellence, we attain it.

IMP's IDS II design system and ACL/DCL cell libraries produce cost-effective designs for our customers and handles both analog and digital simulation.

Design Capture	Simulation	Physical layout	Verification	Pattern generation	Wafer fabrication		Metallization	Packaging	
Design solution entered into the design system.	Circuit operation simulated using electronic models.	Circuit elements electronically arranged and interconnected.	Circuit checked for adherence to design and process rules.	Manufacturing masks made from the completed design database.	Circuit geometries transferred to the wafer using masks and photolithographic techniques.	Dopants implanted via etched openings to form circuit component structures.	Metallization used to connect circuit components and form pads for wire bonding.	After testing, completed wafer is cut into individual circuits.	Chips mounted and external wire connections made before packages are sealed.

6 7

**International Micro-
electronics Products
1988 Annual Report**
Annual Report

Richard Klein
Art Director

Jim Karageorge
Photographer

**RKD, Inc.
Palo Alto, CA**
Design Firm

**International
Microelectronics
Products**
Publisher/Client

Drager & Mount
Typographer

George Rice & Sons
Printer

**Fluorocarbon
1987 Annual Report**
Annual Report

Ron Jefferies
Art Director

Susan Garland
Designer

Russ Widstrand
Photographer

**The Jefferies Association
Los Angeles, CA**
Design Firm

Fluorocarbon Company
Publisher/Client

CAPCO
Typographer

Anderson Lithograph Co.
Printer

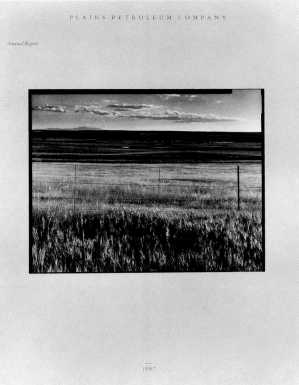

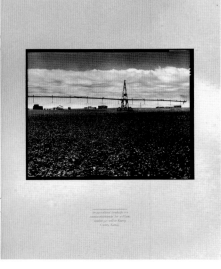

**Plains Petroleum Company
Annual Report 1987**
Annual Report

Thomas Ema
Art Director/Designer

Dan Sidor
Photographer

**Ema Design
Denver, CO**
Design Firm

Plains Petroleum Co.
Publisher/Client

Hart Typography
Typographer

Gritz Visual Graphics
Printer

**Goucher College,
1987 Annual Report
A Season of Growth**
Annual Report

**Kate Bergquist and
Anthony Rutka**
Art Directors

Kate Bergquist
Designer

Kate Bergquist
Artist

Bill Denison
Photographer

**Rutka Weadock
Baltimore, MD**
Design Firm

Goucher College
Publisher/Client

General Typographers, Inc.
Typographer

Lebanon Valley Offset
Printer

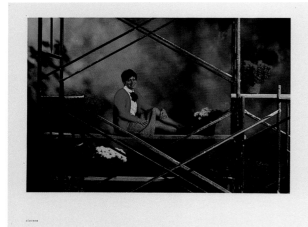

Real Estate Development

Henry A. Lambert
Senior Vice President—
Real Estate Investments
and Operations
Reliance Group
Holdings, Inc.

Real estate development
has been a significant
source of profits for the
company since we entered
the field through the
formation of Reliance
Development Group
(RDG) in 1977.
 We are engaged in all
aspects of commercial
development, including
site selection and
assembly, construction,
leasing and building
management. In addition,
RDG provides leasing and
management services for
approximately 250 of our
branch offices throughout
the U.S. and abroad.
 We continually review
opportunities to invest in
projects and limit our
involvement to those that
offer sufficiently attractive
rates of return. We do our
analyses in-house and
maintain a staff of about
30 professionals.
 1987 was a highly
profitable year for RDG,
with the sale of a completed
23-story post-modern
office tower in downtown
Los Angeles; a 16-story
office building in Glendale,
CA; and several parcels of
commercial property in
the New York City suburb
of Huntington, NY.
Pre-tax gains on real
estate transactions were
$24 million for the year,
and have totaled more
than $90 million over the
last six years.
 Typically, Reliance
Group will commit a
portion of the total
project cost in the form of
equity, with the balance
provided by non-recourse

construction loans from
major banks.
 Reliance has
approximately $200
million invested in current
projects. In March 1987,
we completed a 22-story,
230,000 square-foot office
tower in Tucson which is
now being leased. Also in
Tucson, we have completed
and are leasing a 15-acre
shopping center. In Fort
Worth, we have acquired
an office building and
are developing shopping
center properties. In San
Francisco, we purchased
the Oriental Warehouse
property and envision a
large development on the
site. And, in the South of
France, RDG is expanding
and refurbishing a resort
property, the Grand Hotel
du Cap Ferrat.
 In July, RDG was chosen
to negotiate exclusively
for the development of
a 37-acre tract adjacent
to the Santa Monica, CA
airport. The multi-year
project would entail
construction of office
buildings, a studio complex,
retail stores and child
care facilities. RDG was
chosen after intense
competition from other
major developers.

(16)

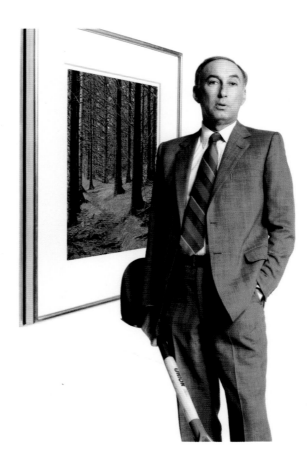

Reliance Group Holdings, Inc. Annual Report 1987
Annual Report

Bennett Robinson
Art Director

Bennett Robinson and Erika Siegel
Designers

Bill Hayward
Artist

Corporate Graphics, Inc. New York, NY
Design Firm

Reliance Group Holdings, Inc.
Publisher/Client

Pastore Depamphilis & Rampone
Typographer

Anderson Lithograph Co.
Printer

Goucher College 1988 Annual Report, Setting the Stage
Annual Report

Kate Bergquist
Art Director

Gary Kelley
Artist

Barry Holniker
Photographer

Rutka Weadock Baltimore, MD
Design Firm

Goucher College
Publisher/Client

The Type House
Typographer

E. John Schmitz & Sons, Inc.
Printer

Lord Peter Wimsey
Poster

Sandra Ruch
Art Director

**Paul Davis and
Jeanine Esposito**
Designers

Paul Davis
Artist

**Paul Davis Studio
New York, NY**
Design Firm

Mobil Oil Corporation
Publisher/Client

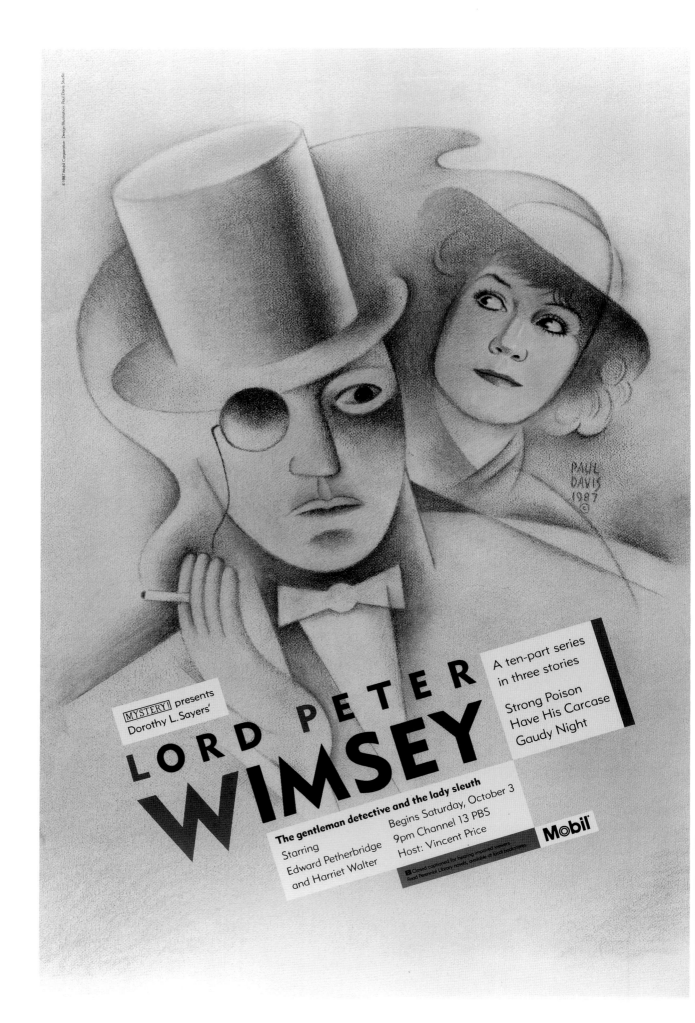

TOM:AIGA/Washington DC
Poster Announcement

Jack Beveridge, Eddie Byrd, and Nick Seay
Art Directors

**Beveridge Byrd Seay
Arlington, VA**
Design Firm

AIGA/Washington, DC
Client

Phil's Photo and IBM Displaywriter
Typographer

Virginia Lithograph Co.
Printer

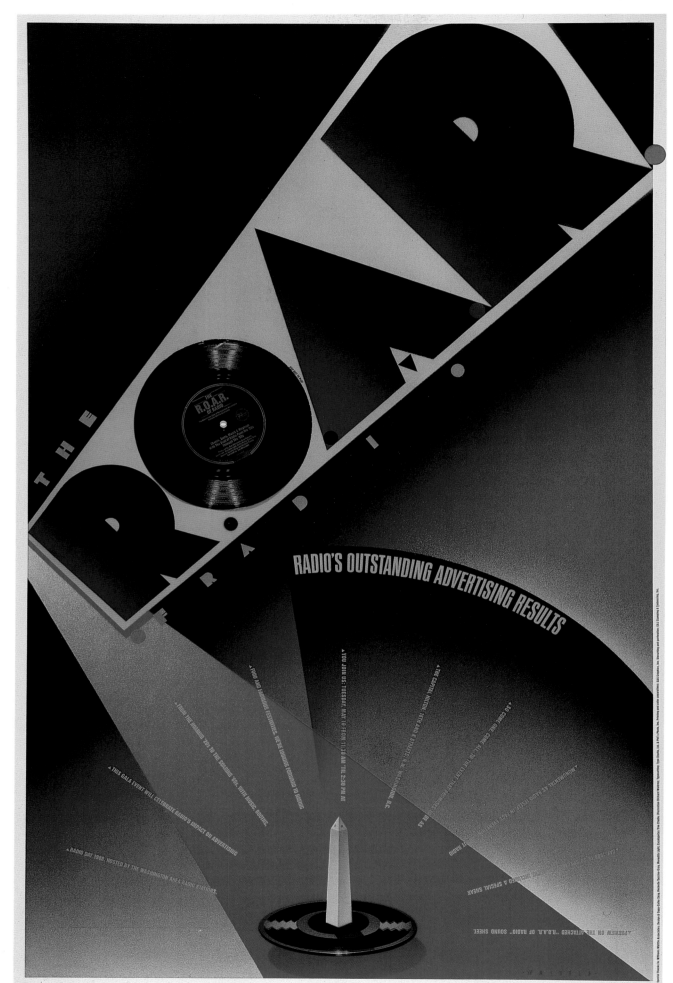

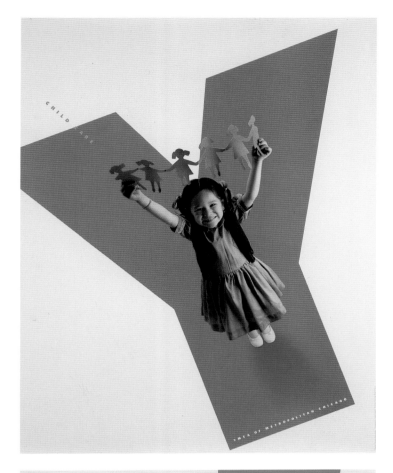

**YMCA Health Enhancer
Child Care, Sports and
Recreation**
Posters

Pat Samata and Greg Samata
Art Directors

Mark Joseph
Photographer

**Samata Associates
Dundee, IL**
Design Firm

YMCA of Metropolitan Chicago
Publisher/Client

Paul Thompson
Typographer

George Rice & Sons
Printer

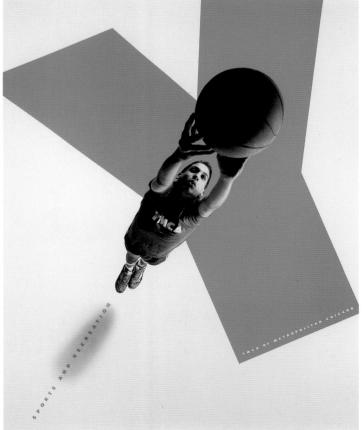

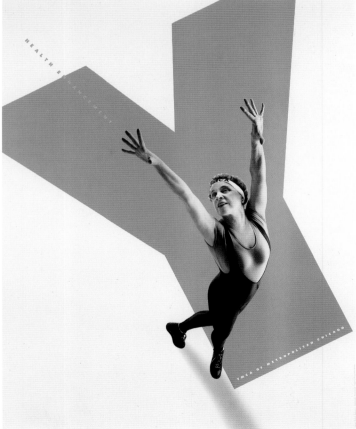

Would you still eat them?
Poster

Tracy Wong
Art Director/Designer

Steve Hellerstein
Photographer

**Goldsmith/Jeffrey
New York, NY**
Agency

New York Lung Association
Client

GTI
Typographer

Spectragraphics
Printer

Would you still eat it?
Poster

Tracy Wong
Art Director/Designer

Steve Hellerstein
Photographer

**Goldsmith/Jeffrey
New York, NY**
Agency

New York Lung Association
Client

GTI
Typographer

Spectragraphics
Printer

Would you still drink it?
Poster

Tracy Wong
Art Director/Designer

Steve Hellerstein
Photographer

**Goldsmith/Jeffrey
New York, NY**
Agency

New York Lung Association
Client

GTI
Typographer

Spectragraphics
Printer

Would you still eat it?
Poster

Tracy Wong
Art Director/Designer

Steve Hellerstein
Photographer

**Goldsmith/Jeffrey
New York, NY**
Agency

New York Lung Association
Client

GTI
Typographer

Spectragraphics
Printer

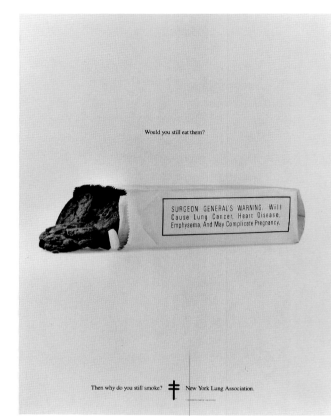

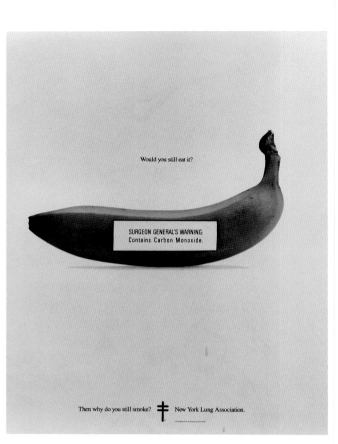

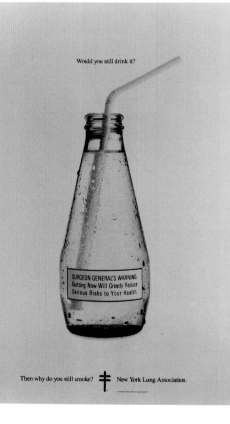

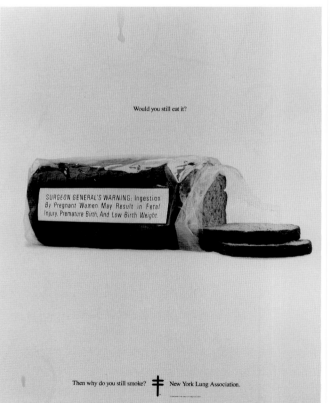

106

Cincinnati: Heritage of Fine Printing
Poster

Mike Zender
Art Director/Designer

Mike Zender
Photographer

**Zender & Associates, Inc.
Cincinnati, OH**
Design Firm

Johnston Paper, Berman Printing, and RPI Color Service
Clients

Zender & Associates, Inc.
Typographer

Berman Printing
Printer

a heritage of fine printing

**Too much fun Isn't always
a pretty picture. Party Safe.**
Poster

Craig Frazier
Art Director/Designer

Craig Frazier
Artist

**Frazier Design
San Francisco, CA**
Design Firm

Friday Night Live
Client

Display Lettering & Copy
Typographer

Graphic Arts of Marin
Printer

Too much fun isn't always a pretty picture. Party safe.

The Exclusive French Linen
and Rayon Tempting Papers
Poster

Charles S. Anderson
Art Director/Designer

Charles S. Anderson and
Lynn Schulte
Artists

The Duffy Design Group
Minneapolis, MN
Design Firm

French Paper Co.
Client

Lino Typographers
Typographer

Litho Specialties
Printer

**Ouch: Hand Injuries,
Back Injuries, Eye Injuries**
Poster Series

Douglas G. Harp
Art Director

Andreas Vesalius
Artist

**Corning Corporate Design
Corning, NY**
Design Firm

Corning Glass Works
Publisher

Typogram
Typographer

Brodock Press
Printer

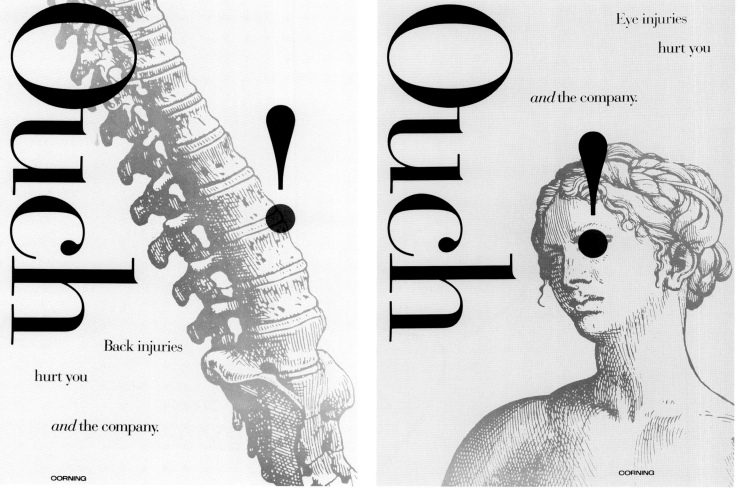

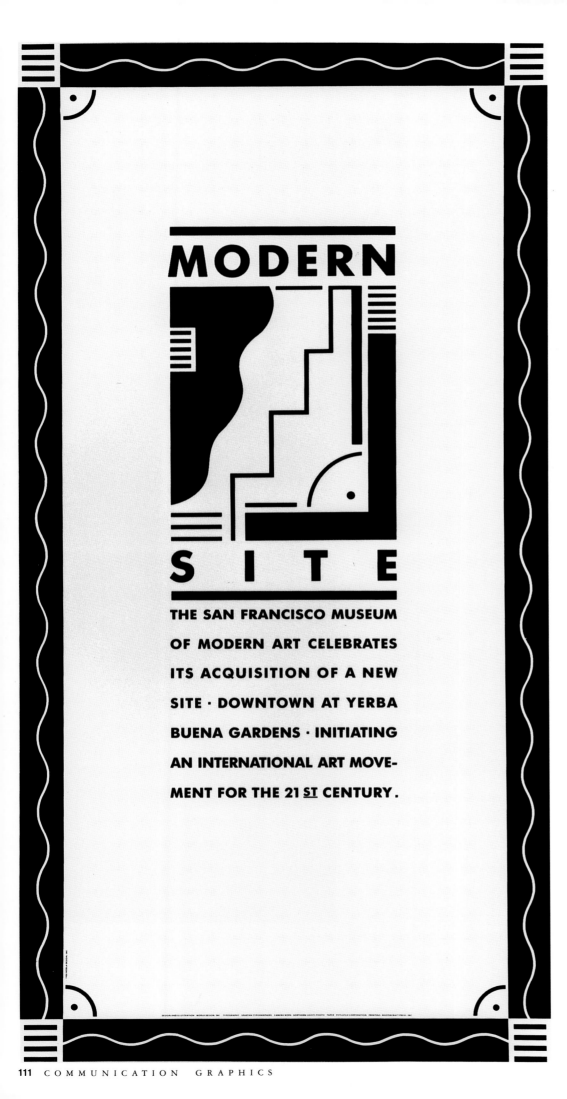

Modern Site
Poster

Jennifer Morla
Art Director/Designer

Jennifer Morla
Artist

Morla Design, Inc.
San Francisco, CA
Design Firm

San Francisco Museum of
Modern Art
Client

Spartan Typographers
Typographer

Mastercraft Press
Printer

**American Helix: An
Introduction**
Brochure

Jerry King Musser
Art Director

**Jerry King Musser
Harrisburg, PA**
Design Firm

American Helix Technology Corp.
Client

Centennial Graphics
Typographer

BSC Litho Co.
Printer

Strathmore Rhododendron
Promotional Brochure

**Michael Mabry and
Mike Scricco**
Art Directors

Michael Mabry
Designer

Lynda Barry and Anthony Russo
Artists

**Jeurgen Teller and
Jeffery Newbury**
Photographers

**Michael Mabry Design
San Francisco, CA**
Design Firm

Keiler Advertising
Agency

Strathmore Paper Co.
Publisher/Client

Andresen Typographics
Typographer

Anderson Lithograph Co.
Printer

1801 K Street

1801 McGill College Avenue

1981 McGill College Avenue

1801 K Street

Louis Dreyfus Property Group
Real Estate Brochures Series

Carrie Berman, Tom Wood, and Peg Patterson
Designers

Patterson Wood Partners New York, NY
Design Firm

Louis Dreyfus Property Group
Client

Typogram
Typographer

The Hennegan Company
Printer

**The Rockefeller
Foundation
1913 to 1988**
Promotional Booklet

Rick Landesberg
Art Director

Various
Photographers

**Landesberg Design
Associates
Pittsburgh, PA**
Design Firm

**The Rockefeller
Foundation**
Publisher/Client

Allegro Graphics, Inc.
Typographer

Hoechstetter Printing Co., Inc.
Printer

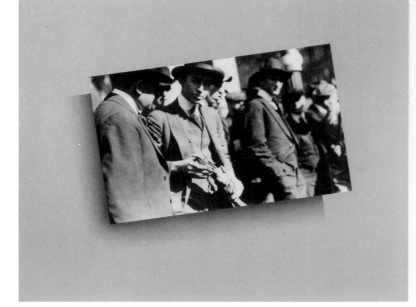

**The Spirit of Progress:
The Story of The East
Ohio Gas Co.**
Promotional Booklet

Timothy Lachina
Art Director

Various
Photographers

**Kapp & Associates
Cleveland, OH**
Design Firm

The East Ohio Gas Co.
Publisher/Client

Bohme, Inc.
Typographer

Bedford Lithograph Co.
Printer

Design Logic
Capabilities Brochure

David Frej
Art Director

**Francois Robert and
Tom Wedell**
Photographers

**Nancy Lerner
Lerner Associates, Ltd.**
Writer

**Influx
Chicago, IL**
Agency

Design Logic
Publisher/Client

CAPS
Typographer

Pinaire Lithographing Inc.
Printer

**A Historical Review of
Annual Report Design**
Cooper-Hewitt Museum
Catalog

Kit Hinrichs
Art Director

Lenore Bartz
Designer

**Barry Robinson and
William Whitehurst**
Photographers

**Pentagram Design
San Francisco, CA**
Design Firm

Potlatch Corporation
Publisher/Client

Spartan Typographers
Typographer

Heritage Press
Printer

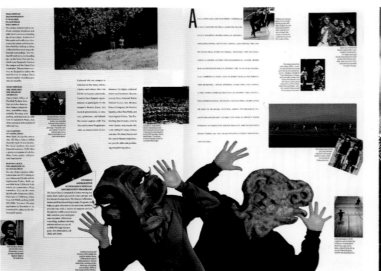

**Santa Cruz/University of
California**
Brochure

Linda Hinrichs
Art Director

Natalie Kitamura
Designer

**Will Mosgrove, Barry
Robinson, George Hall, Don
Fukuda, Shmuel Thaler, and
Nikolay Zurek**
Photographers

**Pentagram Design
San Francisco, CA**
Design Firm

**University of California at
Santa Cruz Admissions**
Client

Spartan Typographers
Typographer

Interprint
Printer

UC Santa Cruz
Viewbook Brochure

Linda Hinrichs
Art Director

Natalie Kitamura
Designer

**Will Mosgrove, Nikolay Zurek,
George Hall, Don Fukuda,
and Shmuel Thaler**
Photographers

**Pentagram Design
San Francisco, CA**
Design Firm

**University of California at
Santa Cruz Admissions**
Publisher/Client

Spartan Lithographers
Typographer

Anderson Lithograph Co.
Printer

SINCE ITS FOUNDING IN 1868, THE UNIVERSITY OF CAL-
IFORNIA HAS BECOME THE WORLD'S PREMIER PUBLIC
UNIVERSITY, ESTABLISHING A SYSTEM OF NINE DIS-
TINCT CAMPUSES, UNITED BY EXCELLENCE AND
STRENGTHENED BY DIVERSITY. MINDFUL OF ITS
RICH TRADITION AND IN ANTICIPATION OF AN EXCIT-
ING FUTURE, THE UNIVERSITY OF CALIFORNIA ESTAB-
LISHED THE SANTA CRUZ CAMPUS IN 1965 WITH A
SINGULARLY PROFOUND VISION: TO COMBINE THE
UNIVERSITY'S RENOWNED STRENGTHS IN SCHOLAR-
SHIP AND RESEARCH WITH A DEVOTION TO UNDER-
GRADUATE TEACHING.

Reinhart McMillan:
Beauty Always New...
Brochure

Carmen Dunjko
Art Director/Designer

Debrah Samuel
Photographer

Carmen Dunjko Associates
Toronto, CAN
Design Firm

Reinhart McMillan Hair, Inc.
Client

Canadian Composition
Typographer

Campbell Graphics
Printer

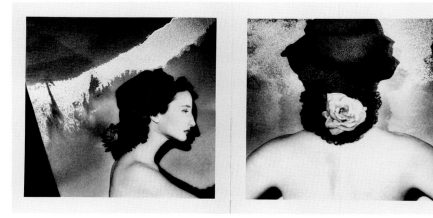

Rembrandt: As Printmaker
Catalog

Bruce Patrick
Art Director

Bruce Patrick and
Jonathan Skousen
Designers

Rembrandt
Artist

David W. Hawkinson
Photographer

Brigham Young University
Graphics
Provo, UT
Design Firm

Brigham Young University,
College of Fine Arts and
Communications
Client

Jonathan Skousen
Typographer

Brigham Young University
Print Services
Printer

A Design Dialogue

A Design Dialogue
Self-Promotional Booklet

The Brownstone Group, Inc.
Art Director

The Brownstone Group, Inc.
South Norwalk, CT
Design Firm

The Brownstone Group, Inc.
Publisher

Type by Design
Typographer

Lavigne Press
Printer

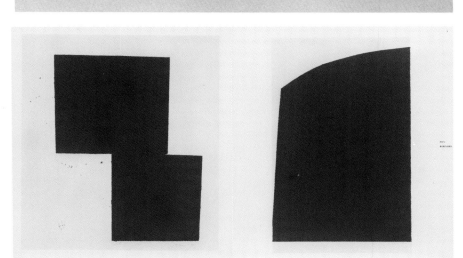

RICHARD SERRA

AT GEMINI

1983-1987

Richard Serra At Gemini
1983-1987
Catalog

John Coy
Art Director

Corinne Tuite
Designer

Richard Serra
Artist

Douglas Parker, Sidney Felsen, and Charlie Christ
Photographers

COY, Los Angeles
Culver City, CA
Design Firm

Gemini, G.E.L.
Publisher/Client

Photo Type House
Typographer

Alan Lithograph, Inc.
Printer

The Oliver Carr Company
1989 Calendar Desk Diary
Calendar

Nancy Garruba and
Michael Dennis
Art Directors

Nancy Garruba Studios
Washington, DC
Design Firm

The Oliver Carr Co.
Client

Trade Typographers
Typographer

Dickson's Inc.
Printer

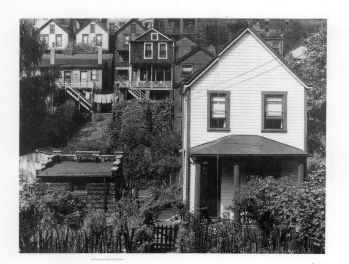

HOME: Fannie Mae, Fifty
Years of Opening Doors for
American Home Buyers
Brochure

Peter Harrison and
Susan Hochbaum
Art Directors

Susan Hochbaum
Designer

Various
Artists and Photographers

Pentagram Design
New York, NY
Design Firm

Fannie Mae
Publisher/Client

Typogram
Typographer

Sterling Roman Press, Inc.
Printer

Our Vision: Newport Harbor Art Museum
Capital Campaign Brochure

John Coy
Art Director

John Coy and Richard Atkins
Designers

COY, Los Angeles Culver City, CA
Design Firm

Newport Harbor Art Museum
Client/Publisher

Typecraft, Inc.
Typographer

NEWPORT HARBOR
ART MUSEUM

THE BUILDING

THERE IS A VITAL LINK between the container and the contained. A museum holds works of art; our new building must be a work of art. What a building looks like, what a building is, says much about its makers, its users and the purposes to which it is put.

The Newport Harbor Art Museum will develop a facility in keeping with our new site, the community's expectations, and a unique vision of what a modern and contemporary art museum in Southern California should be.

The Board of Trustees, after nearly two years of research, selected Italian architect, Renzo Piano to design the new museum. Three of his most important projects during his twenty-five year career are the Georges Pompidou Cultural Center in Paris, a cultural and entertainment center including a museum, galleries, library, research center and theaters; and the Schulumberger Ltd. Headquarters in Paris, which is a renovation and conversion of an early 20th century industrial complex into a factory with an urban park and offices. His design for the Menil Collection Museum in Houston, Texas, has won critical acclaim for its innovative design. The Menil, founded by Dominique de Menil for modern, contemporary and ethnographic art, was completed in 1987 and houses 10,000 works. The museum is surrounded by a park, houses and support structures, forming a "village museum."

"For the museum I want a certain amount of surprise. The desire to discover: A moment of silence . . . like when you go into the dark and need time to get your eyes adjusted. That's what I want for the spirit."
—Renzo Piano
Architect

THE NEED

IN 1977, when the Newport Harbor Art Museum moved into its present building, we believed that it would be adequate for a generation or more. Two unforeseen developments altered that prediction: Orange County and its cultural needs grew very rapidly, and the Museum's audience, programs and collections quickly outgrew its 23,000 square-foot facility.

The continuing expansion of Orange County is a very important basis for the Museum's own expansion: by the year 2000, our County's population is expected to increase by 40% over the 1980 census—from 2 million to 2.7 million.

We cannot meet the cultural expectations of a vastly larger populace in our present facility.

The receptivity of our community to development in the arts is now well known. The completion of the Orange County Performing Arts Center; the vital contribution South Coast Repertory makes to the cultural life of our region, and our own well-attended exhibition and educational programs all testify to a strong and continuing demand for cultural activities of the highest quality.

The anticipated growth of the County, and the Museum's own needs for more space, have been carefully examined by the Board of Trustees. Our four urgent concerns are: galleries for the Museum's Permanent Collection, expansion of the temporary exhibition galleries, increased educational programs, and an education center. Our studies have concluded that the optimum solution is construction of an initial 75,000 square-foot complex.

Sam Francis
UNTITLED
1957 (detail)
gouache on paper
22 x 30"
Collection Newport
Harbor Art Museum;
Purchased by the Acquisition Committee with a
Matching Grant from the
National Endowment for
the Arts, a federal agency
PC.79.6

?/Why in the world...
Brochure

Stephen Frykholm
Art Director

**Stephen Frykholm and
Lisa Jaroszynski**
Designers

Earl Woods
Photographer

**Herman Miller, Inc.
Zeeland, MI**
Design Firm

Herman Miller, Inc.
Publisher/Client

Type House
Typographer

Etheridge Company
Printer

The range of heights is greater.

The back moves up and down.

It meets ANSI /BIFMA VDT guidelines.

?

Bressler Group
Capabilities Brochure

**Virginia Gehshan and
Jerome Cloud**
Art Directors

Jerome Cloud
Designer

**Cloud & Gehshan
Associates, Inc.
Philadelphia, PA**
Design Firm

Bressler Group
Publisher/Client

Duke & Co. Typographers
Typographer

Indian Valley Printing, Ltd.
Printer

**Surface Design Technologies
Product Catalog: Volume 1**
Catalog

**Tom Antista and
Petrula Vrontikis**
Art Directors

Petrula Vrontikis
Designer

Henry Blackham
Photographer

**Antista Design
Santa Monica, CA**
Design Firm

Surface Design Technologies
Publisher/Client

CCI Typographers
Typographer

Alan Lithograph Co.
Printer

**San Francisco Opera:
66th Season**
Subscription Brochure

Mark Coleman
Art Director

Sally Hartman
Designer

**Ron Scherl, Carolyn Mason-
Jones, and Greg Peterson**
Photographers

Jeffery Newbury
Photo Illustrator

Michael Joyce
Illustrator

**Coleman Souler
San Francisco, CA**
Design Firm

Andresen Typographics
Typographer

Anderson Lithograph Co.
Printer

Porsche
Brochure

Joe Duffy
Art Director

**Joe Duffy, Charles S. Anderson,
and Haley Johnson**
Designers

J. Evans and Lynn Schulte
Artists

Jeff Zwart
Photographer

**The Duffy Design Group
Minneapolis, MN**
Design Firm

**Porsche Cars of
North America**
Client

Typeshooters
Typographer

Williamson Printing
Printer

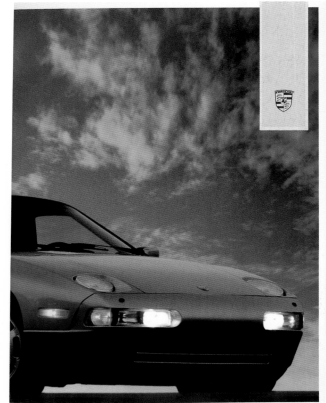

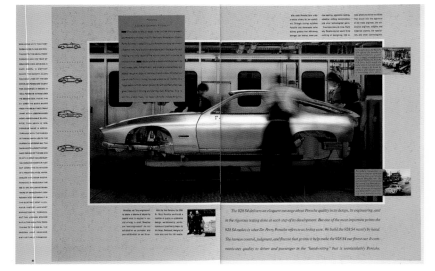

**The 1988 Bendixen Redding
Weekly Planner**
Calendar Appointment Book

**Ursula Bendixen and
Suzanne Redding**
Designers

Various Press Sheets
Illustrations

**Bendixen Redding
San Francisco, CA**
Design Firm

Bendixen Redding
Publisher

Jet Set
Typographer

San Francisco Litho
Printer

The Elders:
Ordinary Lives,
Uncommon Times
Promotional Series

Richard Hess
Art Director

Ellie Eisner and Kathy Phillips
Designers

Dmitri Kasterine and others
Photographers

Various
Artists

Hess & Hess
Norfolk, CT
Design Firm

Champion International
Corporation
Client

Franklin Typographers, Inc.
Typographer

Lebanon Valley Offset
Printer

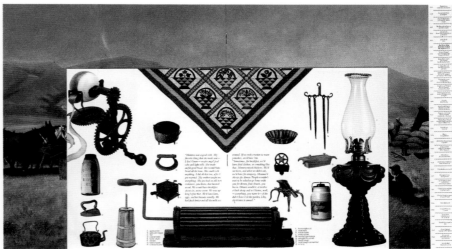

**New York Stock Exchange
1987 New Listings**
Yearbook

Leslie Smolan
Art Director

Alyssa A. Adkins
Designer

Rodney Smith
Photographer

**Carbone Smolan Associates
New York, NY**
Design Firm

Greg Furman
Publisher/Client

New York Stock Exchange
Client

Typographic Innovations (TGI)
Typographer

Anderson Lithograph Co.
Printer

1987
New Listings

NYSE

Best Buy Co., Inc.

Best Buy Co., Inc., sells nationally recognized, brand-name consumer electronics, major appliances, entertainment software, home office products and 35mm photographic equipment through 40 retail superstores located throughout seven midwestern states. The Company inventories more than 2,500 principal products supplied by over 185 manufacturers. Additionally, the Company provides a wide range of customer services, including factory-authorized warranty services, extended service plans and installation. The Company also operates video movie rental outlets adjacent to many of its retail superstores.

Carriage Industries, Inc.

Carriage Industries, Inc. is a vertically integrated manufacturer of tufted carpet. The Company is a major supplier to original equipment manufacturers in the manufactured housing, recreational vehicle and marine industries. In addition, the Company is the leading supplier to the exposition and trade show markets and is becoming an important supplier for the multifamily housing, hospitality and commercial markets.

The Company's production facilities and corporate offices are in Calhoun, Georgia.

Catalyst Energy Corporation

Catalyst Energy Corporation owns and operates a diversified mix of electricity- and steam-generation assets, including conventional coal-fired plants, hydroelectric plants, cogeneration plants, district steam heating and cooling systems, alternative fuel plants and waste-to-energy plants. A large portion of its energy output is sold at wholesale directly to utilities. However, Catalyst also sells a significant portion of its output (primarily steam) at retail to nonutility users. The Corporation is the largest independent power producer in the U.S. and the nation's second-largest steam producer.

Chicago Pacific Corporation

Chicago Pacific is an international home products company with strong presence in the appliance and furniture industries. Through a strategic acquisition program launched in November 1985, the following brand names were added to its ranks: Hoover, Rowenta, Kittenger, Pennsylvania House, McGuire, Garilocke and Brown Jordan. Hoover and Rowenta provide the Company with a major international position in the appliance market, while the remaining companies provide Chicago Pacific with a presence in the high-end furniture industry.

"You'll be more likely to succeed in a business if it involves something you know and love rather than something born of research and market analysis alone."

Gary Comer
President
Lands' End, Inc.

6

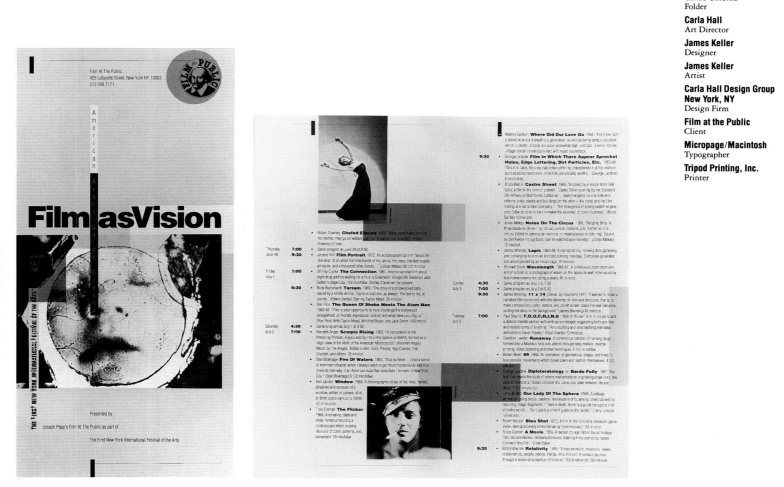

**Film as Vision:
American Avant-
Garde Cinema**
Folder

Carla Hall
Art Director

James Keller
Designer

James Keller
Artist

**Carla Hall Design Group
New York, NY**
Design Firm

Film at the Public
Client

Micropage/Macintosh
Typographer

Tripod Printing, Inc.
Printer

LEX
Real Estate Promotional Book

Gail Wiggin
Art Director

Amos Chan
Photographer

Charles Culp
Writer

**Gail Wiggin Design
New York, NY**
Design Firm

The Lexington Group
Publisher/Client

**Canfield Printing, Inc.
New York, NY**
Printer

EON/Painters of decorative surfaces...
Booklet

Susan Slover
Art Director/Designer

Kelly Campbell
Photographer

Susan Slover Design
New York, NY
Design Firm

EON
Client

Paragon Typographics Inc.
Typographer

Perfect Image
Printer

24 Richmond Hill
Real Estate Brochure

**Carrie Berman, Tom Wood,
and Peg Patterson**
Designers

Karen Knorr
Artist

Patterson Wood Partners
New York, NY
Design Firm

Louis Dreyfus Property Group
Client

Typogram
Typographer

**Brigham Young University:
One Clear Call**
Promotional Booklet

McRay Magleby
Art Director

George H. Bowie
Executive Editor

Norman A. Darais
Copywriter

John Snyder
Photographer

**Brigham Young University
Graphics
Provo, UT**
Design Firm

**Brigham Young University,
President's Office**
Publisher/Client

Jonathan Skousen
Typographer

**Brigham Young University
Print Services**
Printer

B R I G H A M

Y O U N G

U N I V E R S I T Y

O N E C L E A R

C A L L

LOWERING

THE COLORS,

CENTRAL

QUAD,

OCTOBER

I love this nation. . . . It is a great and glorious nation with
a divine mission, brought into being under the inspiration of heaven.

EZRA TAFT BENSON

Gladly adhering to patriotic traditions, students at BYU
are proud to express their love for the United States of America. In the morning
and evening of each school day, the students stop and turn toward
the center of campus when the flag is raised or lowered during the playing
of the national anthem. Respect for the homeland is inherent in
Latter-day Saint theology: "We believe in being subject to kings, presidents,
rulers, and magistrates, in obeying, honoring, and sustaining the law."

Jeff Corwin/Portraits
1986-1987
Self-Promotional Booklet

Kimberly Baer
Art Director

Jeff Corwin
Photographer

Kimberly Baer Design
Associates
Venice, CA
Design Firm

Jeff Corwin
Client

Mondo Typo
Typographer

Atomic Press
Printer

John Sculley, CEO, Apple Computer

Chevron Hydraulic Oils
Study Guide

Liz Miranda-Roberts
Art Director

Chevron Corporation Design
Group
San Francisco, CA
Design Firm

Chevron Corporation
Publisher

Chevron Corporation
Typography
Typographer

Foreman Liebrock
Printer

This is the Church....
Architects' Self-Promotion Folder

Lori B. Wilson
Art Director

Ron Guidry
Photographer

The Graham Group
Dallas, TX
Design Firm

The Meleton Group
Client

Craddick Production Art
Typographer

Print Service
Printer

This is the church.

This is the steeple.

the
CONTINUING
SAGA OF
HOLLY FABRIC
a fairy tale
#1728

[construction began]
walls came down ↓. new ones went ↑ up.
Ronald, prince o'papers hung.
E-beth, Liz, and Beth watched.
Cecily got married. Kimberly shined.
Laura looked on in disbelief. and, young prince Charlie
was too new 2 know. friends fled.
■ what had young Holly done? ■

seen
Holly had ② resort ② covering both eyes so as not ②
look
there seemed ② be no end in sight.
(even for stephen who worked well in② the night.)

The Continuing Saga
of Holly Fabric
Promotional Booklet

Rick Valicenti
Art Director

Michael Giammanco
Designer

THIRST
Chicago, IL
Design Firm

Holly Hunt, Ltd.
Publisher/Client

Typographic Resource
Typographer

Paper Express
Printer

Forenza Paninaro
Point of Purchase Promotion

Tom Styrkowicz
Art Director

Debbie Warrenfeltz
Designer

**The Oxmox Design
Corporation
Columbus, OH**
Design Firm

The Limited
Client

Dwight Yeager Typographers
Typographer

West-Camp Press, Inc.
Printer

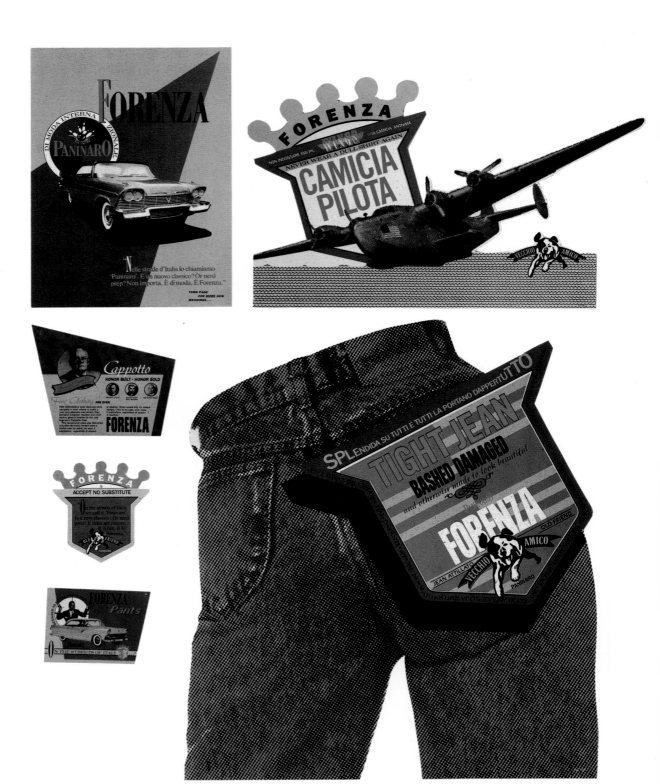

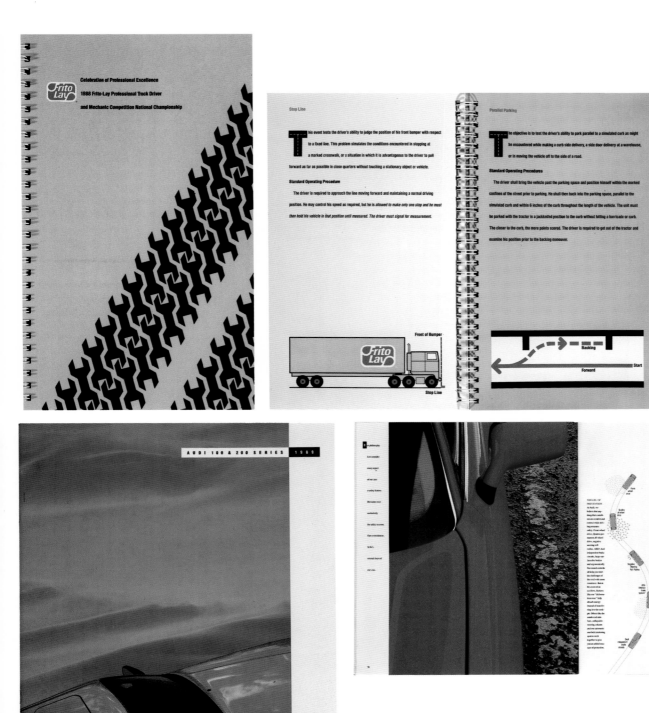

**Frito-Lay Celebration
of Professional Excellence**
Championship Handbook

John Swieter
Art Director

Jim Vogel
Designer

Jim Vogel
Artist

**Swieter Design
Dallas, TX**
Design Firm

Frito-Lay, Inc.
Publisher/Client

Typography Plus
Typographer

Frito-Lay (In-house)
Printer

Audi 100 & 200 Series 1989
Catalog Brochure

Barry Shepard
Art Director

**Karin Burklein Arnold, Barry
Shepard, Steve Ditko, and
Douglas Reeder**
Designers

Rick Rusing
Photographer

**SHR Design Communications
Scottsdale, AZ**
Design Firm

Audi of America, Inc.
Publisher/Client

Mary Meek
Typographer

Bradley
Printer

Rhona Hoffman Gallery
Stationery

Michael Glass
Art Director

Michael Glass Design, Inc.
Chicago, IL
Design Firm

Rhona Hoffman Gallery
Client

Anzo Graphics
Computer Typographers
Typographer

Solo Printing
Printer

Design Logic
Stationery

David Frej
Art Director

Influx
Chicago, IL
Design Firm

Design Logic, Inc.
Client

CAPS
Typographer

Wagner Printing
Printer

The Friends of Photography
Stationery

Michael Mabry
Designer

Michael Mabry Design
San Francisco, CA
Design Firm

The Friends of Photography
Client

Reardon and Krebs
Typographer

Technigraphics
Printer

Sleeman Brewing
& Malting Co.
Stationery

Paul Browning and
Joanne Véronneau
Art Directors

Joanne Véronneau
Designer

Taylor & Browning Design
Associates
Toronto, CAN
Design Firm

The Sleeman Brewing
& Malting Co.
Client

Cooper & Beatty, Ltd.
Typographer

Adams Engraving
Printer

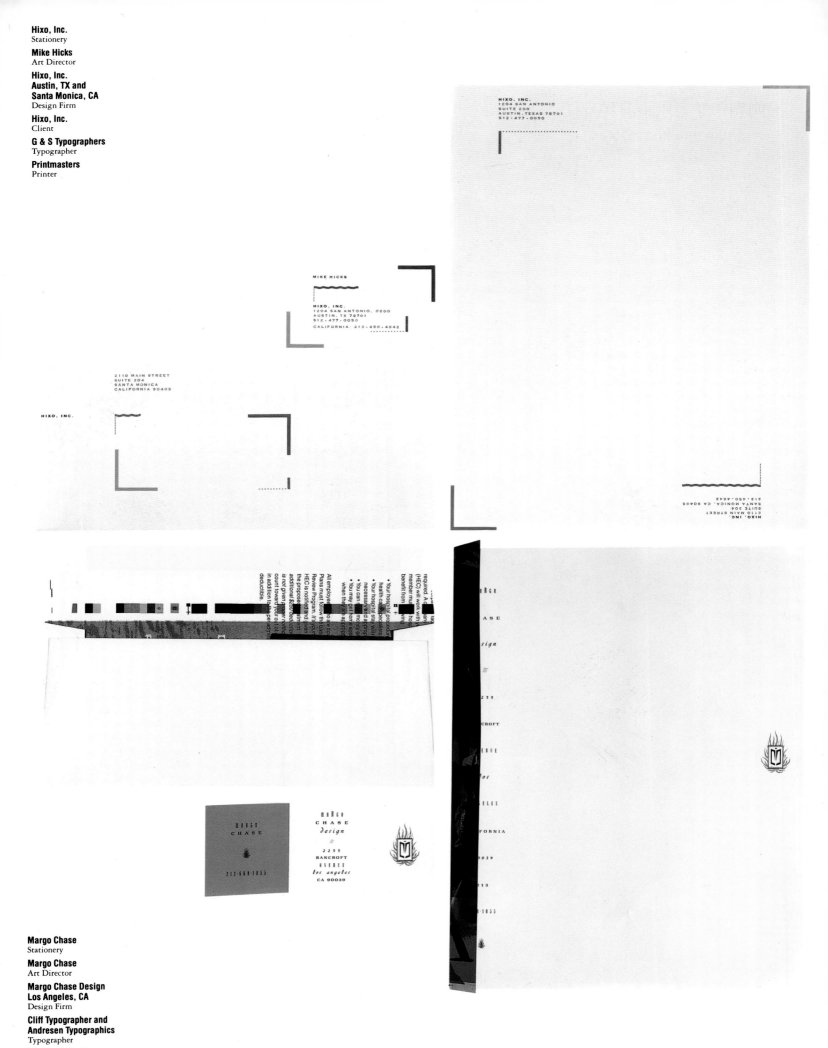

Hixo, Inc.
Stationery

Mike Hicks
Art Director

**Hixo, Inc.
Austin, TX and
Santa Monica, CA**
Design Firm

Hixo, Inc.
Client

G & S Typographers
Typographer

Printmasters
Printer

Margo Chase
Stationery

Margo Chase
Art Director

**Margo Chase Design
Los Angeles, CA**
Design Firm

**Cliff Typographer and
Andresen Typographics**
Typographer

Westland Graphics
Printer

Patterson Wood Partners
Stationery

Carrie Berman
Art Director

Patterson Wood Partners
New York, NY
Design Firm

PATTERSON WOOD PARTNERS

133 WEST 19TH STREET
NEW YORK NEW YORK 10011
212 691.7734

Tom Wood

PATTERSON WOOD PARTNERS

133 WEST 19TH STREET
NEW YORK NEW YORK 10011
212 691.7734

Peg Patterson

PATTERSON WOOD PARTNERS

133 WEST 19TH STREET
NEW YORK NEW YORK 10011
212 691.7734

PATTERSON WOOD PARTNERS

133 WEST 19TH STREET
NEW YORK NEW YORK 10011
212 691.7734

PATTERSON WOOD PARTNERS
133 WEST 19TH STREET
NEW YORK NEW YORK 10011
212 691.7734

Rod Dyer Group Inc.
Design & Advertising
Business Cards

Rod Dyer
Art Director

Steve Twigger
Designer

Paul Lieth
Artist

Rod Dyer Group Inc.
Design & Advertising
Los Angeles, CA
Design Firm

Rod Dyer Group Inc.
Client

Anderson Printing Co.
Printer

Metalmorphosis:
Sculpture and Metal Fabrication
Stationery

Catherine Lorenz
Art Director

Catherine Lorenz
Los Angeles, CA
Design Firm

Metalmorphosis
Client

Promedia
Typographer

McPhearson Printing Co.
Printer

Cameron D. Popkin
Stationery

Olive Neroy and
Michael Hodgson
Art Directors

Michael Hodgson
Designer

Ph.D.
Santa Monica, CA
Design Firm

Cameron D. Popkin
Client

Golf Group Ltd.
Stationery

Forrest Richardson
Art Director

Richardson or Richardson
Phoenix, AZ
Design Firm

Golf Group Ltd.
Client

DigiType
Typographer

Tolleson Design
Stationery

Steven Tolleson
Art Director

Tolleson Design
San Francisco, CA
Design Firm

Tolleson Design
Client

Spartan Typographers
Typographer

Simon Printing
Printer

A Decade of Design
Notovitz & Perrault, Inc.
Self-Promotional Booklet

**Joseph M. Notovitz and
Jean C. Perrault**
Designers

**Notovitz & Perrault Design, Inc.
New York, NY**
Design Firm

Notovitz & Perrault Design, Inc.
Publisher/Client

Art-Pro Graphics, Inc.
Typographer

**L. P. Thebault Co.
Parsippany, NJ**
Printer

**September: A Month of Days
from Mead and Gilbert Papers**
Calendar

Peter Harrison
Art Director

Susan Hochbaum
Designer

Various
Artists and Photographers

**Pentagram Design
New York, NY**
Design Firm

Mead Paper Company
Publisher/Client

Typogram
Typographer

Sterling Roman Press, Inc.
Printer

Children's Museum of Manhattan
Invitation

Michael Bierut
Art Director

Michael Bierut and Alan Hopfensperger
Designers

Vignelli Associates New York, NY
Design Firm

Children's Museum of Manhattan
Client

Concept Typographic Services, Inc.
Typographer

Ambassador Arts
Printer

American Cancer Society: California
Special Recognition Award

Jean Wiley
Art Director

Elizabeth Ingebretsen
Designer

Wiley Design Sacramento, CA
Design Firm

American Cancer Society, California Division
Client

Ad Type Graphics
Typographer

The Marier Engraving Company
Printer

New Music America
Poster Mailer

Robert Appleton
Art Director/Designer

Robert Appleton
Photographer

Appleton Design, Inc.
Hartford, CT
Design Firm

Tigertail Productions
Client

Miami Dade Community
College
Typographer

Bayside Publishing Corp.
Printer

26

THE 26 LETTERS

Twenty-six. Not a very big number until one considers the diversity of thoughts which can be created through the simple arrangement of the letters of the alphabet. From this amusing collection of characters we are able to create more than 500,000 words, an infinite number of sentences, some well-written headlines, Johnny Carson's monologue and several shoe and brassiere sizes. A frightening thought when you consider that nobody bothers to regulate or license such activity. DigiType is pleased to present this historical tribute to our twenty-six alphabetical characters in anticipation that it will stimulate characters with character to look to us for great characters of all kinds.

DigiType

*3118 North Seventh Avenue
Phoenix, Arizona 85013
602-264-2425*

Ee

THE LETTER E

The most frequently used letter in the English alphabet. In fact, the most frequently used letter in the last sentence. And the last. But in the one just before this one, the letter "T" was used most frequently. During World War II an American flag bearing the letter "E" was presented to army and navy contractors who met or surpassed production schedules. The "E" stood for "Excellence". This is contrary to baseball's use of the letter "E", actually "e", which stands for "error." While some errors are worse than others, the absolute worst occurred in the Summer of 1931 when Joe Sprinz of the Cleveland Indians tried to catch a ball dropped from an airplane at 800 feet. The ball was caught but his jaw was broken. He obviously didn't respect (m)V = M or E = MC². At DigiType we have lots of energy to set your type. Call 602-264-2425.

The 26 Letters
Promotional Notepad

Forrest Richardson and Valerie Richardson
Art Directors

Jim Bolek, Diane Gilleland, and Rosemary Connelly
Designers

Forrest Richardson
Writer

Richardson or Richardson Phoenix, AZ
Design Firm

DigiType
Client

DigiType
Typographer

Aristocrat Lithographers
Printer

The Technology Center of Silicon Valley, P-CAD, FMC and The Learning Company Present

Robot Odyssey
Conference Invitation

Steven Tolleson
Art Director

Steven Tolleson and Nancy Paynter
Designers

Tolleson Design San Francisco, CA
Design Firm

The Technology Center of Silicon Valley
Publisher/Client

Apple Macintosh SE
Typographer

On Paper
Printer

Christmas Stamps Greetings
Self-Promotional Item

Tony Naganuma
Art Director

Karen Sasaki, Wes Aoki, Kean Hiroshima, and Denise Ikeda
Designers

Naganuma Design & Direction
San Francisco, CA
Design Firm

About Face Typography
Typographer

First California Press
Printer

Christmas '88/Proust Eggtimer
Self-Promotional Item

**Tibor Kalman and
Marlene McCarty**
Designers

**M&Co.
New York, NY**
Design Firm

M&Co.
Client

Trufont
Typographer

Harrington Press
Printer

Creativitea
Self-Promotional Item

Butler Kosh Brooks
Art Director

**Butler Kosh Brooks
Los Angeles, CA**
Design Firm

Welsh Graphics
Printer

The Lowe, Winter 1988
Art Museum Newsletter

**Laura Latham and
Sharka Brod Hyland**
Art Directors

Sharka Brod Hyland
Designer

**Pinkhaus Design Corporation
Miami, FL**
Design Firm

The Lowe Art Museum
Publisher/Client

Sharka Brod Hyland
Typographer

Haff-Daugherty Graphics, Inc.
Printer

The Lowe, Fall 1988
Art Museum Newsletter

Laura Latham
Art Director

**Pinkhaus Design Corporation
Miami, FL**
Design Firm

The Lowe Art Museum
Publisher/Client

Daly Images
Typographer

Haff-Daugherty Graphics, Inc.
Printer

Odyssey: The Art of Photography at National Geographic

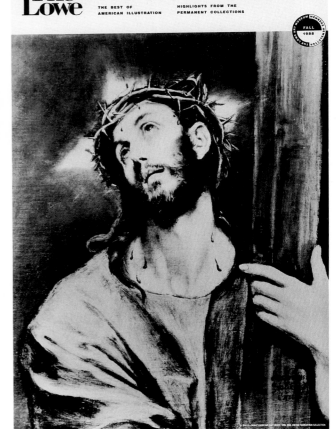

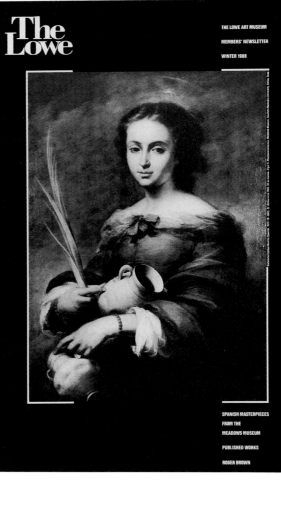

The Lowe, Winter 1988
Art Museum Newsletter

Laura Latham
Art Director

**Pinkhaus Design Corporation
Miami, FL**
Design Firm

The Lowe Art Museum
Publisher/Client

Daly Images
Typographer

Haff-Daugherty Graphics, Inc.
Printer

M1: News from Harry Macklowe
Newsletter

Michael Bierut
Art Director

**Michael Bierut and
Alan Hopfensperger**
Designers

Various
Artists and Photographers

**Vignelli Associates
New York, NY**
Design Firm

**Harry Macklowe Real Estate
Company**
Publisher/Client

Graphics Technology
Typographer

Combine Graphics
Printer

Spark
Newsletter

Rick Valicenti
Art Director

Michael Giammanco
Designer

**THIRST
Chicago, IL**
Design Firm

A. C. Nielson
Publisher/Client

Tardis Typography
Typographer

The Davidson Group
Printer

Zoo Views
Newsletters

Ken Cook and James Cross
Art Directors

Ken Cook
Designer

Various
Photographers

**Cross Associates
Los Angeles, CA**
Design Firm

**San Francisco
Zoological Society**
Publisher/Client

Andresen Typographics
Typographer

Graphic Center
Printer

Art Center and layout past, present, and future.

color

Nineteen eighty-eight has been a colorful year for computers. Although color computers have been around for several years, it is only recently that they have become a standard tool in many business operations. Previously, color was best left to complex, computerized image assembly systems costing a quarter of a million dollars. Today, color page layouts and graphics are available to anyone with a personal computer.

The introduction of the PostScript® page description language started the ball rolling. PostScript language programs give artists the same kind of control over their images that word processing programs give writers over their writing. Built into the language are the tools needed to create printed color separations (such as those used in desktop publishing) and color slides (such as those used in desktop presentations). Add to this the introduction of the Display PostScript® system, which for the first time gives users a way to see accurately on the computer screen what their work will look like in its final form.

With the development of color laser printers with PostScript interpreters, color proofs, formerly costing $150, can now be produced for as little as $1.50—and in a fraction of the time it would take using conventional methods! Recognizing that there is a large market for this type of printing, some manufacturers will soon be selling devices that can print PostScript language files—such as those created with Adobe Illustrator 88™—directly onto 35mm color film.

Although conventional printing techniques have not changed much over the past twenty years, the elimination of layout and paste-up costs, plus the ability to produce your own four-color process negatives, have reduced the cost of color printing considerably. Soon the introduction of high-speed color printers will give desktop publishers all the tools they need to produce small quantities of color work without spending a fortune.

Advancements in color graphics technology are not restricted to desktop publishing either. Some magazines now print their page layouts directly to negatives. All color separations are handled automatically, eliminating several steps in the printing process. Scitex, a major manufacturer of professional image assembly systems, recently announced the development of a system that will be compatible with the PostScript page description language. R.R. Donnelley, the largest commercial printer in North America, uses a PostScript interpreter with its Pulsar™ Publishing System to produce direct-to-plate color separations.

In the future, expect to see further refinements in graphics and color technology. Eventually, the only restrictions on the development of an idea will be those of your imagination. You'll be able to send your jobs over the phone to the print shop. Once there, the images will be printed directly onto the printing plates, eliminating the need for photostats and negatives entirely. As print shops tool up for this kind of production, there will be an inevitable reduction in prices, leading to an explosion of color printed material. The future looks colorful indeed!

colophon 6

Adobe Systems' news publication

Volume 6
January
1989

curveto

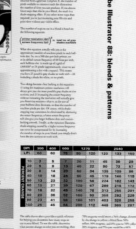

Adobe Illustrator 88: blends & patterns

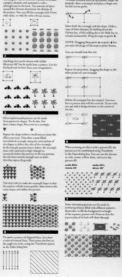

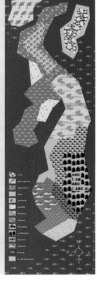

MAP A

Art Center Review: 4
Newsletter

Kit Hinrichs
Art Director

**Terri Driscoll and
Lenore Bartz**
Designers

**John Hersey, Nina Norins,
and John Cuneo**
Illustrators

**Steven A. Heller, Jim Blakeley,
Jim Miho, Rick Eskite, and
Henrik Kam**
Photographers

Pentagram Design
San Francisco, CA

Art Center College of Design
Client

Eurotype
Typographer

ColorGraphics
Printer

Colophon 6
Newsletter

Russell Brown
Art Director

Laurie Szujewska
Designer

**Adobe Systems, Inc.
San Francisco, CA**
Design Firm

Adobe Systems, Inc.
Publisher/Client

**Laurie Szujewska and
Adobe Fonts**
Typographer

Williamson Printing Co.
Printer

**The Friends of Photography
Workshop 1988**
Program Announcement

**Michael Mabry and
Andrew Brubaker**
Designers

Various
Photographers

**Michael Mabry Design
San Francisco, CA**
Design Firm

The Friends of Photography
Publisher/Client

On Line Typographers
Typographer

Winn Press
Printer

**Alternate Site Provider
Report: An Update**
Survey

**Jack Beveridge, Eddie Byrd,
and Nick Seay**
Art Directors

**Beveridge Byrd Seay
Arlington, VA**
Design Firm

**Health Industry Manufacturers
Association**
Publisher/Client

IBM Displaywriter
Typographer

Virginia Lithograph Co.
Printer

Louis, Boston
Catalog

Tyler Smith
Art Director/Designer

John Goodman, Chris Maynard, and Myron
Photographers

Tyler Smith Providence, RI
Design Firm

Louis, Boston
Publisher/Client

National Bickford Foremost
Printer

American Landscapes.

American Landscape
Self-Promotional Brochure

Michael Toth
Art Director

Michael Toth and Vickie Schafer
Designers

Sante D'Orazio
Photographer

Toth Design Carlisle, MA
Design Firm

The Work of Ford Beckman Crowthers, USA
Client

Berkeley Typographers
Typographer

Williamson Printing
Printer

Process and Product: The Making of Eight Contemporary Masterworks
Catalog

2D3D Studio
Art Director

Douglas Baz
Photographer

2D3D Studio
Design Firm

**Bard College
Annandale-on-Hudson, NY**
Publisher

Type West and Apple Laserwriter
Typographer

Lithocraft
Printer

Washington College
Booklet

**Kate Bergquist and
Anthony Rutka**
Art Directors

Kate Bergquist
Designer

Bill Denison and Don Carstens
Photographers

**Rutka Weadock
Baltimore, MD**
Design Firm

Washington College
Publisher/Client

General Typographers, Inc.
Typographer

Lebanon Valley Offset
Printer

Hell-Bent for the White House

Champion Kromekote 2000 and Pageantry Text.

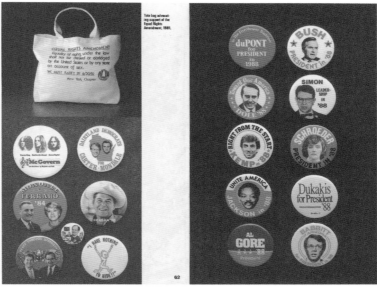

Tote bag advocating support of the Equal Rights Amendment, 1981.

62

Reynolds • DeWalt Printing Inc.

Let's face it—some people think New Bedford is a fishing town somewhere between Dorchester and Antarctica. That's too bad. If they're history buffs or families out for a drive, they're missing New England at its best . . . one hour from Boston.

A lot of smart designers, print buyers, and corporate communicators know something else about New Bedford. It's the home of Reynolds—DeWalt Printing . . . quality work and unheard-of service.

We're a full-service printer providing typesetting, artwork, paste-up, camera, stripping, and binding of all configurations. One to multi-color printing. Color separations, halftones or duotone reproduction. And specialized finishing operations including diecutting, embossing, and leaf stamping—right in the same building.

Our in-house capabilities give us—and our customers—control over each step of the process. And because of the lower overhead of our New Bedford location, we offer our services at prices five to ten percent lower than our Boston-area competitors.

Hell-Bent for the White House
Promotional Booklet

James Miho
Designer

Sally Anderson-Bruce
New Milford, CT
Photographer

Miho Design
Design Firm

Champion International
Publisher/Client

Reynolds DeWalt Printing Inc.
Promotional Booklet

Clifford Stoltze
Art Director/Designer

Various
Photographers

Clifford Stoltze
Boston, MA
Design Firm

Reynolds DeWalt Printing Inc.
Publisher/Client

Monotype
Typographer

Reynolds DeWalt Printing Inc.
Printer

Portraits of Park City
by Pop Jenks
Historical Catalog

Don Weller
Art Director

Pop Jenks
Photographer

The Weller Institute for
the Cure of Design
Park City, UT
Design Firm

Park City Historical Society
Publisher/Client

Whipple and Associates
Typographer

Paragon Press
Printer

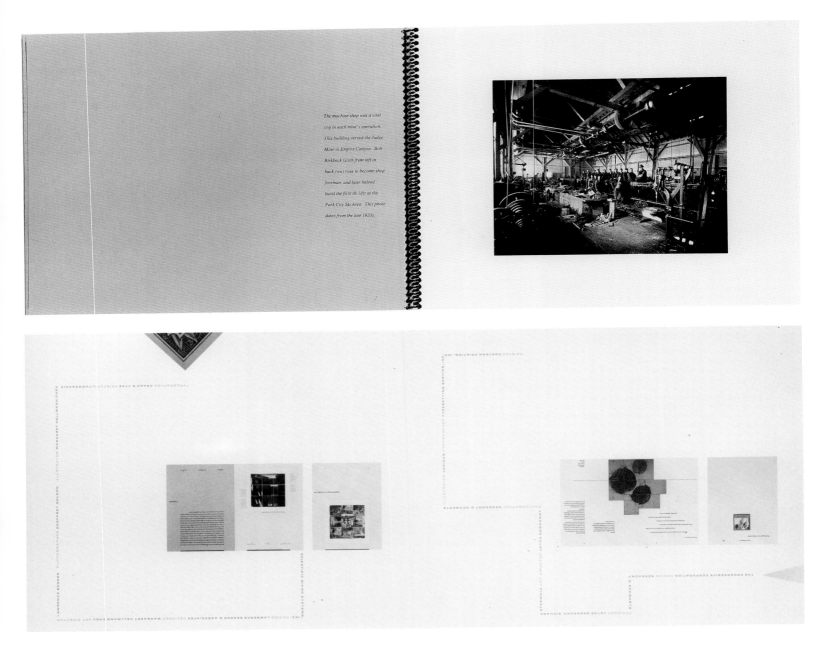

The machine shop was a vital cog in each mine's operation. This building served the Judge Mine in Empire Canyon. Bob Birkbeck (sixth from left in back row) rose to become shop foreman, and later helped build the first ski lifts at the Park City Ski Area. This photo dates from the late 1920s.

Mead Annual Report
Show 1988
Show Catalog

Pat Samata and Greg Samata
Art Directors

Mark Joseph and
Dennis Dooley
Photographers

Samata Associates
Dundee, IL
Design Firm

Mead Paper Co.
Publisher/Client

Ryder Types
Typographer

Rohner Printing Co.
Printer

Walt Disney Concert Hall 1988
Competition Guidelines

Deborah Sussman
Art Director

Felice Matare
Designer

**Sussman/Prejza & Co., Inc.
Santa Monica, CA**
Design Firm

**Music Center of Los Angeles
County**
Publisher/Client

Andresen Typographics
Typographer

Graphic Magic
Printer

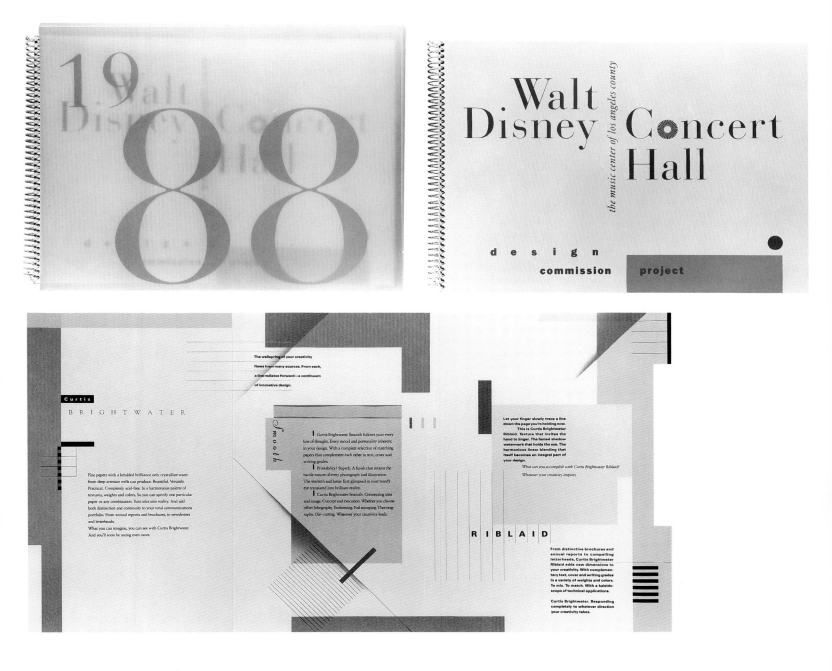

Curtis Brightwater
Paper Promotional Folder

Lucille Tenazas
Art Director

**Tenazas Design
San Francisco, CA**
Design Firm

James River Corp.
Publisher/Client

Andresen Typographics
Typographer

Cannon Press
Printer

Legends Co., USA
Catalog

Rick Valicenti
Art Director

Michael Giammanco
Designer

Rob Latour
Photographer

**THIRST
Chicago, IL**
Design Firm

Legends Co.
Publisher/Client

Typographic Resource
Typographer

The Davidson Group
Printer

INTERDISCIPLINARY PROGRAMS AT THE INSTITUTE

Because the Institute houses all the arts under one roof it is uniquely suited to facilitate interdisciplinary exchange. Although the schools of theater, art, dance, film/video, music and critical studies work independently creating their own classes and requirements, they encourage students to design special projects and participate in classes that involve several disciplines. Many existing classes are by their very nature interdisciplinary and reflect the synthesis of mediums found in contemporary performing and visual arts. These courses are open to a limited number of students from all departments and are subject to the approval of the individual instructors. Examples include: dance courses which facilitate the collaboration of composers and choreographers, a workshop that utilizes student directors who are shared between the theatre school and the film/video school and an inter-school workshop on creativity.

After completing one full academic year, upper division and graduate students may petition for the right to create their own inter-school degree program. In addition, the Institute invites visiting multi-media artists who initiate and oversee specifically designed cross-disciplinary projects for the Institute as a whole.

The last three weeks of spring semester are distinctive in that it is a time when the departments of dance, theatre, film/video, art, music and critical studies come together for interdisciplinary workshops, seminars and performances in an atmosphere of exploration.

With more than 250 performances a year, informal concerts and a continuing series of changing gallery exhibits, CalArts offers a wide range of possibilities for the sharing of aesthetic ideas.

THE INTERCULTURAL ARTS PROGRAM

In these final years of the 20th Century, vast global immigrations and the relative facility of international travel have combined with technology and the media to ensure immediacy of world communications and true cultural interaction.

The artistic treasures of all peoples are available, as never before, to enrich the lives and the work of visual and performance artists, dancers and choreographers, actors and directors, composers and instrumental performers, filmmakers and animators.

Today's artists have the opportunity to confront unfamiliar aesthetics in depth and come to terms with the potentialities, as well as the limitations of their own traditions. To these ends, the InterCultural Arts Program was inaugurated in 1988-89.

Since CalArts began in 1970, efforts have been made in each of the Schools to draw upon the wealth of world art whenever possible.

World Music, a department within the School of Music, has been an especially rich wellspring of intercultural art for the entire Institute. For although its African, Indian and Indonesian performing ensembles and associated courses have been uniquely an integral part of the music curricula from the start, they have figured prominently in the programs of students from all other Schools, as well.

The faculty in World Music (listed below) has provided the nucleus of the new InterCultural Arts Program. As the activities expand to embrace all of the disciplines, further international faculty appointments are anticipated for other Schools of the Institute.

In the meantime, residencies of visiting artists from around the world—for varying lengths of time throughout the year—are sponsored jointly by the Schools and the InterCultural Arts Program to ensure proper integration with on-going programs in each discipline.

Lectures, classes and workshops offered during the visitors' residencies may be taken by students in all Institute programs, subject, in some instances, to certain requirements of the artist(s) in charge. And since much of the world's art calls into play several disciplines at once, projects under the aegis of visiting artists usually involve students and faculty from several Schools. Productions that evolve from those projects can lead to crosscultural and interart collaboration at both faculty and student levels.

Nicholas M. England, *Director*

John Bergamo, *Percussion*
Amiya Dasgupta, *North Indian Music*
Alfred Ladzekpo, *African Music and Dance*
Kobla Ladzekpo, *African Music and Dance*
Beatrice K. Lawluvi, *African Music and Dance*
Taranath Hattangady Rao, *North Indian Music*
K.R.T. Wasitodiningrat, *Javanese Music, Master of the Gamelan*
Nanik Wenten, *Javanese Dance*
Nyoman Wenten, *Balinese Music*

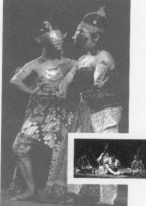

California Institute of the Arts
School Catalog

Edward Fella, Jeffery Keedy, and Lorraine Wild
Designers

Steven Callis and Steven Gunther
Photographers

**Agenda
Los Angeles, CA**
Design Firm

California Institute of the Arts, Office of Public Affairs
Publisher/Client

Denise Karatsu
Typographer

Donahue Printing
Printer

**Make Your Mark on Signature
from Mead**
Promotional Brochure

John Van Dyke
Art Director

Terry Heffernan
Photographer

**Van Dyke Company
Seattle, WA**
Design Firm

Mead Paper Company
Publisher/Client

Typehouse
Typographer

MacDonald Printing
Printer

*Make Your Mark
on Signature from Mead*

A touch of satin. Signature's dull stock has its own beauty. No other paper offers quite this combination of low reflection and high resolution. So no other paper delivers this combination of depth and clarity. Certainly no other dull stock has Signature's special tactile quality. You have to remind yourself it's paper that you're holding; your hand remembers satin.

THE UNIVERSITY OF BRITISH COLUMBIA

Dr. Cecil Green
Honorary Chairman of The UBC Campaign

**Dr. Cecil Green/The University
of British Columbia**
Campaign Announcement

Terrance Zacharko
Art Director

Kristine Quan
Designer

**Zacharko Design Partnership
Vancouver, CAN**
Design Firm

**The University of British
Columbia**
Client

Contempratype
Typographer

Hazeldine Press Ltd.
Printer

Nathan Hale Golden Lager
Packaging

Peter Good
Art Director

Peter Good
Artist

Peter Good Graphic Design Chester, CT
Design Firm

Connecticut Brewing
Client

Comp One
Typographer

Creative Label Co.
Printer

Diffa: 1986 Napa Valley Sauvignon Blanc
Packaging

Michael Manwaring
Art Director

The Office of Michael Manwaring San Francisco, CA
Design Firm

Diffa (Design Industries Foundation For AIDS)
Client

Tra Vigne Extra Virgin Olive Oil
Packaging

Michael Mabry
Designer

Michael Mabry
Artist

Michael Mabry Design San Francisco, CA
Design Firm

Real Restaurants
Client

MasterType and On Line Typographers
Typographers

Herdell Printing
Printer

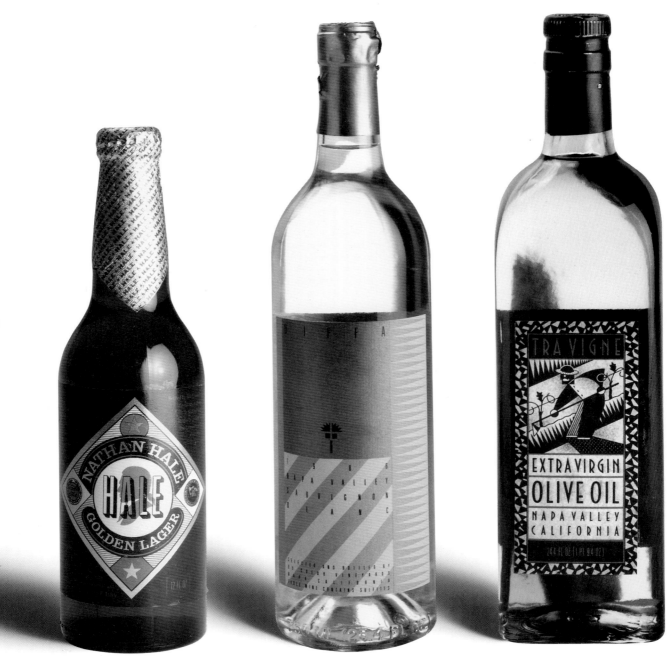

Chateau Ste. Michelle
Gift Packaging

John Hornall
Art Director

Jani Drewfs and Mary Hermes
Designers

**Kevin Latonea and
Sylvia South**
Photographers

**Hornall Anderson
Design Works
Seattle, WA**
Design Firm

Chateau Ste. Michelle
Client

George Rice & Sons
Printer

Oola Pick and Mix Bag
Packaging

Paula Scher
Art Director

Paula Scher and Debra Bishop
Designers

Paula Scher
Artist

**Koppel & Scher
New York, NY**
Design Firm

Oola
Client

Continental Extrusion
Printer

Il Fornaio
Spaghetti Packages and
Shopping Bag

**Michael Mabry and
Margie Chu**
Designers

Michael Mabry
Artist

**Michael Mabry Design
San Francisco, CA**
Design Firm

Il Fornaio
Client

**Andresen Typographics and
On Line Typographers**
Typographers

**Ivey Hill (Packaging)
Champion International Corp.
(Shopping Bag)**
Printers

Finale
Packaging

Joe Duffy
Art Director

**Joe Duffy and
Charles S. Anderson**
Designers

Joe Duffy
Artist

**The Duffy Design Group
Minneapolis, MN**
Design Firm

Wenger Corp.
Publisher

Typeshooters
Typographer

Williamson Printing
Printer

It'll have you believing. . .
Advertisement

Mark Hughes
Art Director

Frank Fleizach
Writer

Clint Clemens
Photographer

**HDM Advertising
New York, NY**
Agency

Peugeot Motors of America
Client

The New 505

IT'LL HAVE YOU BELIEVING THE WORLD IS FLAT.

It's rough out there. A fact you're painfully reminded of every time you drive your car. Because while the stiffer suspensions in most of today's cars make them handle better, they also make them ride harder. Which means they're good on curves and bad on bumps.

In a Peugeot, however, it's a whole different world. Whether you choose the newly restyled 505 Turbo or STX V-6, you can snake around curves with the sure-footed precision of a world class performance sedan and enjoy in the process what *Motor Trend* magazine has called "perhaps the nicest all-around ride in the automotive world."

To achieve this state of engineering perfection, Peugeot has complemented a powerful, exceptionally smooth-running, overhead-cam, fuel-injected engine with a unique combination of the most technologically advanced handling features available.

But deserving of most of the credit for allowing this degree of control and comfort to successfully co-exist in a Peugeot, are its unique double-chamber shock absorbers. With twice as many valves as ordinary shocks, they match their response to variations of road and load, soaking up bumps, jolts and potholes with veritable aplomb. They are designed, built and *patented* by Peugeot, which is why no other car in the world can offer you quite the same motoring experience.

And to ensure all this smoothness reaches that part of you that can appreciate it most, Peugeot has equipped the Turbo and the STX V-6 with seats that *Motor Trend* has called "among the most comfortable in the world." They are filled with a special body-contouring foam, covered with a buttery-soft, hand-fitted leather (optional on the Turbo), and feature 121 possible adjustments to afford you maximum lumbar and lateral support.

If this is your year for a European performance sedan, call 1-800-447-2882 for a dealer where you can test drive the Peugeot 505 STX V-6 or Turbo. After all, wasn't the road to success hard enough?

 PEUGEOT NOTHING ELSE FEELS LIKE IT

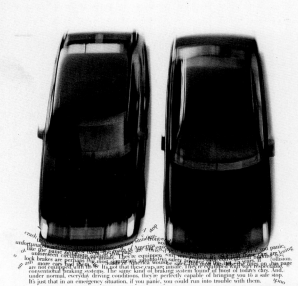

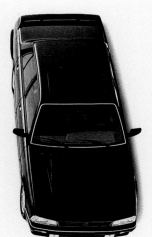

The four-wheel disc anti-lock braking system on the Peugeot 505 Turbo, on the other hand, is so advanced it can even help save you from yourself. Unlike conventional brakes that can "lock up" when you hit them hard, throwing the car into an uncontrolled skid, Peugeot's ABS brakes are automatically pumped by a computer fifteen times a second. Which means you have the ability to steer and thus retain control. Even during a panic stop in the rain.

But we didn't feel that a car with one of the world's most sophisticated braking systems was safe enough. So we equipped it with precise, speed-sensitive, power steering for maximum control at highway speeds; zero-offset front-suspension for increased directional stability; and independent rear suspension combined with a TORSEN® limited-slip differential to help maintain traction even on uneven, slippery road surfaces. (The 505 Turbo isn't the only car in the world with these features. The STX V-6 has them too.)

Why not call 1-800-447-2882 for the name of a dealer near you where you can learn more about the safety features in a Peugeot. That way you can avoid getting a crash course in some other car.

A FEW WORDS ABOUT THE ADVANTAGES OF THE BRAKING SYSTEM IN A PEUGEOT.

 PEUGEOT NOTHING ELSE FEELS LIKE IT

A few words. . .
Advertisement

Mark Hughes
Art Director

Frank Fleizach
Writer

Clint Clemens
Photographer

**HDM Advertising
New York, NY**
Agency

Peugeot Motors of America
Client

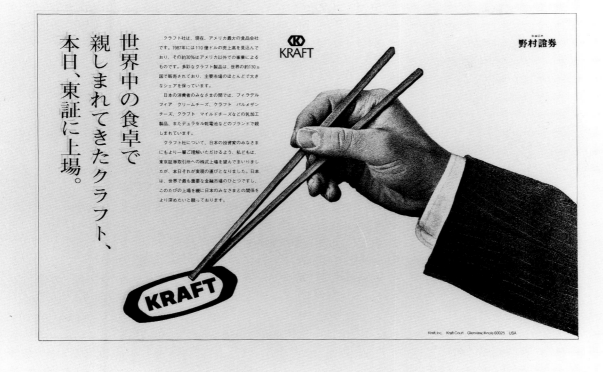

Kraft
Japan Stock Exchange
Advertisement

Joseph Michael Essex
Art Director/Designer

Russel Ingram
Photographer

**Essex Partnership
Chicago, IL**
Design Firm

Kraft, Inc.
Client

Master Typographers
Typographer

Dolan Wohlers Chair Calendar
Calendar

Don Johnson
Art Director

Bonnie Berish
Designer

George Diebold
Photographer

**Johnson & Simpson
Newark, NJ**
Design Firm

Dolan Wohlers
Publisher/Client

Elizabeth Typesetting Co.
Typographer

Dolan Wohlers
Printer

Fabric: Nimbus

Fabric: Grande Nouveau

Designtex: Nimbus, Grande Nouveau
Advertisements

Rick Biedel
Art Director/Designer

Don Penny
Photographer

Bonnell Design
New York, NY
Design Firm

Designtex
Client

Typogram
Typographer

Concrete: Season's Greetings
Self-Promotional Item

Jilly Simons
Art Director

**David Robson and
Joe VanDerBos**
Designers

Franco Vecchio Studio
Artist

**Concrete
Chicago, IL**
Design Firm

Concrete
Publisher

Paul Baker Typography
Typographer

Paper Express
Printer

Ideal Serviceman
Promotional Item

Mark Anderson
Art Director

Earl Gee and Sue Cretarolo
Designers

Earl Gee and Sue Cretarolo
Artists

**Mark Anderson Design
Palo Alto, CA**
Design Firm

Herman Miller, Inc.
Client

Z Typography
Typographer

T&J Graphic Arts
Printer

IF YOUR CAR LOOKS LIKE THIS YOU SHOULD CALL O'NEILL'S AUTO BODY WORKS
4808 STINE RD., BAKERSFIELD, CA 93313 (805) 397-4500 PATRICK J. O'NEILL, PRES.

**Happy Holidays From
Lauren Smith Design**
Plastic Template Greetings

Lauren Smith
Art Director

**Lauren Smith Design Inc.
Palo Alto, CA**
Design Firm

Lauren Smith Design Inc.
Client

Frank's Type
Typographer

Pickett Industries
Printer

If your car looks like this. . .
Business Card

Stavros Cosmopulos
Art Director

**Cosmopulos, Crowley & Daly
Boston, MA**
Agency

Patrick J. O'Neill
Client

Arrow Composition
Typographer

President Press
Printer

Richmond Printing
Flip Book Moving
Announcement

Don Goodell
Art Director

Michael Borofsky
Designer

Michael Borofsky
Artist

**Piland, Goodell & Pirnie, Inc.
Houston, TX**
Design Firm

Richmond Printing
Client

Typografiks
Typographer

Richmond Printing
Printer

Zolo
Playsculpture Packaging

**Byron Glaser and
Sandra Higashi**
Art Directors/Designers

**Higashi Glaser Design
New York, NY**
Design Firm

Higashi Glaser Design
Client

Vulcan Typography
Typographer

Duta Warna
Printer

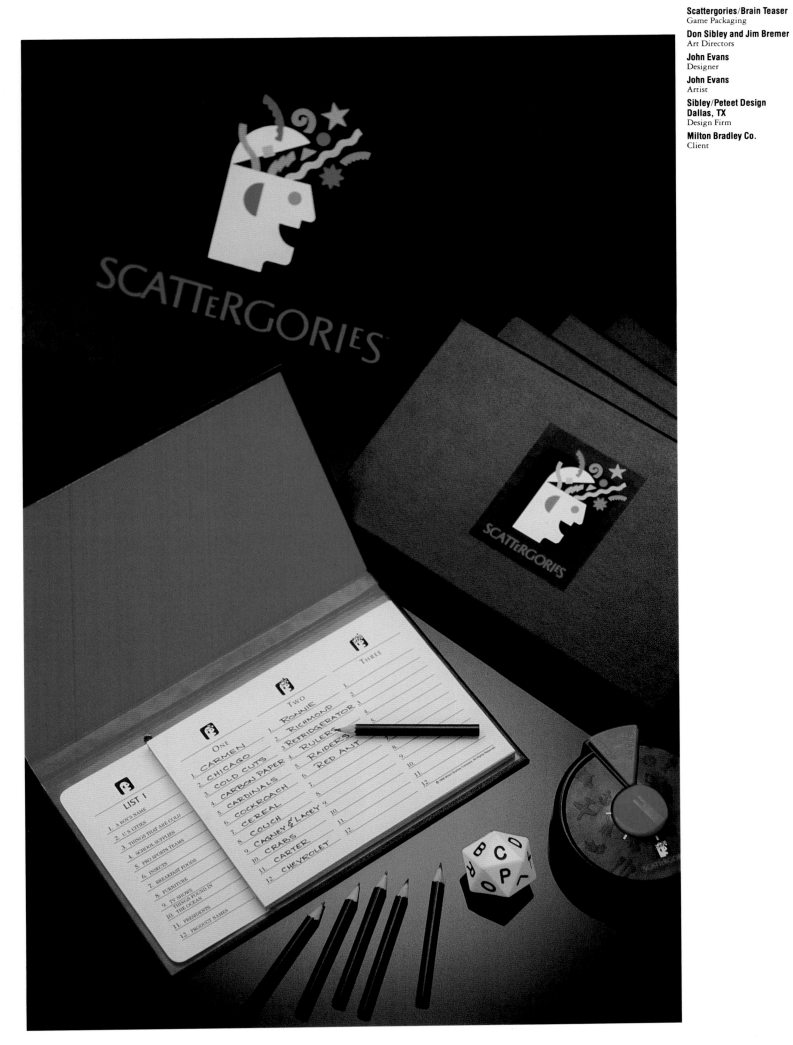

Scattergories/Brain Teaser
Game Packaging

Don Sibley and Jim Bremer
Art Directors

John Evans
Designer

John Evans
Artist

Sibley/Peteet Design
Dallas, TX
Design Firm

Milton Bradley Co.
Client

**Eskind Waddell: Awards
1987/1988**
Self-Promotional Folder

**Roslyn Eskind and
Malcolm Waddell**
Art Directors

The Image Bank of Canada
Photographer

**Eskind Waddell
Toronto, CAN**
Design Firm

Eskind Waddell
Publisher/Client

Cooper & Beatty
Typographer

MacKinnon-Moncur Ltd.
Printer

Empress Graphics, Inc.
Separations

True Stories, Tall Tales
Promotional T-Shirt

Dan Olson
Art Director

**Dan Olson and Chittamai
Suvongse**
Designers

**John Ryan & Co.
Minneapolis, MN**
Design Firm

AIGA/Minnesota
Client

RKD: The Business of Design
Self-Promotional Capabilities
Brochure

Richard Klein
Art Director

Paul Schulte and Mark Smith
Designers

RKD, Inc.
Palo Alto, CA
Design Firm

RKD, Inc.
Publisher/Client

Drager & Mount
Typographer

Various
Printers

Promotional Brochures

Graphic Design is becoming increasingly important in our age

Manuals

Morissa Rubin

of information. Good design communicates your message more

Graphic Design

Computer Screens

clearly, efficiently, and economically. Appropriate use of

Logo Symbol Design

technology further aids in the creation of effective graphic

Identity Development

design products.

Morissa Rubin is a graphic designer whose work is bridging the graphics and computer fields. She received her Bachelor of Fine Arts in graphic design from the Rhode Island School of Design and her Masters degree from Massachusetts Institute of Technology for her work done at the Visible Language Workshop. She has produced printed materials, screen designs, and other digital images for such companies as Houghton Mifflin, Interleaf, Camex, Britannica Software, and Wang Labs.

Starting Up!

For more information please call
Morissa Rubin 415•528•7421

**Morissa Rubin: Graphic
Design/Starting Up**
Self-Promotional Folder

Morissa Rubin
Art Director

**Morissa Rubin Graphic
Design**
El Cerrito, CA
Design Firm

Minuteman Press
Printer

The Book Show

I have often looked over the work in a show like this one and wondered why some of the items were included, and why others were excluded (often my own). It is an interesting process, this getting together as a group and judging another group of peoples' work. It is interesting because the interplay between the judges brings out their individual perceptions, tastes and prejudices. It shows that everyone comes to a piece of work a little differently, carrying with them their own histories and experiences.

And isn't that how we all enter a bookstore? We have different wants, tastes, and budgets. We have our own favorites even before we get into the store.

The exhibit assembled here represents some very thoughtful consideration by five people who may have little in common other than their great knowledge and love of books. The group comes from different backgrounds, disciplines, and cities. What survived their scrutiny represents the best in book design today.

The sixty-eight books selected were judged against criteria that was different for each category. Fanciful, hand-made publications were not judged against textbooks, for instance. As the show appears here in the annual, the books will be seen as a group. But the books are not really part of a group; they are individual works with their own value, their own special reason for being. I hope that you enjoy the books we chose, I hope you are able to see the exhibit in person, and I hope that you wonder why some of these books were selected while others weren't.

Jerry Herring
Chairperson

The Book Show
Call for Entry

Herring Design
Design Firm

Peggy Skycraft
Marbled Designs

Polychrome Corp.
Plates

Westvaco Corp.
Paper

Grover Printing Company
Printing

AIGA Book Show

to college, so I enjoyed my year in Vienna, but not the free-wheeling instruction at the Kunstgewerbeschule.

Then, fortunately, I was able to study in Florence with Victor Hammer, a portraitist and craftsman my mother had lately met in London; it happened he too was Viennese. As one of his apprentices I learned to draw what I saw and to help in the hand-printing workshop. I progressed from admiring San Clemente to being gripped by Brunelleschi's immense vision in Santo Spirito—architecture began to take on a deeper reality at that point. Hammer recommended the books of Gottfried Semper, the nineteenth-century architectural theorist now widely recognized but then still forgotten. Semper had strongly influenced John Wellborn Root in Chicago and Otto Wagner in Vienna, two architects Wright especially admired. My years in Florence were truly educational, but the rigors of the Great Depression pulled me back to the United States.

How Fallingwater Began

Settled in New York, a would-be painter of twenty-four, I felt disconnected from the thoughts and ways of America after long study in Europe. A friend recommended Frank Lloyd Wright's *An Autobiography*; reading it I believed Wright saw what I was missing. I went out to Spring Green in Wisconsin, and Wright agreed to let me join the Taliesin Fellowship in October, 1934, though I had no plan to become an architect. Soon my parents came to visit; they were moved by the extraordinary beauty of Wright's home and its landscape, and impressed by the devoted enthusiasm of the apprentices. Wright and my father were both outgoing, winning, venture-some men, and father quickly felt the power of Wright's genius. Mrs. Wright and my mother were cosmopolitan, and romantic in their taste for poetry; mother responded to Mrs. Wright's courageous character. Before the year's end Wright stopped off in Pittsburgh to discuss several projects with my parents; one was a country house to replace a rudimentary cottage that had served for over a decade. Father and Wright drove to the mountain property to consider a site; I went along. This was Wright's first view of our forested land and its waterfall. Sun, rain, and hail accented the rugged terrain and the swollen stream. Wright was led down old stone steps to a flat expanse of rock at the base of the falls; here we and our friends liked to bask between forays into the ever-icy water. Looking up Wright must have been fascinated by the torrent pouring over the fractured ledge; he saw a great opportunity for architecture.

Bear Run flows beneath rugged ledges and over smooth rock shaped by glaciers, constantly changing its song.

OPPOSITE: Another postcard from the days of the Shriners. The double-decked terrain was unified when Wright built the house above the falls.

Alan James Robinson

The Raven
Book Title

Alan James Robinson
Designer

Cheloniidae Press
Publisher

Leslie Smolan

Great Desserts
Book Title

Leslie Smolan
Art Director

Irvin Blitz
Photographer

Stewart Tabori & Chang
Publisher

Hazelnut Succès

You could hardly find a more aptly named dessert than Hazelnut Succès to fete a newly graduated M.B.A. or a budding entrepreneur. Invite a group for drinks and coffee, bring out this star-studded cake, and join your friends in wishing the honoree all the best. This extremely elegant dessert can be made in stages. Once assembled, it keeps well in the refrigerator for up to 24 hours before serving.

1 cup plus 2 tablespoons
 (5 ounces) lightly toasted
 and skinned hazelnuts
1 cup confectioners' sugar
6 egg whites, at room
 temperature
Pinch of cream of tartar
1 cup granulated sugar
Hazelnut Praline Buttercream,
 at room temperature (recipe
 follows)
⅔ cup Hazelnut Praline (recipe
 follows)
12 hazelnuts in their skins, for
 garnish

1 Preheat the oven to 250°. Line 2 large baking sheets with parchment paper and trace a 10-inch circle onto each piece of parchment.
2 Finely grate the toasted hazelnuts (a rotary nut grater works best) into a bowl. Sift in ¾ cup of the confectioners' sugar and toss to mix thoroughly.
3 In a large bowl, beat the egg whites and cream of tartar on low speed until foamy, about 2 minutes. Increase the speed to high and beat until the whites nearly double in volume and stiff peaks form. Gradually beat in the granulated sugar, 1 tablespoon at a time. Beat until the whites are dense and glossy and form stiff peaks.
4 With a large rubber spatula, lightly fold in the nut mixture until no white streaks remain.
5 Use a tiny amount of the nut meringue to anchor the corners of the parchment to the baking sheet. Spoon half of the meringue onto one of the circles and, with a thin metal spatula, spread into an even layer to fill the circle. Form a second circle with the remaining meringue on the other baking sheet.
6 Bake the nut meringues in the upper and lower thirds of the oven, switching positions once, until lightly browned and crisp throughout when tapped, 1 to 1½ hours. The amount of time it takes to dry out will depend on the humidity of the day. Let cool to room temperature. (The recipe can be prepared to this point up to 2 days ahead.) Wrap the meringue layers, with the parchment still attached to the bottom (for stability), in a large sheet of foil to seal.
To assemble the dessert:
7 Peel off the parchment paper from the meringue layers. Set one layer on a flat surface and spread evenly with 2 cups of the Hazelnut

Recipe continues on the next page

Waves and Plagues
Book Title

Ed Marquand
Design

The Contemporary Museum (Honolulu) and Chronicle Books
Publishers

THE ART OF
MASAMI TERAOKA

AIDS SERIES
MAKIKI HEIGHTS
DISASTER

1988, watercolor on paper, mounted as a
four-panel screen, 77 ¹/₂ × 155 in.
Space Gallery, Los Angeles

The latest realization of *Makiki Heights Disaster* is this tour-de-force four-panel screen, done in watercolor using the broad calligraphic line of the traditional Japanese brush (*fude*). The painting is identified in the far right cartouche as "Snake and Toad." The narrative reads from right to left in the traditional manner of a handscroll and opens with a scene of two lovers resting on the veranda of a temple structure. The man is grimacing, for the woman has just announced that they will have to use a condom. Around them are rumpled tissues, a traditional symbol for sexual activity. The woman holds a huge condom package, on which is written, "giant-size model, newly improved, special sale (30% discount)." Her male counterpart holds an illustrated book entitled "On the Use of Condoms," which reads in part: "Try not to be bitten by poisonous snakes; you must use a condom ..." Behind the amorous partners is a lattice window, on which a number of shinto fortune-telling papers (*omikuji*) have been tied, suggesting perhaps the ominousness of predicting the future.

The scene is placed in Makiki Heights, and in the distance, a glimpse of Diamond Head can be seen. Both Makiki Heights and Diamond Head are identified in cartouche to the left. The lushness of the Hawaiian setting is given a Gothic heaviness. Vampire bats hover throughout the scene; lightning streaks signify the awesome power of nature. Weaving in and out of the composition are the luminous trails of two disembodied ghost heads.

The main focus of the right half of the screen is a huge coiled snake, symbol of the AIDS virus and its means of transmission, being eaten by a giant grotesque toad. This theme, identified in cartouche as the title of the screen, offers one of the main messages of the work. Traditionally, the toad is a fearsome animal who, within the ukiyo-e world, is always depicted as a bad ghost. Teraoka's iconography suggests that an even fiercer virus than AIDS awaits us — the ecological nightmares caused by man have come full circle, and nature now revolts against man himself.

The second focus of the complex composition, in the left half of the screen, features a samurai and a Caucasian woman, identified in cartouche as Lynda Hess, attempting to open a huge condom package. A monstrous snake is shedding a torn condom and spitting sperm-like venom at the samurai. To protect himself, the warrior has covered his head with his umbrella-like *kasa* hat (see cat. no. 32 for a study of this detail). Overseeing this bizarre scene is U.S. Surgeon General C. Everett Koop, carefully delineated so that his face is recognizable. He is dressed in white robes decorated with calligraphy, an attire reminiscent of garments worn by a *yamabushi*, or mountain priest, but also associated with death (white robes are used in ritual suicide, *seppuku*). The characters on the white field of the robe translate "Condom Master." The waters below represent a flood that struck Oahu on New Year's Eve of 1987, taken by Teraoka as an ominous sign of nature's

MOMENTUM PLACE

Dallas
John Burgee Architects with Philip Johnson,
Architects

Botticino Classico Marble, Rojo Alicante Marble
Nero Marquina Marble

Eugene O'Neill: Complete Plays
Book Title

Eugene O'Neill
Author

Books: Bruce Campbell
Jacket and Case: R. D. Scudellari
Designers

Gun Larson
Calligrapher

The Library of America
New York, NY
Publisher

Graphic Technology
Jacket Typographer

Coral Graphics
Box and Jacket Printer

R. R. Donnelley & Sons Co.
Printer

Paul Royster and Emily Cohen
Production Managers

Ecusta Nyalite
Paper

R. R. Donnelley & Sons Co.
Binder

R. D. Scudellari
Jacket Designer

Gun Larson
Jacket Calligrapher

In The Houses of Ireland
Book Title

Marianne Heron
Author

J. C. Suarès
Art Director

J. C. Suarès and Paul Zakris
Designers

Walter Pfeiffer
Photographer

Stewart, Tabori & Chang
New York, NY
Publisher

Arkotype, Inc.
Typographer

Toppan Printing Co., Ltd.
Printer

Kathy Rosenbloom
Production Manager

#106 gloss coated
Paper

Toppan Printing Co., Ltd.
Binder

J. C. Suarès and Paul Zakris
Jacket Designer

Walter Pfeiffer
Jacket Phtographer

Lahore
Book Title

Samina S. Quraeshi
Author

Samina S. Quraeshi
Art Director

**Samina S. Quraeshi
and Michael Rock**
Designers

**Shepard/Quraeshi Associates
Watertown, MA**
Design Firm

**Samina S. Quraeshi
and Richard Shepard**
Photographers

Concept Media
Publisher

Tien Wah Press, Ltd.
Typographer

Tien Wah Press, Ltd.
Printer

Pat Theseira, Concept Media
Production Manager

157 gsm Matt art
Paper

Samina S. Quraeshi
Jacket Designer

**Samina S. Quraeshi
and Richard Shepard**
Jacket Photographers

Zahir Ad-Din Muhammad Babur
(1483-1530), *copy of a Mughal
painting, from the Punjab Archives.*

*Exotic Flowers; Mughal, gouache,
c.1635. This dazzling image
of exotic flowers, lovingly rendered
with insects alighting on them
and gold clouds drifting above,
is a testament to the culture of
beauty and opulence that became
the mark of the Mughal Empire.*

THE GOLDEN ERA OF THE MUGHALS

2

Fresh from a lovely and picturesque country, crossed by beautiful streams
and blanketed in luxurious vegetation, the followers of Babur contemplated
with dismay the prospect of a prolonged stay in the inhospitable region of
India. The happy recollections of Ferghana and its neighbouring mountains
made them anxious to return home, but Babur in an eloquent speech
dissuaded them, impressing upon them the incalculable advantages of
founding a new empire in India after the brilliant victories they had gained.
His words had the desired effect, and the empire so founded was destined to
become one of the greatest ever to rule an Asian country.

The first place of importance to benefit from the establishment of the
Mughal monarchy in the Punjab was naturally Lahore. It served as the
crown city for many years; and later, when the royal court shifted to Agra
and Delhi, Lahore remained a favoured and influential place.

The first 'Mughal', Babur, died in the Charbagh at Agra on December 26,
1530. His son and successor Humayun ascended the throne after him and
designated the city of Lahore for rule by his brother Kamran. Delighted with
his prestigious acquisition, the prince began extensive building operations
there, erecting a beautiful palace with gardens extending to the north side of
the Ravi. In 1540, however, Humayun was defeated and driven out of India
by the able and determined Afghan chief Sher Shah Suri in collaboration
with the ungrateful and ambitious governor of Lahore, his brother Prince
Kamran. Sher Shah was succeeded by a son and grandson while Humayun
took refuge with Shah Tahmasp of Persia. The descendants of Sher Shah
maintained power for fourteen years.

The story of Humayun's flight was recorded by his faithful ewer-bearer
Jauhar. In October of 1542, a small caravan of seven horsemen and a few

THE GOLDEN ERA OF THE MUGHALS 69

What It Feels Like to Be a Building
Book Title

Forrest Wilson
Author

Marc Meadows and Robert Wiser
Art Directors

Robert Wiser
Designer

Meadows & Wiser
Design Firm

Forrest Wilson
Illustrator

Preservation Press/National Trust for Historic Preservation Washington, DC
Publisher

General Typographers Inc.
Typographer

John D. Lucas Printing Co.
Printer

#80 Mohawk Superfine
Paper

American Trade Bindery
Binder

Robert Wiser
Jacket Designer

Forrest Wilson
Jacket Illustrator

This would happen

if buttresses did not push in.

The Artist in His Studio
Book Title

Alexander Liberman
Author

Alexander Liberman
Art Director

Sandro Franchini
Designer

Franchini + Cabana
Design Firm

Alexander Liberman
Photographer

**Random House, Inc.
New York, NY**
Publisher

The Type Crafters, Inc.
Typographer

**Arti Grafiche Amilcare
Pizzi S.p.A.**
Printer

Dennis E. Dwyer
Production Manager

**135 GSM gloss coated
Tenero Coat**
Paper

**Arti Grafiche Amilcare
Pizzi S.p.A.**
Binder

**Sandro Franchini,
Franchini + Cabana**
Jacket Designer

Alexander Liberman
Jacket Photographer

Chagall

V ence, a tiny walled hilltop village in the south of
France, became in the postwar years a center of
intense artistic life, attracting artists, dealers, col-
lectors, students, and snobs. Matisse's white and
blue chapel is the temple of this new Athens. Vence seems the
undisputed capital of that small stretch of Mediterranean
coast between Cannes and Nice. Like a rival city-state of the
Italian Renaissance, only Vallauris, where Picasso once lived,
disputed its dominance.

To visit the Midi has become a fashionable requisite for
anyone interested in today's art. The names of Picasso,
Braque, Chagall, Léger, and Matisse are heard from the lips
of countless tourists disporting themselves on the promenades
and beaches. The evocation of these prestigious names con-
fers a stamp of cultural approval upon the lazy, carefree
holiday life of the Riviera. A tourist may feel that he has
participated in a creative adventure merely by swimming next
to Picasso or Chagall. In the Midi these artists have become
the nobles of the land. Their wishes are respected, their
activities reported; they are a new royalty.

Marc Chagall, an *émigré* from Russia, who has lived in
Germany and America as well as in France, is a relative
newcomer; he bought his white villa at Vence in 1949. Marcel
Proust once stayed in it, and the studio, a garage-like building
next to the house proper, was once used by Paul Valéry, the
great poet, when he painted. The two buildings are on the
side of a steep hill, and the magnificent well-kept garden is
like a gigantic green staircase descending to the entrance gate.

On a large stone terrace in front of the house a garden
table was set for tea. I sat with his wife and waited for Chagall
to come from his studio. Intense sunlight streaked through
the bitter-clean-smelling leaves of the eucalyptus trees. We
were surrounded by flowers; the spottiness of their colors
combined with the broken-up patterns of light and shadow
created a sensation of visually enclosed space.

Valentine, or "Vava," Chagall's second wife, sat at the
table ready to pour the tea. She is Russian; her jet-black hair,
her black eyes, black blouse, and black slacks accentuated

165

David Hockney: A Retrospective
Book Title

R. B. Kitaj, Gert Schiff, Henry Geldzahler, Anne Hoy, Christopher Knight, Kenneth Silver, Lawrence Weschler, and David Hockney
Authors

Sandy Bell
Designer

David Hockney
Artist

Los Angeles County Museum of Art Design Department
Design Firm

Los Angeles County Museum of Art, Los Angeles, CA and Harry N. Abrams, Inc. New York, NY
Publishers

Andresen Typographics and Aldus Type Studio
Typographers

Nissha Printing Co., Ltd.
Printer

Espel
Paper

Nissha Printing Co., Ltd.
Binder

Sandy Bell
Jacket Designer

HOCKNEY ON STAGE

KENNETH E. SILVER

WHEN IN 1975 David Hockney created his first opera design—for Igor Stravinsky's *The Rake's Progress*, directed by John Cox at Glyndebourne, England—no one could have predicted, not even the artist himself, the kind of influence that theater would exert on his art in the following years. I think it is no exaggeration to say that Hockney's work for the stage has brought about a revolution in his aesthetic (if one understands the term *revolution* in Vico's sense of both a dynamic change and a return to first principles). Every sphere of his activity, from paintings to photocollages and prints, has been transformed by what he has done and what he had learned in the theater. Indeed it is the very shape of his aesthetic—in both a literal and a figurative sense, as I hope to show—which Hockney has been redrawing since that summer at Glyndebourne.

Not that anyone should have been or was surprised by Hockney's entry into the theater. In point of fact it was not his first time out as a designer of sets and costumes; in 1966 he did both for a production of Alfred Jarry's *Ubu Roi* at the Royal Court Theatre in London. Besides Hockney had studied Shakespeare's plays in school and so was at home with both the form and content of theater. We have only to look, as Martin Friedman has done so thoroughly, at the first decade of Hockney's career as a painter in order to recognize the fascination that theater held for the artist from the start.[1] In works like *Closing Scene, Play within a Play* (fig. 1), and *Seated Woman Drinking Tea, Being Served by a Standing Companion*, all of 1963, we find the stage and/or theater curtain invoked as metaphor for the illusion of three dimensions that artists since the Renaissance have projected onto the two dimensions of the canvas or wall.

Moreover, as he began to sense while struggling to paint the double portrait of George Lawson and Wayne Sleep (1972–75), Hockney had arrived at a kind of impasse in his painting by the

time Cox approached him about *The Rake's Progress*. So meticulously illusionistic had his art become—and we should not forget that this was the moment of Super Realism's popularity—that he sought, as he himself has said, a "release from naturalism."[2] To be sure, the search for egress from an aesthetic cul-de-sac must have functioned as no more than background to the immediate release that the opera commission represented, to wit, a chance to leave the studio and its lonely (and at the moment, frustrating) problems in order to work collectively (especially appealing in the light of Hockney's great love for and knowledge of music). *The Rake's Progress* is an eclectic and unusual combination of elements likely to bring about interesting results: an eighteenth-century English tale—originally told in pictures by Hogarth—set to music by Stravinsky, a twentieth-century Russian.

Hockney's production of *The Rake's Progress* was—and is, for it is still performed by the New York City Opera—a great success. The visual conceit is that of Hogarth's engravings reinterpreted and brought to three-dimensional life by Hockney (fig. 2). As is well known, Hockney depicts the opera by means of colossally rendered cross-hatching, so that everything in the production, including the costumes, is made up of a white ground scored with black, red, blue, or green lines (the colors of eighteenth-century printer's inks). The order and severity of the ubiquitous "etched" network is a brilliant interpretation of Stravinsky's combination of twentieth-century modernism and eighteenth-century classical reference, as the choice to "collapse" this three-dimensional world of parable into a mock-two-dimensional representation is a breathtaking simulacrum

Fig. 1. *Play within a Play* (detail), 1963 (complete image p. 96)

67

Degas
Book Title

**Andrew Forge and
Robert Gordon**
Authors

Judith Michael
Art Director/Designer

Edgar Degas
Artist

**Harry N. Abrams, Inc.
New York, NY**
Publisher

Sarabande Press
Typographer

Amilcare Pizzi, S.P.A.
Printer

Shun'ichi Yamamoto
Production Manager

Gardamatt Brillante
Paper

Lego
Binder

Judith Michael
Jacket Designer

Horses and Riders

Many of the subscribers to the Opera—the men whom Degas observed hanging about behind the scenes—would have also been members of the Jockey Club. Horse racing was the height of fashion, and the great races at Longchamp were among the highlights of the season. This was a fairly recent development, an aspect of the general enthusiasm for the ways of English society that had been a feature of French taste since the 1830s.

Degas's interest in the races, which as we have seen was first aroused when he visited the Valpinçons' estate in Normandy, was purely as a subject for painting. There is no evidence that he rode himself nor, as Ronald Pickvance tells us, that any of his pictures describe actual races, particular horses, or real racing colors. The world of the turf that he presents is, in its details, largely his own invention.

There are two periods when the horse race was an important subject: first during the 1860s and then for a while during the early 1880s. During the first period, which follows from the *Scène de Steeple-Chase*, Degas was mainly interested in horse racing as a social spectacle. *Le Défilé*, also known as *Chevaux de Course (Devant les Tribunes)*, and *Le Faux Départ* are both pictures that re-create the atmosphere of the race course with the horses seen against the background of the crowd. The *Aux Courses en Province* gives a wonderful impression of the racegoer's day under open skies: mounted spectators dotted over the plain, and in the far distance a race in progress. There is a Brueghel-like displacement of focus: the landau in the middle distance contains a tiny portrait of the Valpinçons' newborn son in the lap of his nurse, shaded by a parasol and attended to by his mother.

The social occasion of the races provides the context for several studies of individual figures: Manet dressed at his most elegant, lounging at the rail; the mysterious woman behind the binoculars. There are also many studies of riders in the saddle. These range from swift sketchbook notes surely made directly to highly worked drawings in pencil or a variety of other mediums, such as gouache and oil paint on paper, which were almost certainly done in the studio—where, it is said, Degas once had a dummy horse complete with harness on which to pose his models.

These are among his most beautiful drawings. He discovers exactly how riders sit, how their legs mold themselves to the horse's girth, how they look downward from under the long peaks of their caps or, relaxed, turn back to look behind them, the free hand resting on the horse's rump. Degas looks with peculiar intensity at the way the reins are held, or the way the feet rest in the stirrups and at the exact inclination of the rider's body.

Observations of this kind were essential to the expression of movement. The horse's movement could be seen more clearly through the rider's action than it could be directly drawn. The movement of a horse is like the movement of a wave in that it

Thoroughbred

*You hear the violence of his approach,
His strong, harsh breathing. With the dawn
The training starts, the groom is rigorous:
Scattering dew, the fine colt gallops on.*

*Like daylight drawn out of the eastern sky,
The power of the blood allows the steed
—So young and so inured to discipline—
The right to lord it over lesser breeds.*

*Casual and discreet, ambling it would seem,
He enters his stable—the oats are there.
He is ready: Now he belongs to the race.*

*And for the manipulations of a bet
He must begin—a dark horse on the field!
Nervously naked in his silken gown.*

EDGAR DEGAS

Aux Courses (At the Races). c. 1876–77

73

Pierre Dubreuil: Photographs 1896-1935
Book Title

Tom Jacobson
Author

Patrick Dooley
Art Director/Designer

Pierre Dubreuil
Photographer

Patrick Dooley Design
Design Firm

Dubroni Press
San Diego, CA
Publisher

Andresen Tucson Typographic Service
Typographer

Gardner Lithograph Co.
Printer

Richard Benson
Tri-Tone Negatives

Karma natural
Paper

Roswell Bookbinding
Binder

24. *Le Croquet*, c. 1932

Elliott Erwitt/Personal Exposures
Book Title

Elliott Erwitt
Author

James L. Mairs
Editor

Katy Homans
Designer

Elliott Erwitt
Photographer

W. W. Norton & Co.
New York, NY
Publisher

Zimmering & Zinn, Inc.
Typographer

Imprimere Jean Genoud, SA
Printer

Andrew Marasia
Production Manager

Biberist dull fine art coated
Paper

Imprimere Jean Genoud, SA
Binder

Katy Homans
Jacket Designer

Elliott Erwitt
Jacket Photographer

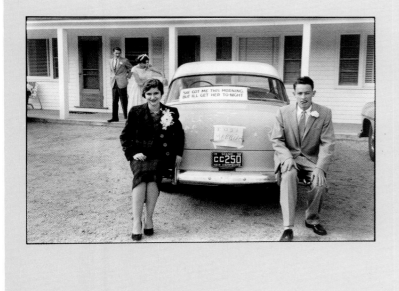

New Hampshire, 1958

84

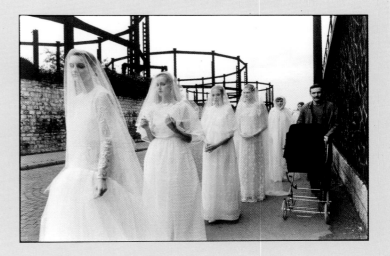

Paris, 1978

85

Carnegie International 1988
Book Title

Sara McFadden and Joan Simon
General Editors

Karen Salsgiver
Art Director/Designer

Karen Salsgiver Design New York, NY
Design Firm

Various
Photographers

The Carnegie Museum of Art
Publisher

Trufont Typographers, Inc.
Typographer

Lebanon Valley Offset, Inc. (Cover)
Balding & Marshall, International, Ltd. (Text)
Printers

Nancy Robins
Production Manager

#100 Lustro Cover (Cover)
#100 Skyesilk (Text)
Baldang & Mansell International Ltd.
Binder

Karen Salsgiver
Jacket Designer

Togashi
Marble Jacket Photographer

Per Kirkeby

Born 1938, Copenhagen

Lives and works in Copenhagen;
Laes, Denmark; and Karlsruhe,
West Germany

Kirkeby once defined geology as "the science of the powers behind the forms . . ." Changing careers in the early '60s, Kirkeby the scientist transferred this definition—nearly intact—to art. He considers drawings, sculptures, and paintings as relics which mirror the powers of their creation. Yet art has an advantage over science; every picture can be both an object of study and a theory at the same time—earth's crust and geology.

Kirkeby's works do not encode their message in abstract theories, but rather bear witness to those creative powers which they take as their theme. For Kirkeby, painting documents an event. Whereas with film, a medium in which he also works, associations are strung along in a temporal sequence, continuously imposing new meaning, painting is the sum of layering. Kirkeby keeps these layers transparent. He treats pictorial space as if it were temporal. At the same time, his use of materials recalls the classical tradition, thereby calling up all manner of fleeting associations. The viewer's memory and personal store of knowledge complete the works' meaning.

Kirkeby, in a way, is a conceptualist. His paintings, drawings, brick sculptures, and written texts focus on a process of structures evolving. This process cannot be named categorically. This linguistic hybrid reflects Kirkeby's idea of creation: although working in a spontaneous mode, form and texture develop.

His brick sculptures, produced since 1973, can also be understood as metaphors for the structure underlying every work of art. The idea for the brick sculpture is formed quickly and intuitively by modeling plaster. He then "interprets" the resulting form by reconstructing it brick by brick. The creative power which is responsible for the plaster model is the same as for the modular brick sculpture. Process is structure and structure is process. Kirkeby's real topic is the essential combination of spontaneity *and* order. A work of art which can be said to comprise both esthetic object and theory surpasses the common views of creativity, which have historically separated reason and subjectivity. Kirkeby shows that beyond scientific thinking there is a poetical understanding of the world which is not analytical but which has its reasons.

—*Stephan Schmidt-Wulffen*
Translated from German by Clara Seneca

Selected Solo Exhibitions

1988
Galerie Michael Werner, Cologne. Catalogue by Per Kirkeby. Also 1986 (catalogue by Per Kirkeby); 1984 (catalogue by Andreas Franzke); 1983 (catalogue by Per Kirkeby); 1982 (catalogue by A.R. Penck); 1980 (catalogue by Rudi Fuchs, Johannes Gachnang and Per Kirkeby); 1978; 1974.

1987
Centre de Création Contemporain de Tours. Catalogue by Bernard Lamarche-Vadel.
Museum Ludwig, Cologne. Traveled. Catalogue by Troels Anderson, Andreas Franzke, Siegfried Gohr and Peter Schjeldahl.
Museum Boymans-van Beuningen, Rotterdam. Catalogue by Wim Crouwel, Per Kirkeby and Karel Schampers.

1986
Mary Boone Gallery, New York. Catalogue by Peter Schjeldahl.
Städtisches Museum Abteiburg Mönchengladbach. Catalogue by Troels Anderson, Johannes Gachnang, Hannelore Kersting, Per Kirkeby and Dirk Stemmler.
Whitechapel Art Gallery, London. Catalogue by Tony Godfrey, Per Kirkeby and Nicholas Serota.

1985
The Fruitmarket Gallery, Edinburgh. Traveled. Catalogue by Troels Anderson.
Den Fries Udstillingsbygningen, Copenhagen. Catalogue by Peter Langesen.

1984
Strasbourg Museum. Catalogue by Marie Jeanne Geyer and Per Kirkeby.

1983
DAAD Galerie, West Berlin. Catalogue by Johannes Gachnang.

1982
Stedelijk van Abbemuseum, Eindhoven. Catalogue by Rudi Fuchs, Johannes Gachnang and Per Kirkeby.

1979
Kunsthalle Bern. Catalogue by Johannes Gachnang and Theo Kneubühler.

1978
Kunstraum München. Catalogue by Hermann Kern and Per Kirkeby.

1977
Museum Folkwang, Essen. Catalogue by Zdenek Felix and Troels Anderson.

1964
Hovel-Bildiotek, Copenhagen.

Selected Group Exhibitions

1988
Zeitlos, West Berlin. Catalogue.

1987
Skulptur Projekte, Münster. Catalogue.

1986
Falls the Shadow, Recent British and European Art, Hayward Gallery, London. Catalogue.
Europa/Amerika—Die Geschichte einer künstlerischen Faszination seit 1940, Museum Ludwig, Cologne. Catalogue.

1985
Carnegie International, Museum of Art, Carnegie Institute, Pittsburgh. Catalogue.

1984
von hier aus, Messegelande, Düsseldorf. Catalogue.

1982
Zeitgeist, Martin-Gropius-Bau, West Berlin. Catalogue.
Documenta VII, Kassel. Catalogue.

1981
A New Spirit in Painting, Royal Academy of Arts, London. Catalogue.

1980
La Biennale di Venezia. Catalogue. Also 1976.

1962
Den Eksperimenterende Kunstskole, Copenhagen.

Selected Bibliography

de Waal, Allan, Troels Anderson and Per Hovdenakk. *Per Kirkeby: Norge Sverige Danmark 1975/76*. Copenhagen 1975.
Dückers, Alexander. *Erste Konzentration*. Munich 1982.
Gachnang, Johannes. "New German Painting." *Flash Art*, February–March 1982.
————. "Vom Gesicherten zum Wesentlichen-Spaziergange: Gedanken zur Kunst in Dänemark." *Bauen und Wohnen*, December 1981.
Gohr, Siegfried. "The Situation and the Artist." *Flash Art*, February–March 1982.
Horn, Luis and Per Kirkeby. *Per Kirkeby, Übermalungen 1964–1984*. Munich 1984.
Hunov, John. *Per Kirkeby: Oeuvre Katalog, 1970–1977*. Copenhagen 1979.
Kirkeby, Per. *Fortgesetzter Text—Hinweise*. Bern-Berlin 1985.
————. *Rodin, la port de l'enfer*. Bern-Berlin 1985.
————. *Selected Essays from Bravura*. Eindhoven 1982.
Kolberg, Gerhard. "Per Kirkebys erste Monumentalskulptur im Museum Ludwig." *Kölner Museums—Bulletin*, 1987.
Maloch, Friedemann. "Per Kirkeby." *Kunstforum International*, October–November 1987.
McGill, Douglas C. "Art People: Per Kirkeby, Danish Artist and Paradox." *The New York Times*, 13 June 1986.
Rein, Ingrid. "Ausstellung: 39, Biennale/Arte vivre '80." *Pantheon*, October–December 1980.
Schmidt-Wulffen, Stephan. "Enzyklopädie der Skulptur." *Kunstforum International*, October–November 1987.

Nach der Abnahme, 1987–88
oil on canvas
118⅛ × 137⅞ in. (300 × 350 cm.)
Courtesy of Mary Boone/Michael Werner Gallery, New York.

Visual Thinking: Methods for Making Images Memorable
Book Title

Henry Wolf
Author

Henry Wolf
Art Director

Henry Wolf and David Blumenthal
Designers

Henry Wolf Productions, Inc. New York, NY
Design Firm

Various
Illustrators and Photographers

American Showcase, Inc.
Publisher

Characters Typographic Services
Typographer

Amilcare Pizzi, S.p.A.
Printer

Kyla Kanz
Production Manager

R-400 Matt satin
Paper

Amilcare Pizzi, S.p.A.
Binder

Henry Wolf
Jacket Designer

Henry Wolf
Jacket Photographer

If you came across a bottle labeled with a skull and crossbones, you would not be tempted to taste its contents. A red traffic light automatically makes your foot push the brake pedal. Symbols are graphic devices prompting you to action: sometimes warning of impending danger, other times informing or classifying. They are shorthand for complex ideas. Symbols overcome language barriers and provide instant recognition. The yellow box says Kodak, even if you are illiterate. The curly script says Coca-Cola, even before you read the words. Flags are symbols: the Union Jack means England, the red disc, Japan, the Stars and Stripes, America, reaffirming not just the fact but a lot of the legends around the fact. The symbol is a powerful conjurer of a thousand images, all at once. The danger in using symbols is the danger of the cliché: an effective symbol has always been seen a thousand times before. Milton Glaser's ingenious I ♥ New York has now been copied in hundreds of versions, varying from imitation to insanity.

Because of its ability to compel people to action, the symbol has become a selling tool. Companies are protecting their logotypes with copyrights and restricting their use via complicated manuals. Books governing the applications of the IBM or AT&T logos are the size of a small telephone directory. Updating or changing a trademark like Mobil's, replacing the prancing Pegasus with the updated red "O," cost close to a hundred million dollars.

For a designer or photographer, the use of the symbol depends on the ingenuity with which you apply it in a way different from its original intent. The surrealists picked on the Mona Lisa as "The Painting," not because it was the greatest painting ever made, but because of its fame, its history of having been stolen and returned. It was a perfect target. They defaced it, collaged it, paraphrased it, copied it, and each time it became even more "valuable." The Greek Pygmalion legend of the sculptor who shaped the perfect woman and made her come to life became G. B. Shaw's Pygmalion and later, in its third reincarnation, Lerner & Loewe's My Fair Lady. The symbol thrives on revival and is strengthened through each adaptation. It reduces misunderstandings created by language and other differences. Symbols are a reaffirmation of our basic sameness.

Jasper Johns. Three Flags, 1958.
The symbol, in repetition, becomes more than the sum of its parts.

In Milton Glaser's ingenious substitution of a picture for a word, the "heart" image actually reads as "love."

The Pygmalion legend in three incarnations: As a 19th century painting; as the subject of a film of G.B. Shaw's Pygmalion, starring Leslie Howard and Wendy Hiller; and as Lerner and Loewe's musical My Fair Lady, starring Audrey Hepburn and Rex Harrison.

5
Manipulated Symbols

48

Bradbury Thompson: The Art of Graphic Design
Book Title

Bradbury Thompson
Author

Bradbury Thompson
Designer

Bradbury Thompson and others
Illustrators

Yale University Press New Haven, CT
Publisher

Finn Typographic Service
Typographer

Meriden-Stinehour Press
Printer

Ken Botnick
Production Manager

#100 Celesta dull/Westvaco
Paper

Tomahawk Cover/Mohawk
Endpapers

Zahrndt, Inc.
Binder

Bradbury Thompson
Jacket Illustrator and Designer

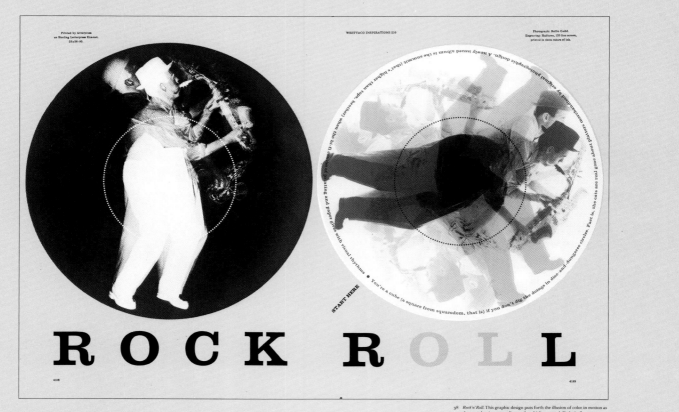

The black record on the left comes alive
with the colorful music of a spinning record on the right,
and the words too become a part of the visual music
as graphic design brings together
the arts of photography, typography, and printing.

38 *Rock'n'Roll.* This graphic design puts forth the illusion of color in motion as the saxophonist comes alive on the whirling record. Technically, process printing plates were not employed, as just one halftone plate was printed in three process inks and on three different angles to avoid a moiré pattern. 1958

30

31

High Bridge
Book Title

Clayton Schanilec
Editor

Gaylord Schanilec
Art Director/Designer

Gaylord Schanilec
Illustrator

Gaylord Schanilec
Minneapolis, MN
Publisher

Gaylord Schanilec
Typographer

Gaylord Schanilec
Printer

Basingwerk Heavyweight
Paper

Campbell-Logan Bindery
Binder

Graphis Diagram I
Book Title

Leslie A. Segal
Author

B. Martin Pedersen
Art Director

Marino Bianchera and Martin Byland
Designers

Various
Illustrators

Walter Zuber
Photographer

Graphis US Inc./Graphis Press Corp. New York, NY
Publisher

Setzerei Heller
Typographer

Toppan Printing Co., Inc.
Printer

Toppan Printing Co., Inc.
Binder

B. Martin Pedersen
Jacket Designer

Various
Jacket Illustrators

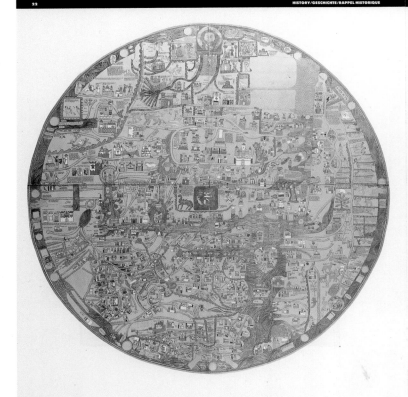

■ 5 The Ebstorf map of the world originating from 1255. It shows an impression of a world of limited vision. Based on an 1896 print from the picture archives of the Austrian National Library, Vienna.

■ 5 Die Ebstorfer Weltkarte, entstanden um 1255. Sie zeigt die Vorstellung einer nach aussen eng begrenzten Welt. Nach einem Druck von 1896 aus dem Bild-Archiv der Österreichischen Nationalbibliothek, Wien.

■ 5 La mappemonde d'Ebstorf, dessinée vers 1255. Elle fournit l'image d'un monde étriqué, sans ouverture sur l'extérieur. D'après une gravure de 1896 figurant dans les archives de la Bibliothèque nationale autrichienne à Vienne.

■ 6 Map of the world circa 1570/73 by Abraham Ortelius, which depicts Australia as "a land unknown to man". The quotation by Cicero liberally translated, means: "Ah, what human endeavours can be regarded as great when compared to the eternal greatness of the whole world?" From the Ryhiner collection of the Municipal and University Library, Berne.

■ 6 Erdkarte um 1570/73 von Abraham Ortelius, welche den Erdteil Australien als -von niemandem bekanntes Land- bezeichnet. Der Satz von Cicero lautet sinngemäss: -Ach, was kann in menschlichen Dingen schon Grosses gesehen werden angesichts der ewigen Grösse dieser ganzen Welt.- Aus der Ryhiner-Sammlung der Stadt- und Universitätsbibliothek Bern.

■ 6 Planisphère terrestre d'Abraham Ortelius, vers 1570/73, où l'Australie figure comme -pays connu de personne-. La citation de Cicéron signifie: -Que peut-on donc voir de grand dans les entreprises humaines si l'on considère l'immensité éternelle de tout cet univers!- Document figurant à la collection Ryhiner de la Bibliothèque municipale et universitaire de Berne.

Graphic Style
Book Title

Steven Heller
Author

Sam Antupit
Art Director

Seymour Chwast
Designer

Pushpin Editions
Packager

Various
Illustrations

Harry N. Abrams, Inc.
New York, NY
Publisher

Concept Typographic Services, Inc.
Typographer

Nissha Printing Co., Ltd.
Printer

Shun'ichi Yamamoto
Production Manager

128 Fukiage Matte
Paper

Nissha Printing Co., Ltd.
Binder

Seymour Chwast
Jacket Designer

Seymour Chwast
Jacket Illustrator

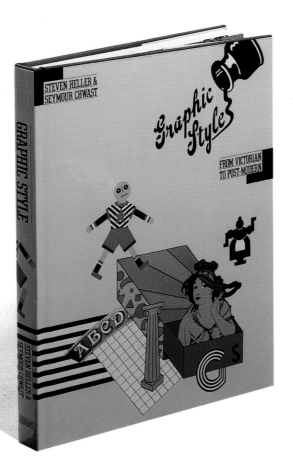

ART DECO

FRENCH

Despite Modernism's efforts to simplify design, the urge to decorate and be decorated was not dead, never having been totally renounced by the middle class, whose creature comforts demanded ornament of some kind. Art Deco was a symbolically appropriate style for this purpose, since it made overt references to luxury and extravagance. The influential French fashion designers catered to such demands not only in their clothing design but also in their packaging. The perfumer Coty, for example, commissioned the craftsman René Lalique to produce ornate labels for his bottles. Parisian department stores like Les Grands Magasins, Galeries Lafayette, and Au Bon Marché gave special attention to those products in all departments—from cosmetics to liquors to tobaccos—that evoked the *au courant* spirit.

342. Designer unknown. Fan advertising champagne, date unknown. Courtesy John and Margaret Martinez
343. Designer unknown. *Cocktail Grand Luxe.* Advertisement card, 1932.
344. Designer unknown. *Campeones.* Cigarette package, c. 1928. Courtesy Rikuyo-sha Publishing, Inc., Tokyo
345. Designer unknown. *Rhum.* Package design, c. 1928. Courtesy Rikuyo-sha Publishing, Inc., Tokyo
346. Designer unknown. Face powder box, c. 1930. Courtesy Rikuyo-sha Publishing, Inc., Tokyo
347. Designer unknown. Face powder box, c. 1930. Courtesy Rikuyo-sha Publishing, Inc., Tokyo

130

131

The Pied Piper of Hamelin
Book Title

**Robert Browning,
Revised by Terry Small**
Author

Joy Chu
Art Director

Michael Farmer
Designer

Terry Small
Illustrator

**Gulliver Books/
Harcourt Brace Jovanovich
San Diego, CA**
Publisher

Thompson Type
Typographer

**Horowitz/Rae Book
Manufacturers, Inc.**
Printer

**Warren Wallerstein and
Ginger Boyer**
Production Managers

Bellbrook Laid
Paper

**Horowitz/Rae Book
Manufacturers, Inc.**
Binder

Michael Farmer
Jacket Designer

Terry Small
Jacket Illustrator

he stepped up to the council table
And said, "Your honors, I am able
By secret magic to enchant
All creatures living beneath the sun
That creep or swim or fly or run.
What I can do most wizards can't.
Chiefly I reserve my charm
For creatures that'll do you harm—
The mole and toad, the newt and viper—
And people call me the Pied Piper."

(And here they noticed round his neck
A scarf of red and yellow stripe
To match his coat of the selfsame check.
And at the scarf's end hung a pipe;
And his fingers, they noticed, were always straying
As if impatient to be playing
Upon this pipe, as low it dangled
Over his garment so old-fangled.)

THE PIED PIPER OF HAMELIN ❖ 13

More Tales of Uncle Remus
Book Title

Julius Lester
Author

Atha Tehon
Art Director

Jane Byers Bierhorst
Designer

Jerry Pinkney
Illustrator

Dial Books for Young Readers
New York, NY
Publisher

Maple-Vail Book
Manufacturing
Group
Text Typographer

Set-To-Fit
Jacket Typographer

Arcata Graphics
Printer

Shari Lichtner
Production Manager

#70 Michigan Matte, 488 ppi
Paper

Arcata Graphics
Binder

Jane Byers Bierhorst
Jacket Designer

Jerry Pinkney
Jacket Illustrator

Book Title

James A. Sebastian
Art Director

**James A. Sebastian,
John Plunkett, and
Frank Nichols**
Designers

Designframe, Inc.
Design Firm

**Colorcurve Systems, Inc.
New York, NY**
Publisher

Typogram
Typographer

**Colwell General and
The Hennegan Co.**
Printers

The Behring Collection
Book Title

Rob Haeseler
Author

Steve Renick
Designer

Rob Haeseler, Mark Snyder, and Buz Marble
Photographers

Czeslaw Jan Grycz
Production Manager

Behring Educational Institute Press
Publisher

Interactive Composition Corp.
Typographer

Toppan Printing Co., Ltd.
Printer

Satin Kin-Fuji 186 GSM
Paper

Toppan Printing Co., Ltd.
Binder

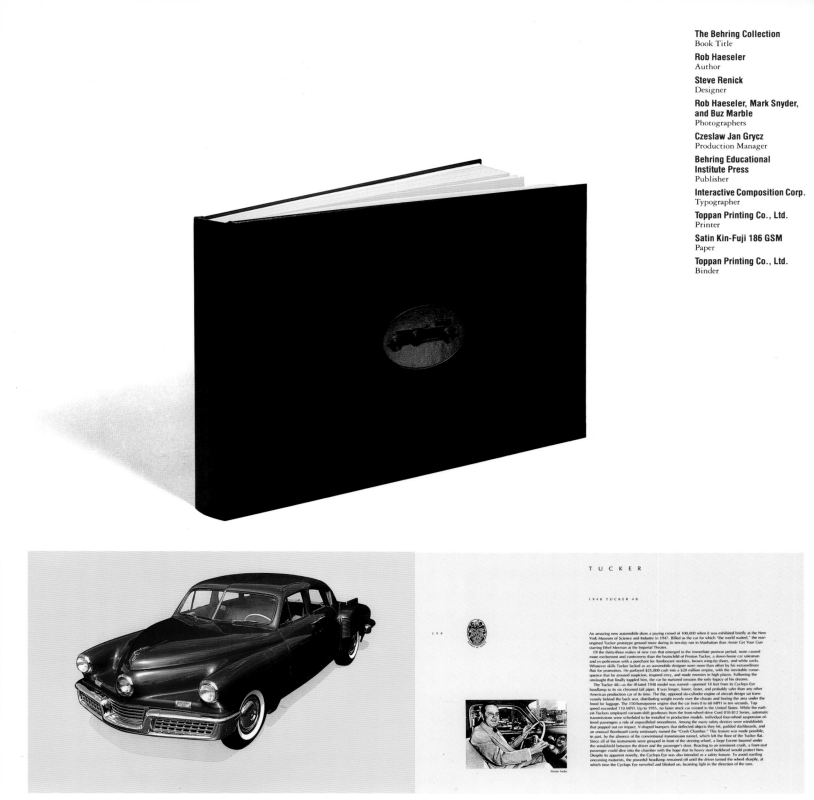

The Hawk's Tale
Book Title

John Balaban
Author

Joy Chu
Art Director

Camilla Filancia
Designer

David Delamare
Illustrator

Harcourt Brace Jovanovich
San Diego, CA
Publisher

N-K Graphics
Typographer

Horowitz/Rae Book
Manufacturers, Inc.
Text Printer

Coral Graphics
Jacket Printer

Eileen McGlone
Production Manager

#60 Supple Offset, Machine
Finish
Paper

Horowitz/Rae Book
Manufacturers, Inc.
Binder

Camilla Filancia
Jacket Designer

David Delamare
Jacket Illustrator

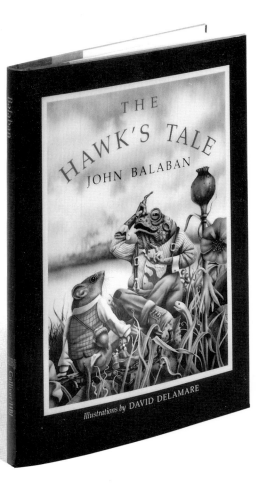

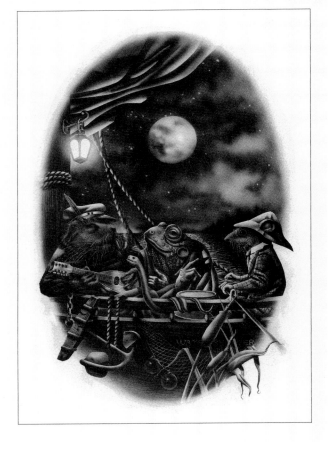

If ever you had some goods to haul
Anywhere on the water's way,
You've heard no doubt of Pelagon
And his boat, the Water Skeeter,
For of all the tradin' craft afloat
There's none on the River to beat her.

I tried every rocky inlet
And tacked every sandy shore.
My guess is that they'll be saying
For another thirty or more:
You've heard no doubt of Pelagon
And his boat, the Water Skeeter,
For of all the tradin' craft afloat
There's none on the River to beat her.''

When the Captain finished his song, he stood up, coughed, knocked the dead ashes from his pipe, and returned the mandolin to the chest. Then, taking over the oars from Mr. Trembly, he rowed the boat into quiet water in the lee of a wooded island where an owl was hooting softly in a dead tree that hung over the foggy stream. ''Drop anchor, snake,'' whispered the Captain, ''and drop 'er quiet-like.'' He gave a nod toward the dead tree silhouetted against the moon. ''Mr. Toad,'' he said, ''you tuckered out or just thinking?''

Wrapped snug in a blanket to keep the damp air from his old bones, the toad sat with his back against

26

Science & Peace
Book Title

Linus Pauling
Author

John Thos. Bennett
Gardyloo Press
Corvallis, OR
Designer

Oregon State University
Foundation
Publisher

John Thos. Bennett
Gardyloo Press
Typographer

John Thos. Bennett
Gardyloo Press
Printer

Sandy Tilcock
Binder

within a few months by 11,021 scientists, of forty-nine countries. On January 15, 1958, as I presented the Appeal to Dag Hammarskjöld as a petition to the United Nations, I said to him that in my opinion it represented the feelings of the great majority of the scientists of the world.

The Bomb-Test Appeal consists of five paragraphs. The first two are the following:

We, the scientists whose names are signed below, urge that an international agreement to stop the testing of nuclear bombs be made now.

Each nuclear bomb test spreads an added burden of radioactive elements over every part of the world. Each added amount of radiation causes damage to the health of human beings all over the world and causes damage to the pool of human germ plasm such as to lead to an increase in the number of seriously defective children that will be born in future generations.

Let me say a few words to amplify the last statement, about which there has been controversy. Each year, of the nearly 100,000,000 children born in the world, about 4,000,000 have gross physical or mental defect, such as to cause great sufferings to themselves and their parents and to constitute a major burden on society. Geneticists estimate that about 5 per cent, or 200,000 a year, of these children are grossly defective because of gene mutations caused by natural high-energy radiation—cosmic rays and natural radioactivity, from which our reproductive organs cannot be protected. This numerical estimate is rather uncertain, but geneticists agree that it is of the right order of magnitude.

Moreover, geneticists agree that any additional exposure of the human reproductive cells to high-energy radiation produces an increase in the number of mutations and an increase in the number of defective children born in future years, and that this increase is approximately proportional to the amount of the exposure.

10

The explosion of nuclear weapons in the atmosphere liberates radioactive fission products—cesium 137, strontium 90, iodine 131, and many others. In addition, the neutrons that result from the explosion combine with nitrogen nuclei in the atmosphere to form large amounts of a radioactive isotope of carbon, carbon 14, which then is incorporated into the organic molecules of every human being. These radioactive fission products are now damaging the pool of human germ plasm and increasing the number of defective children born.

Carbon 14 deserves our special concern. It was pointed out by the Soviet scientist O. I. Leipunsky in 1957 that this radioactive product of nuclear tests would cause more genetic damage to the human race than the radioactive fallout (cesium 137 and other fission products), if the human race survives over the 8000-year mean life of carbon 14. Closely agreeing numerical estimates of the genetic effects of bomb-test carbon 14 were then made independently by me and by Drs. Totter, Zelle, and Hollister of the United States Atomic Energy Commission. Especially pertinent is the fact that the so-called "clean" bombs, involving mainly nuclear fusion, produce when they are tested more carbon 14 per megaton than the ordinary fission bombs or fission-fusion-fission bombs.

A recent study by Reidar Nydal, of the Norwegian Institute of Technology, in Trondheim, shows the extent to which the earth is being changed by the tests of nuclear weapons. Carbon 14 produced by cosmic rays is normally present in the atmosphere, oceans, and biosphere in amounts such as to be responsible for between 1 and 2 per cent of the genetic damage caused by natural high-energy radiation. Nydal has reported that the amount of carbon 14 in the atmosphere has been more than doubled because of the nuclear weapons tests of the last ten years, and that in a few years the carbon-14 content of human beings will be two or three times the normal value, with a consequent increase in the gene mutation rate and the number of defective children born.

Some people have pointed out that the number of grossly

11

Frontier New York
Book Title

Paul Goldberger
Author

Paul Anbinder
Art Director

Marty Lubin
Designer

Betty Binns Graphics
Design Firm

Jan Staller
Photographer

Paul Anbinder
Hudson Hills Press, NYC
Publisher

U.S. Lithograph, typographers
Typographer

Toppan Printing Co., Ltd.
Printer

Paul Anbinder
Production Manager

Flying Horse NK Hi-Kote #105
(157 gsm)
Paper

Toppan Printing Co., Ltd.
Binder

Marty Lubin/Betty Bins
Graphics
Jacet Designer

Jan Staller
Jacket Photographer

**Judith Golden:
Cycles, A Decade of
Photography**
Book Title

Judith Golden
Author

Michael Mabry
Designer

Michael Mabry Design
Design Firm

Judith Golden
Photographer

**David Featherstone/The
Friends of Photography
San Francisco, CA**
Publisher

On-Line Typography
Typographer

Dai Nippon Printing Co., Ltd.
Printer

Peter Soe, Jr.
Production Manager

Michael Mabry
Jacket Designer

Summer Changeover

Body

PLATE
10

PLATE
11

Invisible City
Book Title

Various
Authors

Ken Schles and Jack Woody
Designers

Ken Schles
Photographer

Twelvetrees Press
Pasadena, CA
Publisher

Toppan Printing Co, Ltd.
Printer

Thomas Long
Production Manager

Toppan Printing Co., Ltd.
Binder

Jack Woody
Jacket Designer

Ken Schles
Jacket Photographer

We The Homeless
Book Title

**Victoria Irwin and
Robert M. Hayes**
Authors

**Michael Bierut
Vignelli Associates
New York, NY**
Designer

Stephenie Hollyman
Photographer

**Philosophical Library, Inc.
New York, NY**
Publisher

DVW Graphics
Typographer

Arcata Graphics
Printer

Like children everywhere, homeless children can be cheerful and full of boisterous play. But there are subtle signs of bewilderment too. At a New York City community center with a special program for children who live in welfare hotels, the drawings by grade-schoolers can be stark.

One, for instance, is of a mother, brothers, and sisters, and in the background an apartment building has flames coming out of the window. In another drawing, a child has drawn a picture of a cat, scrawling underneath that the pet is now dead.

Ellen L. Bassuk, a Harvard Univerity Medical School psychiatrist, has studied homeless children. She says that preschool homeless often lag in major developmental milestones, such as walking, talking, and playing with building blocks. Among older homeless children, she encountered a significant degree of depression and anxiety.

"Almost every kid I talked to had thought about suicide," she says. There are often very few services available to these children. For example, only twenty percent of the preschoolers in her study had access to Head Start programs, universally viewed as a successful program for the poor.

In shelters, children are often hyperactive, sometimes the result of a high-sugar diet from the fast-food their mothers buy because there is no kitchen to prepare better food. Because they are often clustered with other young children, health problems can multiply more rapidly.

And homeless families are not always obviously homeless, because they try hard to stay invisible. In California, several advocates for the homeless note that in the past homeless families avoided seeking social services because of the fear that their children would be put in foster care. Laws have been strengthened to protect them. But the fear lingers.

Many families are not intact. In urban areas, where the homeless are often part of families that have been on welfare for generations, husbands are scarce. Mothers sometimes have
24

children from more than one father. Denise eats a healthy if bland dinner with her two babies, Sahkeda, three, and Arlina, two, in a noisy soup kitchen at St. Benedict's in Milwaukee. She bristles when a visitor comments on her lovely family.

"No, it's not. The family is not all here," says Denise, a high school dropout who explains that her oldest son and daughter are living with her parents. "I want them to be with me."

Dr. Bassuk says her studies show that family problems are complicated when women have little self-esteem or have been victims of abuse. Two-thirds of the homeless mothers in her survey came from disrupted homes. Most mothers do not have mental-health problems. But many have had housing difficulties for the past five years. Many had been in shelters before, or had doubled up or tripled up with friends and relatives.

Without financial assistance, housing, and a wide range of support services, these families move from one unstable situation to another, says Bassuk. From a policy point of view, shelters or interim housing is just another stop on a cycle.

Homeless parents find that in their day-to-day life they become "public parents." In shelters they are told when to get up, and if there is no daytime program they have to leave, sometimes as early as 6:30 A.M. Inadequate income leaves them dependent on providers.

Parents often have little say over where their children attend school. Homeless children from Westchester County in New York are sometimes cabbed an hour and a half to school. And motel and hotel owners put greater strictures on their homeless guests.

One motel owner in Westchester County slapped Joann's son Raymond as he was playing in the parking lot, because he thought the boy had scratched his automobile with a bicycle. Joann was angry, but she says she was helpless to complain. The only thing she could do was ask to leave the motel.

Joann sits in a new motel room with her long-time companion, Richard. Three of their children are sleeping in the two large beds—the youngest sleeps with her parents. The

couple says their life is on hold. And they talk of what it is like to have most of their life public. Teachers ask their children questions about how they are treated at home, probing for potential abuse.

"They ask, does your mommy do this?" says Joann, a soft-spoken high school dropout who quit her job at a factory to take care of her youngest child. "They take it too far."

"Then they put a lot of pressure on us," says Richard, an unemployed dropout who failed to pass a general educational development test (GED). He wants to try it again before he enrolls in a job-training course.

Their oldest daughter is in foster care, because Joann was under "a lot of stress," says Richard. They visit her regularly. There is much warmth between the parents and the three youngest children. The couple, who live in a motel in Poughskeepsie, say they work hard to survive when things get tough.

"We just sit down and talk to one another," says Richard as four-year-old Shontay leans against his shoulder. "We do a lot of things with the family, try to get them to understand, let them know what is happening. We are both in this situation, not one."

Children are not the only homeless with heightened vulnerability and loneliness. Some of those most at risk, most cut off from possible help, are the chronically mentally ill who make up an estimated 35 to 50% of the homeless.

"The streets have become the mental asylums of the eighties," says Dr. Farr of the Los Angeles County Department of Mental Health.

In Griffith Park in Los Angeles, Judy lives in a camp in the wooded hills behind Hollywood. An almost elfin woman dressed in layers of clothes with a dog leash around her neck and a scarf over her head, she is initially hostile toward visitors, shaking the big stick she always carries.

But her eyes sparkle and she smiles as she shows her guests around her camp, arranged according to a "show script." Here, she says, is the "family circle," where "a mother and a six-
25

Geoffrey Beene
Book Title

Marylou Luther
Author

Jack Woody
Designer

Various
Photographers

**National Academy of
Design/Geoffrey Beene
New York, NY**
Publisher

Toppan Printing Co., Ltd.
Printer

Thomas Long
Production Manager

Toppan Printing Co., Ltd.
Binder

Jack Woody
Cover Designer

Jack Deutsch
Cover Photographer

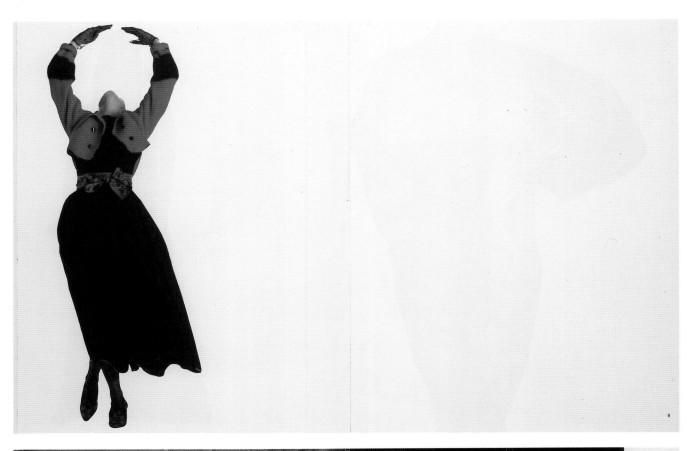

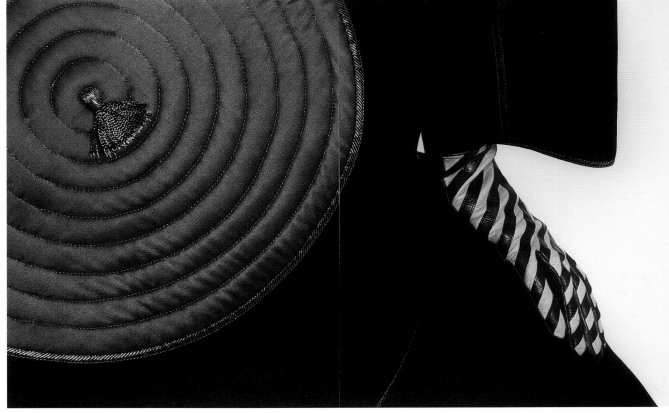

Issey Miyake: Photographs by Irving Penn
Book Title

Nicholas Callaway
Editor

Irving Penn and Kiyoshi Kanai
Art Directors

Kiyoshi Kanai
New York, NY
Designer

Irving Penn
Photographer

New York Graphic Society
Publisher

Michael Bixler
Typographer

Nissha Printing Co., Ltd.
Printer

Nicholas Callaway
Production Manager

186 gsm Mitsubishi Super Matte Art
Paper

Nissha Printing Co., Ltd.
Binder

Kiyoshi Kanai
Jacket Designer

Irving Penn
Jacket Photographer

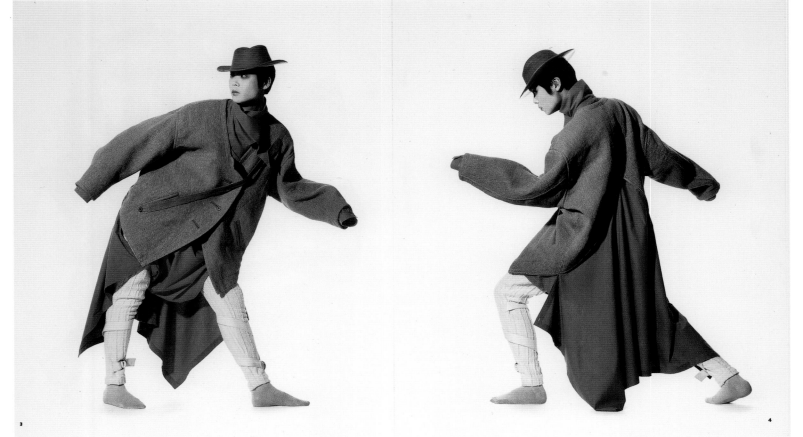

William James Bennett
Master of the Aquatint View
Book Title

Gloria Gilda Deak, Dale Roylance, Roberta Waddell, and Theresa Salazar
Authors

Donna Moll
Art Director/Designer

William James Bennett
Illustrator

The New York Public Library
New York, NY
Publisher

Meriden-Stinehour Press
Typographer

Meriden-Stinehour Press
Printer

Rene Arsenault
Production Manager

Mohawk Superfine
Paper

Meriden-Stinehour Press
Binder

with Bennett as one of eleven charter members. They soon called themselves the Associated Artists in Water-Colours. Rooms for presenting their work to the public were taken on Lower Brook Street. When the inaugural exhibition opened in April of the following year, membership had increased to eighteen, with another eighteen listed in the catalogue as exhibitors.[21] The familiar name of William Westall is there as a member, and there are two other names, listed as exhibitors, that have significance for our story. The first is that of Mary Gartside, an ambitious aesthetician who could already claim one major illustrated book to her credit and who had just employed Bennett to work on a second (see figs. 3, 4).[22] The other noteworthy name is that of Frederick Nash, a distinguished artist with a specialty in architecture who was to marry Bennett's sister.[23]

The Associated Artists' initial presentation was not the first public exhibit of paintings in which no oils were hung. That distinction belonged to The Society of Painters in Water-Colours, a pioneering group that held its first exhibition in 1805 with a presentation of 275 pictures.[24] It was enthusiastically received. During the seven weeks' duration of the show, nearly twelve thousand people paid admission; most of the watercolors were sold. The Society's aim in insisting on an exclusivity of watercolor drawings was directed toward underscoring the distinctions between oil and watercolor art, and providing the latter a more favorable ground for appreciation than when judged side by side with paintings in oil. It was well known that in the annual exhibitions of the Royal Academy at Somerset House, the best gallery in that building (there were several) was reserved solely for paintings in oil. Watercolors, generally kept small in size because of the accommodation and expense of glass, were hung in the subordinate galleries; still, they were usually outnumbered and were at an obvious disadvantage in the

view of the fairest of judges when opposed on the walls to "half an acre of canvass [sic], covered with the strongest tints, enriched with the most gaudy colors, and glazed with a varnish calculated to heighten the already too powerful effect."[25] It was with great expectations, then, that the Society opened its first show in galleries at 20 Brook Street to flaunt an art which sought its basic appeal in the use of transparent pigments. A pictorial record of one of their exhibitions (in galleries later leased on old Bond Street) is preserved for us in a lively aquatint conceived by Thomas Rowlandson and Augustus Pugin, and published in *The Microcosm of London*.[26] The Society was to undergo a change of name, and indeed of aims and of fortunes, but eventually, in 1881, it became the Royal Society of Painters in Water-Colours under the patronage of Queen Victoria.

The Bennett circle of watercolorists were careful in avowing at the outset that they entertained no hostility toward this pioneering Society. They simply felt that there was room for two organizations devoted to an art that was fast gaining an appeal, and said so in their catalogue: "The rapid advance which this class of art had made, its powers of reaching greater excellence, if judiciously employed, and the propriety of separating drawings and pictures in water-colours from the immediate contact of those produced with other materials, were probably the motives for forming that society; the same opinions, the same feelings led to the association of the artists, who now, for the first time as a distinct body, submit their works to public inspection."[27] Membership in the Associated Artists was not held to a limited number, as it was in the Society, and female members were given the right to vote on all occasions. This tribute to the capacity of women artists was, like the first innovation, a distinct advancement. The coexistence of the two bands of watercolorists was lauded by *The Microcosm of London*, which ex-

Fig. 4 [*Still life with dead birds and gun*]. 1808. Colored aquatint, after Mary Gartside. From *Ornamental Groups*. Arents Collections [checklist no. 1]

The Ark
Book Title

Arthur Geisert
Author

Susan Sherman
Art Director/Designer

Arthur Geisert
Illustrator

**Houghton Mifflin Co.
Boston, MA**
Publisher

**Litho Composition Inc. and
Morgan Woodtype**
Typographers

Murray Printing Co.
Printer

Donna Baxter
Production Manager

#80 Monadnock
Paper

Nicholstone Bindery
Binder

Susan Sherman
Jacket Designer

Arthur Geisert
Jacket Illustrator

X
Book Title

Frank Graziano
Author

Judy Anderson
Art Director/Designer

Judy Anderson
Illustrator

X Press
Seattle, WA
Publisher

Eagen Printing
Typographer

X Press
Printer

Speckletone, Strathmore, Canson
Papers

X Press
Binder

THE CASE OF MRS. X
(State Museum for the Irremediably Deranged)

The Doctors behind the mirror unwrapped their sandwiches and watched. It was a Tuesday like any other. Brown bags and fig newtons. The same mirror-mimed spider tangled in its legs, the same diaper white web of lights. Mrs. X gathered her absence, paced to her place beside the other patients, and sat. Her dim drugged eyes were painted gray from the inside, their suspicion, their viciousness, fogged. Bemuddled. The mirror knew that. Everyone said grace. Mrs. X picked up her spoon and dipped it into the alphabet soup. The movement rippled the image of her skin on the broth. Her face wobbled in the bowl. She understood the distortion. And there, on the spoon, in the chickenfat refracting the fluorescent light, there it was before her at last: an x draped over a pea.

Either everything means or nothing does. This was no accident. Good thing she looked before she ate. Mrs. X hunched over her bowl, concealing the x-ed pea with her enormous breasts, casting glances up and down the table, across the cafeteria, over the mirror that returned her gaze populated, othered, bound in a conspiracy of reflections. She shuddered. Time was running short. The Doctors were already moving through the mirror, one waving his sandwich to the others, their white smocks billowing like sails. It was now or never.

The Doctors, looking at the mirror, see Mrs. X.

Mrs. X closed her eyes and concentrated. She made herself small. She entered the macaroni x spread-eagle, face down, inflating the pea with her breath until it lifted like a balloon straddled by a corpse and she, Mrs. X, rose above the table, above the institutionalized heads with soup spoons sticking out of their mouths, out the window and over roofs with chimneys lisping thin soaps of smoke, over treetops and clouds and away out of orbit into unchartered space, Mrs. X and her pea, weightless and ecstatic, although it's possible medication could treat this.

A butterfly bandage on a
blinded eye.//A crippled
child rocking on a ball.//
A pair of crossed arms
defending a head.

A limp x, a collapsed pea,
a flabby, cancerous broth.

A tiny body riding the earth
through space.

The Heart Sutra
Book Title

Sang Yoon
Art Director/Designer

Sang Yoon
Illustrator

Sang Yoon
Harrisonburg, VA
Publisher

Sang Yoon
Typographer

Moonlight Express
Printer

Rice Paper
Paper

Sang Yoon
Binder

Sang Yoon
Jacket Designer

Here, Sariputra,
form
is emptiness,
emptiness
is form,
form
is not
other than
emptiness,
and
emptiness
is not
other than
form.
That which
is
form
equals
emptiness,
and
that which
is
emptiness
is
also form.
Precisely
the same
may be said
of form
and
the other
skandhas:
feeling,
perception,
impulse
and
consciousness.

The World at My Fingertips
Book Title

Donna Ratajczak
Author

Esther K. Smith
Art Director/Designer

Purgatory Pie Press
New York, NY
Publisher

Dikko Faust
Typographer

Dikko Faust
Printer

Georgia Luna
Production Manager

Text: Fabriano Rosapina
Pop-up: Kitikata
Cover and Endsheets:
Elephant Hide
Papers

Faust & Smith
Binders

Flowers
Book Title

Philip Gallo
Author

Michael Tarachow
Designer

Pentagram Press
Design Firm

Pentagram Press
Minneapolis, MN
Publisher

Michael Tarachow
Typographer

Pentagram Press
Printer

Text: Hosho
Endsheets: Fabriano Ingres
Wrapper: Papier a Inclusions
Florales
Papers

Pentagram Press
Binder

Optimum Flower Watching Time

In February where I live optimum flower watching
Time runs noon till two.
Anything works for a vase. Right now,
The cut-glass pitcher Susan gave me
The time I was painting a picture of daffodils,
And she brought over some daffodils.
The sun comes through the window,
And what I've learned to wait for
Is the sun spotlighting the flowers,
And making any petal different from the other.
Summer, the light changes and FWT comes earlier,
But I work nights, so I'm asleep.
And Fall—so many flowers in Summer,
Plus Fall the prettiest season here,
I don't think flowers again till Winter—
Till Winter reminds me how little I need:
Some flowers, some time,
And a place to stay.

In The Beginning
Book Title

Virginia Hamilton
Author

Joy Chu
Art Director

Barry Moser
Designer

Barry Moser
Illustrator

**Harcourt Brace Jovanovich
San Diego, CA**
Pulisher

Thompson Type
Typographer

Holyoke Lithograph
Printer

**Warren Wallerstein and
Ginger Boyer**
Production Managers

Mountie Matte
Paper

**Horowitz/Rae Book
Manufacturers, Inc.**
Binder

Camilla Filancia
Jacket Designer

Barry Moser
Jacket Illustrator

earth in the shell. And there was also a pigeon in there and a hen with five toes.

Great God did as he was told. He went down to the marsh land, sliding down the spider silks. Then he threw the earth out from the shell and spread it about him. He put the pigeon and the hen down on the bit of earth from the shell.

The pigeon and the hen began scratching and scratching the earth with their feet. It didn't take long for them to scratch the soil over the whole marsh-waste. That was how the firm, hard ground came to be.

Great God went back up to the sky. There he found Olorun waiting.

"It is done. I've formed the ground, and it is solid and true," Great God said.

Olorun sent down Chameleon to take a look at the work of Great God.

Now, Chameleon took his time about most things. He walked slowly, and he went down the spider line from the sky carefully. He rolled his big eyes around, looking at everything. And slowly he changed his color from sky blue to earth brown as he walked the land Great God had made.

"Well, the earth is plenty wide," Chameleon told Olorun when he had returned, "but it's not quite dry enough."

"Go again," Olorun commanded. And Chameleon went down from the sky a second time.

He came back to report once more to the Owner of the Sky.

Chameleon

The Mysterious Tale of Gentle Jack and Lord Bumblebee
Book Title

George Sand
Author

Atha Tehon
Art Director

Gennady Spirin and Amy Berniker
Designers

Gennady Spirin
Illustrator

Dial Books for Young Readers New York, NY
Publisher

Maxwell Photographics
Typographers

Publicaciones Fher, S.A.
Printer

Shari Lichtner
Production Manager

135 grs Edimat
Paper

Publicaciones Fher, S.A.
Binder

Gennady Spirin and Amy Berniker
Jacket Designer

Gennady Spirin
Jacket Illustrator

**From Dark to Light
Wood Engravings for The
Stone House Press**
Book Title

Joan and John Digby
Essayists

Morris A. Gelfand
Introduction

John De Pol
Author

Morris A. Gelfand
Designer

John De Pol
Illustrator

**The Stone House Press
Roslyn, NY**
Publisher

Out of Sorts Letter Foundry
Typographers

Morris A. Gelfand
Printer

Morris A. Gelfand
Production Manager

Mohawk Letterpress
Paper

**Alphia-Pavia Bookbinding Co.,
Inc.**
Binder

John De Pol
Cover Paper Designer

10. Walnut. *Heartwood*, 1983 (see also Broadside 6, fig. 47a)

Ridge, New Jersey has, indeed, the air of an English country house. He and his wife, Thelma, have lived there for over thirty years, acquiring as part of their mutual interest a collection of antiques, mostly English, including an array of fine wooden tea caddies, many pairs of candlesticks and candelabras, three original wood blocks engraved by Thomas Bewick, dark, stamped with age, and hard as bone. A great diversity of ornate clocks tick quietly to themselves in the settled quietness of the living room. On the walls are antique prints, several by Thomas Rowlandson and a letter handwritten by George Cruikshank, whose wry humor finds a sympathetic spirit in John De Pol. Among the books is a collected William Wordsworth and numerous volumes devoted to England. Every now & then an eighteenth century grand-

**The Riveside Anthology
of Literature**
Book Title

Douglas Hunt
Author

**Anthony L. Saizon and
Mary Mars**
Art Directors

Anthony L. Saizon
Designer (Cover and Text)

Michael McCurdy
Illustrator

**Houghton Mifflin Co.
Boston, MA**
Publisher

**New England
Typographic Services (Text)
Composing Room of
New England (Cover)**
Typographers

**R. R. Donnelley &
Sons Co. (Text)
Lehigh Press
Lithographers (Cover)**
Printers

**Martha Drury and Priscilla
Bailey**
Production Managers

Port Huron #28 Featherweight
Paper

R. R. Donnelley & Sons Co.
Binder

To Challenge Our Assumptions About Life:
The Art of Fiction

The fifty stories in the following pages are collected under the name of fiction, but having a name in common does not mean that they are alike in every important respect. The horse, the whale, and the bat are all called mammals, but that fact does not make us declare the whale a disappointment because it does not run like a horse or fly like a bat. Yet we very often fail to take a story on its own terms. If we have learned that great fiction must be realistic, we may dismiss Nathaniel Hawthorne's story "Rappaccini's Daughter," with its poison gardens and impossible characters, as a "mere fairy tale." If we conclude too hastily that stories should be filled with beauty and romance, we may read Guy de Maupassant's "The String" and wonder why we should care about its realistic details: the men who walk with their left shoulders raised and their torsos twisted from the pull of the horse-drawn plough, their blue smocks "starched, shining as if varnished." Yet both stories are extraordinary, and it is a pity that we should blind ourselves to the virtues of either one.

The principle that draws these fifty stories together is, frankly, diversity. They represent a wide range of literary techniques, themes, and periods. But beneath the diversity are some common characteristics. All the stories create a separate world that stands beside this everyday one and becomes a commentary on it. All

challenge our complacent and sometimes unexamined assumptions about life. Perhaps most significantly, all explore a region opened up by the oldest recorded stories, the region of our deep hopes and fears.

THE EXPRESSION OF DEEP HOPES AND FEARS: THE STORY AND THE TALE

Biography, psychology, and history attempt to explain our lives by referring to objective reality. They are built on the solid rock of what we now call "the data." Traditional tales, myths, and fables are built on another rock: the psyche—the wishes, hopes, and fears of humankind, which have remained remarkably constant over the centuries. In fact, the story, like the dream, can be a machine that allows these wishes, hopes, and fears to take on a form and substance. In the ancient fable, King Midas wishes to have unlimited wealth, wishes that everything he touches would turn to gold. Everything he touches does—branch, stone, sod, apple, bread, wine—and he is therefore doomed to starve unless the gods release him from his greedy wish. In one version he reaches out to touch his daughter and is horrified when she turns into a gold statue. The story has the logic of a dream or nightmare. So, too, does the story of Cinderella. Cinderella experiences the things we have

Six Crows
Book Title

Leo Lionni
Author

Denise Cronin
Art Director

Elizabeth Hardie
Designer

Leo Lionni
Illustrator

**Alfred A. Knopf Books for
Young Readers
New York, NY**
Publisher

Centennial Graphics, Inc.
Typographer

National Litho Co.
Printer

Norann Hohe
Production Manager

#80 Sterling Litho Satin
Paper

Bookbinders Inc.
Binder

**Leo Lionni and
Elizabeth Hardie**
Jacket Designer

Leo Lionni
Jacket Illustrator

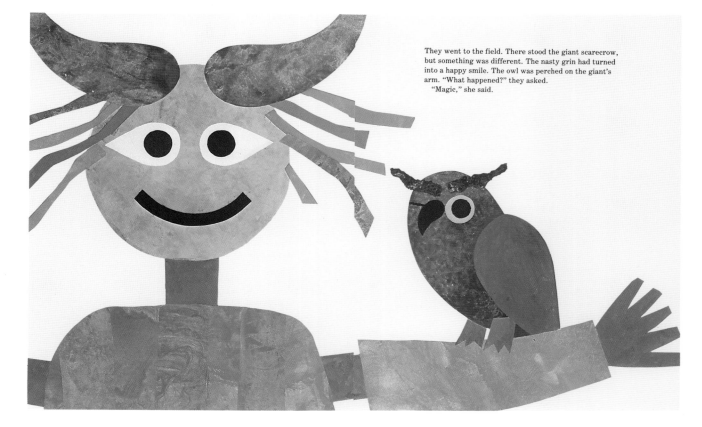

They went to the field. There stood the giant scarecrow, but something was different. The nasty grin had turned into a happy smile. The owl was perched on the giant's arm. "What happened?" they asked.

"Magic," she said.

The Porcupine Mouse
Book Title

Bonnie Pryor
Author

Ellen Friedman
Art Director

**Ellen Friedman and
Maryjane Begin**
Designers

Maryjane Begin
Illustrator

**Morrow Junior Books
New York, NY**
Publisher

Expertype
Typographer

General Offset Co. Inc.
Printer

Esilda Martinez
Production Supervisor

#80 Sterling Litho Satin
Paper

Bookbinders, Inc.
Binder

Ellen Friedman
Jacket Designer

Maryjane Begin
Jacket Illustrator

All American Photoletteing
Jacket Letterer

Mama Mouse's house was very crowded. She couldn't even sweep the floor without tripping over one of her mouse children. There were children on the chairs. There were children behind the chairs. There were children on the beds and under the beds. Children were in the bathtub, and more were in the kitchen sink. One day, there was even a child hanging from the chandelier.

**Album/The Portraits of
Duane Michals**
Book Title

Duane Michals
Author

Jack Woody
Designer

Duane Michals
Photographer

**Twelvetrees Press
Pasadena, CA**
Publisher

Duane Michals
Calligrapher

Toppan Printing Co., Ltd.
Printer

Thomas Long
Production Manager

Jack Woody
Jacket Designer

Darryl Patterson
Jacket Photographer

Self portrait shaking hands with my father

Self portrait, as a death mask

As I age, while I still have time,
my true self, that random and illusive
ourselves to be this kaliedescope of passions
unknown moment, suspended between ~~one~~
uncertainties, and doomed to fade with
mystery be photographed? What is left

I yearn to know now, more than ever,
thing, decorated with personality. We believe
and distractions. We are a brilliant and
memory and anticipation, anxious in our
our consciousness. How can such a
for us but amazement?

Duane Michals

Herb Ritts/Pictures
Book Title

Jack Woody
Designer

Herb Ritts
Photographer

Twin Palms, Publishers
Altadena, CA
Publisher

Toppan Printing Co., Ltd.
Printer

Thomas Long
Production Manager

Toppan Printing Co., Ltd.
Binder

Jack Woody
Jacket Designer

Herb Ritts
Jacket Photographer

A River Dream
Book Title

Allen Say
Author

Susan Sherman and Allen Say
Art Directors

Susan Sherman
Designer

Allen Say
Illustrator

**Houghton Mifflin Co.
Boston, MA**
Publisher

Litho Composition Inc.
Typographer

**Horowitz/Rae Book
Manufacturers, Inc.**
Printer

Donna Baxter
Production Manager

#80 Command Matte
Paper

**Horowitz/Rae Book
Manufacturers, Inc.**
Binder

Susan Sherman
Jacket Designer

Allen Say
Jacket Illustrator

Mark said good night to his uncle and climbed into his room through the window. A short while later, when his parents opened the door, Mark pretended to be fast asleep.

"Leave it to my brother," Mother whispered. "Sending fishing lures to a sick child. Why, they're all over the bed. He could have hurt himself!"

"Look," said his father. "His temperature seems almost normal."

"Thank goodness," said his mother.

And Mark fell asleep.

30

The Baker's Dozen
Book Title

Heather Forest
Author

Joy Chu
Art Director

Camilla Filancia
Designer

Susan Gaber
Illustrator

**Gulliver Books/
Harcourt Brace Jovanovich
San Diego, CA**
Publisher

Thompson Type
Typographer

Tien Wah Press
Printer

**Warren Wallerstein and
Eileen McGlone**
Production Managers

130 gsm Matt Art
Text Paper

120 gsm Artpaper
Jacket paper

Tien Wah Press
Binder

Camilla Filancia
Jacket Designer

Susan Gaber
Jacket Illustrator

The next morning when Van Amsterdam took his loaves from the oven, he was shocked to discover that his bread tasted salty. His pies were sour. His cookies were so hard they couldn't be bitten. Everything he made turned out wrong. "I don't understand," he said. "Has it been so long since I used a proper measure that I have forgotten my recipes? Well, perhaps tomorrow will be better."

Perennials: A Fiftieth Anniversary Selection from the Berg Collection
Book Title

Lola L. Szladits
Author

Donna Moll
Art Director/Designer

Various
Illustrators

The New York Public Library
New York, NY
Publisher

Meriden-Stinehour Press
Typographer

Meriden-Stinehour Press
Printer

Rene Arsenault
Production Manager

Mohawk Superfine
Paper

Meriden-Stinehour Press
Binder

PERENNIALS | *1701 – 1800*

THE EIGHTEENTH CENTURY is represented in the Berg Collection by fine copies of the major authors, and a voluminous archive of the Burney family. Approximately 2,500 manuscripts and autograph letters, including a large portion of the original manuscript of Fanny Burney's *Evelina* (1778), are at the heart of the Burney Papers. In its associations, a copy of Charles Burney's *A General History of Music* (1776–89), once the property of Samuel Johnson and with his autograph inscription, might look like a family blessing. The Kilmarnock edition of Robert Burns's *Poems* (1786) was a small one, of which existing copies are very rare. It keeps company in the Berg Collection with a manuscript of "O my Love's like the red, red rose," copied by Burns in a 1794 letter to Alexander Cunningham. Defoe, Swift, Addison, Fielding, Smollett, and Sterne are all represented in fine editions and copies. Alexander Pope is on our shelves in volumes that look as if they had rolled off the presses only yesterday. Among our unique Blake titles, the most beautiful copy of *Europe—a Prophecy* (1794) is one of the Collection's great treasures.

32

33

Off Season
Book Title

Joseph E. Brown
Author

Joy Chu
Art Director

Don McQuiston
Designer

McQuiston & Daughter
Design Firm

Various
Photographers

**Harcourt Brace Jovanovich
San Diego, CA**
Publisher

Thompson Type
Typographer

Tien Wah Press
Printer

**Warren Wallerstein and
Eileen McGlone**
Production Managers

130 gsm Artpaper
Text Paper

240 gsm C-I-S Artboard
Cover Paper

Tien Wah Press
Binder

Don McQuiston
Jacket Designer

William Neill
Jacket Photographer

Ophelia's English Adventure
Book Title

Michele Durkson Clise
Author

Tim Girvin, Tim Girvin Design, Inc. and Gael Towey, Clarkson N. Potter, Inc.
Art Directors

Stephen Pannone, Tim Girvin Design, Inc.
Seattle, WA
Designer

Michele Durkson Clise
Photo Art Direction

Tim Girvin
Illustrator/Calligrapher

Marsha Burns
Photographer

Clarkson N. Potter, Inc.
Publisher

Dai Nippon Printing Co., Ltd.
Printer

Stephen Pannone
Jacket Designer

Marsha Burns
Jacket Photographer

Tim Girvin
Calligrapher

Anemone on stage

of the town. Anyone from the movies or theater," explained Ricky.

"But what have they got to do with saving Bruinyes House?"

"Not a lot. But that's television."

"Well, I want nothing to do with it." And Zenobia stomped off to find something to sell.

Two hours later, Ricky Jaune got fifteen seconds on international television, just long enough to smile and tell the world that he was learning to play the accordion. Ophelia got on for twenty-five seconds and told everyone to shop at Bruinyes House if they couldn't come to Bazaar des Bears. Conrad, Clarence, Zenobia, and M. Ritz never got on at all. But somehow they survived.

The treasure hunt began in the early afternoon and lasted almost three hours. In the end the *B* was found by a ninety-five-year-old retired farmer by the name of Herbert Nottingham (yes, distantly related to the sheriff who made so much trouble for Robin Hood). While everyone else climbed trees and poked into bushes and behind armoires, Herbert scraped with his boot at a large pile of broken paving stones. Needless to say the treasure wasn't there, but when Herbert finally finished and realized he had been wrong, he threw his hat so hard against one of the scaffolds holding up a booth that the whole thing came down. The *B* had been hidden on top of one of the poles. It fell right into his hands and for the first time in twenty-nine years he smiled. But just as Dr. Churchill was about to present the prize there was a great commotion.

"Come quickly," cried Edwina, bursting in. "Someone has just gone out of turn at croquet!"

"Is that a crime?" inquired Clarence.

"Take away their ball," suggested Conrad. "Or better yet, their mallet."

"Rap their knuckles," added Aunt Vita.

"That's just it," exclaimed Edwina, pointing excitedly. "They don't have any."

"Mallets?" asked Conrad.

"Knuckles," said Edwina, "or hands, arms, legs, head."

"Then how can they play croquet?" said Ophelia.

"Nobody knows, but however they do it, they're winning," explained Edwina. "Though not necessarily by the rules."

"It must be the ghost," said Ophelia, vindicated at last.

The bears hurried off to see. Sure enough, in the middle of a somewhat desolate croquet court a ball was being hit by a mallet with no discernible source of propulsion.

"I don't know how it can do that," said Dr. Churchill, "and expect to win."

CROQUET SOCIETY RULES BOOK

World of Wonders
Book Title

**Starr Ockenga and
Eileen Doolittle**
Authors

**Starr Ockenga and
Floyd Yearout**
Art Directors

Susan Marsh
Designer

Eileen Doolittle
Illustrator

Starr Ockenga
Photographer

**A Floyd Yearout Book
Houghton Mifflin Co.
Boston, MA**
Publisher

Monotype Composition Co.
Typographer

Mazzucchelli
Printer

Floyd Yearout
Production Manager

Gardamatt Brillante
Paper

Ollivoto Co.
Binder

Susan Marsh
Jacket Designer

Starr Ockenga
Jacket Photographer

Eileen Doolittle
Jacket Illustrator

3 Three wishes bring a three-ring circus,

With ghosts and goats and bears on chairs. 3

Thoughts While Tending Sheep
Book Title

W.G. Ilefeldt
Author

James K. Davis
Art Director

June Marie Bennett
Designer

Lars Hokanson
Illustrator

Crown Publishers, Inc.
New York, NY
Publisher

Westchester Book
Composition, Inc. and
Arnold & Debel, Inc.
Typographers

Phoenix Color Corp.
Jacket Printer

Fairfield Graphics
Text Printer

Robert Collett
Production Manager

#70 Offset
Paper

Fairfield Graphics
Binder

June Marie Bennett
Jacket Designer

Lars Hokanson
Jacket Illustrator

MY DEBUT

The things we remember from early childhood are often remembered only because we have heard them from some adult who was there at the time and tells us about it. I do not consider that remembering. Photographs do the same thing. For instance, there is a snapshot in an old album of me seated inside an open valise holding a little white dog in my arms. The valise was about the size of the leather bag doctors used to carry with them when they made house calls, which gives an idea of how long ago that was and how small I was at the time.

I mention the snapshot only because I do not remember the dog or who took the picture. It was probably my father. He was always doing funny things, so I am told. I have to rely on the word of others because he was not around long enough for me to remember him.

Mother once told me about a concert he was giving somewhere in Texas. It was probably Dallas or Fort Worth. She was in the audience while I was left in the care of a black woman, a kind of live-in baby-sitter who also accompanied us when we traveled. I do not remember her name for I was only two and a half at the time and there is no one left to tell me.

Thinking I was safely asleep in my father's dressing room, my baby-sitter left me to go to the wings to hear him sing. Somehow, I managed to slip by her, right out onto the stage, and stood next to him while he was in the middle of a song. You can imagine the audience's response, to say nothing of the distress my mother must have felt. I just stood there beside him and, as though it were the most natural thing to do, he reached down and held my hand until the song was over, then led me offstage and back into the care of a very stricken and self-chastised baby-sitter.

My father returned for the applause, which was probably greater than it would have been had I not appeared and had he not carried it off so well.

16 ◆

◆ 17

Remembering Rory
Book Title

Steven M. L. Aronson
Editor

Karen Salsgiver
Art Director/Designer

**Karen Salsgiver Design
New York, NY**
Design Firm

Various
Photographers

Hon. Anne Cox Chambers
Publisher

Michael & Winifred Bixler
Typographer

**Lebanon Valley Offset, Inc.
(Duotones)
Michael and Winifred Bixler
(Text)**
Printers

Karen Salsgiver
Production Manager

Mohawk Superfine
Paper

**Mueller Trade Bindery
(Sheets)
Harcourt Bindery (Slipcase
and ¼ leather handmade
binding)**
Binders

Karen Salsgiver
Cover and Slipcase Designer

Kenneth Jay Lane

Rory was a part of my education—and an important part. One couldn't spend any time with him without beginning to see things through his eyes. He invented, I think, aesthetic order! He must have had a Japanese ancestor somewhere way back.

Billy Baldwin always referred to the "taste trust," and Rory Cameron was a charter member.

Rikki-Tikki-Tavi
Book Title

Rudyard Kipling
Author

Rita Marshall
Art Director/Designer

Delessert/Marshall
Design Firm

Monique Felix
Illustrator

Creative Education Inc.
Mankato, MN
Publisher

Dix Type, Inc.
Typographer

Worzalla Publishing Co.
Printer

#80 Patina Matte
Paper

Worzalla Publishing Co.
Binder

Rita Marshall
Jacket Designer

Monique Felix
Jacket Illustrator

"H'sh! Nag is everywhere, Rikki-tikki. You should have talked to Chua in the garden."

"I didn't—so you must tell me. Quick, Chuchundra; or I'll bite you!"

Chuchundra sat down and cried till the tears rolled off his whiskers. "I am a very poor man," he sobbed. "I never had spirit enough to run out into the middle of the room. H'sh! I mustn't tell you anything. Can't you *hear*, Rikki-tikki?"

Rikki-tikki listened. The house was as still as still, but he thought he could just catch the faintest *"scratch-scratch"* in the world—a noise as faint as that of a wasp walking on a windowpane—the dry scratch of a snake's scales on brickwork.

"That's Nag or Nagaina," he said to himself; "and he is crawling into the bathroom sluice. You're right, Chuchundra; I should have talked to Chua."

He stole off to Teddy's bathroom, but there was nothing there, and then to Teddy's mother's bathroom. At the bottom of the smooth plaster wall there was a brick pulled out to make a sluice for the bath water, and as Rikki-tikki stole in by the masonry curb where the bath is put, he heard Nag and Nagaina whispering together outside in the moonlight.

"When the house is emptied of people," said Nagaina to her husband, "*he* will have to go away, and then the garden will be our own again. Go in quietly, and remember that the big man who killed Karait is the first one to bite. Then come out and tell me, and

Two Bad Ants
Book Title

Chris Van Allsburg
Author

**Susan Sherman and
Chris Van Allsburg**
Art Directors

Susan Sherman
Designer

Chris Van Allsburg
Illustrator

**Houghton Mifflin Co.
Boston, MA**
Publisher

**Composing Room of New
England**
Typographer

Acme Printing Co.
Printer

Donna Baxter
Production Manager

Paloma Matte
Paper

**Horowitz/Rae Book
Manufacturers, Inc.**
Binder

Susan Sherman
Jacket Designer

Chris Van Allsburg
Jacket Illustrator

It was late in the day when they departed. Long shadows stretched over the entrance to the ant kingdom. One by one the insects climbed out, following the scout, who had made it clear—there were many crystals where the first had been found, but the journey was long and dangerous.

6

They marched into the woods that surrounded their underground home. Dusk turned to twilight, twilight to night. The path they followed twisted and turned, every bend leading them deeper into the dark forest.

7

Globe High School Mathematics
Book Title

Debra R. Clithero, Ricardo Flores, Albert F. Kempf, Leo Gafney, and Michael J. O'Neill
Authors

Steven Curtis
Art Director

Steven Curtis and Georgine Knoll George
Designers

Various
Illustrators

John Payne (Cover), Charles Shotwell, and Ralph Brunke
Photographers

Globe Book Company
Publisher

**Ligature, Inc.
Chicago, IL**
Design Firm

Interactive Composition Corp.
Typographer

Von Hoffman Press, Inc.
Printer

Diane Grigg
Production Manager

#50 Mead Pub Matte
Paper

Von Hoffman Press, Inc.
Binder

The Way Things Work
Book Title

David Macaulay
Author

**David Macaulay and
Peter Luff**
Art Directors/Designers

David Macaulay
Illustrator

**Houghton Mifflin Co.
Boston, MA**
Publisher

Artes Graficas
Printer

Jeanette Graham
Production Manager

Artes Graficas
Binder

**David Macaulay and
Peter Luff**
Jacket Designers

David Macaulay
Jacket Illustrator

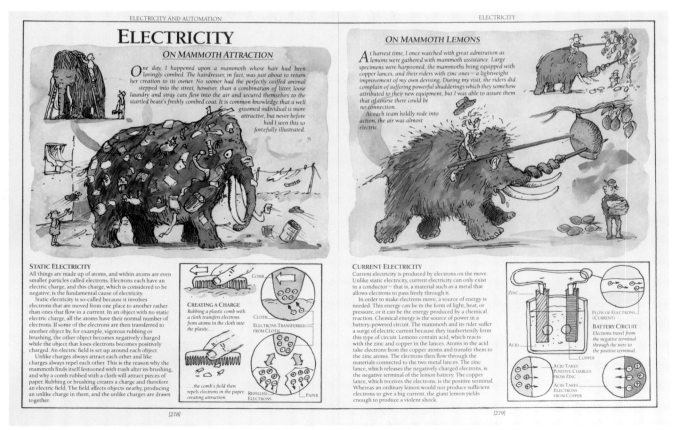

ELECTRICITY

ON MAMMOTH ATTRACTION

One day, I happened upon a mammoth whose hair had been lovingly combed. The hairdresser, in fact, was just about to return her creation to its owner. No sooner had the perfectly coiffed animal stepped into the street, however, than a combination of litter, loose laundry and stray cats flew into the air and secured themselves to the startled beast's freshly combed coat. It is common knowledge that a well groomed individual is more attractive, but never before had I seen this so forcefully illustrated.

STATIC ELECTRICITY

All things are made up of atoms, and within atoms are even smaller particles called electrons. Electrons each have an electric charge, and this charge, which is considered to be negative, is the fundamental cause of electricity.

Static electricity is so-called because it involves electrons that are moved from one place to another rather than ones that flow in a current. In an object with no static electric charge, all the atoms have their normal number of electrons. If some of the electrons are then transferred to another object by, for example, vigorous rubbing or brushing, the other object becomes negatively charged while the object that loses electrons becomes positively charged. An electric field is set up around each object.

Unlike charges always attract each other and like charges always repel each other. This is the reason why the mammoth finds itself festooned with trash after its brushing, and why a comb rubbed with a cloth will attract pieces of paper. Rubbing or brushing creates a charge and therefore an electric field. The field affects objects nearby, producing an unlike charge in them, and the unlike charges are drawn together.

CREATING A CHARGE
Rubbing a plastic comb with a cloth transfers electrons from atoms in the cloth into the plastic...

...the comb's field then repels electrons in the paper, creating attraction.

COMB

CLOTH

ELECTRONS TRANSFERRED FROM CLOTH

REPELLED ELECTRONS

PAPER

[278]

ON MAMMOTH LEMONS

At harvest time, I once watched with great admiration as lemons were gathered with mammoth assistance. Large specimens were harpooned, the mammoths being equipped with copper lances, and their riders with zinc ones — a lightweight improvement of my own devising. During my visit, the riders did complain of suffering powerful shudderings which they somehow attributed to their new equipment, but I was able to assure them that of course there could be no connection.

As each team boldly rode into action, the air was almost electric.

CURRENT ELECTRICITY

Current electricity is produced by electrons on the move. Unlike static electricity, current electricity can only exist in a conductor — that is, a material such as a metal that allows electrons to pass freely through it.

In order to make electrons move, a source of energy is needed. This energy can be in the form of light, heat, or pressure, or it can be the energy produced by a chemical reaction. Chemical energy is the source of power in a battery-powered circuit. The mammoth and its rider suffer a surge of electric current because they inadvertently form this type of circuit. Lemons contain acid, which reacts with the zinc and copper in the lances. Atoms in the acid take electrons from the copper atoms and transfer them to the zinc atoms. The electrons then flow through the materials connected to the two metal lances. The zinc lance, which releases the negatively charged electrons, is the negative terminal of the lemon battery. The copper lance, which receives the electrons, is the positive terminal. Whereas an ordinary lemon would not produce sufficient electrons to give a big current, the giant lemon yields enough to produce a violent shock.

ZINC

ACID

+

COPPER

FLOW OF ELECTRONS (CURRENT)

BATTERY CIRCUIT
Electrons travel from the negative terminal through the wire to the positive terminal.

ACID TAKES POSITIVE CHARGES FROM ZINC

ACID TAKES ELECTRONS FROM COPPER

[279]

Hey Willy, See the Pyramids
Book Title

Maira Kalman
Author

Tibor Kalman, Maira Kalman, and Emily Oberman
Designers

Maira Kalman
Illustrator

Viking Kestrel
New York, NY
Publisher

Trufont Typographers
Typographer

South China Printing
Printer

Elizabeth Walker
Production Manager

Maira Kalman and Tibor Kalman
Jacket Designers

Maira Kalman
Jacket Illustrator

Maira Kalman
Jacket Letterer

green face

My cousin Ervin
has a green face
and orange hair.
He is a scientist
and he told me about germs
and about something
that is called nothing.
His mother has very small ears
but she hears everything.

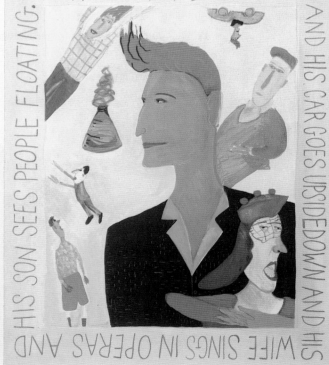

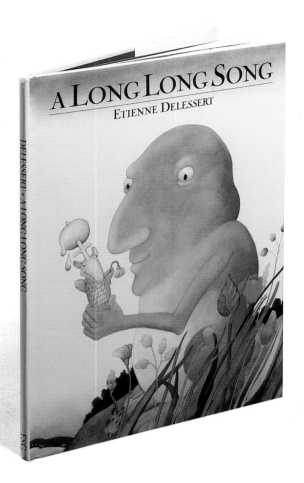

A Long Long Song
Book Title

Etienne Delessert
Author

Etienne Delessert
Art Director

Rita Marshall
Designer

Etienne Delessert
Illustrator

Michael Di Capua Books and Farrar, Straus & Giroux New York, NY
Publisher

Affolter and Typogram
Typographers

Horowitz/Rae Book Manufacturers, Inc.
Printer

Tom Consiglio
Production Manager

#80 Moistrite Matte
Paper

Horowitz/Rae Book Manufacturers, Inc.
Binder

Rita Marshall
Jacket Designer

Etienne Delessert
Jacket Illustrator

Dictionary of the Khazars
Book Title

Milorad Pavic
Author

Virginia Tan
Art Director

Iris Weinstein
Designer

Alfred A. Knopf, Inc.
New York, NY
Publisher

Dix Type, Inc.
Typographer

R. R. Donnelley & Sons
Printer

Andrew Hughes
Production Manager

#60 Finch opaque natural
vellum
Paper

R. R. Donnelley & Sons
Binder

Paris, New York: 1982-1984
Book Title

Kazimierz Brandys
Author

Bernie Klein
Art Director

J.K. Lambert
Designer

**Random House, Inc.
New York, NY**
Publisher

Penn Set, Inc.
Typographer

**Arcata Graphics/Fairfield
Graphics**
Printer

Linda Kaye
Production Manager

#55 Sebago Antique Cream
Paper

July 1982

Sand
Book Title

Raymond Siever
Author

Lisa Douglis
Art Director

Tom Cardamone, Vantage Art
Illustrator

Various
Photographers

**W.H. Freeman & Co. and
Scientific American Library
New York, NY**
Publishers

York Graphic Services
Typographer

Kingsport Press
Printer

Julia De Rosa
Production Manager

#60 Patina Matte
Paper

Kingsport Press
Binder

Tui de Roy
Jacket Photographer

Comparison of the Wellfleet vicinity on Cape Cod in 1887 (right) with today (opposite). Large coastal areas around Wellfleet Bay have been filled in by sand, silt, and mud brought in by longshore and tidal currents in the last 100 years. In the same period the eastern ocean shoreline has retreated about 0.1 km.

Beyond Tradition
Book Title

Lois Essary Jacka
Author

David Jenney
Art Director/Designer

Jerry Jacka
Photographer

**Northland Publishing Co., Inc.
Flagstaff, AZ**
Publisher

Arizona Typographers
Typographer

Dai Nippon Printing Co., Ltd.
Printer

Anne Baird
Production Manager

Dai Nippon Printing Co., Ltd.
Binder

David B. Jenney
Jacket Designer

Jerry Jacka
Jacket Photographer

OPPOSITE: Born of Hopi ceremonies and carved according to tradition from the root of the cottonwood tree, these stylistic sculptures surpass the realm of kachina dolls and enter a new arena of aesthetic spirituality. This pair was carved by John Fredericks and are representations of Crow Mother, Angwusnasomtaka (left) and Hototo (right), both 22½" tall.

5 Dreams and Visions

As those first American Indians forged a pathway into the unknown with their primitive art, they left a faint trail that others would follow. Today, as life and legends are given new eloquence through contemporary art, Native Americans gaze back down that pathway, clearly envisioning the ancient ones. Linked to the past by their heritage and ancient rituals, many artists say they feel the presence of their ancestors, and believe they are guided and directed through dreams and visions.

"Oh, yes, I do believe that," asserts Joseph Lonewolf. "I believe that the old ones are my guides and mentors still, showing me in my dreams and visions how to use the old Mimbres designs in new ways, just as they direct my hands and heart when I work those envisioned symbols into my pots."

"Dreams" was the reply from artist after artist when asked about their inspiration. Jesse Monongye was taught to make jewelry by his father, Preston, who was noted for his distinctive style of tufa-cast jewelry and was one of the first to use gold. However, Jesse admits that he was "slightly bored and only 'playing' at silver work" until his mother appeared in a dream. From her graveside she spoke to him, saying he would be "a famous Indian" if he would take the files and jewelry tools she offered. From that time on, Jesse pursued his work in earnest.

"I do what I do because I'm an architect, an artist, a Hopi...and a dreamer," remarked the successful Dennis Numkena. His dreams have led him far—from a small Hopi village in northern Arizona to international recognition of his art and architecture. Dreams will lead still further, for they enable the artist to both capture the past and envision the future. Sculp-

169

Robes of Elegance: Japanese Kimonos of the 16th–20th Centuries
Book Title

Ishimura Hayao and Maruyama Nobuhiko
Authors

Lida Lowrey
Art Director/Designer

North Carolina Museum of Art Design Department
Designer

National Museum of Japanese History, Sakura; National Museum of Modern Art, Tokyo
Photography

North Carolina Museum of Art Raleigh, NC
Publisher

Marathon Typography Service, Inc.
Typographer

Dai Nippon Printing Co., Ltd.
Printer

L.K.Color-220 kg (Cover) Satin Kinfuji Dull #89 (Text) Extra Black, NT Rasha-A/2 Mini Book, 150 kg (Endsheets)
Papers

Parallels & Contrasts
Book Title

Stephen White, John Bullard, Mus White, Nancy Barrett, Arthur Ollman, Helmut Gernsheim, and Ben Maddow
Authors

Dennis Reed
Art Director/Designer

Robert Schlosser
Photographer

Stephen White Editions and New Orleans Museum of Art New Orleans, LA
Publishers

R. S. Typesetting
Typographer

InterPacific
Printer

Quintessence Gloss 100# (Text)
Karma Natural (Cover)
Papers

InterPacific
Binder

48 Unidentified
Untitled (children
playing in the water)
1895

41 Eugene Hutchinson
Untitled (triptych of
mills and workers at
the Colorado Fuel &
Iron Co.)
1929

68

69

Paravent
Book Title

Anne MacDonald Walker
Author

Michael Mabry
Designer

Michael Mabry Design
Design Firm

Various
Artists

Artspace/Ann Walker
San Francisco, CA
Publisher

On-Line Typography
Typographer

James H. Barry
Printer

Margie Chu
Production Manager

Michael Mabry
Jacket Designer

DAVID BATES

BORN IN DALLAS,
TEXAS, 1952
LIVES IN DALLAS, TEXAS

"CLOVIS," 1986
ACRYLIC ON WOOD
3 PANELS:
EACH PANEL 86" x 26"

On Flowers
Book Title

Kathryn Kleinman and Sara Slavin
Authors

Kathryn Kleinman, Sara Slavin, and Michael Mabry
Art Directors

Michael Mabry
Designer

Michael Mabry
Design Firm

Kathryn Kleinman
Photographer

Chronicle Books San Francisco, CA
Publisher

On-Line Typography
Typographer

Toppan Printing Co., Ltd.
Printer

Piper Murakami
Production Manager

Michael Mabry
Jacket Designer

The Line of Beauty

Flower lovers are inveterate fact gatherers: Dissolve a little Epsom salts in the water (1 tsp. salts to 1 quart water) when you bring your watering can around the geraniums, and they will bloom prolifically. Or force a rosebud open early by choosing buds that feel a bit soft to the touch, then blow hard into the top of the bud. Or bury nails in the ground around your blue hydrangeas, and their color will deepen. ¶ Sound principles of botany are involved in most of these old wives' tales. Even flower arranging includes principles of aesthetics, made to be followed, and broken. Some flower arrangers employ what is called the Hogarth Curve. William Hogarth (1697–1764), an English painter and engraver, saw beauty in curves rather than geometric shapes. In 1745, he painted a self-portrait posed beside his dog, Trump. The painting hangs in the Tate Gallery in London, and if you visit it, you'll see a palette in the painting, inscribed with a lazy, serpentine line and the words, "line of beauty." ¶ Later, in his *Analysis of Beauty*, Hogarth explained that he considered this curve the most perfect figure humans could devise. In classic flower arrangements it has become a guideline for creating pleasing shapes. ¶ A love for variations frees you to consider the curve and then abandon it, or to create your own curve simply by gathering flowers in every tone of pink, purple, and cream and tying them up with ribbon.

RUSSELL PAGE

The Education of a Gardener by Russell Page, first published in 1962, remains a classic text filled with useful information. It is, like the author himself, lively and respectful both of the landscape and of amateur gardeners. Page's study of English, French, Italian, and Japanese gardening traditions resulted in an extraordinary and individual sense of color, design, and style. "I never saw a garden from which I did not learn something," he wrote.

77

Understanding Biology
Book Title

**Peter H. Raven and
George B. Johnson**
Authors

Kay M. Kramer
Art Director

Susan E. Lane
Design Coordinator

William C. Ober
Illustrator & Illustration
Coordinator

**Times Mirror/Mosby College
Publishing
St. Louis, MO**
Publisher

The Clarinda Co.
Typographer

Von Hoffman Press, Inc.
Printer

Jerry A. Wood
Production Manager

#50 Warren's Somerset
Paper

Von Hoffman Press, Inc.
Binder

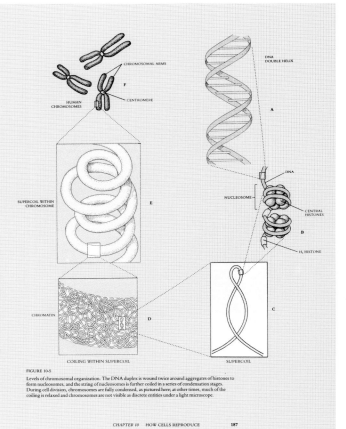

The growth of a bacterial cell to an appropriate size induces the onset of cell division. First, new plasma membrane and cell wall materials are laid down in the zone between the attachment sites of the two "daughter" DNA genomes. This begins the process of binary fission. **Binary fission** is the division of a cell into two equal or nearly equal halves. As new material is added in the zone between the attachment sites, the growing plasma membrane pushes inward (invaginates), and the cell is progressively constricted in two (Figure 10-3). Initiating the constriction at a position between the membrane attachment sites of the two daughter DNA genomes provides a simple and effective mechanism for ensuring that each of the two new cells will contain one of the two identical genomes. Eventually the invaginating circle of membrane reaches all the way into the cell center, pinching the cell in two. A new cell wall forms around the new membrane, and what was originally one cell is now two.

Bacteria divide by binary fission, a process in which a cell pinches in two. The point where the constriction begins is located between where the two replicas of the chromosome are bound to the cell membrane, ensuring that one copy will end up in each daughter cell.

CELL DIVISION AMONG EUKARYOTES

The evolution of the eukaryotes introduced several additional factors into the process of cell division. Eukaryotic cells are much larger than bacteria, and they contain genomes with much larger quantities of DNA (Figure 10-4). This DNA, however, is located in several individual chromosomes, rather than in a single, circular molecule. In these chromosomes, the DNA is associated with proteins and wound into tightly condensed coils (Figure 10-5). The eukaryotic chromosome is a structure with complex organization, which contrasts strongly with the single, circular DNA molecule that plays the same role in bacteria.

FIGURE 10-3
Bacteria divide by a process of simple cell fission. Note here the septum forming between the two daughter cells.

FIGURE 10-4
A human chromosome contains an enormous amount of DNA. The dark element at the bottom of the photograph is the protein matrix of a single chromosome. All of the surrounding material is the DNA of that chromosome.

FIGURE 10-5
Levels of chromosomal organization. The DNA duplex is wound twice around aggregates of histones to form nucleosomes, and the string of nucleosomes is further coiled in a series of condensation stages. During cell division, chromosomes are fully condensed, as pictured here; at other times, much of the coiling is relaxed and chromosomes are not visible as discrete entities under a light microscope.

The Guild Handbook of Scientific Illustration
Book Title

Elaine R. S. Hodges
Editor

Louis Vasquez
Art Director

East End Graphic Arts
Design Firm

Various
Illustrators

Van Nostrand Reinhold New York, NY
Publisher

Dix Type, Inc.
Typographer

Arcata Graphics/Halliday
Printer

Sandra Cohen
Production Manager

Arcata Graphics/Halliday
Binder

7/Coquille Board

Candy Feller and Elaine R. S. Hodges

Coquille board is a textured, uncoated drawing paper about the weight of three-ply Bristol board. The texture or grain is impressed into the paper during manufacture. It is commonly used for quick sketches, often for artwork in newspaper ads. With a little more attention, however, it can be used for scientific illustrations, producing aesthetically pleasing as well as functional results (fig. 7-1). It depicts color patterns very successfully (fig. 7-2; see also fig. 19-19).

Coquille board drawings are usually rendered in black and white, but the surface is also suitable for pastels and colored pencils. A technique using color is described toward the end of this chapter.

Two factors favor using this technique: time and money. Compared with other methods of showing form, color pattern, and habitus, rendering on coquille board takes very little time to learn or practice. It costs little to produce coquille board drawings, not only because it takes less time than such techniques as pen-and-ink and carbon dust to cover an area with shading, but also because the materials are relatively inexpensive. Such characteristics make it particularly useful to freelance illustrators as well as to scientists who do their own drawings. These drawings can be made to simulate the characteristics of other techniques (pen-and-ink stippling, halftone, lithography). If the artist emphasizes blacks and whites and minimizes grays, coquille board drawings can be photographed for printing as line art; hence, the printer avoids the additional expense of preparing halftone copy (fig. 7-3).

7-1. Conté pencils on fine coquille board. Alga, *Penicillus lamourouxii*, by Candy Feller. Courtesy of James Norris, Smithsonian Institution.

7-2. Conté pencils on fine coquille board used to render patterns. Ink was used for eye, nostril, and outline. Frog parts: head of *Leptodactylus labyrinthicus*, tibia of *L. flavopictus*, by Fran Irish. Courtesy of W. Ronald Heyer, Smithsonian Institution.

7-3. Venus Spectracolor no. 1406 pencil on coarse coquille board. Original is 13 inches (33cm) square. *(a)* Halftone reproduction. *(b)* Line reproduction. *(c)* Much-reduced line reproduction. Lichens, *Pilophorus robustus*, by Lucy C. Taylor © 1978. Courtesy of Department of Botany, University of Wisconsin, Madison.

128

Pacific Flavors: Oriental Recipes for a Contemporary Kitchen
Book Title

Hugh Carpenter
Author

Rita Marshall
Designer

Teri Sandison
Photographer

Stewart, Tabori & Chang New York, NY
Publisher

Trufont Typographers, Inc.
Typographer

Arti Grafiche Amilcare Pizzi, S.p.A.
Printer

Kathy Rosenbloom
Production Manager

#100 gloss coated
Paper

Arti Grafiche Amilcare Pizzi, S.p.A.
Binder

Rita Marshall
Jacket Designer

Teri Sandison
Jacket Photographer

BEAUTIFUL GARDEN VEGETABLES

■ C H A P T E R 8

If you are just starting an adventure with Oriental cooking, this is the perfect chapter with which to begin your experiments. These brilliantly colored, crunchy vegetables capture the essence of how Chinese, Thai, and Vietnamese cooks treat vegetables. Using produce available at every supermarket, these recipes combine easy cooking techniques with quickly made sauces. The subtle blend of flavors and textures makes these recipes perfect accompaniments to any American or European entrée.

Each recipe steps beyond traditional Oriental seasonings and methods to make a new statement. A black bean sauce enriched with butter bathes steamed asparagus; baby carrots are sautéed until a citrus-anise essence turns them

206

Wild Mushroom Stir-Fry. 207

with its zucchini, tomato, and niçoise olives, this salad
is steeped in the Mediterranean palate, and palette. But
if you want to emphasize the taste of the American South-
west, substitute just one ingredient: cilantro for flat-leaf
parsley. This dish gives new life to leftover corn bread,
which dries out so quickly.

Openers
Book Title

Jo Mancuso
Author

**Amy Nathan and
Kathryn Kleinman**
Art Directors

Jacqueline Jones
Designer

Kathryn Kleinman
Photographer

**Chronicle Books
San Francisco, CA**
Publisher

On-Line Typography
Typographer

William Stewart
Calligrapher

Toppan Printing Co., Ltd.
Printer

David Barich
Editor

Jacqueline Jones
Jacket Designer

Kathryn Kleinman
Jacket Photographer

AVOCADO CRUMBLE SALAD

86

Round Buildings, Square Buildings & Buildings That Wiggle Like A Fish
Book Title

Philip M. Isaacson
Author

Denise Cronin
Art Director

Jane Byers Bierhorst
Designer

Philip M. Isaacson
Photographer

Alfred A. Knopf Books for Young Readers New York, NY
Publisher

Centennial Graphics, Inc.
Typographer

Tien Wah Press
Printer

Elaine Silber
Production Manager

135 GSM Nijmegen
Paper

Tien Wah Press
Binder

Jane Byers Bierhorst
Jacket Designer

Philip M. Isaacson
Jacket Photographer

57

Michelangelo and seems to sit like a king over that ancient city. It is so large that it has a life of its own, apart from the church below it. The church faces a great courtyard called a piazza. The Piazza of St. Peter's (57) is shaped like an ellipse—a not quite round circle. It's as if two giant hands had tugged at a once-round piazza and pulled it into a longer, narrower shape. The ellipse of the piazza makes the dome above it seem very solid. The tug-of-war between their two forms—forms that will last forever—is one of art's great dramas.

To see a roof we usually have to look up. Once in a while, however, we can look down on one. This is the eight-hundred-year-old roof of the wonderful Cathedral of Pisa in Italy (58). You would see it like this if you climbed its bell tower, the Leaning Tower of Pisa, for a

58

**Frank Lloyd Wright
In The Realm of Ideas**
Book Title

**Bruce Pfeiffer and
Gerald Nordland**
Authors

Joyce A. Kachergis
Art Director/Designer

Joyce A. Kachergis Book Design
Design Firm

**The Frank Lloyd Wright
Foundation**
Photographs

**Southern Illinois University
Press
Carbondale and
Edwardsville, IL**
Publisher

G & S Typesetters
Typographer

Toppan Printing Co., Inc.
Printer

Natalia Nadraga
Production Manager

**86#,128 gsm Premium
V-Matte**
Paper

Toppan Printing Co., Inc.
Binder

Joyce A. Kachergis
Jacket Designer

**The Frank Lloyd Wright
Foundation**
Jacket Illustration

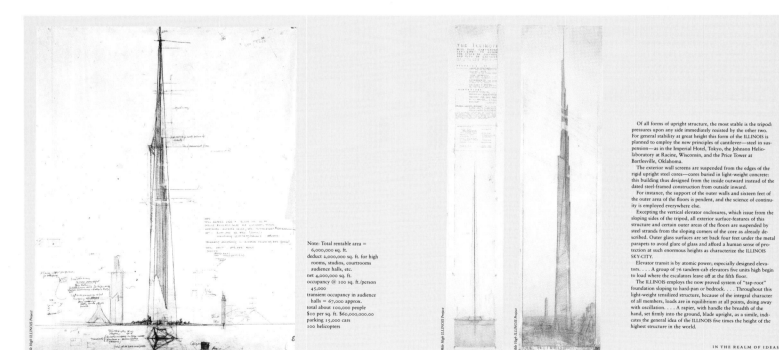

Note: Total rentable area =
 6,000,000 sq. ft.
deduct 2,000,000 sq. ft. for high
 rooms, studios, courtrooms
 audience halls, etc.
net 4,000,000 sq. ft.
occupancy @ 100 sq. ft./person
45,000
transient occupancy in audience
 halls = 67,000 approx.
total about 100,000 people
$10 per sq. ft. $60,000,000.00
parking 15,000 cars
100 helicopters

Of all forms of upright structure, the most stable is the tripod: pressures upon any side immediately resisted by the other two. For general stability at great height this form of the ILLINOIS is planned to employ the new principles of cantilever—steel in suspension—as in the Imperial Hotel, Tokyo, the Johnson Helio-laboratory at Racine, Wisconsin, and the Price Tower at Bartlesville, Oklahoma.

The exterior wall screens are suspended from the edges of the rigid upright steel cores—cores buried in light-weight concrete: this building thus designed from the inside outward instead of the dated steel-framed construction from outside inward.

For instance, the support of the outer walls and sixteen feet of the outer area of the floors is pendent, and the science of continuity is employed everywhere else.

Excepting the vertical elevator enclosures, which issue from the sloping sides of the tripod, all exterior surface-features of this structure and certain outer areas of the floors are suspended by steel strands from the sloping corners of the core as already described. Outer glass surfaces are set back four feet under the metal parapets to avoid glare of glass and afford a human sense of protection at such enormous heights as characterize the ILLINOIS SKY-CITY.

Elevator transit is by atomic power; especially designed elevators. . . . A group of 76 tandem-cab elevators five units high begin to load where the escalators leave off at the fifth floor.

The ILLINOIS employs the now proved system of "tap-root" foundation sloping to hard-pan or bedrock. . . . Throughout this light-weight tensilized structure, because of the integral character of all members, loads are in equilibrium at all points, doing away with oscillation. . . . A rapier, with handle the breadth of the hand, set firmly into the ground, blade upright, as a simile, indicates the general idea of the ILLINOIS five times the height of the highest structure in the world.

IN THE REALM OF IDEAS 87

THE MENTAL PICTURE 8

Looking

aiga call for entries
illustrating the future

Forward

Looking Forward
Call for Entry

Henrietta Condak
Designer

Robert Van Nutt
Illustration

Arnold & Debel
Typography

Danbury Printing & Litho. Inc.
Printing

Looking Forward

The "Looking Forward" exhibition was an attempt to explore the area between science fiction art and topical graphics. We were looking for images that dealt with the future, but not as a total fantasy. The jury felt that the submissions were interesting, but that many of them did not deal with the specific subject matter required. The topic turned out to be much more limited than we had expected, which is reflected in the small number of entries chosen for the exhibition. As a society we seem to be generating a volume of words in this area and very few images.

Marshall Arisman
Chairperson

Marshall Arisman

The Park is Mine
Illustration

Penthouse 1981
Publisher

Decline of the 60's
Illustration

Playboy June 1988
Publisher

Anita Kunz

Nature
Illustration

Toronto Life
April 1988
Publisher

Gravity's Rainbow
Book Jacket

Picador
Publisher

Fabrizio La Rocca
Fodor's 89 Soviet Union
Fodor's 89 New England
Art Director

Vignelli Associates
Designer

Fodor's Travel Publications
A Random House Company
Publisher

Soviet Union **$16.95**

53 Years of Travel Experience ★★★★

Fodor's 89

Soviet Union
*With Essays
on History and Art*

Facts at Your Fingertips
Travel documents, special-interest tours, what to pack, customs, currency, getting to and around the Soviet Union

Essays
Background essays on Russian history, culture, literature, and art

Sightseeing
Complete region-by-region coverage of major attractions, including details on museums, monuments, and other sights in Moscow and Leningrad

Hotels and Restaurants
Reviews of more than 500 hotels and restaurants, plus a primer on the country's traditional and regional cuisines

Maps
17 pages of maps and city plans

ISBN 0-679-01700-3

Fodor's Great Britain **$14.95**

53 Years of Travel Experience ★★★★

Fodor's 89

Great Britain
*Completely Rewritten
and Updated*

Fodor's Choice
The experts choose the top hotels, prettiest villages, leading shops, grandest castles, coziest pubs, and more

Highlights '89
The most important tourism developments in the past year

Before You Go
Tours, special events, packing tips, travel with children, budget airfare, car rentals, currency, and climate

Hotels and Restaurants
Detailed reviews of more than 750 pubs and restaurants; ratings of some 800 hotels, B&Bs, and country inns

Essays
A close look at Victorian Britain, Scotland, and the arts

Maps
More than 35 new maps pinpoint every attraction and all of London's top restaurants, hotels, and shops

Guy Billout

Power Failure
Illustration

The Atlantic Monthly
April 1987
Publisher

Illustration

The Quality Review
Spring 1987
Publisher

**Ted Colangelo Associates
An agency for interesting
times**
Self-Promotional Book

**Kurt Gibson
Greenwich, CT**
Designer

Mark Penberthy
Artist

Ted Colangelo Associates
Design Firm

Ted Colangelo Associates
Publisher

**Jones Intercable Inc.
1987 Annual Report**
Annual Report Illustration

**Rod Dyer and
Steve Twigger
Los Angeles, CA**
Art Directors

Steve Twigger
Designer

**Jeff Corwin, Brian Grimwood,
Ursula Brookbank, Monxo
Algora, Steve Twigger**
Artists

Rod Dyer Group, Inc.
Design Firm

Jones Intercable, Inc.
Client

How to Save our National Parks
Magazine Illustration

Judy Garlan
Boston, MA
Art Director

Wayne McLoughlin
Artist

The Atlantic Monthly Co.
Publisher

After the Big One
Magazine Illustration

Patrick J.B. Flynn
Madison, WI
Art Director

Mark Marek
Artist

The Progressive
Publisher

FRANK LLOYD WRIGHT

Wright's last years were no less controversial, or less prophetic, than his early ones. When he was well into his eighties, Wright's plans for the Guggenheim Museum in Manhattan and the Civic Center in California's Marin County seemed eccentric even in those sophisticated communities. Now, of course, no painter in America could envision his work exhibited more effectively than in the Guggenheim, and no citizens could be prouder of their civic center than the residents of Marin County.

ARCHITECTURE

GROUND HOG

The shadow of the ground hog, or the ancient secret locked in the office vault at the *Old Farmer's Almanac*—either may be as reliable as the pointer wielded by a TV weathercaster.

Personal Computers
Magazine Illustration

Hans-Georg Pospischil
Designer

Seymour Chwast
New York, NY
Artist

The Pushpin Group
Design Firm

Frankfurter Allgemeine
Magazin
Client

Dr. Bruno Dechamps
Publisher

Kommt ein EG-Kommissar auf den Hof und sagt: "Grüß Gott!" Aber er sagt es zu seinem portablen PC, der ihm dasselbe entgegenleuchtet. Die Bauernfamilie hinter ihm murmelt "Mein Gott" und staunt: Auf dem Schirm erscheint Europa auf dem Stier, doch der verwandelt sich in eine Kuh, die ungemolken Milch gibt, die ihr bald bis zum Hals steigt, bis Europa am oberen Bildrand nach Luft schnappt und schließlich im Milchsee ertrinkt. Die Bäuerin kichert erschrocken, weil sie Nichtschwimmerin ist. Der Kommissar bleibt ernst und schiebt eine Floppy Disk ein, um die Rentabilitätsdaten des Hofes mit anderen EG-Höfen zu vergleichen, und läßt eine hofgemachte Milchflut hochrechnen. Sie macht dem Bauern Angst und rote Wangen. Dann rollt ein wunderschönes Ei über den Screen, stellt sich geschickt auf die Spitze, knickt sich selbst energisch an und steht, als stünde Kolumbus dahinter. Tut es auch, denn die zentrale Rechnereinheit läßt nun einen verlockenden "Vorschlag" blinken: Bitte Eingabe aller zwölf Kühe des Hofes auf giftgrüner Schirm-Weide, dann Zugabe EG wie Europäische Grenzwertberechnung. Antwort des PC: Jede Kuh um ein Drittel reduzieren, Abschlachtprämie sichern, den Neubesamungsverzichts-Bonus aufstocken, Gutschrift der Milchpfennig-Ausfallgarantie und Antrag auf Landschaftspflege-Subvention für wilde Weiden. Die Alternative, da ein Drittel Kuh nicht mehr recht auf die Beine käme: Milch an Schweinezucht, Umlenkprämie einstreichen, Schweineberg-Interventionsbetrag abrufen. Die Kontostände reizen den Bauern. Ob beides geht? Gerade will der Kommissar noch die besonderen Vorteile der viehfreien Milchwirtschaft vortasten, in der nicht mehr erst die Milch, sondern gleich das Geld verpulvert wird, schon schüttelt ihm der Bauer überwältigt die Hand, da spuckt der Drucker ein von lauter Nullen umrandetes Bild aus: "Kuh im Gras." Wo das Gras, fragt die Bäuerin. Das habe die Kuh gefressen, erklärt der PC-Besitzer stolz. Und wo ist dann die Kuh? "Wieso?" fragt der Kommissar. "Die ist doch nicht so dumm und bleibt da stehen, wo sie alles kahlgefressen hat!"

Man wird alt wie eine Kuh und lernt immer noch, dazu hat man ja den PC, den höchst individuellen Personal Computer. Selbst dem bäuerlichen Einzelunternehmer hilft er, aus Eiern und Euern Gewinne zu ziehen. So geraten auch Höfe unter die Schirmherrschaft eines PC. Früher hackte man Rüben, heute hackt man Tastaturen.

WURM AM SCHIRM

*Von Udo Pini
Illustrationen
Seymour Chwast*

Der schönste Platz ist immer an der Theke gewesen, bis ihm der Arbeitsplatz am Personal Computer den Rang streitig machte. Seit der PC tragbar ist, kehrt er mitsamt Besitzer an die Theke zurück.

Kommt ein Mann in die Bar und bestellt sich einen Kaffee. Kaum leuchtet der Schirm, kaum blinzelt ihm der eilfertige Cursor, der Lichtpunkt, mit grünem, schnellem Phosphor zu, daß er bereit und hinter ihm alles geladen sei, da leuchten Nanosekunden später auch die Augen des Mannes. Endlich Ende der Funkpause, endlich Lunchtime. Ein PC wird gefüttert, und ein Mann kann sich satt sehen. Er hat die Speisekarte eingegeben, die Cocktailliste dazu und auch die Getränke kalorienweise aufgelistet. Im Lunchprogramm stecken Morgengewicht, Zielvorgabe des Diätprogramms und der Wurm: Ein Kaffee ohne Zucker wäre noch drin, wenn er ihn eingäbe, aber heute gibt's keinen Aperitif und keine Vorspeisen, strenggenommen. Bei null Verzehr wäre beides übermorgen wieder möglich, wenn er jetzt aus dem Ham- einen Fishburger und aus dem Eis einen Salat machte. Das neue Futterprogramm, hatte der Software-Shop beworben, würde sich durch Fasten fast von selbst bezahlt machen. Also Kaffee und Zwieback und weiter: Die verantwortungsbewußte CP oder Computer-Persönlichkeit würdigt die vorbeiduftenden Spaghetti à la carbonara keines schmachtenden Blickes und gibt lieber ein, was sie dafür ausgeben würde. Der PC läßt postwendend einleuchten, daß der Preis noch im selbstgesetzten Mittags-Budget drin ist. Wenn man bloß jetzt ordentlich ordern dürfte. Gegenrechnung: Eine Woche Verzicht auf Zucker und Sahne und Zabaglione und dafür jetzt die Carbonara mit drei Löffeln Parmesan? Zunächst antwortet der PC nicht, dann aber blinkt er: "Abzuraten, bessere Wahl möglich!" Da korrigiert der Mann sein Morgengewicht nach unten, hastet und tastet alles noch mal und schämt sich, weil der PC "Guten Appetit!" wünscht, und das in drei Sprachen. Dann aber freut sich der Mann und beschließt, eine runde Person zu bleiben wie Peter Ustinov. Der meinte auch, nach Jahrhunderten voller Fragen ohne Antwort hätten wir nun mit Computerhilfe eine Menge Antworten, zu denen uns nur die Fragen noch nicht einfielen. Muß man denn alles fragen?

26

Personal Computers
Magazine Illustration

Hans-Georg Pospischil
Designer

Seymour Chwast
New York, NY
Artist

The Pushpin Group
Design Firm

Frankfurter Allgemeine
Magazin
Client

Dr. Bruno Dechamps
Publisher

How the Universe Works
Magazine Illustration

Judy Garlan
Boston, MA
Art Director

Tom Lulevitch
Artist

The Atlantic Monthly Co.
Publisher

How to Save our National Parks
Magazine Illustration

Judy Garlan
Boston, MA
Art Director

Wayne McLoughlin
Artist

The Atlantic Monthly Co.
Publisher

THE NIGHT
THE CREATURES
CAME OUT
FROM BEHIND
THE MACHINES.

THE APPLE INTERNATIONAL
SALES MEETING HALLOWEEN PARTY
OCTOBER 31, 1985

CRUISER STRIKE FORCE 2000

The year is 2020. A U.S. Navy task force is escorting a merchant convoy when trouble explodes. Soviet-made Blackjack bombers spearhead a sudden raid by air, surface and subsurface forces. Metcalf-class vertical launch missile cruisers respond to the threat, firing surface-to-air missiles, antiship sea skimmers, antisubmarine rockets and quad-pack short-range missiles. Low on the waterline to enhance stealth, the block-two strike cruiser in the foreground holds twice as many missiles as the first-generation Metcalf cruiser in the background — and four times the firepower of the vintage Ticonderoga-class cruisers on the horizon. Packing this futuristic might, the U.S. Navy stands ready to fight the sea battles of tomorrow — in a world that hopes it never has to.

Popular Mechanics
PM ILLUSTRATION BY TOM FREEMAN

The Night the Creatures Came Out From Behind the Machines
Halloween Party Masks

Clement Mok
San Francisco, CA
Art Director

Steven Guarnaccia
Artist

Apple Creative Services
Design Firm

Apple Computers
Publisher

Cruiser Strike Force 2000
Magazine Illustration

Bryan Canniff
New York, NY
Art Director

Tom Freeman
Artist

Popular Mechanics,
Hearst Magazines
Publisher

Expand Your Universe . . .
Poster

Marty Neumeier
Atherton, CA
Art Director

Marty Neumeier
Artist

Neumeier Design Team
Design Firm

National Advanced Systems
Client/Publisher

Shadowfax
Folksongs for a Nuclear
Village
Poster

Tommy Steele
Hollywood, CA
Art Director

Roland Young
Designer

Michael McMillan
Artist

Pete MacArthur
Photographer

Capitol Records
Publisher

2036:A Bicentennial Odyssey
Magazine Illustration

Nancy McMillan
Art Director

Steven Guarnaccia
New York, NY
Artist

Texas Monthly
Publisher

After a nuclear exchange
not even the most ardent
ideologue is going to
be able to tell the ashes
of communism from the
ashes of free enterprise.
Calendar Illustration

Patrick J.B. Flynn
Madison, WI
Art Director

Ron Hauge
Artist

The Progressive
Publisher

Productolith
Promotional Booklet
Illustrations

Rick Valicenti
Chicago, IL
Art Director/Designer

Tom Valk and Corinne Pfister
Photographers

Thirst
Design Firm

Consolidated Papers, Inc.
Client

CELLOPHANE

IN THE NOT TOO DISTANT FUTURE, EVERYONE WILL BE DOING
THE CELLOPHANE RAP ● RAPPING WITH FRIENDS AND
NEIGHBORS NOT ON A CELLULAR PHONE, BUT ON
CELLOPHANE ● THE NEW CELLOPHANE IS AN IMPLANT FOR
THE EAR COMPLETE WITH COMPUTER MICRODISHES ● THE
MANUFACTURER PROMISES GREAT RECEPTION. OF COURSE,
PEOPLE WILL LOOK PRETTY ODD TALKING TO THEMSELVES
IN PUBLIC ● AND MOST TEENAGERS WILL EXPERIENCE
CONSTANT #, *, ', *, @ IN THEIR EARS ● BUT THIS NEW
CELLOPHANE WILL HAVE REAL ~~sticking~~ POWER ● WE PREDICT
IT'LL HAVE THE WHOLE MARKET WRAPPED UP IN NO TIME

H RMONIC A

Break out the «HARMONICA» in the year 2000, and you won't
find anyone shaking, rattling or rolling. Far from it.
The new «HARMONICA» subliminally promotes harmonious relations
in the home, school or office. It's the ultimate Muzak
system. Thanks to the «HARMONICA», forty million couples
are dancing the Tango every night. Students are learning their
A·B·C's with less M·A·Y·H·E·M. Umpires even convinced the
Big Leagues to put a «HARMONICA» in every dugout.
They haven't heard a discouraging word all season. Next up ▶
taxi cabs.

**Electro Rent Corporation
Annual Report 1986**
Annual Report

**John Cleveland
Los Angeles, CA**
Art Director

Jim Marrin
Designer

Scott Morgan
Photographer

John Cleveland, Inc.
Design Firm

Electro Rent Corporation
Client

**3Com Corporation
1987 Annual Report**
Annual Report

**Craig Frazier
San Francisco, CA**
Art Director

**Craig Frazier and
Deborah Hagemann**
Designers

John Hersey
Artist

Frazier Design
Design Firm

3Com Corporation
Client

THIS MACHINE WANTS TO
HELP YOU

*Computers are impartial, thorough,
accurate and, sometimes, friendly to patients.
But they haven't replaced your therapist.*

BY CHRISTOPHER JOYCE

DORIS IS 42 YEARS OLD AND FEELING LOW. She has decided to get professional help. After her first session in a psychologist's office, this profile emerges:
The patient appears to be an angry, suspicious person who has difficulty with impulse control. She is evasive and defensive about acknowledging problems. . . she resents authority and is likely to be argumentative and irritable in social relations, especially with the opposite sex. . . .
At present, she appears to be depressed. She views herself as unhappy and useless. . . . If she denies depression and maintains a facade of cheerfulness, the possibility of suicide should be assessed carefully. . . . She appears to be a person who represses and denies emotional distress.

Doris created her own profile without the help of another human being. She did it by sitting in front of a personal computer and answering a long list of questions about herself. Within minutes of Doris's last keystroke, the computer composed the above profile and printed it out in the office of Doris's psychologist.

Like psychologist Harry Harlow's surrogate monkey mothers clothed in terry cloth, computers can often fill in for flesh and blood. While some professionals resent the intrusion of machines into this most personal of professions, computers are rapidly replacing the paper-and-pencil tests that take up so much of a psychologist's time.

Mental-health professionals are often required to crunch either numbers or symbols. Doris's profile, for example, is the product of the Minnesota Multiphasic Personality Inventory (MMPI), a time-tested instrument that gives psychologists their first glimpse into the minds of their patients. The MMPI presents 566 statements to which the person answers either true or false. The test is peppered with zingers such as: "If people had not had it in for me I would have been much more successful." Or: "I have never indulged in any unusual sex practices." Standard scoring procedures that have evolved over years of research then correlate the patterns of answers with categories of personality disorders, such as depression or chronic anxiety.

In 1961 psychologist Raymond Fowler, then at the University of Alabama, was one of the first to program the MMPI into a computer. As computerized interpretation of MMPI's took hold, other tests followed the digital trail. These included the Beck Depression Inventory, the Shipley-Institute of Living Scale, the Sixteen Personality Factor Questionnaire and myriad other diagnostic interviews and psychological histories.

Many psychological tests and interviews still are given by human interviewers, but few are performed as systematically as those conducted by computers, Fowler says. "If a person has lots of questions to ask you, he or she might say, 'Tell me about yourself, tell me about your problems.' If there is something that cues, then he'd ask another question and dig on deeper into it, but little areas might be left out that would be important. . . . But the

ILLUSTRATION: MIRKO ILIC

©1988 National Federation of Coffee Growers of Colombia

Signs of intelligent life.

As they moved closer to what they thought to be an abnormally shaped crater, all three astronauts seemed to smile at once.
After all, it's what every astronaut has hoped to find.

Not Juan Valdez® per se, but some sign of intelligence on a planet other than earth.
Filled with excitement, they thought not of the roasters who have prospered from keeping *the richest coffee in the world*™ around, but

of their own fame and fortune that might come as a result.
With that in mind, toasting their success with a steaming hot cup of Colombian Coffee seemed like a very

intelligent idea indeed.
For more information write to: 100% Colombian Coffee Program, P.O. Box 8545, New York, New York 10150. Or call **1-800-223-3101.**

**Peace: The Beauty of
Friendship Overcomes the
Beast of War**
Poster

**Steff Geissbuhler
New York, NY**
Art Director/Designer

Steff Geissbuhler
Artist

**Chermayeff & Geismar
Associates**
Design Firm

Shoshin Society Inc.
Publisher

To Remember is Not Enough
Poster

Rafal Olbinski
Forest Hills, NY
Art Director/Designer

Rafal Olbinski
Artist

Rafal Olbinski Studio
Design Firm

American Foundation for AIDS Research
Client

Inside Outliners
Magazine Illustration

Christopher Burg
San Francisco, CA
Art Director

John Hersey
Artist

***Macworld* Magazine**
PCW Communications
Publisher

Inside Outliners

*A guide to outliners: programs that
put a new twist on an old idea*

by Robert C. Eckhardt

I remember how much I hated learning to outline, back in junior high. I rated outlining up there with sentence diagramming as a technique designed by teachers to make writing as unpleasant and difficult as humanly possible. I used to copy and recopy outlines to get them right—and then dismiss the whole exercise as futile once I'd written a paper that bore little relation to my hard-fought plan.

But outlines, and my attitude toward them, have changed now that my pencil and piles of cast-off outlines have been replaced by a Macintosh and an outliner program. And the change is partly because the outlines I create now hold the potential to be far more than just skeletons for future writing projects. Outliners can serve, among other things, as simple databases, appointment books, automatic-dialing phone books, and storage bins for pictures or stray text.

So before you dismiss outliners as just updated versions of an old torture technique, consider what this burgeoning area of Macintosh applications can do for you.

I. Configurations

All outliners perform the same basic job: they provide an easy way to create classic outlines (with subordinate topics nested under general topics) and to move, rearrange, temporarily hide, alphabetize, and otherwise organize all the topics. Similar though they may be at heart, however, outliners come in many different forms, from desk accessories or minor segments of major applications to full-scale applications replete with extras. Which kind of outliner is for you depends on how you intend to use it, the amount of RAM in your Macintosh, and several other factors.

You can call up desk accessory outliners like *Acta, Voilà,* and Outlook (included in *SideKick*) at any time from almost any application—whether you're using a 512K Macintosh or running with a full MultiFinder set.

But because they are desk accessories, these programs lack many of the special features that application outliners offer. And although they are small by application standards, desk accessory outliners can still add considerable bulk to your System file—from 40K for *Acta* to 113K for Outlook.

Application outliners, such as *ThinkTank* and *MaxThink*, work with other applications under MultiFinder, but only if you have enough memory. Running *ThinkTank,* for example, with only one other program requires at least one megabyte of RAM. If you don't have enough memory, you must quit your current application, open the outliner, save your outliner work, and finally, reopen your application. Since outlining is rarely an end in itself, using an outliner in this way largely defeats its purpose. If you can spare the memory, however, an application outliner such as *ThinkTank* used under MultiFinder is just as convenient as a desk accessory, and more powerful.

As outlining catches on, more application outliners are combining full-powered outlining with other useful functions. The best known of these high-powered models is *More*, which can convert outlines into presentation graphics, create appointment calendars in outline form, and even dial the phone for you. *MindWrite* doubles as a basic *MacWrite*-like word processor. In both *More* and *MindWrite,* the outliner and the other parts of the program work together to make a whole that is greater than the sum of its parts.

The outline view in *Microsoft Word 3.0* is an example of the final type of outliner: a minor outlining facility resident within a major application. Unfortunately, *Word's* outline view seems more stuck-on than built-in. Although switching between outlining and writing views is quick and easy, the outline facility

124 December 1987

Macworld 125

Fit to Print

by Erfert Nielson

*Font fine points
and typesetting tips
for professional-looking
publications*

These days everybody's a desktop publisher. With LaserWriter time for rent at the corner copy shop, anyone with a Mac and a manuscript can turn out the ubiquitous "near-typeset-quality" publication. If you want your desktop-published document to stand out from the crowd, you need to know the ins and outs of Macintosh fonts. A low-budget publication won't look low-budget if you know a few tricks, including how to choose the right fonts for the job, access special characters, and fix character-spacing problems. As you move into more advanced Mac typesetting, you'll also need to know how to troubleshoot printing problems and manage your growing font collection.

Font Basics

Let's begin by defining a font. Glossing such a basic term might seem unnecessary, but the word *font* means something different in Mac circles than in the typesetting world. In typesetting terms, a font is the physical incarnation of a *typeface*—a set of characters distinguished by a unique design (for example, Helvetica). In the early days of typesetting, every size of a given typeface had to be designed as a separate font. With the advent of digital typesetting, different sizes could be generated by scaling a single master, so the terms *typeface* and *font* became somewhat interchangeable.

In Mac parlance, a font is a set of characters of a certain typeface, in a certain style (roman or italic, for example), weight (thin, bold, and so on), or width (condensed or extended). Therefore, Times Roman and Times Italic are distinct fonts, but 12-point and 10-point Times Roman are different sizes of the same font.

The LaserWriter Plus contains 35 built-in fonts. Although 35 fonts sounds like a healthy selection, remember that fonts are defined by style attributes such as bold or italic. The LaserWriter Plus actually offers style variations on only 10 font *families*. Of these, 4—Courier, Symbol, Zapf Chancery, and Zapf Dingbats—aren't suitable for long passages of text, or *body copy*. That leaves a total of 6 font families—4 serif and 2 sans serif. (*Serifs*, the small strokes capping the ends of a

Erfert Nielson is a Macworld contributing editor and one of the magazine's founding members.

character's main strokes, help the eye distinguish characters that would otherwise become a thicket of uniformly weighted lines.) Since sans serif fonts are generally frowned on for body copy, we're left with 4 families of text fonts: Times, New Century Schoolbook, Palatino, and Bookman.

Choosing a Font Library

Needless to say, a selection of 4 font families doesn't give you much to work with. Luckily, more than 150 *downloadable* families are available. These fonts can be temporarily stored in the printer's memory and printed in the same fashion as built-in fonts. Downloadable fonts consist of two components: *screen fonts*, which are installed in a Font menu and displayed on the screen as you type, and *printer fonts*, the PostScript character descriptions that are sent to the LaserWriter or another PostScript-compatible device. (For a detailed description of the font-downloading process, see "Font Facts," *Macworld,* February 1987.)

For around $40 to $180 apiece, you can add fonts to your collection, building up a font library to suit your publishing style. While Adobe Systems, creator of the LaserWriters' built-in fonts, is considered by most to be the premier font developer, several other companies produce good-quality PostScript fonts—many of them at bargain prices. The "Font Sampler" gives you a taste of the kinds of fonts available from various companies, as well as an indication of their quality. To see an example of how fonts differ from one manufacturer to another, look at Figure 1, which compares two similar fonts executed by different companies.

Criteria for selecting a font library vary from one publisher to another, but in general you'll probably want a basic set of serif and sans serif fonts that look good together, since sans serif fonts are often used as headlines, chapter headings, and so on, in publications consisting primarily of serif type. You may also want to purchase an occasional special-purpose font, but be careful—although a decorative or novelty font can be an attention grabber, if used only once or twice such a font can be an expensive impulse buy.

144 April 1988

Macworld 145

Fit to Print
Magazine Illustration

Joanne Hoffman
San Francisco, CA
Art Director

John Hersey
Artist

***Macworld* Magazine**
PCW Communications
Publisher

The Macintosh Data Exchange
Magazine Illustration

Christopher Burg
San Francisco, CA
Art Director

Max Seabaugh
Artist

Macworld **Magazine**
PCW Communications
Publisher

The Macintosh Data Exchange

by Prasad Kaipa and Edwin Haskell

Need to transfer data? Here's a look at ways you can move data between programs and machines.

The ability to combine elements from various documents into a single report is one of the Macintosh's strengths. But merging elements from different applications is often not as straightforward as it seems. Although you can transfer text, numbers, and graphics between applications using the Clipboard, even with the simplest data transfers difficulties sometimes arise.

There are three types of transfers: between applications, between Macs, and between a Mac and a word processing machine or another computer. Each type of transfer has unique problems. The simplest procedure is to transfer text or graphics from one application to another. Transferring files between Macs and other computers generally requires a cable, modem, or AppleTalk network.

Data Transfer Basics

The three tools for transferring data between applications are the Clipboard, the Scrapbook, and the Notepad. The Clipboard acts as a temporary holding area for text, numbers, or graphics. Whenever you cut or copy data, it goes onto the Clipboard. You can paste the Clipboard's contents elsewhere in the same file or into another file created with the same or a different application.

The Scrapbook automatically stores data that has been cut or copied with the Clipboard. Like the Clipboard, it retains format information. While the Clipboard

can store only one set of data, the Scrapbook can transfer multiple data items from one file to another.

The Notepad, as its name implies, is a simple memo processor capable of storing and manipulating small amounts of unformatted text. You enter text into the Notepad from the keyboard or the Clipboard. However, such text does not retain formatting information.

To Format or Not

Most data-transfer problems result from incompatible data formats. Suppose, for example, that you wish to transfer information from *Microsoft File* to an *Excel* worksheet with the *Switcher*. You copy the desired File record onto the Clipboard, but when you switch to *Excel* and try to paste the record into the worksheet, you get a message that the data is in the wrong format. However, if you paste the *File* data into the Scrapbook first, you can choose to save the data in an unformatted form. You can then copy and paste the unformatted data into an *Excel* document. Once you save the unformatted Scrapbook data, the Clipboard data will also be unformatted, so you can paste the Clipboard data directly into the worksheet.

Other applications give you similar formatting options when you paste data into the Scrapbook or quit. Being aware of

these options helps if you have difficulty transferring information between applications.

Choosing Formats

Some applications can read and write more than one file format. The two main format types are application-specific and transfer. Application-specific formats are meant to be read only by the application that created them, while transfer formats are meant to be read by many applications.

The common transfer formats are SYLK, WKS, PICT, bit map, and text. SYLK files, originally used with Microsoft's *Multiplan* spreadsheets, contain text as well as formula and formatting information. Similarly, the WKS format used by Lotus's *1-2-3* on the IBM PC encodes both data and formulas but is not compatible with Lotus's *Jazz* format. PICT files created by applica-

tions like *MacDraw* contain information for drawing the objects in a picture, whereas bit-mapped files, such as those created with *MacPaint*, contain information on the individual points that make up a picture. Text files, which have the simplest transfer format, contain ASCII codes for the text from applications like *MacWrite* and *Word*. Text files, however, contain neither formatting information, such as margin and tab settings, nor font or character attributes, such as boldface and italics. The degree of compatibility between different data types and applications varies (see Table 1).

Importing and Exporting Data

Many applications allow you to open application-specific files created by other programs. *Microsoft Word*, for example, can open files created by *MacWrite* and can convert them to *Word* format. *Excel*

Many applications allow you to open application-specific files created by other programs.

and *Jazz* can open files from *Multiplan*, *Chart*, and *1-2-3*.

Many database applications import files created by other database programs and export files to other applications. *dBase Mac, Double Helix, Omnis 3 Plus,* and *Business Filevision* all have extensive import and export capabilities.

You can always transfer text files between databases as long as the two applications can save and read data in text format. Most databases can read text files that contain field and record delimiters, such as commas, spaces, quotation marks, and tabs. However, many databases cannot transfer the record-formatting information and graphics fields.

Glue, from Solutions, provides its own format for saving images created in applications like *MacDraw, MacPaint,*

Reality Transformed

Process images almost as easily as revising text

"All the pictures which science now draws of nature and which alone seem capable of according with observational fact are mathematical pictures...."

—Sir James Hopwood Jeans, 1930

by Brita Meng

In the simplest sense, image processing means manipulating a picture—modifying, enhancing, or analyzing it. Adjusting the brightness on a television set is one type of image processing; by changing analog voltages, you alter the brightness of the picture displayed on the screen.

The Macintosh, however, manipulates digital information. To process Mac images, applications like ImageStudio or Digital Darkroom use mathematical formulas to manipulate the individual picture elements or *pixels* that make up each image.

Image processing differs from computer graphics. Whereas applications such as paint programs allow you to create computer-generated images from scratch, image processing lets you analyze and alter images from real-world sources such as video recorders, satellite cameras, and CAT scanners.

The Rudiments of Image Processing

To enter an image into the Mac, the image must be digitized by an input device, for example a scanner or a video camera. Scanners and digitizers break down a continuous-tone image, such as a photograph, into an array of pixels. With the appropriate scanner, each pixel can include gray-level or color information.

Digitizers take input from a video source like a camera. Pixelogic's ProViz, Mass Micro's ColorSpace, and Comtrex's Imagizer are all examples of digitizers. Frame grabbers capture a single video frame from a camera or a video cassette recorder (VCR) in 1/30 second; video equipment displays data at 30 frames per second. Data Translation's QuickCapture and Color-Capture and TrueVision's NuVista board are examples of frame grabbers. Grabbed images can be stored, displayed, and processed on the Mac. Before being processed, the entire digitized image must be loaded into the Mac's RAM or, if the Mac uses external hardware, into the memory of a dedicated image processor.

To display an image accurately while you work with it, you need a monitor that displays gray levels or color, particularly if you're working with a continuous-tone image. Some operations manipulate pixels so

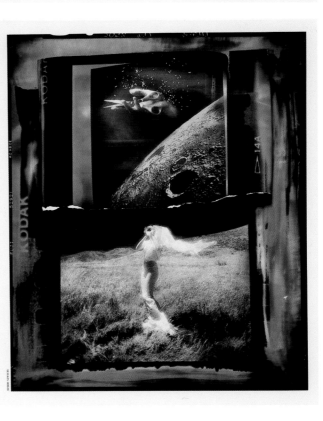

Reality Transformed
Magazine Illustration

Christopher Burg
San Francisco, CA
Art Director

Jeffery Newbury
Artist

Macworld **Magazine**
PCW Communications
Publisher

SNA's Schizophrenic future
Newspaper Illustration

Dianne Barrett
Framingham, MA
Art Director/Designer

Steve Lyons
Artist

Network World Publishing
Publisher

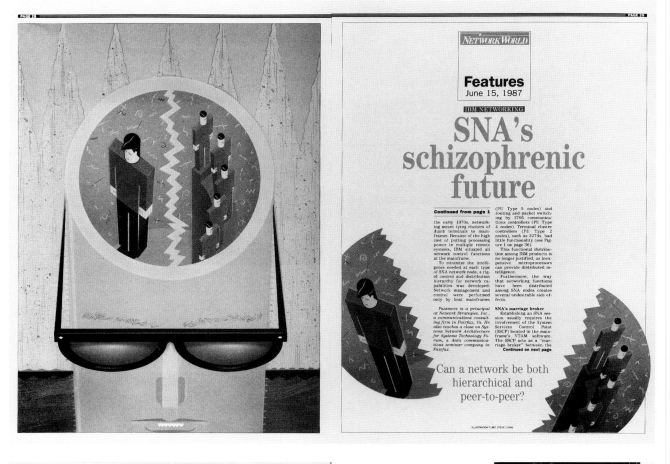

1984 Lomas &
Nettleton Mortgage
Investors
Annual Report Spread

Steve Miller
Dallas, TX
Designer

Jack Unruh
Artist

Richards Brock Miller
Mitchell and Associates/The
Richards Group
Design Firm

Lomas & Nettleton Mortgage
Investors
Client

Privacy—the right to be alone—is among those rights most valued by a civilized people. We guard it at home with solid front doors and sturdy back fences; and pursue it out-of-doors, in parks and wildernesses. When the world is too much with us, we seek to be away from it all—meaning, closer to ourselves. And we insist on quiet time. For reflection, and for self-renewal. Our society not only tolerates privacy, it cherishes it. No wonder the phrase "Big Brother is watching you" has become an infamous slogan, and the horror most often associated with Orwell is that of being watched, via telescreens and other monitoring devices. It's sad for us to be too much alone, but it would be tragic should we not be able to be by ourselves.

Pacific Telesis Group
Electronic Mail
Promotional Booklet
Illustration

Neil Shakery, Pentagram
San Francisco, CA
Art Director/Designer

Charly Franklin
Photographer

Jonson Pedersen Hinrichs &
Shakery
Design Firm

Pacific Telesis Group
Client

THE TECHNOLOGY WE MARKET

Pacific Telesis Group markets the most sophisticated communications technology in the world. Since 1988, Pacific Bell has spent nearly $2.5 billion a year to deploy new technologies. As a result of this effort:

☐ Over 60 percent of the company's 18.9 million access lines are served by software-controlled computerized switches; that percentage is even greater in highly urbanized areas, with downtown Los Angeles and San Francisco exceeding 90 percent; the total for all access lines will reach nearly 100 percent by 1991.

☐ Pacific Bell has been the industry leader in deploying fiber optics, a transmission technology that permits a half-inch cable to transmit more than 400,000 simultaneous conversations with virtually no distortion. In 1982, 50 percent of AT&T's production of fiber optics cable went for Pacific Bell projects.

☐ Today, 88 percent of circuits between the company's central offices are digital; the total will reach 93 percent by 1992.

☐ Pacific Bell has built a fiber optics network, the most modern in the world, to meet the communications needs of the 14,000 athletes and 8,000 news media representatives who will attend the 1984 Olympic Games in Los Angeles; this system will provide everything from broadcast quality television to electronic mail service.

Electronic mail is one of the many telecommunications services which will become increasingly useful to our customers—be they major corporations which send thousands of computer messages to offices throughout the world, small retailers who use telephone lines to verify credit information for their customers, or individuals who use home computers to shop or bank by phone.

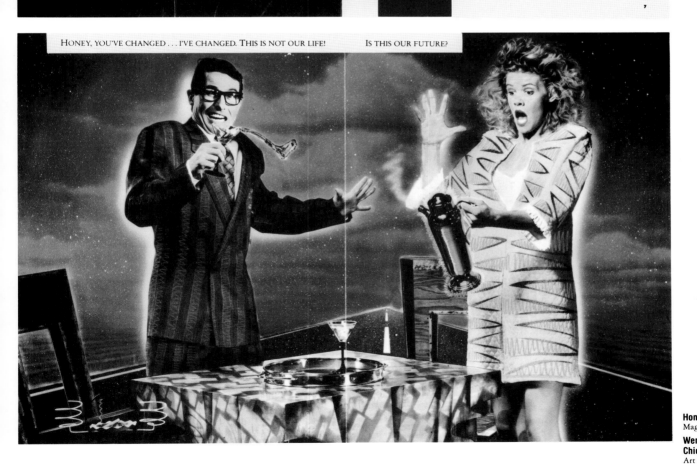

HONEY, YOU'VE CHANGED . . . I'VE CHANGED. THIS IS NOT OUR LIFE! IS THIS OUR FUTURE?

Honey, You've Changed . . .
Magazine Illustration

Wendy Edwards Lowitz
Chicago, IL
Art Director/Designer

Jack Perno
Photographer

Tony Griff
Color Enhancer

Moira & Co.
Design Firm

Northwestern Printing House
Client

How POSTSCRIPT improved my looks.
Poster

Marty Neumeier
Atherton, CA
Art Director

Christopher Chu
Les Chibana
Artists

Neumeier Design Team
Design Firm

Adobe Systems, Inc.
Client/Publisher

How PostScript improved my looks.

I'm responsible for developing and producing newsletters, reports, brochures, presentations, catalogs, diagrams and illustrations at a large corporation.

At first my job seemed glamorous, but wait till I tell you.

I couldn't have been here more than six months before I realized I was already six months behind. My pile of assignments began to rival the Himalayas. At the same time, my quality was going downhill fast. My latest brochure looked like a head-on collision with a '52 Studebaker.

It looked bad, and I looked bad.

My options weren't much prettier. I could a) work more hours, b) admit failure and beg for mercy, c) job the work out and lose control, or d) consider a new career as a crash-test driver. The answer, happily, turned out to be none of the above.

What saved me was PostScript software from Adobe Systems.

WHAT EXACTLY IS IT?

You can't see it, touch it, or hear it. You can't even buy it. But *without* the PostScript language, you aren't getting the real magic behind electronic publishing. I'll explain.

When you produce an image on a laser printer, your application tells your printer how the image should look, using a "page description language." That's PostScript.

Your printer, by virtue of a built-in PostScript interpreter, translates this language into type, line art, digitized photographs, or a combination of the three.

TAKE TYPE

Let's say you need to produce a price list ASAP. Ordinarily, you'd spec the copy, send out for type, wait a day for it, send it back for corrections, wait a day for it, paste it up, send it to the print shop and wait another day. Working time: five days.

Using a personal computer, a word processing program and a laser printer equipped with a PostScript interpreter, you can produce the same price list in only two hours. Which leaves much more time to improve your layout.

HERE'S HOW IT WORKS.

You start with your copy on a disk. Then, from your software menu you choose a typestyle. Laser printers with PostScript interpreters come with a variety of built-in typefaces, and you can buy additional fonts from the fast-growing Adobe Type Library. These aren't off-brand copies or clones with funny names—they're the real typefaces from ITC and Mergenthaler.

Next, you arrange your type right on the computer screen, watching for ways to improve your price list as you go.

INSTANT PRICE LIST.

When you're finished fine-tuning your job on the screen, simply send it to your laser printer, and presto!

Or, if you need to print it offset, you can give your disk to a service center that has a high-resolution printer with the PostScript interpreter. You'll get back perfect type, camera-ready, just the way you designed it. Application files made without the PostScript language won't let you do that.

But type is only part of the picture. PostScript software can also improve your graphics. It's built into programs

like the Adobe Illustrator 88 package. Not only will PostScript software allow your artwork to be more creative, it'll cut your working time down to size.

GRAPHICALLY SPEAKING.

For example, you can create a line drawing directly on the screen, or scan a thumbnail sketch (or blueprint, or photo, or scrap art) and let Adobe Illustrator 88 software automatically trace it.

Instead of the crude lines you'd normally get, PostScript software lets you create perfect curves, clean diagonals and custom corners, faster than you can say India ink.

It also allows for a wide variety of textures, patterns and halftones, plus any line weights you can think of. Depending on the type of printer you use, you can get resolution as high

as 2540 dots per inch—better quality than any inking job.

You can also get any level of gray the printer can handle. Even shades of difference your eye can't perceive. You can spec color tints, too, right from the PANTONE matching system. You can blend one color into another. You can mask off an area to add depth and shadow. You can manipulate your images. Squeeze them. Distort them. Bend them to your will.

How much of this is possible without PostScript software? Zip.

LET'S TALK PAGE LAYOUT.

Say you want to combine type, line art and photos all on the same page. I've already told you about the type and line. As for the photos, all you need is a digital scanner or nearby service center to scan them for you.

Once you've collected your design elements on disk, a desktop publishing program using PostScript software will

let you mix your ingredients on the page. The beauty of this system, of course, lies in the number of variations you can try before your ideas ever touch paper.

When you *are* ready to print, you have even more choices.

You can produce your job on any laser printer equipped with the PostScript interpreter.

Or you can send your disk to a service center for high-resolution output. You'll get back galleys of completed camera-ready pages, while your laser pages serve as review copies.

Or you can go straight to high-resolution film, only a step away from making plates.

IS THIS A REVOLUTION?

Absolutely. And here's why.

Adobe PostScript software has become the standard language of electronic publishing, the way the internal combustion engine became the standard of the automobile industry. There are already more than 550 programs that support PostScript printers, and the list of new products keeps growing.

Soon computers will come equipped with Adobe's new Display PostScript system. For the first time, what you'll see on the screen is exactly what you'll get.

And remember. PostScript will always be PostScript. So the files you create today will also work in the future, no matter what new PostScript software products come onto the market.

P.S. I LOVE YOU.

Truth be told, I sometimes miss the old days, when a week was considered normal turnaround, and a printed piece didn't have to look so beautiful.

On the other hand, this PostScript software is making *me* look so beautiful, if I could see it, I'd probably kiss it.

You are... party af... customers will be treated to a special preview of our newest product, the unbelievable Swiss Kitchen Knife. It not only minces, dices and chops, it can slice cheese and pull corks all night long (as you will see). Please join us at 5 at the Park Avenue Hotel. RSVP Ann.

STORYBOOK VIDEOS

Five-Year Record of Corn Production in the United States

ADOBE SYSTEMS INCORPORATED

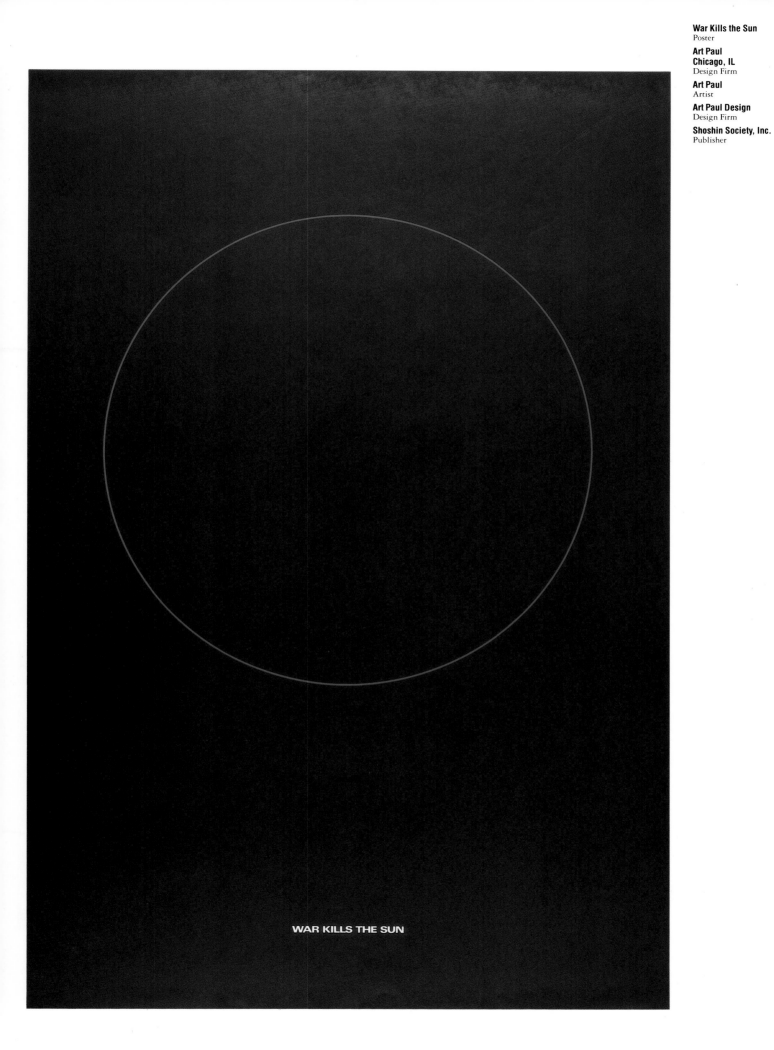

WAR KILLS THE SUN

War Kills the Sun
Poster

Art Paul
Chicago, IL
Design Firm

Art Paul
Artist

Art Paul Design
Design Firm

Shoshin Society, Inc.
Publisher

Stereo Review/**November 1987—Wired**
Magazine Illustration

Sue Llewellyn
New York, NY
Art Director

Anthony Russo
Artist

Diamandis Communications Inc.
Publisher

WIRED

PUTTING TOGETHER AN AUDIO NETWORK FOR
GOOD, CLEAN SOUND THROUGHOUT THE HOUSE

O NE rainy March evening several years ago, I inadvertently bought almost a thousand feet of wire. It was attached to a house my wife and I had fallen in love with, and as we were admiring the window casements and asking what we hoped were pertinent questions about the plumbing, the owner casually mentioned that he had had the whole place wired for audio. We bought the house, of course, and one of my projects was to find out just *how* it had been wired—there were bits of zipcord protruding from holes in every room, but nothing was labeled. Even the former owner had no idea what was connected to what; a nephew had strung the wires, but since he had failed to provide any indication as to where any of them came from or went, the system had never been used.

Like many households, ours has audio of some sort in several rooms. There's a full-blown system in the living room, complete with CD player, open-reel tape deck, turntables of several varieties, and a range of mostly useless signal processors. The family room houses an audio/video setup, while an old receiver and a pair of speakers in the bedroom serve as a clock radio, thanks to a handy little electronic timer. And occasionally we listen to a boombox on the patio when we want to drive our neighbors crazy.

These are all independent systems, with different functions, and normally we use only one at a time. There are occasions, however, when it is useful to tie all of them together. Some of our parties tend to meander from room to room, inside and outside, for instance, and the idea of having musical consistency has some

BY IAN G. MASTERS

BYTE—**Computers I**
Magazine Illustration

Roslyn Frick
Art Director

Steven Guarnaccia
New York, NY
Artist

McGraw-Hill Inc.
Publisher

The Inspectors
Magazine Illustration

Wayne Fitzpatrick
Art Director

Brad Holland
New York, NY
Artist

Science '85
Publisher

TECHNOLOGY FOR PEACE
PART THREE

THE INSPECTORS

Their job is nothing more than monitoring the world's supply of nuclear fuel. Their intent is nothing less than preventing the spread of nuclear weapons.

BY CARL POSEY

THE MAN FROM VIENNA is tense. He has spent an uncomfortable night in a remote corner of this foreign nation, an unfamiliar breakfast will not let itself be digested, and he is preoccupied with rumors that all is not what it seems here. The sight of his destination through a gap in the black trees—the almost windowless gray boxes, the stacks and cooling towers, the domed enclosures where atoms are split for electricity and technical repute—stimulates yet another mental rehearsal of the careful routine the day must follow.

He has gone through it many times before, at places where uranium is purified, loaded into fuel rods, consumed, cooled, or resurrected in another "combustible" form. Whether the plants lie in nations with thousands of nuclear warheads or in nations whose leaders thirst for their first taste of explosive fission, the essence of the routine is always the same. The visitor bears some mild celebrity, for against its instincts, this nation, on this day, relaxes

Carl Posey's novel Prospero Drill *will be published by St. Martin's Press in January. His most recent novel of science and espionage,* Dead Issue, *was published in England last spring.*

44 SCIENCE 85 DECEMBER

its sovereignty, endures his scrutiny, just for him and for what he represents.

To his host, the operator of this facility, the nuclear safeguards inspector from the International Atomic Energy Agency (IAEA) in Vienna is both colleague and adversary. They share a belief in a nuclear future, but its evolution can make great trouble between them. The nation has known of this inspection for only a month, the reactor operator for barely a week. He shrugs. If all goes well, it can be done in one morning without even shutting down the reactor.

What follows lies at the core of the delicate balance between wars that are largely ritual and wars that are hot. The inspector must verify that the movement and location of uranium in this nation are exactly as the host nation says they are. He is here to prove nothing beyond the presence of a certain amount of nuclear material. It is verification, not detection. "Countries do not submit to safeguards to prevent themselves from doing something," explains Hans Blix, the Swedish director general of the IAEA. "They submit because they have decided that they will not make use of a facility for producing weapons. And this willpower, the political will of a country, is where nuclear nonproliferation resides."

BYTE—Computers II
Magazine Illustration

Roslyn Frick
Art Director

Steven Guarnaccia
New York, NY
Artist

McGraw-Hill Inc.
Publisher

Advertising/Zanders
Poster

Seymour Chwast
New York, NY
Art Director/Designer

Seymour Chwast
Artist

The Pushpin Group
Design Firm

Zanders Fein Papier
Client/Publisher

Phases of the Moon/1988
Poster/Calendar

Roger Zimmerman
New York, NY
Designer

Weber Lithography
Client

Peripheral Vision
Poster

Michael Vanderbyl
San Francisco, CA
Designer/Artist

Vanderbyl Design
Design Firm

San Francisco American
Institute of Architects
Client/Publisher

The unleashed power...
Poster

Regine de Toledo
Art Director

Brad Holland
New York, NY
Artist

Committee for Nuclear
Disarmament
Publisher

**Connections
Robotic**
Poster

**Tom Geismar
New York, NY**
Art Director/Designer

Tom Geismar
Artist

**Chermayeff & Geismar
Associates**
Design Firm

Simpson Paper Co.
Publisher

**Monte Dolack Suburban
Refuge**
Self-Promotional Poster

**Monte Dolack
Missoula, MT**
Designer

Monte Dolack
Artist

Monte Dolack Graphics
Design Firm

Monte Dolack Graphics
Publisher

What Is It About?
Magazine Illustration

Judy Garlan
Boston, MA
Art Director

Jean-Michel Folon
Artist

The Atlantic Monthly Co.
Publisher

1930s, one of their arguments for strategic attack on cities and factories deep within enemy territory was the chance it offered to avoid another great bloodletting by troops on the ground. The devastation of London, Coventry, Hamburg, Dresden, Berlin, Hiroshima, and Nagasaki duly followed. The significant change at Hiroshima was that one plane, with one bomb, accomplished what it had taken a thousand planes to do before.

The flood of memoirs that followed the First World War broached the awful disparity between the reasons for the war and the war itself. What was it about? How did it start? Why was it allowed to continue? What did it settle? The war bled a generation white, destroyed three of the four dynasties that had ruled in 1914—the Hapsburgs in Austria-Hungary, the Hohenzollerns in Germany, the Romanovs in Russia—and ended in a vindictive peace, which only set the stage for a new war in 1939. The origins of the war have recently been revived as a subject for scholarly study, for a simple and practical reason: the world of 1914 bears a certain disturbing resemblance to our own. Then, as now, the Great Powers were heavily armed. Two alliances confronted each other. An upstart power—Germany—was demanding an equal role on the world stage. Britain was frightened by Germany's construction of big modern battleships. Why did Berlin need this "luxury fleet," if not to challenge British supremacy on the seas? British Conservatives insisted that new dreadnoughts

must be built to deter the Germans, and damn the expense. In 1908 they campaigned for the ships on the slogan "We want eight and we won't wait!" Crises were frequent; demands were routinely backed up by military gestures implying a threat of war. The Great Powers confronted each other in peripheral arenas—the Balkans then, the Middle East now. When Bismarck was asked what he thought would set off the next big European war, he said, "Some damned foolishness in the Balkans." But perhaps the most disturbing contemporary parallel is the confidence that all this long preparation for war meant nothing; there would be no war. For twenty or thirty years the optimists were right. Until 1914, the diplomats always managed to settle things before armies were mobilized and shots were fired.

Why did they fail in 1914? In a recent essay, Michael Howard confessed that he has lately begun to rethink the whole subject of the origins of the First World War. He said that he used to assume that an event so large must have had causes to match—deep undercurrents of social change and irreconcilable differences between nations, pushing events into a kind of inevitable, fatal slide that no mere statesman could hope to brake. But now Howard is not so sure. Maybe it was simple, after all—the result of bungling. Maybe Lloyd George, the British prime minister during the last half of the war, was right when he said "We all muddled into war." We might call this the tinderbox the-

ory of the causes of wars: The problem is not sources of conflict, things nations might be expected to fight *about*, but simply the readiness for war itself. Military strength on one side inevitably arouses fear in the other, which strives to catch up. The first grows alarmed in turn. In such a world it does not take something large to start a war but something small, something unexpected—an assassination in a provincial town like Sarajevo, say—something that might be considered, perhaps for purely tactical reasons, to require a determined response. After that, one thing can lead to another. The armies of Europe did not *have* to mobilize in the summer of 1914. They just did.

You can see the appeal here to a scholar interested in our own day. Clausewitz says that war is the continuation of policy by other means. It is supposed to make sense. But the outbreak of war in 1914 made no sense. Nothing was at stake that could reasonably be said to justify war on a continental scale. Even statesmen at the time admitted as much. But Europe was ready for war. Once the Great Powers began to mobilize, they could not stop. The statesmen of our own day insist that there will be no great war between Russia and the United States so long as war doesn't make sense. Nuclear weapons make it impossible—but impossible, alas, in Bliokh's sense, which is to say, suicidal.

Michael Howard is currently researching a book on attitudes toward war before 1914, but it is slow going. At Ox-

ford, he is beseiged with requests for interviews, television appearances, book reviews, advice on military matters. He writes and speaks about strategic questions with an unusual degree of detachment. As a historian, he is naturally inclined to see modern parallels to things in the past, and as a British subject he has a keen interest, but no direct involvement, in what the planners in Washington are up to. It is Americans and Russians who run the world now.

In January of 1980, the London *Times* published a letter from Howard criticizing, but also explaining, the NATO "double decision" of 1979, to negotiate limits on Euromissiles while preparing to deploy Pershing IIs and cruise missiles if the negotiations failed. The English historian E. P. Thompson, a veteran of the British left, read Howard's letter and flew off the handle. He was horrified by the prospect of a nuclear war in Europe, which he felt the "double decision" promised, and he wrote a long, ferocious essay, "Protest and Survive," which loosed a whirlwind antinuclear movement in Britain. Thompson has since apologized to Howard for his hasty assumption that Howard was somehow *for* a nuclear war in Europe, or at least willing to run the risk of one. At the time, Howard the scholar was aghast, he wrote, at finding himself facing "the polemical equivalent of Björn Borg on the Centre Court," but of course he made a return volley. His response pointed out that the threat of nuclear war does not stem from any

The Changing Economic
Landscape
Magazine Cover

Judy Garlan
Boston, MA
Art Director

José Cruz
Artist

The Atlantic Monthly Co.
Publisher

The Dynamic of Decline
Magazine Illustration

Judy Garlan
Boston, MA
Art Director

James Endicott
Artist

The Atlantic Monthly Co.
Publisher

Making Babies
Magazine Cover

Rudolph Hoglund
Art Director

Carol Gillot
New York, NY
Artist

Time, Inc.
Publisher

Robowash
Calendar Page

Douglass Grimmett
New York, NY
Art Director/Designer

Chuck Carlton
Photographer

The Grimmett Corporation
Design Firm

Workman Publishing
Publisher

Zurek
Self-Promotional
Advertisement

Nikolay Zurek
San Francisco, CA
Designer

Nikolay Zurek
Photographer

PHOTOMETRO
Publisher

Lotus Development
Corporation
Annual Report Illustration

Michael Weymouth
Cambridge, MA
Art Director

Tom Laidlaw
Designer

Michael Weymouth
Photographer

Weymouth Design Inc.
Design Firm Agency

Lotus Development
Corporation
Client

W.A. Krueger Annual Report 1987
Annual Report Illustration

Alfredo Muccino and Melissa Passehl
San Jose, CA
Art Director

Ken Jacobsen
Artist

Muccino Design Group
Design Firm

W. A. Krueger Co.
Client

Krueger markets build their success on people's interest in individuality and personal selection.

Mᴀᴄᴍɪʟʟᴀɴ, ɪɴᴄ.

Information

is changing the future

of business...now.

1986 Annual Report

Macmillan, Inc., 1986 Annual Report
Annual Report Cover

Philip Gips
Art Director

Kent Hunter
Designer

Mark Penberthy
Artist

Gips & Balkind + Associates/ The GBA Group
New York, NY
Design Firm

Macmillan, Inc.
Client

Vɪᴛᴀʟ Sɪɢɴꜱ

A PATIENT IS MORE THAN THE SUM OF PHYSICAL FINDINGS

BY PERRI KLASS

On morning rounds in the newborn nursery, all of us were going around the room and discussing one baby after another. A nurse was feeding a red-faced little four-pounder while rocking back and forth in a rocking chair. She held him up. "You can round on this baby only if one of you can recognize him," she said.

Well, we couldn't. I mean, usually the babies lie in their labeled beds, and you go look at one expecting to see that baby and only that baby. But let's face it, newborns look alike. And in a room with twenty or so of them, who can recognize one specific baby? The nurse can, because she has spent hours feeding and changing the babies she takes care of, and that's how you get to know a baby. Ask a doctor about a baby in the newborn intensive care unit, and you'll hear about its medical problems, you'll get numbers and lab results and diagnostic possibilities. Ask a nurse, and you'll also get information about the baby's likes and dislikes, its personality.

Of course, if there had been something distinctly wrong with the baby, we would all have recognized him immediately. If he had been in some way abnormal looking, or so desperately ill that he was hooked up to every possible machine—then we would have spent so much time watching by his bedside that this would have been one of the truly familiar bodies in the room.

What does it mean that you can know a baby almost inside out, know what his blood looks like, know the acidity of his urine, know how many calories he's taken in over the past 24 hours, and still not be able to pick him out of a lineup? Well, partly, it means that newborn babies do look pretty much alike. They don't have much hair, so you can't remember them as "the blond one with the curls." They all tend to

You can examine the patient in detail, listen to the heart, lungs, and stomach, feel all pulses—and never see the person

scrunch up their faces and cry when you examine them. But the problem's more general than that.

The fact is, you can examine a patient in detail, listen with care to heart and lungs and stomach, feel all pulses, look deep into the eyes, study a lesion with great attention—and never see the person. That applies to a patient of any age. And there are aspects of medical training that point you in the direction of developing this habit.

As a medical student in the hospital, you run around looking eagerly for "physical findings." I mean, there you are, learning the fine art of physical diagnosis, and you need to see examples of the abnormal. You can listen to a hundred normal hearts, but you still need to hear a murmur. You can feel a hundred normal abdomens, but you need to feel an abdomen with a mass in it. You can do a hundred normal rectal ex-

ams, but you need to do one where the prostate is enlarged. The problem, of course, is that not all patients are eager to have ten avid medical students line up to listen to that fascinating murmur—let alone to feel that intriguing mass, let even further alone to check out that amazing prostate. So word spreads in the hospital, great physical finding on the guy in Room Five, you gotta listen to his murmur. And medical students may wander in and ask permission, and if the guy is nice he gives it, and everyone listens. There's nothing wrong with this; you have to have something shown to you so you can recognize it the next time. But it can lead to a ghoulishly detached way of seeing patients: Did you listen to the murmur in Room Five, did you feel that mass in Room Eight, did you look at the rash in Room Sixteen?

Also, as a medical student, you can get fixed on physical findings; you're convinced your physical diagnosis skills are inadequate, you'll report that someone has a murmur and then no one else will hear one, you'll report that the pulses are normal and it will turn out there are no pulses in the left foot. You often have to decide whether to be honest and describe what you're really seeing or hearing or feeling, or whether just to say whatever you know the senior people have heard or seen or felt. (When a friend of mine was doing gynecology, he was told to feel an internal mass on a patient. He couldn't feel anything, and decided to be honest about it. The senior doctor went back to show him the mass, and found that it had in fact resolved—my friend was right. The senior doctor complimented him on his diagnostic acumen. "Little did he know," my friend said to me, "that I wouldn't have been able to feel the mass even if it had been there. I can never feel masses.")

Anyway, it's perfectly understandable that at the beginning of clinical training you sometimes lose sight of your patients

Dr. Klass is an intern in pediatrics.

DISCOVER · OCTOBER · 1986 **21**

A patient is more than the sum of physical findings
Magazine Illustration

Eric Seidman
Art Director

Mirko Ilić
New York, NY
Artist

Discover **Magazine**
Publisher

Astronomy in Arizona
Poster

Josh Young
Tucson, AZ
Art Director

Lee Barker
Designer

Steward Observatory and
NASA
Photographers

University of Arizona,
Graphic Services
Agency

Steward Observatory,
University of Arizona
Publisher

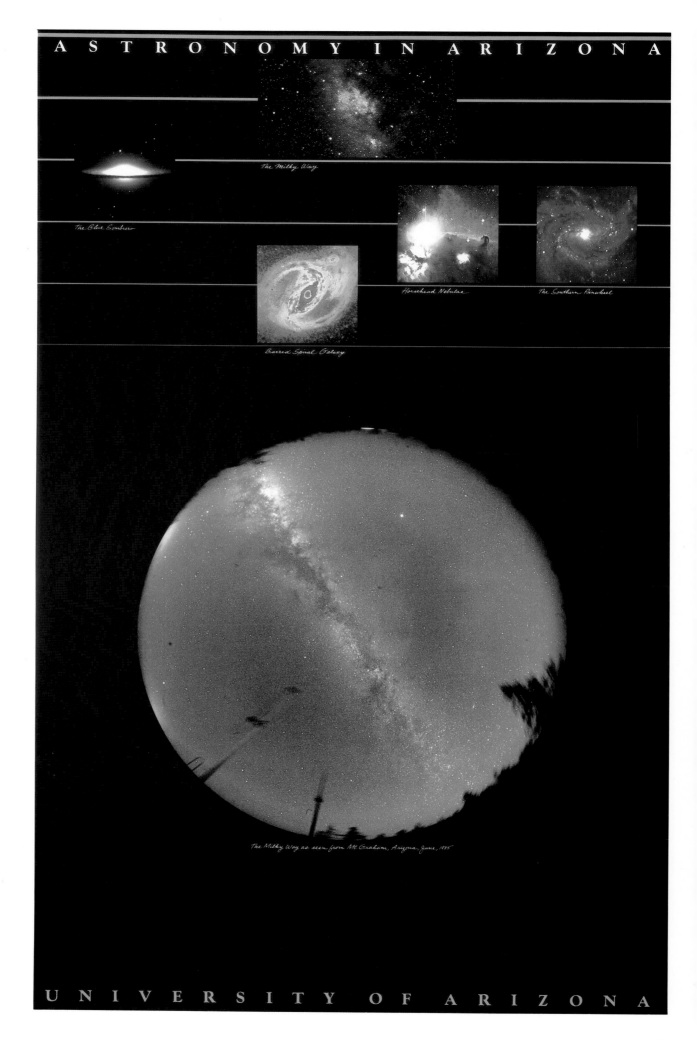

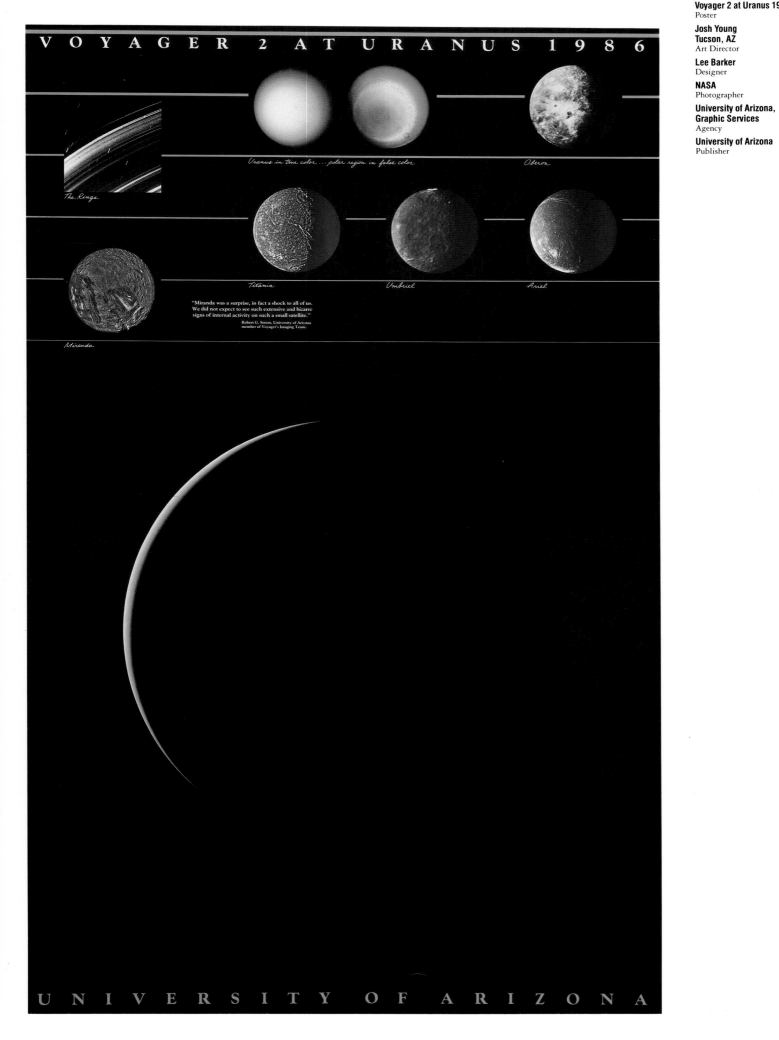

Voyager 2 at Uranus 1986
Poster

Josh Young
Tucson, AZ
Art Director

Lee Barker
Designer

NASA
Photographer

University of Arizona,
Graphic Services
Agency

University of Arizona
Publisher

**Introducing contact lenses
for chickens**
Booklet

**Bruce Crocker
Boston, MA**
Designer

Bruce Crocker
Artist

Eric Bedell
Photographer

Crocker, Inc.
Design Firm

Animalens, Inc.
Client

Introducing contact lenses for chickens.

**L&N Housing Corporation
1985 Annual Report**
Annual Report

**Chris Rovillo
Dallas, TX**
Designer

**Hugo Gernsback, Grant
Hamilton, Buckminster Fuller,
King Camp, Gillette, Hugh
Ferris**
Artists

**Richards Brock Miller
Mitchell and Associates/The
Richards Group**
Design Firm

L&N Housing Corporation
Client

Hugo Gernsback

10,000 Years Hence, a Prediction

1922

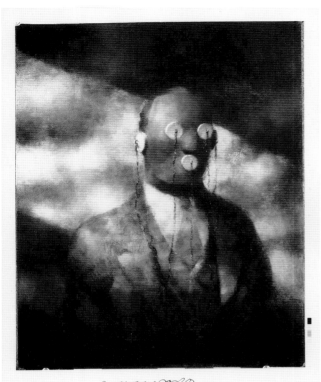

Brad Holland, Kansas City Art Directors Club
Flyer Announcement
Brad Holland
New York, NY
Artist
Kansas City Art Directors Club
Publisher

The Quality Review/Summer '87—Reliability by Design
Magazine Illustration
Peter Deutsch
Art Director
Gene Greif
New York, NY
Artist
Deutsch Design, Inc.
Design Firm
American Society for Quality Control
Publisher

New Music America
Poster/Mailer

Robert Appleton
Hartford, CT
Art Director/Designer

Robert Appleton
Photographer

Appleton Design Inc.
Design Firm

Tigertail Productions
Client

TEK 3
Poster

Michael Vanderbyl
San Francisco, CA
Designer/Artist

Vanderbyl Design
Design Firm

Modern Mode Inc.
Client/Publisher

T E K 3

Sculptured
and
playful
furniture
forms
expressed

In an
imaginative
combination
of
delicate
scale,

brilliant
color
or the
richness
of natural
wood.

A furniture
system
from
Modern Mode
Incorporated.
415.568.6650

Learning Lasts a Lifetime
Poster

Bill Freeland
Art Director

Brad Holland
New York, NY
Artist

LaGuardia Community College/CUNY
Publisher

Learning Lasts A Lifetime

LaGuardia Community College/CUNY ⊛ 718/482-7206

Michael Vanderbyl
Self-Promotional Poster

Michael Vanderbyl
San Francisco, CA
Designer/Artist

Vanderbyl Design
Design Firm

Graphic Sha Publishers
Publisher

MICHAEL VANDERBYL

***Stroll*—Double Issue 6/7**
Magazine Cover

Melissa Feldman
New York, NY
Designer

Alexander Beck for
FORMALHAUT
Photographer

***Stroll* Magazine**
Publisher

A Critique of America
September/October 1987
Magazine Cover

Mary Lou Morreal
San Diego, CA
Art Director

Jimmy Dorantes
Photographer

A Critique of America
Publisher

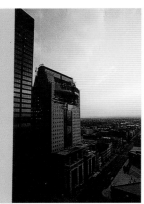

From the Ground Up
The Humana Building
Time-Lapse Book

Julius Friedman
Louisville, KY
Art Director/Designer

Michael Brohm
Photographer

Images
Design Firm

Images/Donna Lawrence
Productions
Publisher

Fastpath/IBM-DEC Synergy
Folder Illustrations

Alfred C. Sanft and
Brad Ghormley
Phoenix, AZ
Designers

John Nelson
Artist

Smit Ghormley Sanft
Design Firm

Intel Corporation
Client

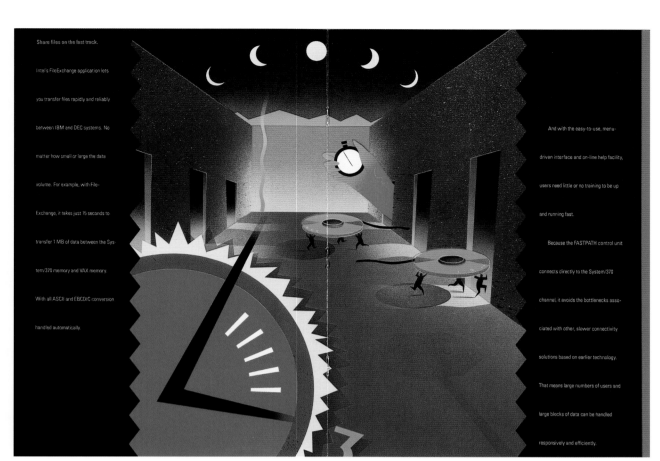

Share files on the fast track.

Intel's FileExchange application lets you transfer files rapidly and reliably between IBM and DEC systems. No matter how small or large the data volume. For example, with File-Exchange, it takes just 15 seconds to transfer 1 MB of data between the System/370 memory and VAX memory. With all ASCII and EBCDIC conversion handled automatically.

And with the easy-to-use, menu-driven interface and on-line help facility, users need little or no training to be up and running fast.

Because the FASTPATH control unit connects directly to the System/370 channel, it avoids the bottlenecks associated with other, slower connectivity solutions based on earlier technology. That means large numbers of users and large blocks of data can be handled responsively and efficiently.

Access two worlds from one terminal.

Intel's FullView Series broadens your users' view of their computing resources. By letting them run full screen applications on either type of system—*from one terminal.*

That's because FullView can automatically transform an IBM 3270-type terminal into a DEC terminal, and vice versa. So that from the same terminal, you can logon to either system as

your security permits, to access data, applications, and special peripherals.

So now, users throughout your organization need just a single terminal on their desks to access both environments. Plus, you can eliminate the licensing cost and administrative burden of duplicating applications software on both systems. And you no longer waste time and money translating and porting information between IBM and

DEC systems.

***The New York Times Book
Review***—Funky Bits, Funky
Bytes
Magazine Illustration

Steven Heller
Art Director

**Mirko Ilić
New York, NY**
Artist

The New York Times
Publisher

***The Los Angeles Times—
We pioneers destroy the
wilderness we love***
Newspaper Illustration

Tom Trapnell
Art Director

**Mirko Ilić
New York, NY**
Artist

The Los Angeles Times
Publisher

**Pierre, Pierre, You are a
Hopeless Realist**
Magazine Cover

Carla Block
Art Director

Everett Peck
Artist

Art Direction/**Advertising
Trade Publishing, Inc.**
Publisher

294

**Minnesota Guide/Lawn &
Garden, Pool & Patio**
Newspaper Supplement
Cover
Lynn Phelps
Minneapolis, MN
Art Director

Daniel Craig
Artist

Star Tribune
Minneapolis/St. Paul
Publisher

**The Omar C. Bradley
Multi-Purpose All-Terrain
Strolling Vehicle Designed
by the Pentagon**
Magazine Illustration

Veronique Vienne
Art Director

Dugald Stermer
San Francisco, CA
Artist

Parenting Magazine
Publisher

**Dimensions '85/Predictions
Henry Ford**
Illustration

Franca Bator
Art Director

John Craig
Soldiers Grove, WI
Artist

**Jonson Pedersen Hinrichs &
Shakery**
Design Firm

Simpson Paper Co.
Publisher

The Cover Show

Serving on a jury is always a learning experience. Just when it seems there is nothing new under the sun, someone manages to come along with a fresh approach and shake up our preconceptions. I could single out, in this respect, Helene Silverman's remarkable series of covers for *Metropolis* Magazine—collages, very painterly in feeling, each different from the next and free of apparent formula or predictability. But there are no "best in show" awards, and in fact every piece selected for this exhibition meets very stringent criteria. Members of the jury looked for exceptional quality and innovation. Covers had to be stimulating in content and excellent in execution, illustration, and typography. Good illustration alone—and there was a lot of extremely good work—was not in itself enough. All elements had to be integrated and work together. It was interesting to note that the strongest work this year fell into certain categories. The most carefully designed covers seemed to be for books, while record covers, to the contrary, were least successful overall. Individually, of course, each of us had a few other favorites we would have liked to add, but in the end we felt that the 84 works selected from among 3,460 entries represent the very highest achievement in cover design this year.

Paul Davis
Chairperson

The Cover Show
Call for Entry

Paul Davis Studio
Design Firm

Gamma One Conversions Inc.
Photography

Tribeca Typographers, Inc.
Typography

Mohawk Paper Mills
Paper

Stevens Press
Printing

Thomas B. Allen

Innovators of American Illustration
Exhibition Poster

Thomas B. Allen
Illustrator

University of Kansas
Client

BOCA
Poster

Thomas B. Allen
Illustrator

Don Trousdell
Designer

Barbar Group
Client

Innovators of American Illustration

Organized by the
Department of Design
and the Spencer
Museum of Art,
The University
of Kansas

A Mid America Arts
Alliance Program
made possible by
Hallmark Cards, Inc.

NORMAL

"Goddess of bossy underlings, normality..." –W.H. Auden, *A Letter to Lord Byron*

"The concept of normality is a surrender." –Hans Keller

$7.50

NORMAL

NUMBER 1 : SUMMER 1986

Eco on Calvino

The Virgin in Yugoslavia

Baghdad/Shanghai

Jasper Johns

Burning Houses

Beirut Under Siege

Robert Mapplethorpe

The Princess Who Fell in Love With the Slave

Conversation with Goya

JOHN DOLLAR
A NOVEL

John Dollar
A Novel
Marianne Wiggins

Marianne Wiggins

Harper & Row

Fred Woodward

Rolling Stone
Michael Jackson in Fantasyland
Magazine Cover

Fred Woodward
Art Director/Designer

Anita Kunz
Illustrator

Straight Arrow Publishers
Publisher

Rolling Stone
Madonna
Magazine Cover

Fred Woodward
Art Director/Designer

Herb Ritts
Photographer

Roy Kratochvil
Photo Editor

Straight Arrow Publishers
Publisher

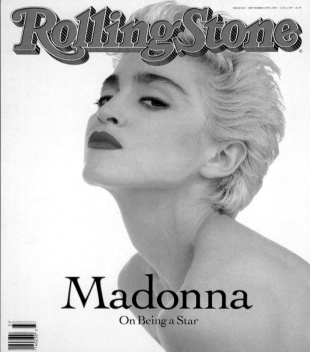

FEBRUARY 1988 $2.00 / $2.50 Can.

The Atlantic

JAMES FALLOWS IN THE PHILIPPINES / SEAMUS HEANEY ON OSCAR WILDE

LOVE TRIANGLES

*From Oedipus Complex to adultery,
an ancient obsession*

BY ETHEL S. PERSON

AUGUST 1988 $2.50

The Atlantic

RELIGION AND VIOLENCE: THE SIKHS / THE ART MUSEUM AS BAZAAR

ARE WE ALONE?
BY GREGG EASTERBROOK

THE ALIEN-SEEKING BUSINESS IS A
DISCOURAGING ONE, BUT SOME
SCIENTISTS ARE STILL WAIT-
ING FOR A CALL FROM
OUT THERE

ONE DOLLAR · DECEMBER 18, 1978

How Jim Jones
Seduced San Francisco
By Jeanie Kasindorf

NEW WEST

The Making of a
Madman

By Phil Tracy

THE BILLIE HOLIDAY STORY VOLUME II

This album contains previously released material.

**Oregon Shakespearean
Festival Association**
Promotional Kit Cover

**Ken Parkhurst
Los Angeles, CA**
Art Director

Denis Parkhurst
Designer

Denis Parkhurst
Artist

**Ken Parkhurst &
Associates, Inc.**
Design Firm

**Oregon Shakespearean
Festival Association**
Publisher

**Commercial Printing
Company**
Printer

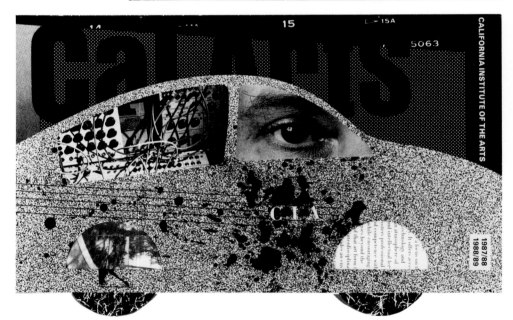

*California Institute of
the Arts 1987/88, 1988/89*
Catalog Cover

**John Coy
Culver City, CA**
Art Director/Designer

John Coy
Artist

COY, Los Angeles
Design Firm

California Institute of the Arts
Client

CCI Typographers
Typographer

**Nissha Printing Company,
Limited**
Printer

If I Ran TV. . .
Brochure Cover

Jeffrey Keyton
New York, NY
Art Director

Lane Smith
Art Director

Nickelodeon
Design Firm

Nickelodeon
Publisher

Ascenders Typographic
Service Inc.
Typographer

Benchmark Graphics
Printer

Issey Miyake: Photographs
by Irving Penn
Book Jacket

Kiyoshi Kanai
Art Director/Designer

Nicholas Callaway
Editor

Irving Penn
Photographer

Kiyoshi Kanai Inc.
Design Firm

New York Graphic Society/
Little, Brown and Company
Publisher

Michael and Winifred Bixler
Typographer

Nissha Printing Company,
Limited
Printer

**Beautiful Faces and
Champion's Color Collection**
Brochure Cover

**Paula Scher
New York, NY**
Art Director/Designer

Paula Scher
Artist

Koppel & Scher
Design Firm

**Champion International
Corporation**
Client

Koppel & Scher
Letterers

L. P. Thebault Company
Printer

SPY: Kennedy Bashing!
Magazine Cover

Alexander Isley
New York, NY
Art Director

Neil Selkirk (body)
Dennis Brack (head)
Photographers

SPY Publishing Partners
Design Firm

SPY Publishing Partners
Publisher

Trufont Typographers, Inc.
Typographer

United Litho Co.
Printer

SPY: The SPY 100
Magazine Cover

Alexander Isley
New York, NY
Art Director

Various
Photographers

SPY Publishing Partners
Design Firm

SPY Publishing Partners
Publisher

Trufont Typographers, Inc.
Typographer

United Litho Co.
Printer

SPY: Jerks
Magazine Cover

Stephen Doyle
New York, NY
Art Director

Rosemarie Sohmer
Designer

Chris Callis
Photographer

Drenttel Doyle Partners
Design Firm

SPY Publishing Partners
Publisher

Trufont Typographers, Inc.
Typographer

Partners in Performance:
First Bank System 1987
Promotional Kit

Charles S. Anderson
Minneapolis, MN
Art Director/Designer

Charles S. Anderson and
Lynn Schulte
Artists

The Duffy Design Group
Design Firm

First Bank Systems, Inc.
Client

Typeshooters
Typographer

Litho Specialties and
Process Displays
Printer

Partners in Performance:
First Bank System 1987
Booklet Cover

Charles S. Anderson
Minneapolis, MN
Art Director/Designer

Charles S. Anderson and
Lynn Schulte
Artists

The Duffy Design Group
Design Firm

First Bank Systems, Inc.
Client

Typeshooters
Typographer

Litho Specialties
Printer

IDCNY 26: Chair Fair
Trade Newsletter Cover

Massimo Vignelli
New York, NY
Art Director

Michael Bierut
Designer

Lori Shulweis
Photographer

Vignelli Associates
Design Firm

International Design
Center, New York
Publisher

Concept Typographic
Services, Inc.
Typographer

Combine Graphics
Printer

Anything Goes
Theater Program

David Garner
Art Director

James McMullan
New York, NY
Designer/Artist

James McMullan, Inc.
Design Firm

Metropolis: April 1986
Magazine Cover

Helene Silverman
New York, NY
Art Director/Designer

Helene Silverman
Artist

Metropolis Magazine
Publisher

**Metropolis: September
1986**
Magazine Cover

Helene Silverman
New York, NY
Art Director/Designer

Helene Silverman
Artist

Metropolis Magazine
Publisher

THE ARCHITECTURE & DESIGN MAGAZINE OF NEW YORK

METROPOLIS

DEC 1986 $3.50

YOU CAN TELL A BOOK BY ITS COVER

WHAT CHILDREN READ IN ARCHITECTURE BOOKS

WARD BENNETT'S LIFE IN DESIGN

THE HEYDAY OF HIGHWAY AND BRIDGE BUILDING

NEW TOWNS PLANNED IN ISRAEL

THE ARCHITECTURE & DESIGN MAGAZINE OF NEW YORK

METROPOLIS

APRIL 1988 $3.95

WHAT IS A TYPEFACE?

SERVING UP FAST FOODS

BEAUTY IN BUILDING SITES

STABLES FOR CARS

CERAMICS & ARCHITECTURE

Metropolis: December 1986
Magazine Cover

**Helene Silverman
New York, NY**
Art Director/Designer

Helene Silverman
Artist

Metropolis Magazine
Publisher

Metropolis: April 1988
Magazine Cover

**Helene Silverman
New York, NY**
Art Director/Designer

**Helene Silverman and
Jeff Christensen**
Artist

Metropolis Magazine
Publisher

**The New Yorker:
March 10, 1986**
Magazine Cover

Lee Lorenz
Art Director

**Brad Holland
New York, NY**
Artist

The New Yorker
Publisher

**The New Yorker:
November 23, 1987**
Magazine Cover

Lee Lorenz
Art Director

**Brad Holland
New York, NY**
Artist

The New Yorker
Publisher

**Metropolis: October
1986**
Magazine Cover

**Helene Silverman
New York, NY**
Art Director/Designer

Elaine Ellman
Photographer

Metropolis Magazine
Publisher

**Metropolis: December
1987**
Magazine Cover

**Helene Silverman
New York, NY**
Art Director/Designer

Helene Silverman
Artist

Metropolis Magazine
Publisher

**Hard-Boiled Defective
Stories**
Paperback Cover

Louise Fili
New York, NY
Art Director

Charles Burns
Designer/Artist

Pantheon Books
Publisher

Charles Burns
Letterer

Coral Graphics
Printer

SLAP
Brochure Cover

John Coy
Culver City, CA
Art Director

John Coy and Kevin Consales
Designers

Kevin Consales
Artist

Charles Labiner
Copywriter

COY, Los Angeles
Design Firm

**Hopper Papers/
Georgia-Pacific Corporation**
Client

CCI Typographers
Typographer

Lithographix, Inc.
Printer

Martini Ranch/Holy Cow
Album Cover

Laura LiPuma
Burbank, CA
Art Director

Lou Beach
Collage Artist

Sire Records Co./Warner Bros. Records Inc.
Publisher

Dvorak/Smetana
Album Cover

Carin Goldberg
New York, NY
Art Director/Designer

Carin Goldberg Graphic Design
Design Firm

Nonesuch Records
Publisher

The Type Shop Inc.
Typographer

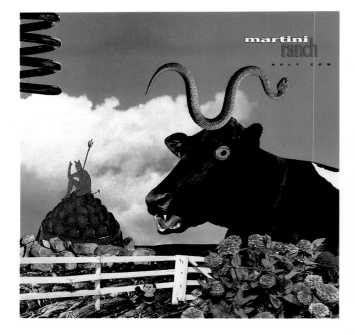

ArtCenter Review: 2
In-House Magazine

Kit Hinrichs
San Francisco, CA
Art Director

Kit Hinrichs and Lenore Bartz
Designers

Henrik Kam
Photographer

Pentagram Design
Design Firm

Art Center College of Design
Publisher

Reardon & Krebs
Typographer

ColorGraphics
Printer

The Ultimate Album Cover Album
Book Jacket

Paula Scher
New York, NY
Art Director, Designer, and Artist

Koppel & Scher
Design Firm

Prentice Hall Press
Publisher

The Type Shop Inc.
Typographer

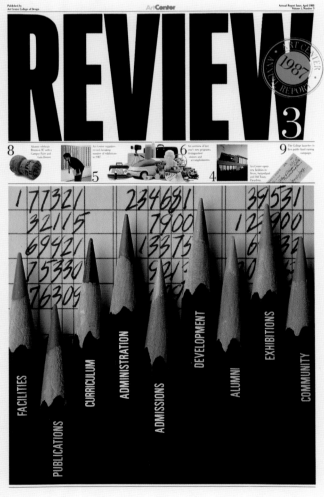

ArtCenter Review: 3
In-House Magazine

Kit Hinrichs
San Francisco, CA
Art Director

Kit Hinrichs and
Karen Boone
Designers

Steven A. Heller
Photographer

Pentagram Design
Design Firm

Art Center College
of Design
Publisher

Spartan Typographers
Typographer

ColorGraphics
Printer

Basic Blythe
Album Cover

Stacy Drummond
New York, NY
Art Director/Designer

Peter Kuper
Artist

CBS Records
Design Firm

CBS Records
Publisher

Cyber Graphics
Typographer

Shorewood Packaging
Corporation
Printer

The Best of Blue Note:
Volume 2
Album Cover

Paula Scher
New York, NY
Art Director/Designer

Koppel & Scher
Design Firm

Blue Note Records
Publisher

The Type Shop Inc.
Typographer

Queens Litho
Printer

Chapter 8 Forever
Album Cover

Tommy Steele
Art Director

Andy Engel
Studio City, CA
Designer/Artist

Andy Engel Design, Inc.
Design Firm

Capitol Records
Publisher

P A U L · S I M O N
G R A C E L A N D

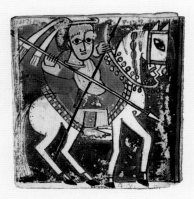

Paul Simon/Graceland
Album Cover

**Jeffrey Kent Ayeroff and
Jeri McManus-Heiden
Burbank, CA**
Art Directors

Kim Champagne
Designer

**Icon from Langmuir Collection,
Peabody Museum of Salem, MA
Mark Sexton**
Photographer

Warner Bros. Records Inc.
Publisher

**Mule, The Dream of a Beast,
Night in Tunisia, Sempreviva**
Paperback Cover Series

**Keith Sheridan
New York, NY**
Art Director

**Craig Warner and Keith
Sheridan**
Designers

Keith Sheridan
Artist

**Keith Sheridan Associates,
Inc.**
Design Firm

Aventura (Vintage Books)
Publisher

Boro Typographers
Typographer

Longacre Press
Printer

Uma Thurman . **Raoul Felder** . **Dan Dorfman** . **Alison Lurie**
Transcendental *On Love and* *On Wall Street* *The Politics*
Chic *the Law* *of Fashion*

FAME

Fame
Magazine Cover

Philip Gips
New York, NY
Art Director

Riki Sethiadi
Designer

David Seidner
Photographer

Frankfurt Gips Balkind
Design Firm

Anametrics, Inc.
Publisher

Lebanon Valley Offset
Company
Printer

Graphis: 256/1988
Magazine Cover

B. Martin Pedersen
Art Director/Designer

Ben Verkaaik
Artist

Graphis US Inc.
Design Firm

B. Martin Pedersen
Publisher

Graphic Technology
Typographer

Dai Nippon Printing
Co., Ltd.
Printer

Plan: Dossier Invention et Innovation
Journal Cover

Daniel Charron
Montreal, CAN
Art Director

Alain Levesque
Artist

Charron Concept
Design Firm

Ordre des Ingénieurs du Québec
Publisher

Contact Typographers
Typographer

Interweb
Printer

Real Estate Industries Centre
Brochure Cover

Bill Cahan
San Francisco, CA
Art Director

Erik Adigard
Designer

Erik Adigard
Artist

Cahan & Associates
Design Firm

Continental Development
Corporation
Publisher

EuroType
Typographer

MasterCraft
Printer

Herb Ritts Pictures
Book Jacket

Jack Woody
Altadena, CA
Designer

Herb Ritts
Photographer

Twin Palms Publishers
Publisher

Toppan Printing Co.
Printer

Album: The Portraits of Duane Michals 1958–1988
Book Jacket

Jack Woody
Altadena, CA
Designer

Duane Michals
Photographer

Twelvetrees Press
Publisher

Toppan Printing Co.
Printer

Squibbline, Winter 87
In-House Magazine

Anthony Russell
New York, NY
Art Director

Barbara Nieminen
Designer

Diego Rivera
Artist

Anthony Russell, Inc.
Design Firm

Squibb Corporation
Publisher

Squibb Corporation
Typographer

The Hennegan Company
Printer

American Illustration 6
Book Jacket

Walter Bernard
Art Director

Barbara Nessim and
James McMullan
New York, NY
Artists

WBMG, Inc.
Design Firm

Harry N. Abrams, Inc.
Publisher

**CCAC: California College
of Arts and Crafts**
Catalog Cover

**Michael Mabry
San Francisco, CA**
Art Director

Michael Mabry
Illustrator

**Leslie Flores and
Baron Wolman**
Photographers

Michael Mabry Design
Design Firm

**California College of Arts
and Crafts**
Publisher

**Andresen Typographics
and Macintosh**
Typographers

Alonzo Printing
Printer

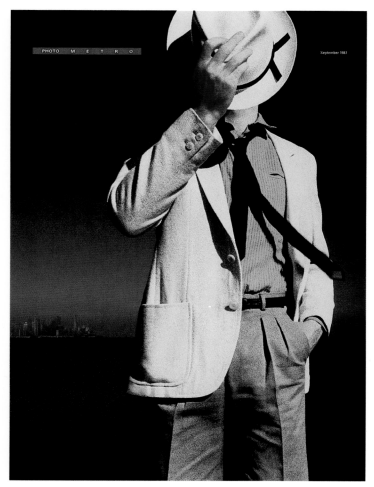

**PHOTOMETRO
September 1987**
Magazine Cover

**Henry Brimmer
San Francisco, CA**
Art Director

**Brimmer, Randall,
and Mejia**
Designers

Charly Franklin
Photographer

PHOTOMETRO
Publisher

Metro Type
Typographer

The Lawsuit Mess/How to Fix It
Magazine Cover

Everett Halvorsen
Art Director

Edward Sorel
New York, NY
Artist

Forbes
Publisher

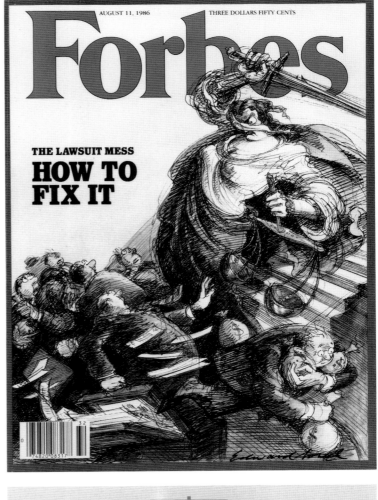

Jim Dine: Drawings 1973–1987
Catalog Cover

Julius Friedman
Louisville, KY
Art Director

Jim Dine
Artist

Images
Design Firm

Contemporary Arts Center
Publisher

QC Type, Inc.
Typographer

Pinaire Lithographing Corporation
Printer

13 Cocktails and a Punch
Self-Promotional Booklet
Cover

**Stephen Doyle and
Thomas Kluepfel
New York, NY**
Art Directors

**Rosemarie Sohmer and
Katy Delehanty**
Designers

Drenttel Doyle Partners
Design Firm

Drenttel Doyle Partners
Client

Trufont Typographers Inc.
Typographer

Pollack Litho Inc.
Printer

Nevertheless, we have improved man's lot and enriched his civilization with rye, bourbon, and the martini cocktail.

The Summer Book
Paperback Cover

**Louise Fili
New York, NY**
Art Director

James McMullan
Designer/Artist

Pantheon Books
Publisher

James McMullan
Letterer

Longacre Press
Printer

Small Family with Rooster
Book Jacket

**Andy Carpenter
New York, NY**
Art Director

James Steinberg
Designer

James Steinberg
Artist

St. Martin's Press
Publisher

Phoenix Color Corp.
Printer

Adweek Portfolio Creative Services Directory
Directory Cover

Walter Bernard and Milton Glaser
New York, NY
Art Directors

Shelley Fisher
Designer

Matthew Klein
Photographer

WBMG, Inc.
Design Firm

A/S/M Communications, Inc.
Publisher

Seven Graphic Arts
Typographer

Toppan Printing Co.
Printer

Il Fornaio
Dinner Menu Cover

Michael Mabry
San Francisco, CA
Designer

Michael Mabry
Artist

Michael Mabry
Design
Design Firm

Il Fornaio
Client

James H. Barry
Company
Printer

**Franz Kafka: The Castle, Diaries,
and The Complete Stories**
Paperback Cover Series

**Louise Fili
New York, NY**
Art Director

Anthony Russo
Artist

Pantheon Books
Design Firm

Pantheon Books
Publisher

The Type Shop Inc.
Typographer

Longacre Press
Printer

John Steinbeck:
The Grapes of Wrath
Book Jacket

Neil Stuart
New York, NY
Art Director/Designer

Don Bolognese
Artist

Viking Penguin, Inc.
Design Firm

Viking Penguin, Inc.
Publisher

Neil Stuart
Typographer

Walks in Gertrude
Stein's Paris
Paperback Cover

Clane Graves
Art Director

Roy Thatcher Clark
Designer

Formaz, Inc.
Design Firm

Gibbs M. Smith, Inc.
Publisher

Andresen Typographics
Typographer

The Viennese
Book Jacket

Alex Gotfryd
New York, NY
Art Director

Carin Goldberg
New York, NY
Designer

Doubleday
Publisher

Mary Emmerling's American
Country Hearts
Book Cover

Gael Towey
New York, NY
Art Director/Designer

Chris Mead
Photographer

Clarkson N. Potter, Inc./
Crown Publishers Inc.
Publisher

Trufont Typographers, Inc.
Typographer

Toppan Printing Co.
Printer

Nobody Knows the Trails Better: US West
Annual Report Cover

Charles S. Anderson and Joe Duffy
Minneapolis, MN
Art Directors

Sharon Werner and Charles S. Anderson
Designers

Westlight Studios
Photographer

The Duffy Design Group
Design Firm

US West
Client

Typeshooters
Typographer

Williamson Printing
Printer

Partners for the Long Ride: US West
Annual Report Cover

Sharon Werner
Minneapolis, MN
Art Director

Sharon Werner and Haley Johnson
Designers

Dan Weaks
Photographer

The Duffy Design Group
Design Firm

US West
Client

Typeshooters
Typographer

Williamson Printing
Printer

Prentice Hall Press Book News
Magazine Cover

Suzanne Zumpano Brooklyn, NY
Art Director/Designer

Barbara Nessim New York, NY
Artist

Idea Consortium
Design Firm

Prentice Hall Press
Publisher

Cardinal Type Services Inc.
Typographer

Fleetwood Printing
Printer

The Right Place, The Right Time
Brochure Cover

Walter Bernard and Milton Glaser New York, NY
Art Directors

Augustus Saint-Gaudens
Artist

WBMG, Inc.
Design Firm

The Cooper Union
Publisher

Associated Offset Co., Inc.
Printer

Simpson Filare

ITALIAN GRAPHIC DESIGN

ANNUAL

Italian Graphic Design
Brochure Cover

**James Cross and Michael Mescal
Los Angeles, CA**
Art Directors

Michael Mescal
Designer

Cross Associates
Design Firm

Simpson Paper Company
Client

Andresen Typographics
Typographer

George Rice & Sons
Printer

**Annual Report Covers
Are A Bore**
Booklet Cover

**John Waters
New York, NY**
Art Director

Donna Gonsalves
Designer

**John Waters Associates,
Inc.**
Design Firm

**John Waters Associates,
Inc.**
Publisher

Typogram
Typographer

Dubin & Dubin
Printer

Mead Signature
Promotional Folder Cover

Malcolm Waddell
Toronto, CAN
Art Director/Designer

The Image Bank, Canada
Photographer

Eskind Waddell
Design Firm

Mead Paper
Client

Cooper & Beatty
Typographer

Empress Graphics, Inc.
Separations

MacKinnon-Moncur
Limited
Printer

Mead Annual Report Show
Catalog Cover

Jann Church
Newport Beach, CA
Art Director

Walter Uri
Photographer

Jann Church Partners Advertising
& Graphic Design
Design Firm

Mead Paper
Client

Classic Type
Typographer

Super Rite Foods Inc.
1987 Annual Report
Annual Report Cover

Anthony Rutka
Baltimore, MD
Art Director

Kate Bergquist
Designer

Rutka Weadock Design
Design Firm

Super Rite Foods, Inc.
Client

General Typographers, Inc.
Typographer

Lebanon Valley Offset, Inc.
Printer

IDCA '88
Conference Brochure
Cover

Woody Pirtle
New York, NY
Art Director, Designer,
and Artist

Pentagram Design
Design Firm

International Design
Conference in Aspen
Publisher

Robert J. Hilton
Company, Inc.
Typographer

Heritage Press
Printer

**P.S./The Quarterly
Journal of The Poster Society**
Journal Cover Series

**George Tscherny
New York, NY**
Art Director/Designer

George Tscherny
Photographer

George Tscherny, Inc.
Design Firm

The Poster Society
Client

**Pastore DePamphilis Rampone,
Inc., Southern New England
Typographic Service, Inc., and
CTC Typographers Corporation**
Typographers

S.D. Scott Printing Company, Inc.
Printer

Tr. 4
Newsletter Cover

Bart Crosby
Chicago, IL
Art Director

Carl Wohlt
Designer

Crosby Associates Inc.
Design Firm

Typographic Resources
Client

Typographic Resources
Typographer

Rohner Printing Company
Printer

UCLA Extension:
Winter Quarter
Catalog Cover

Inju Sturgeon
UCLA Creative
Director

Ken Parkhurst
Designer/Artist

Ken Parkhurst &
Associates, Inc.
Design Firm

UCLA Extension
Marketing Department
Publisher

Flow of the River
Brochure Cover

Rick Vaughn
Albuquerque, NM
Art Director

Delilah
Artist

Vaughn/Wedeen
Creative, Inc.
Design Firm

Hispanic Culture
Foundation
Publisher

Starline Typesetting
Typographer

Starline Printing
Printer

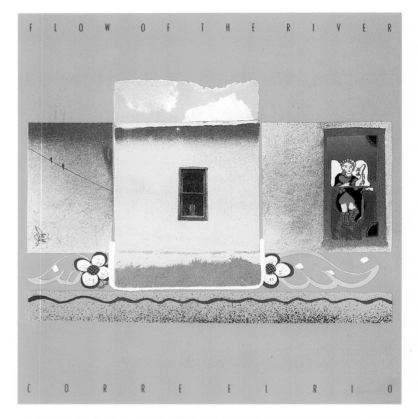

Seven Turning Points
H.J. Heinz Company 1988
Annual Report
Annual Report Cover

Bennett Robinson
New York, NY
Art Director

Bennett Robinson and Erika Siegal
Designers

Corporate Graphics, Inc.
Design Firm

H.J. Heinz Company
Client

Typogram
Typographer

Anderson Lithograph Company
Printer

Cogs in the Wheel: The
Formation of Soviet Man
Book Jacket

Carol Carson
New York, NY
Art Director

Chip Kidd
Designer

Henri Cartier-Bresson
Photographer

Alfred A. Knopf, Inc.
Publisher

Chip Kidd
Typographer

Phillips Offset
Printer

The Judgment Day Archives
Book Jacket

Sharon Smith
Art Director

Mark Fox
San Francisco, CA
Designer

Mark Fox
Artist

Blackdog
Design Firm

Mercury House
Publisher

Andresen Typographics
Typographer

R.R. Donnelley & Sons
Printer

**At Twelve: Portraits of
Young Women**
Book Jacket

Steve Dietz
Art Director

Louise Fili
Designer

Sally Mann
Photographer

Aperture Foundation
Publisher

David Seham Assoc.
Typographer

Meridan-Stinehour Press
Printer

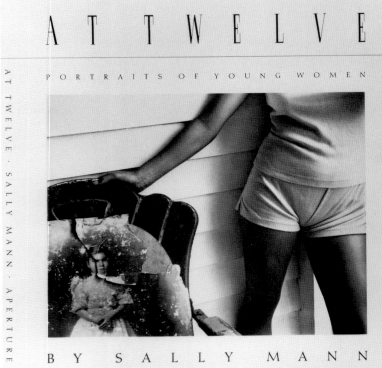

**The Truth about Lorin
Jones**
Book Jacket

**Steve Snider
Boston, MA**
Art Director

Fred Marcellino
Designer

**Little, Brown and
Company**
Publisher

Phoenix Color Corp.
Printer

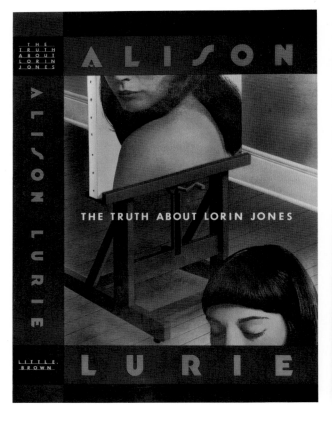

**Where Learning Comes
To Life**
Freshman Admissions
Guide Cover

Bill Freeland
Art Director

**James McMullan
New York, NY**
Artist

James McMullan, Inc.
Design Firm

**LaGuardia Community
College**
Client

Natural History
Book Jacket

**Carol Carson
New York, NY**
Art Director

Barbara DeWilde
Designer

James Armat
Artist

Alfred A. Knopf, Inc.
Publisher

Expertype
Typographer

Coral Graphics
Printer

The Death of Rhythm
and Blues
Book Jacket

Louise Fili
New York, NY
Art Director

Javier Romero
New York, NY
Artist

Javier Romero Studio
Design Firm

Pantheon Books
Publisher

The Type Shop Inc.
Typographer

Longacre Press
Printer

NCSD00000
Self Promotional Brochure Cover

**Stephanie Coustenis, Domenica
Genovese, Douglas B. Hutton,
George Kibler, Kathy Mannix,
June Ray Smith, Philip
D. Stouffer, Susann T. Studz,
Armand Thieblot, Bernice
Thieblot, Linda Thorne, Kelly
Walsh, and Marian Wingrove**
Art Directors/Designers

Richard Stein
Artist

**The North Charles Street
Design Organization**
Design Firm/Publisher

Peake Printers
Printer

Cinématheque Québécoise
Brochure Cover

Nelu Wolfensohn
Montreal, CAN
Art Director

Graham Holloway
Artist

Graphisme Lavalin
Design Firm

Cinématheque Québécoise
Publisher

Compoplus
Typographer

Atelier des Sourds
Printer

Trends:
The Journal of the Texas
Art Education Association
Journal Cover

Ron Bartels
Austin, TX
Art Director

Michael Sawyers
Designer

The University of Texas
at Austin
Design Firm

Texas Art Education
Association
Client

Schweers Typesetting
Typographer

The Lithoprint Company
Printer

Frans Masereel: The City and Landscapes and Voices
Paperback Cover Series

Louise Fili
New York, NY
Art Director

Frans Masereel
Artist

Pantheon Books
Publisher

The Type Shop Inc.
Typographer

Longacre Press
Printer

Let knowledge grow

Queens College, CUNY • Undergraduate Bulletin • 1988-1989

Queens College: Let knowledge grow
Bulletin Cover

Milton Glaser
New York, NY
Art Director

Milton Glaser and Suzanne Zumpano
Designers

Milton Glaser
Artist

Milton Glaser, Inc.
Design Firm

Queens College of the City University of New York
Client

Pastore DePamphilis Rampone, Inc.
Typographer

Queens College
Printer

Fire-PAL Report
Annual Report Cover

Forrest and Valerie Richardson
Phoenix, AZ
Art Directors

Forrest Richardson and Rosemary Connelly
Designers

Bill Timmerman
Photographer

Richardson or Richardson
Design Firm

Fire-PAL (Phoenix Fire Department)
Client

DigiType
Typographer

Prisma Graphic Corporation
Printer

The Peron Novel
Book Jacket

Louise Fili
Art Director

Julian Allen
New York, NY
Artist

Pantheon Books
Publisher

Design Firms and Agencies

Publishers, Publications and Clients

Typographers, Letterers and Calligraphers

Printers, Binders, Engravers, Fabricators and Separators